THOMAS EAKINS

VOLUME I

The Ailsa Mellon Bruce Studies in American Art

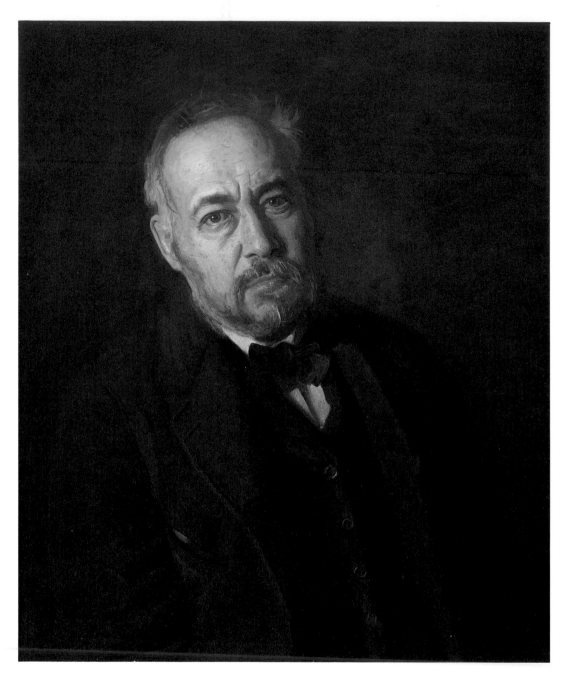

SELF-PORTRAIT
1902. Oil. 30 × 25. G 358
National Academy of Design

THOMAS EAKINS

Lloyd Goodrich

PUBLISHED FOR THE
NATIONAL GALLERY OF ART, WASHINGTON · 1982
HARVARD UNIVERSITY PRESS
CAMBRIDGE, MASSACHUSETTS, AND LONDON, ENGLAND

Library of Congress Cataloging in Publication Data

Goodrich, Lloyd.
Thomas Eakins.

(The Ailsa Mellon Bruce studies in American art; v. 2)
Bibliography: p.
Includes index.
1. Eakins, Thomas, 1844–1916. 2. Artists—
United States—Biography. I. Eakins, Thomas, 1844–1916.
II. National Gallery of Art (U.S.) III. Title. IV. Series.
N6537.E3G6 1982 709′.2′4 [B] 82-12170
ISBN 0-674-88490-6 (set)

Contents

Preface

THOMAS EAKINS is recognized today as the strongest purely realistic artist of late nineteenth- and early twentieth-century America. But in his lifetime he was the most neglected and misunderstood major painter of the period. Many of his chief works were rejected by the art establishment. He sold few paintings and received few commissions. He was a great innovating teacher, but was forced to resign as head of the Pennsylvania Academy of the Fine Arts by the academy's prudish directors. He had only a single one-man exhibition in his whole life. Aside from a few friendly critics in early years, reviewers attacked or ignored him until his old age. Not one article on him as a painter was published in his lifetime. Yet so strong was his character that he continued to create uncompromisingly realistic works throughout the forty years of his professional career.

Only after his death in 1916 did more recognition begin. The man chiefly responsible for this was Bryson Burroughs, Curator of Paintings at the Metropolitan Museum of Art, and himself a painter. In 1917 he organized a memorial exhibition that gave the first opportunity to see Eakins' life work. Henry McBride of the New York *Sun*, the most sophisticated and prophetic critic of the time, devoted three long reviews to the show. Other liberal critics began to write about Eakins, especially Walter Pach, Frank Jewett Mather, Jr., and Forbes Watson, editor of *The Arts*, the magazine supported by Gertrude Vanderbilt Whitney. In *The Arts* in 1923 and 1924 Burroughs' son, Alan, published the first full-length articles on Eakins and the first checklist of his known works, totaling 343.

I was a friend of Bryson Burroughs, and a lifelong friend of his son-in-law, the painter Reginald Marsh. Marsh and I shared the Burroughses' belief in Eakins, and as associate editor of *The Arts* I wrote about him. By 1929 I had become a contributing editor, with more time for writing but less income, and Marsh and I conceived the idea of my writing a full-length book on Eakins. He lent me $500 to start it, and wrote Mrs. Eakins in Philadelphia about our plan. She replied: "I appreciate very much your desire to publish an illustrated dis-

course on the Eakins work. I believe, however, the Eakins pictures will never be popular, and for this reason, I think your project may not repay you for the time and expense." But she agreed to help me, and thenceforth no one could have been more helpful.

During the next three years, 1930 through 1932, I spent much time in Philadelphia. Mrs. Eakins was still living in the old family house at 1729 Mount Vernon Street, which had been her husband's home since he was thirteen. She had been a favorite pupil of his, and now, in her late seventies, had resumed painting. Intelligent, liberal-minded, and kindhearted, with a keen sense of humor, Susan Macdowell Eakins, though physically small and slight, had inexhaustible energy. Devoted to her husband's memory, she had preserved everything of his: not only his paintings and sculpture, but every sketch and study, his beautiful perspective drawings, his letters, and the manuscripts of his lectures. She had a remarkable memory; in our many conversations and her many letters to me when I was back in New York, she was a unique source of firsthand information. No biographer could have been more fortunate than I was.

Sharing the Mount Vernon Street house was Miss Mary Adeline Williams, who had been a childhood friend of Eakins and his family. She, too, was generous with reminiscences of Tom Eakins. Susan Eakins' sister Elizabeth Macdowell Kenton, an occasional visitor, was also helpful.

When Eakins was in Paris as a student at the École des Beaux-Arts from 1866 to 1869, and then in Spain for six months, he had written to his father once a week: long letters telling of his studies, his ideas on art, his problems in beginning to paint. His father had kept these letters, and Mrs. Eakins lent them to me or copied them (with some minor editing, as I discovered later). She also lent me the original notebook, in French, which he had kept in Spain, recording his discovery of Velázquez in the Prado. All these documents I copied in toto. Their present whereabouts, and even existence, are unknown.

From Paris, Eakins had written almost as often to his favorite sister, Frances (later Mrs. William J. Crowell): letters even more filled with his ideas —on art, music, religion, languages. When I visited her in 1931 at her farm in Avondale, Pennsylvania, she gave me biographical information, but said she owned no letters from him. After her death in 1940 many letters came to light, in the possession of her daughter Dr. Caroline Crowell, who gave them to the Archives of American Art in 1974. Frances Crowell's memory may have failed (she was eighty-three when I visited her); but also there had been a rift between brother and sister. Many of Dr. Crowell's letters were incomplete, with pages missing. In the late 1970s the other halves came to light, and are now owned by the Wyeth Endowment for American Art, through whose generosity they are quoted in this book.

In 1930 Mrs. Eakins and Miss Williams had just given the Pennsylvania

Museum (now the Philadelphia Museum of Art) seventy works by Eakins—a magnificent gift, seldom equaled. But in the Mount Vernon Street house were many paintings still unsold, including some of his finest: some hanging; many more in his fourth-floor studio, unframed, some canvases unstretched and rolled up. I examined all the works in the house and made notes and individual catalogue pages on them. If they had not been photographed (few had been) I made drawings of them. I had not yet begun to use a camera—which I still regret.

Mrs. Eakins had two notebooks in which her husband and she had recorded his pictures, with dates, exhibitions, asking prices, and sales—if any. I copied them, again in toto. (And again, their present survival is unknown.) She gave me the names of current owners if she knew them; those she did not know I traced through other sources. So I was able to locate and see almost all the works recorded. In this research I had the constant and generous assistance of Henri Gabriel Marceau, Curator of Fine Arts of the Pennsylvania Museum and later its Director, who in 1930 had organized a large exhibition celebrating the gift by Mrs. Eakins and Miss Williams, and who had published a checklist of 373 items. The result of my research, search, and examination was the catalogue raisonné in my book, totaling 515 works. Since the book was published, a number of other works have turned up, mostly studies, sketches, and pictures painted away from Philadelphia and not recorded.

A large proportion of the works owned by those other than Mrs. Eakins were portraits. A good many of the sitters were still living, most of them friends or former students of Eakins. I was able to interview almost all of these sitters, and they had much to tell about his character, ideas, habits, and methods of work. I am still indebted to them for a great deal of the personal information included in my earlier book as well as this one. I did not use a tape recorder, which would have dried up the flow of frank talk, but immediately after each interview I wrote full notes on it. These friends and sitters included Mrs. Stanley Addicks (née Weda Cook), Adolphe Borie, Mrs. James Mapes Dodge, Mr. and Mrs. Nicholas Douty, Mrs. Mary Hallock Greenewalt, Mrs. E. Farnum Lavell (née Eleanor S. F. Pue), Monsignor Hugh T. Henry, Harrison S. Morris, Samuel Myers, Ernest Lee Parker, and Mrs. Lucy Langdon W. Wilson. Others outside of Philadelphia responded by letters: Professor Leslie W. Miller, a sympathetic and informative professional colleague of Eakins, Mrs. Robert C. Reid (née Maud Cook), Mrs. John B. Whiteman (née Alice Kurtz), and Miss Amelia C. Van Buren (who strangely enough wrote that she had no particular reminiscences of Eakins). The families of a number of deceased sitters provided further personal information.

I was fortunate to talk with ten of Eakins' former students. The one closest to him was the sculptor Samuel Murray, at first his assistant and then his colleague, who had shared his studio for eleven years, and who took the place of

the son that Eakins never had. Irish by descent, talkative and humorous, he enjoyed telling everything he remembered about his beloved master and friend. He was not strong on exact matters such as dates, and some of his stories, I came to realize, were not entirely correct. But next to Mrs. Eakins he was the most generous with time and information.

Another highly helpful former student was Charles Bregler, who had recorded Eakins' sayings to his pupils and had published them in *The Arts*, and who gave me permission to republish them. Other students who provided valuable firsthand information were Thomas J. Eagan, David Wilson Jordan, Frank B. A. Linton, Edmond T. Quinn, Frank W. Stokes, James L. Wood, James Wright, and Francis J. Ziegler. The sportswriter Clarence W. Cranmer, who was acting as Mrs. Eakins' sales representative, was a mine of data on Eakins' prizefighting and wrestling subjects.

In 1930, the same year that I began my research, the Whitney Museum of American Art was founded. Through *The Arts* I had become a friend of the museum's first Director, Juliana R. Force, and she asked me to write and edit a series of monographs on contemporary American artists. But I was committed to Eakins and had to decline. She then offered me a salary to finish the book. This once-in-a-lifetime opportunity was one more evidence of the understanding and generosity of two remarkable women, Mrs. Force and Gertrude Vanderbilt Whitney. Through their wholehearted support I now had full time to complete research and to write the book, which the Whitney Museum published in early 1933.

Before publication I had sent a copy of the manuscript to Mrs. Eakins, asking her to correct any factual errors. In her reply she wrote: "I wonder about the amount of writing about a man who did not care to be written about." This was a bit of a shock until I realized that it was just what Eakins himself would have said. Answering a request for biographical information in the 1890s, he had given the bare facts, ending: "For the public I believe my life is all in my work."

The book sold slowly, but by 1940 it was out of print. In the late 1960s the Harvard University Press, with the sponsorship of the National Gallery of Art and the Ailsa Mellon Bruce Foundation, suggested a revised edition, as one of the Ailsa Mellon Bruce Studies in American Art, of which the first was Jules D. Prown's two-volume *John Singleton Copley*. Rereading my 1933 book, I realized that it could not be republished: the work of a writer in his early thirties, it was too literary and too laudatory. And much new material had accumulated since 1933: Eakins' letters to Frances Eakins, additional information from friends and students, the discovery of unrecorded pictures, the results of research by younger scholars, and the whole field of his photography, inadequately covered in the early book. Also, there had been so many changes in

ownership of his works, so many publications, exhibitions, and reproductions, that the 1933 catalogue was completely out of date.

Moreover, in 1933 I had not used the full texts of Eakins' letters or of contemporary reviews and documents. Nor had I by any means used all the information given by the people I had talked and corresponded with. Mrs. Eakins was still living, as were friends and students, and although there was nothing derogatory in what they had told me—quite the contrary—much of it was too personal.

Fortunately I had kept all my 1930s material: copies of Eakins' letters, of his Spanish notebook and the record of his works; letters from friends and owners; transcripts of interviews; and my catalogue pages on pictures examined. So this book, about four times as long as the 1933 one, has an almost entirely new text.

The present two volumes are to be followed by a third: a catalogue raisonné of Eakins' works in all mediums except photography.

Since 1933 the literature on Eakins has increased enormously. The first sizable contribution was Margaret McHenry's *Thomas Eakins who painted* (1946), the product of her extensive interviewing of Eakins' friends and students, particularly Samuel Murray, who supplied ample reminiscences, some of which she accepted too uncritically; and Charles Bregler, who after Mrs. Eakins' death in 1938 had preserved his master's letters, and who provided the complete texts of several of which Mrs. Eakins had copied only excerpts for me. Miss McHenry presented this mass of material in odd disorganized form, but it is full of firsthand personal information, some of it incorrect.

Sylvan Schendler's *Thomas Eakins* (1967) was a thoughtful, perceptive study of Eakins' mind and art examined in the context of the contemporary American cultural scene, philosophical and literary as well as artistic; taking account of the limitations of his environment and their effect on him, but stressing the strength and depth of his art. The 158 well-chosen black-and-white illustrations presented the most complete pictorial survey of his work up to then. I am indebted to Mr. Schendler for making available several letters from Eakins' surviving sitters.

A number of illustrated monographs on Eakins with shorter biographical and critical texts began to appear in the 1940s: Roland J. McKinney's (1942); James Thomas Flexner's in the Metropolitan Museum's Miniature series (1956); Fairfield Porter's, with a definitely negative text (1959); the catalogue of the National Gallery's Eakins exhibition, 1961, with text by myself; and the catalogue of the Whitney Museum's exhibition, 1970, again with text by me, published also in hardcover.

There was no adequate coverage of Eakins' photography until 1972, when Gordon Hendricks, who had organized the exhibition, "Thomas Eakins: His Photographic Work," at the Pennsylvania Academy in 1969, published *The Photographs of Thomas Eakins*, cataloguing and reproducing 291 photographs by or related to Eakins.

In 1974 Mr. Hendricks, who had written several thoroughly researched magazine articles on individual paintings, published *The Life and Works of Thomas Eakins*, the longest and most fully illustrated biography to date. In it he assembled practically all the information then available about the artist's life, some from sources which had not been previously used fully, such as the archives of the Pennsylvania Academy and the Philadelphia Museum, the Sartain family papers, the Bregler and Murray collections in the Hirshhorn Museum, the half of Eakins' letters to his sister Frances that are now in the Archives of American Art, and contemporary reviews and news stories. Although many of the innumerable details were irrelevant to Eakins as an artist, the book was the most complete biography so far. In his Preface the author deplored what he considered the lack of accurate biographical information in previous writings on Eakins, saying: "It was a recognition of this state of affairs—the relatively small amount of work done and even that flawed by lack of documentation—that led to my own work. . . . The facts must be set down, their sources given, and fact cleanly separated from opinion." Unfortunately, however, the book contains numerous errors in what are purported to be facts, including facts easily verifiable from original sources. In the Notes to the present book I have attempted to correct the most serious of these errors.

The largest collections of Eakins' works are those of the Philadelphia Museum of Art and the Hirshhorn Museum and Sculpture Garden. The Philadelphia Museum's holdings, going back to 1928, made it a natural center for Eakins studies. Its Conservator, the late Theodor Siegl, was not only the most experienced and knowledgeable expert on the painter's technical methods, but through the years assembled information on the museum's works, until he became a leading Eakins authority. In the early 1970s he began to prepare for publication a handbook on the Eakins collection, with complete information on each work. He had almost finished this project at the time of his tragic death in 1976. Work on the handbook was carried on by his assistant, Elizabeth Havard, whose gift for thorough, accurate research made her an Eakins scholar in her own right. I was glad to make my records available to her, and she reciprocated generously with every kind of information. The handbook, *The Thomas Eakins Collection*, published in 1978 with a broadly based, illuminating biographical and critical introduction by Evan H. Turner, the museum's former Director, is a model of scholarship. I am much indebted to Theodor Siegl, Dr. Turner, and Ms. Havard for their unfailing cooperation in my own research.

I am also very grateful to Darrel Sewell, the museum's Curator of American Art, for his constant cooperation, and his invaluable help in securing photographic material in color and in black and white, for the illustrations in this book.

THe Hirshhorn Museum's large Eakins collection is the result of Joseph Hirshhorn's enthusiastic collecting for over twenty years, aided by Abram Lerner, now Director of the museum. In 1961 Mr. Hirshhorn acquired the paintings, sculpture, drawings, documents, and memorabilia that had been preserved by Charles Bregler; and, four years later, Samuel Murray's extensive collection of Eakins' studies, photographs, clippings, and other personal material. In 1977 the museum held a large exhibition of its Eakins works, supplemented by documentary material from the Bregler and Murray collections. Accompanying the exhibition was a major catalogue, *The Thomas Eakins Collection of the Hirshhorn Museum and Sculpture Garden*, also published as a book. The research for the exhibition and the catalogue, and the writing of the text, were by Phyllis D. Rosenzweig of the museum's Department of Painting and Sculpture, who provided full, accurate documentation on every work, whether painting, sculpture, drawing, photograph, letter, or object, including Eakins' palette, camera, and drafting instruments. Thanks to Ms. Rosenzweig's scrupulous scholarship, the publication is an invaluable assemblage of original firsthand material on Eakins' art and life.

In the last decade Eakins as a subject for research has attracted more scholars, especially younger scholars, than any other American artist of his period. The reasons, aside from the quality of his art, are various. He was an artist of unusual mental powers: a rare combination of artist and scientist. He was a man of strong character and opinions, with complex relations, positive and negative, with the society in which he lived. He was both deeply involved in that society, and a rebel against its puritanism. He was a realistic portraitist of the American people of his time; a teacher who revolutionized outworn art educational methods; a sculptor; a pioneer in photography, both still and motion; and an artist whose career, marked by early reputation and later almost total neglect, furnishes a revealing commentary on the nineteenth-century American art scene.

Among the scholars who have made substantial contributions to Eakins research and literature in recent years, in addition to those already referred to, are William Innes Homer, Ellwood C. Parry, III, David Sellin, Barbara Novak, Maria Chamberlin-Hellman, Zoltan Buki, Suzanne Corlette, Moussa Domit, Susan Casteras, Abram Lerner, Darrel Sewell, Louise Lippincott, Sidney Kaplan, Ronald J. Onorato, Gerald M. Ackerman, Lois Dinnerstein, Robert McCracken Peck, and Synnove Haughom. Most of their individual contribu-

tions are described more fully in the Notes to this book. A number of these contributions contain information on particular aspects of Eakins' work fuller and more detailed than I have been able to include. Speaking personally, I am much indebted to these scholars for their research and publications.

Several of these scholars were among the thirteen who contributed essays to a special Eakins issue of *Arts Magazine* in May 1979, edited by Richard Martin, which produced fresh information and viewpoints on a variety of subjects. (The present Preface owes some of its facts and ideas to my article in this issue.)

Certain universities have held graduate seminars on Eakins: those of William Innes Homer at the University of Delaware, Jules D. Prown at Yale, and Ellwood Parry at Columbia; and their students have done valuable original research. In 1977 fifteen of Professor Homer's students, as part of their Eakins seminar, assisted Ms. Rosenzweig with research for the Hirshhorn Museum catalogue; and in 1979–80 fifteen others performed the same function for the Brandywine Museum's joint exhibitions "Eakins at Avondale" and "Thomas Eakins: A Personal Collection," and the excellent accompanying catalogue.

Professor Homer is now working on the publication of the complete texts of all Eakins' writings, including letters and lectures. For this important project I have been glad to make available to him the letters I assembled in 1930 to 1932.

With all this material now available, this book has taken some years to complete. The Harvard University Press has been very patient about this, and I am grateful for their forbearance. In particular, I wish to thank Ann Louise McLaughlin, Senior Editor, whose wisdom and experience produced many improvements in the text and in the order of presentation; and Marianne Perlak, Senior Designer, for her expert handling of the book's complex format.

I also want to express my gratitude to the staff of the National Gallery of Art, which sponsored the book and waited patiently for its completion. The Gallery's former Editor-in-Chief, Theodore S. Amussen, was a most understanding and supportive editor. His Assistant Editor, Paula M. Smiley, has taken off my hands the complicated process of gathering the photographic material for the illustrations, for which I am very grateful to her. I also wish to thank J. Carter Brown, Director of the National Gallery, Charles P. Parkhurst, Assistant Director, John Wilmerding, Curator of American Painting, and Frances P. Smyth, Editor-in-Chief.

Together with the Harvard University Press and the National Gallery of Art, I wish to thank the collectors, museums, galleries, and institutions who have given their generous permission to reproduce works owned by them; and the institutional and individual owners of letters and other documents for their generous permission to quote these letters and documents. About the latter, fuller information is given in the Notes.

During the fifty-two years of my involvement with Thomas Eakins I have had the generous help of many individuals and institutions, in addition to those I have spoken of. I want to express my thanks to:

Seymour Adelman, close friend of Mrs. Eakins in her later years, and constant champion of Eakins, who has written delightfully about them and their home; who formed an outstanding collection of Eakins' paintings, studies, drawings, photographs, letters, journals, and other personalia; and who bought the Mount Vernon Street house and raised substantial funds to preserve it as a community art center and a living memorial to Eakins.

Mr. and Mrs. Daniel W. Dietrich II, knowledgeable collectors and enthusiasts for Eakins' art, who helped the Mount Vernon Street project by buying much of the Adelman collection; who generously made available to me their Eakins letters and journals; and who sponsored the film "Eakins," directed by Christopher Specth in 1971.

Mrs. Eakins' nephew, the late Walter G. Macdowell, his sister Mrs. John Randolph Garrett, Sr., and his daughter Peggy Macdowell Thomas, for information about their paintings and permission to reproduce them. Andrew and Betsy Wyeth, longtime admirers of Eakins, who have assisted generously in conserving his paintings and preserving his letters. Leslie Katz, publisher of finely designed and printed books, who demonstrated his admiration for Eakins by naming his publishing house The Eakins Press. Raphael Soyer, who recorded his love of Eakins' art in his impressive painting *Homage to Thomas Eakins,* now owned by the Hirshhorn Museum; and in his book of the same title. The late William Campbell of the National Gallery of Art, who in 1961 organized the major Eakins Retrospective Exhibition, also shown at the Art Institute of Chicago and the Philadelphia Museum of Art. The Metropolitan Museum of Art, for making available Bryson Burroughs' correspondence about their 1917 Eakins memorial exhibition: in particular, to John K. Howat, Natalie Spassky, Patricia Pellegrini, Archivist, and Maryan W. Ainsworth; and to Margaret P. Nolan and Deanna Cross for their help in furnishing photographs and color transparencies. Sarah Faunce and Linda Ferber of the Brooklyn Museum, for information about the museum's paintings and for cooperation in securing color transparencies. The Archives of American Art/Smithsonian Institution, and its Director, William Woolfenden, and its Archivist, Garnett McCoy, for permission to quote from the Archives' extensive collection of Eakins letters and documents. The staff of the Frick Art Reference Library, for years of courteous assistance to Mrs. Goodrich and myself. Joseph Seraphin of the Olympia Galleries, Philadelphia, who discovered and acquired a group of Eakins' unrecorded photographs, and kindly allowed me to illustrate eleven of them. Lawrence Campbell of the Art Students League of New York, who provided essential facts about Eakins' teaching at the League. The Reverend John J. Shellem, former Director of Libraries, Saint Charles

1. Childhood and Youth

IN THE SECOND HALF of the nineteenth century one of the main artistic tendencies in both Europe and America was naturalism. Innovating artists rejected the classic or romantic subjects of the first half of the century and turned to contemporary life. Abandoning traditional styles, they painted what they saw with their own eyes. In France the chief champion of the new viewpoint was Gustave Courbet, but it had independent exponents in other countries. In the United States the two leading representatives of naturalism were Thomas Eakins and Winslow Homer.

In 1870, when Eakins began to paint the native scene, the dominant artistic viewpoint in America was a combination of romanticism in subject matter and literal representation in style. The Hudson River School was picturing the wild and spectacular features of the continent. Genre painters were depicting old-fashioned rural life with nostalgic sentiment. But so far the American city and the lives of city dwellers had found little reflection in established art.

Thomas Eakins took the middle-class urban world of his place and time— Philadelphia from 1870 to 1910—and with uncompromising realism built his art out of this unromantic material. He concentrated on certain basic human realities: individual men and women, their faces and bodies, their clothes and houses, their outdoor and indoor lives. By the clarity of his vision, the strength and depth of his artistry, and the intensity of his attachment to the people and the things he painted, he gave the enduring life of art to the world in which he lived.

II

Thomas Cowperthwait Eakins was born in 1844 in Philadelphia, the city in which almost his entire life was to be spent. His ancestry was Scotch-Irish on his father's side, English and Dutch on his mother's. His immediate forebears were craftsmen. Alexander Eakins, his paternal grandfather, was a Protestant from Northern Ireland. Family tradition was that his name was originally spelled Akins, that he married Frances Fife in Ireland in 1812, came to

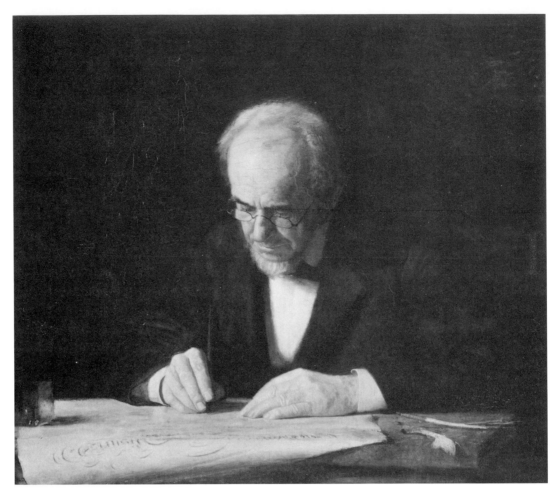

1. THE WRITING MASTER
1882. Oil. 30 × 34¼. G 188*
The Metropolitan Museum of Art; Kennedy Fund, 1917

America, probably that year, and settled on a farm in Valley Forge, Chester County, Pennsylvania. In 1828 he became an American citizen, spelling his name Eakins. He was a weaver, who sometimes traveled by foot in his craft. He and Frances Eakins had four children, the third of whom, Benjamin, future father of the artist, was born on the farm on February 22, 1818.

As a young man Benjamin moved to Philadelphia and became a writing master, engrossing documents such as diplomas, deeds, and testimonials, and teaching the old-style Spencerian hand in private schools; he taught at Friends' Central School for fifty-one years, from 1845 to 1896. In a long life

* G numbers are those of works in the catalogue in Lloyd Goodrich, *Thomas Eakins: His Life and Work*, 1933. These numbers will be retained in the forthcoming catalogue raisonné.

devoted to fine craftsmanship he became a familiar Philadelphia figure, commonly called "Master Benjamin" in Quaker style, though he was not a Friend. A man of complete integrity, kindly and sociable, he was a favorite among his former pupils, especially the young ladies. His son was to perpetuate him in several paintings, notably in *The Writing Master*, when he was sixty-four: a round head, bald brow, shaggy eyebrows, gray eyes, long, clean-shaven upper lip, a fringe of whiskers beneath his chin, strong hands used to precise work, and an expression both firm and benign.

Benjamin Eakins married Caroline Cowperthwait in 1843. Her father, Mark Cowperthwait, a Quaker of English and Dutch descent, born in southern

2. MRS. BENJAMIN EAKINS
c. 1874. Oil. 24 × 20. G 84
Mr. and Mrs. Daniel W. Dietrich II

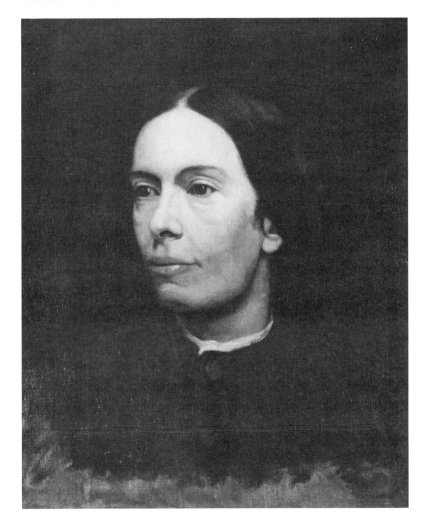

New Jersey, had been a forceful character, big and strong, with a dark complexion that reappeared in his children and grandchildren; he was said to be strict about such matters as women's dress. A shoemaker, he had moved to Philadelphia, where he had also gone into building and accumulated real estate. In 1795 he had married Margaret Jones, also American-born, when he was about thirty and she only fifteen. They had ten children, of whom Caroline, born in 1820, was the youngest. Her father died when she was about seventeen, and because her mother was not a Quaker, she did not grow up in that faith. In a portrait painted by her son from a photograph after her death in her early fifties, she has dark brown eyes and hair and a brunette complexion. The severe style—hair drawn down tight to a bun at the back, plain black dress with a high collar—contrasts with the candid eyes and the wide full-lipped mouth; a strong, sensitive face, suggesting a capacity for deep feeling.

The first child of Benjamin and Caroline Eakins, a boy, was born on July 25, 1844, in the Cowperthwait house at 4 Carrollton Square, Philadelphia (now 539 Tenth Street). He was named Thomas Cowperthwait Eakins, after one of his mother's brothers. When he was eight the family moved to a second house; later, a third; and finally, in July 1857, when the boy was almost thirteen, his father purchased a house at 1725 Washington Street (later changed by the city to 1729 Mount Vernon Street). This was to remain the Eakins home for more than eighty years.

When I first visited 1729 Mount Vernon Street in 1929 to see Mrs. Thomas Eakins, the house and the street were much as they had been in the nineteenth century: a quiet, tree-lined street in a middle-class residential area (which later was to decline into a ghetto). Number 1729 was much like its neighbors: a red brick house with white stone doorsteps, and tall first-floor windows whose blinds were usually closed against the summer heat or the winter snow. The dark, high-ceilinged rooms were filled with mahogany and rosewood furniture, some old, from the Cowperthwaits, some mid-nineteenth-century; pieces that had figured in Eakins' paintings were still there. Outside was a brick-paved backyard with trees and shrubs; and over the walls could be seen similar houses and yards and trees. The whole scene reminded me of paintings by the Dutch Little Masters. Beside the front door was still a silver nameplate: "B. Eakins."

Benjamin Eakins and his family, though far from rich, were in comfortable circumstances; besides income from his profession, he had acquired stocks, bonds, mortgages, and some city real estate; and they lived simply but well. As the years passed, three sisters were born: Frances, Margaret, and Caroline (Fanny, Maggy, and Caddy), respectively four, nine, and twenty years younger than Tom, who was old enough to be Caddy's father. After Fanny, born in 1848, a second son, Benjamin, had been born in 1850, but had died at four months. The testimony of everyone who knew the family, and of Eakins' later

letters, shows that the relations among all the members were unusually close. Especially between father and son there was an exceptional companionship. Both of them liked outdoor activities, which they shared in the country around Philadelphia.

Tom's education began at home and was continued in the city's public schools. At nine he entered the Zane Street Grammar School, from which he graduated in 1857 with high grades. On July 11 of that year he was admitted to the Central High School of Philadelphia. This, the oldest high school in America outside New England, was practically a junior college, with an outstanding faculty and a curriculum as advanced as many colleges of the time, unusual for its emphasis on the sciences; and its pupils represented the pick of the city's young men in intelligence. "Tom C. Eakins," as his name appeared in the school records, just under thirteen when he entered, was almost two years younger than the average of his class. An excellent student, he was always in the upper level of his class: number four of forty-two in his first year, numbers eight and five in the two terms of his second year, numbers five and four in his third year, and number five of the fourteen in his graduating class. (The Civil War had begun, and several of his classmates had enlisted.) His marks were particularly high in mathematics, sciences, and French; good or fair in English and history; high in first-year Latin, but low the next two years. His final average was 88.4.

In drawing, which he studied all four years, he invariably received a grade of 100. This course, taught by Alexander Jay MacNeill, included mechanical drawing and the study of perspective. Several of Tom's student drawings have been preserved. Three of them, dated 1858 and 1859, are of romantic foreign scenes: operatic peasants among ruins; women fording a stream; and a running camel with a half-naked Arab on its back. Evidently copies of prints (so far unidentified) selected by his teacher, they are executed with considerable skill if in a style totally alien to any other known works of his.

Entirely different are (or were, since the present ownership of two is unknown) four drawings: an icosahedron (a twenty-faced polyhedron); a complicated pump, perhaps part of the Philadelphia waterworks; a gear wheel and interlocking worm; and a lathe, titled "Perspective of Lathe / in possession of B. Eakins," signed "Tom Eakins 1860." These drawings, which are three-dimensional, constructed in perspective, and with notes of measurements, are precise and absolutely sure, practically professional—remarkable productions for a boy in his teens, showing a mastery of perspective such as many mature artists never attain. The lettering on the lathe drawing is perfect—a continuation of his father's craftsmanship. His last dated student drawing (evidently from a photograph), signed "Tom C. Eakins July 1861," was of the colossal statue of Freedom by Thomas Crawford, which was soon to be erected atop the Capitol in Washington.

3. PERSPECTIVE OF LATHE IN POSSESSION OF B. EAKINS
1860. Pen and ink, and watercolor. 16⁵/₁₆ × 22. G J6
Hirshhorn Museum and Sculpture Garden, Smithsonian Institution

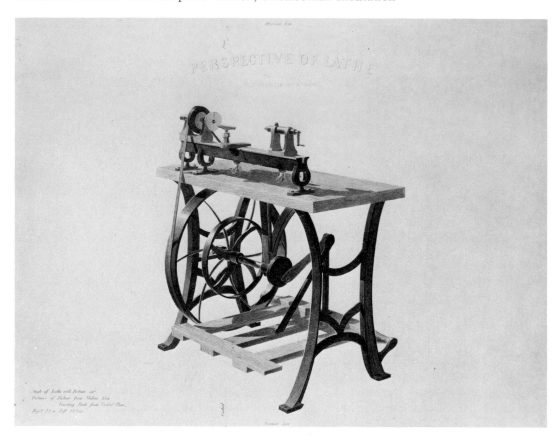

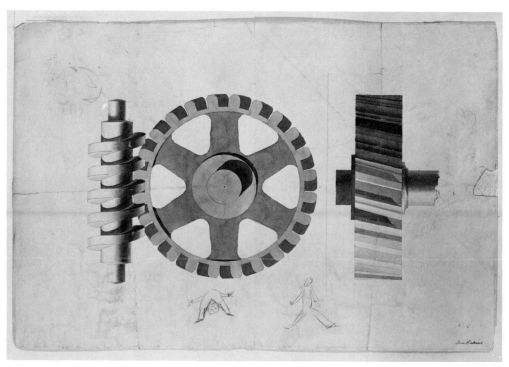

4. DRAWING OF GEARS
c. 1860. Pen and ink, wash, and pencil. 11⁷/₁₆ × 16⁷/₈. G J7
Hirshhorn Museum and Sculpture Garden, Smithsonian Institution

On July 11, 1861, not quite seventeen, he graduated with a degree of Bachelor of Arts. Asked to give a graduation address, he refused, saying that he had done nothing original, that all he had learned had been from books, where others could read it for themselves.

<p style="text-align:center">III</p>

Tom Eakins had grown up to be a strong young man, taller than his father, about five feet nine, but resembling him in many ways: round head, heavy eyebrows, high cheekbones, long upper lip, firm mouth and chin. He had his mother's dark complexion, dark brown eyes, and almost black hair; his color was like that of an Italian or Spaniard. Photographs of the time show a youth with a direct, penetrating gaze; a thoughtful, imperturbable expression; and the general look of a serious, somewhat formidable person. Not yet heavy, as he was to become later, he was powerfully built, with a broad chest; shoulders not extra wide but solid; strong arms; and very strong legs—the build of a runner, swimmer, rower, or skater, more than of a boxer or wrestler. He paid little attention to his personal appearance, and liked old, rough, comfortable clothes.

His boyhood love of the outdoors remained unchanged, as it was to all his life. Philadelphia, with the Schuylkill River and Fairmount Park in the heart of the city, and the broad Delaware River to the east, had always been noted for outdoor sports and recreations; and in the smaller Philadelphia of that day, the country was close to the town. Tom's activities were simple and close to nature: rowing, sailing, swimming, skating, walking, hunting. Both he and his father were fine skaters, the older man adept in fancy figures, the younger noted for speed and endurance, and the ability to skate backward as fast as others could forward. Summers and falls he would accompany his father hunting railbirds in the marshes bordering the Delaware. Benjamin had a small sailboat, and Tom was often out on the river at four o'clock in the morning. The Schuylkill was a busy center for racing shells, and Tom was an oarsman. He especially loved swimming, and was a strong swimmer and an inventive diver. A letter from his good friend and former high school classmate Max Schmitt (later a champion oarsman, and the subject of one of Eakins' first paintings), on May Day 1866, urged a "schwim" in the Schuylkill: "Then shall we again have belly smashers, back bumpers, side switches, etc., etc. Then shall we see [sketches of a youth diving and swimming] and *divers* other beautiful performances by the immortal T.E.C. Guess I'll never beat you in swimming—have given that up!"

But Tom's activities were not merely physical. Already a strong adult character was evident. The atmosphere of his home was liberal, and the young man was revealing a bold inquiring mind, independent thinking, and indifference to conventions. In religion he was an agnostic and anticlerical; in poli-

tics, a libertarian, an antimilitarist, and a Democrat. His ideas and opinions were his own, firmly held and frankly expressed. Endowed with an enormous appetite for knowledge, he pursued studies outside of school and after he graduated. Any subject he embarked on was gone into thoroughly. In high school he had received a grade of 98 in French; and after leaving school he continued to study languages, teaching himself Italian from books. Mathematics and the natural sciences remained dominant interests, increasing with the years. His manual skill was marked; he had a well-equipped workroom, and at seventeen he built a model steam engine, which actually ran.

Among his three sisters Fanny, though four years younger, was growing up close to him in mind and interests. Like many young ladies of the day, she was studying piano, but more seriously than most. Although he played no instrument, Tom shared her love of music. They had many friends of his and her ages, male and female. Among his closest companions were Max Schmitt, William Sartain, and William J. Crowell, all former classmates at Central High School. He was far from girl-shy, and his later letters from abroad sent fond remembrances to a number of young women. His friendships were not confined to his own age-group, but extended to his father's and mother's friends, with whom he was on adult terms while still in his teens—unusually so for a young person.

IV

The Civil War had begun three months before Tom graduated from high school; but perhaps because of his age, his partly Quaker ancestry, or his political beliefs, he did not enlist as did Schmitt and Sartain. The war ended when he was twenty, and there is no evidence that he was ever called up.

In September 1862 he applied for the position of Professor of Drawing, Writing, and Book Keeping in Central High School (at eighteen!), but was passed over in favor of the older artist Joseph Boggs Beale. For a time he helped his father with engrossing and with teaching penmanship; the city directories in 1863 and 1864 listed him as "teacher," and in 1866 as "writing-teacher." But the demand for fine writing was diminishing, and the older man must have realized that there was little future in his profession, which in any case would have been too routine for Tom's active mind.

Benjamin was an amateur painter and had several artist friends, among them George W. Holmes, painter and teacher, under whom many young Philadelphians received their first art instruction. The two men and the youth would go on Sunday walks in the country, taking their lunch, and stopping to sketch; a pencil drawing by Tom showed his elders seated under a tree, with a lunch basket and a bottle. Perhaps connected with these excursions were several landscape drawings by Tom, including a series of trees, somewhat drawing-masterish (probably MacNeill's or Holmes's influence), but precise in ren-

dering the character of each tree, identified by its name. There were also artistic friends of his own generation: Bill Sartain and his sister Emily, and Charles Lewis Fussell, a future landscapist, with whom he sketched. One oil by Fussell shows Tom seated indoors, painting, and naked; already his freedom about nudity was manifesting itself.

Benjamin did not oppose his son's becoming an artist, perhaps considering this a natural step up from his own craft. Tom's professional training began at the Pennsylvania Academy of the Fine Arts, within a year or so of his graduation from high school. The Academy, the oldest art institution in the United States, was then located at Tenth and Chestnut streets, in a Roman-Doric temple designed for impressiveness more than practicality. Its collections consisted of some old masters of doubtful attributions; big historical and biblical paintings by Benjamin West, Washington Allston, and other exponents of the grand style; some fine American portraits by the Peales, John Neagle, Thomas Sully, and other Philadelphians; and a good collection of plaster casts of Greek and Roman sculpture, recently acquired in London and Paris. These must have been about all the works of art that young Eakins could have seen, for there was no other museum in the city—indeed this was one of the few public collections in America. "Over it all there was a stillness," wrote a student of the time. "The smallest noise made an echo; it all seemed majestic."

Edwin Austin Abbey, who entered the Academy in 1868, later recalled its atmosphere: "What a fusty, fudgy place that Philadelphia Academy was in my day! The trail of Rembrandt Peale and of Charles Leslie, of Benjamin West, and all the dismal persons who thought themselves 'Old Masters,' was over the place, and the worthy young men who caught colds in that dank basement with me, and who slumbered peacefully by my side during long anatomical lectures, all thought the only thing worth doing was the grand business, the 'High Art' that Haydon was always raving about."

The Academy school, like the few other American art schools of the time, had little to offer students. In the beginning they were required to draw from the antique casts, and they could attend a series of twenty lectures on anatomy given by a physician, Dr. Amon Russell Thomas. There was no organized curriculum with regular paid instructors. The critic Earl Shinn, a student in the late 1850s and early 1860s, and later a good friend of Eakins, wrote disparagingly in 1884: "No instruction was provided, but the older students assisted their juniors to the best of their ability. During each winter weekly lectures on anatomy were delivered by a physician who had no great opinion of the requirements of a congregation of art students." After a proper period with the antique, the approved student could be admitted to the life class (for men only) to draw from the nude model, three evenings a week. The life class was not only for students but included a considerable proportion of professional artists availing themselves of the opportunity to draw from the model. In the

absence of regular instructors these older men probably gave some informal criticism to the younger ones. One of the most active of these seniors was the Alsatian-born, Paris-trained painter Christian Schussele, twenty years older than Eakins. They undoubtedly knew one another, and Schussele may have given the young man some assistance, but to what extent is unknown.

Only drawing was done in the life class, not painting. That Eakins drew but did not paint, except occasionally outside the school, is confirmed by his letters from Paris in 1867. The classroom was in the basement, "a dark and ill-ventilated cellar," according to Shinn. Because of the difficulty of obtaining female models, they were heavily outnumbered by males and were paid three dollars a session, twice what the men received. The women often wore masks, to hide their identity. The curator of the class was responsible for seeing that nothing untoward occurred, such as "singing, whistling, smoking, loud conversation, or other indecorous conduct." Rule No. 1 was: "No conversation is permitted between the Model and any member of the class."

The first record of Eakins' studying at the Academy was in the fall of 1862, when his name appeared in the Student Register, and he was issued a card (still preserved) dated October 7, admitting "Tom C. Eakins" "to draw from the casts from the antique, and attend the lectures on anatomy." His period of probation must have been relatively short, for on February 23, 1863, at eighteen, he was in possession of another card (also preserved) admitting him "to draw from the life model, and attend the lectures on anatomy." How long he remained at the Academy, like so much else about his early art training, is not definitely know, but he almost certainly continued through the 1865–66 season, ending in April 1866—probably a total of four seasons.

Within these strict limitations, Eakins embarked on study of the human body, which was to be his dominant interest throughout his life as an artist and a teacher. Many years later, recalling the state of American art education in the 1860s, he said to an interviewer: "The facilities for study in this country were meager. There were even no life classes in our art schools and schools of painting. [An exaggeration understandable in view of the contrast between the Academy in the 1860s and in the 1880s when he was its director.] Naturally one had to seek instruction elsewhere, abroad." But in the meantime, in his strong-willed, independent way, he made the best of the means of learning that were available.

Among his presumably early works is a series of twenty-one charcoal drawings, mostly of nude models, about equally divided between men and women. These drawings are all about the same size, twenty-four by eighteen inches, and on similar papers. When and where they were drawn remains a question. None of them were signed or dated by him, and there is no record of their being exhibited or illustrated during his lifetime. They could have been done when he was a student in the Pennsylvania Academy; or in Paris in the late

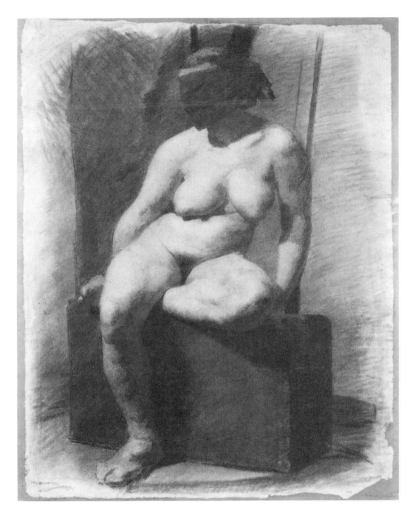

5. SEATED NUDE WOMAN WEARING A MASK
Probably 1863–1866. Charcoal. 24¼ × 18⅝. G 1
Philadelphia Museum of Art; Gift of Mrs. Thomas Eakins
and Miss Mary Adeline Williams

1860s; or, after he returned to America, in the Philadelphia Sketch Club, where he taught evening life classes from 1874 to 1876. Two of the female models wear masks, as they sometimes did in Philadelphia; but even in Paris this happened occasionally. Although there is no definite evidence of where or when these drawings were made, it seems most probable that they were done at the Academy from 1863 to 1866, before he went abroad.

About five of these drawings are comparatively labored and stiff and may have been the earliest. But about fifteen are a good deal more skillful. Most of these fifteen have certain common characteristics and give the impression of having been drawn about the same time. They are not merely linear but in

Childhood and Youth

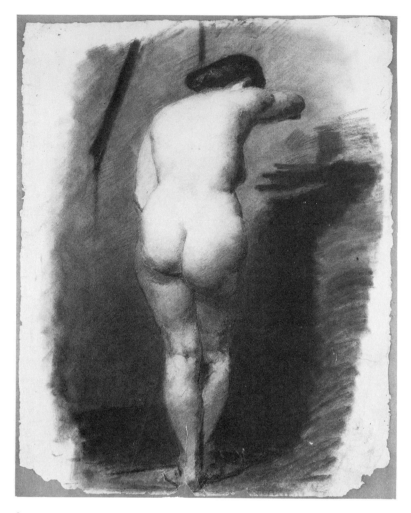

6. STANDING NUDE WOMAN
Probably 1863–1866. Charcoal. 24¼ × 18¾. G 2
Philadelphia Museum of Art; Gift of Mrs. Thomas Eakins
and Miss Mary Adeline Williams

complete tone, with full attention to light and shadows and with backgrounds included, so that the figures are situated in pictorial space. In these respects they are not the usual life-class studies, but painterly drawings; the charcoal stick and the stump are used almost like brushes. The draftsmanship is sure and strong. There is no idealization; most of the women are full-bodied and heavy; pubic hair is not omitted. What particularly distinguishes these drawings is the command of the human body; the roundness and largeness of the forms; and the sense of weight.

Within a few years Eakins was supplementing the Academy's meager education in his own way, by taking courses in anatomy at Jefferson Medical Col-

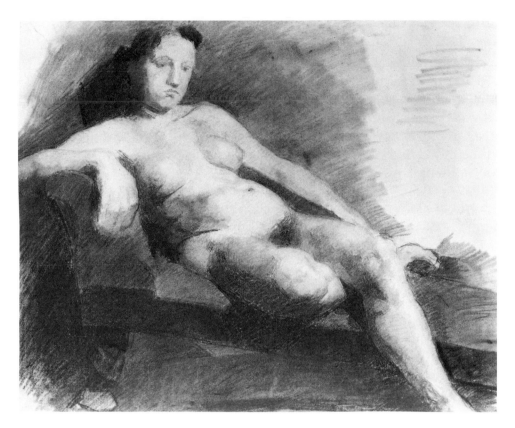

7. NUDE WOMAN RECLINING
Probably 1863–1866. Charcoal. 17½ × 22. G 15
Collection of John R. Gaines. Photograph courtesy of
Hirschl & Adler Galleries

lege in Philadelphia, one of the country's leading medical schools. The exact
dates of his study there are not known, but his surviving cards of admission
show that, probably in the session of 1864–65, he was attending the course in
Practical Anatomy under the eminent surgeon and teacher Dr. Joseph Pan-
coast; and, probably later, in Anatomy under the latter's son, Dr. William H.
Pancoast. Although he had doubtless listened to the lectures on artistic anat-
omy at the Academy, at Jefferson he was undergoing the professional anatomi-
cal training of a medical student. This must have been the most vital part of his
art education in America: learning at first hand the structure and actions of the
human body. The study interested him profoundly, and he pursued it with
characteristic thoroughness, until his anatomical knowledge was as great as
that of most physicians, and considerably greater than that of most artists. In-
deed, there was a story (unconfirmed) that at one time during his studies he
thought of becoming a surgeon.

of time and everything else. . . . But as all earthly things have an end so had my sea-sickness. One night my dreams were better. I dreamed that although sick my head was on your lap. Afterwards I heard one of Fanny's sonatas from beginning to end. I do not think I missed a note, and this I look upon as extraordinary, for if awake I could not [have] begun to remember it." After three days and four nights he came to, had some bread and wine, and "by dinner time my appetite was as good as ever."

Used to boating on the inland Schuylkill and Delaware rivers, he was evidently completely ignorant of the sea and seagoing ships. "The ocean is different from what I expected. The waves are much larger." His letter made shrewd observations about fellow passengers, their pretensions and prevarications. But he liked an elderly Jesuit priest from Louisiana. "He is the most learned man I ever saw and talks French to me by the hour. He has read all the books with which I am acquainted and knows them. He chats about authors, painters, musicians, colleges. . . . He knows anatomy, medicine, and all the languages of Europe. He has never tried to convert me although he knows I belong to no church."

By October 2 he was in Paris.

2. France, 1866 to 1869

PARIS, WHEN EAKINS ARRIVED THERE, was not yet the mecca for American students that it was to become a few years later; other European cities had been and still were centers for them: London, Rome, Düsseldorf, Munich. It was not until after 1870 that scores of young Americans began to flock to Paris, helping to make it the capital of the art world. Eakins was in the vanguard of this invasion. In choosing Paris he was probably influenced by John Sartain, who had connections with the French art establishment; by Bertrand Gardel, a Philadelphia teacher of French and a close friend of Benjamin Eakins; and by the French painter Lucien Crépon, who had lived in Philadelphia, studied at the Pennsylvania Academy, knew the Eakinses and the Sartains, and had now returned to France. From Eakins' first days in Paris, Crépon helped him constantly in practical matters; "he has been my best friend here," the younger man wrote at the end of his first year.

In these final years of the Second Empire, French art was dominated by the official academic establishment, which controlled the annual Salon exhibitions and the École Impériale et Spéciale des Beaux-Arts (after the fall of Napoleon III, the École Nationale des Beaux-Arts). The school, the most prestigious in France, was the one that Eakins had made up his mind to enter. But this was not an easy matter for a foreigner. The names of four other Americans were already on a waiting list, including two older former students of the Pennsylvania Academy, Earl Shinn and Howard Roberts. Shinn had applied as early as the previous June, through the American legation in Paris, which told him in late August that he and the others had been put on the list of the Ministre de la Maison de l'Empereur et des Beaux-Arts, who passed on all applications from foreign students. But on September 25 the legation had informed Shinn that the minister had rejected his application, as "all applications will be postponed for further consideration, there being at present no vacancies in the school." The young Americans were caught in the red tape of the French bureaucracy.

Eakins had come armed with letters of recommendation from John Sartain, including one to Albert Lenoir, secretary of the École des Beaux-Arts, whom

Sartain knew through official art channels. The young man went to see Lenoir, who received him kindly and on October 11 wrote that, although in the previous year all places had been filled at the École, this was no longer true and that Eakins was to get the American minister to France, John Bigelow, to write the French minister officially requesting his admission to the school. This Eakins did, and on the 12th Bigelow wrote the letter, including in his request the four other Americans. The next day Eakins wrote his father: "I will be admitted next week into the imperial school." As Shinn later wrote his family: "The fact is, that while I was rambling in Brittany, young Tom Eakins was exerting himself, in the heat, investigating Directors and bothering Ministers, until he got the whole list of American applicants accepted. They had decided to exclude foreigners."

"When I got Bigelow's letter to the Minister of the House of the Emperor," Eakins' letter of the 13th to Benjamin continued, "I took it to the school and gave it to Lenoir who sent it to its destination. I talked with Lenoir a little while about my studies and we chose Gerome for my professor and as I had already lost much of my time & was anxious about the future, Mr. Lenoir guessed there would be no harm in doing things a little backwards, and to save time he permitted me to go see Gerome before I got my authorization from his Majesty's House. Gerome's studio, the finest I ever saw is surely near one end of Paris. He was painting from a model. I told him my business. He must see my permit. I told him why I had come before getting it and showed him Lenoir's letter. He hesitated a moment, then put down his paints and wrote me [a letter to the Director of the École] 'I have the honor to introduce to you M. Thomas Eakins who presents himself to work in my studio. I pray you will receive him as one of my scholars.'" There must have been more red tape, however, for it was not until Friday, October 26, that he could write his father: "I'm in at last and will commence to study Monday under Gerome."*

Before he could get to work he had to go through the usual initiation of a *nouveau,* described in a letter to Benjamin: "When I got my card of admission the officers told me I could go now into the studio, and they seemed to have a little fun amongst themselves. Asking my way of the employees I was passed along and the last one looking very grave took me in. All the way that I went along I was making up a neat little address to Prof. Gerome explaining to him why I appeared so tardy. Unfortunately for French Literature it was entirely lost as is every trouble you take to imagine what you ever are going to say when such and such a thing arrives.

"The man took me into the room and said, I introduce to you a newcomer

* Eakins' orthography in his letters to his family and friends was individualistic. He omitted commas and sometimes periods. He disregarded accents in French names and words. He translated French titles into English literally: thus *rue de l'Ouest* became West Street, *salon* became saloon. The letters are quoted exactly as written.

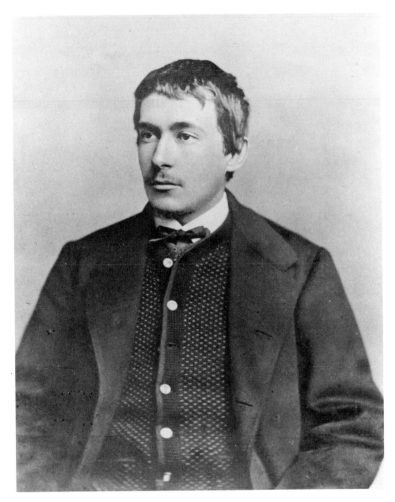

8. Eakins in his middle twenties. Photographer unknown
Silverprint. 6⅛ × 4½. Mr. and Mrs. Daniel W. Dietrich II

and then he quickly went out and slammed the door. There was nobody in there but students. They gave a yell which would have lifted an ordinary roof up, and then crowded around me. Oh the pretty child. How gentle. How graceful. O he is calling us Musheers the fool. Isn't he tall. Give us 20 francs. Half of them screamed 20 francs and the other half the welcome breakfast. When I could get them to hear me I asked what it was. Several tried to explain but their voices were drowned. They all pushed each other and fought and yelled all at once. . . . Twenty auctioneers all crying twenty francs could not have said twenty francs oftener. Who must I give my twenty francs to? To me, me, me, etc. Oh you hogs said the rest. Don't trust them they'll steal etc., etc., and a delightful interchange of courtesies and missiles. Where do you come from? England? My God no, gentlemen, I'm an American. (I feel sure that

France, 1866 to 1869

raised me a peg in their estimation.) Oh the American. What a savage. I wonder if he's a Huron or an Algonquin. Are you rich? No. He lies; he's got a gold mine. They began at last to sit down one by one. I was invited by one to do the same thing. I did so looking to see the stool was not jerked from under me. No sooner was I sat down than one of the students about 30 years old; a big fellow with heavy beard came and sat down with his face within a foot of mine and opposite me. Then he made faces and such grimaces were never equalled. Zeph Hopper would be nowheres. . . . Each new contortion of course brought down the house. I looked pleasantly on and neither laughed nor got angry. I tried to look merely amused. Finally he tired himself out, and then after examining me a little, said he, You've got pimples on your face, what makes them? Pardon me I don't know. I'm not a doctor. Oh the droll, etc., etc., etc. Then he insisted that I should put my bonnet on to see how I looked in it. Not being a model I resisted and wouldn't until I would be ready to go away. Can you speak German said a student. Some of them really did not know what was the language of the Americans. I saw he was no German so I answered him in German, and as he could not respond there was a laugh raised at his expense. I had determined to keep my temper even if I should have to pitch into them and to stay there and have as much of it through with as possible. When they got not quiet but comparatively quiet I took my leave. I thanked them for their kind attention and giving warning to the big fellow that I was now about to put on my bonnet, I thanked him for his politeness and then left. I think the last was a good stroke and the first thing I did next day was to go make friends with the big booby."

After this reception, "I went to see Crepon, I asked him about the twenty francs. Pay them said he by all means and conform to all their old customs as much as you can. They will let you work then." Until another *nouveau* arrived he had to run errands for the other students and get supplies for them, which he did "with as good a grace as I can. . . . They are an ill-mannered set when together but easy to make friends with one at a time. I will be sorry if I ever have an enemy amongst them."

At first he was the only American in Gérôme's class. But within a few days another Philadelphian appeared: Harry Humphrey Moore, a former fellow student at the Pennsylvania Academy. He was deaf and dumb, and his well-to-do family had come to Paris with him. An uncle had accompanied him to see Gérôme, who was interested and agreed to teach him. Eakins took him to the school to confirm his admission, then to call on Gérôme together, and helped him to buy supplies, "for he knows very little of French. I also explained to all the students his affliction and begged them not to amuse themselves at his expense (and they have respected his infirmity), and then introduced him to them. . . . I have no doubt my assuming the protection of Harry has in a mea-

sure protected me also. There is no one in all the studio who knows English, and I'm glad of it." He learned sign language to talk with Moore, and they became close friends.

Earl Shinn, who had also entered the Gérôme studio, wrote home about Moore: "I had him up in the room a fortnight since,—fancy a long evening of utter silence, except the fluttering of paper and scratching of pencils: my wrist ached after he was gone. He is an excellent fellow . . . —and sharp as a razor." And about Eakins' visiting the Moores: "They fool with him and treat him like a little child. . . . He is 21 [*sic*], converses in Italian, French and German, with the manners of a boy. Restricts his conversation pretty much to stories of the Schuylkill boating club. Is the son of the writing master, tall, athletic, black hair and splendid eyes. Look out, young widow [Harry's sister], treating the dangerous young Adonis as a boy."

The French students were no gentler with each other than with the *nouveaux*. "There was a dispute in the studio between two of the fellows as to which was the strongest," Eakins wrote. "It was decided they should wrestle as soon as the model rested. So they stripped themselves and fought nearly an hour, and when they were done, they were as dirty as sweeps and bloody. Since then there has been wrestling most every day and we have had three pairs all stripped at once, and we see some anatomy. The Americans have the reputation of being a nation of boxers. Max Schmitt taught me a little about boxing, which I have forgotten. A French student squared off at me offering to box, I jumped in nothing loth for a little tussel, but another student jerked my opponent away, saying, 'my good man let me give you a piece of counsel never box with an American.'"

"I cannot help thinking very often how slim had been the tight rope on which I walked into the school," he wrote in his second week. "The studio contains some fine young artists, and it is an incalculable advantage to have all around you better workmen than yourself, and to see their work at every stage. . . . I will never forget the first day that Gerome criticized my work. His criticism seemed pretty rough, but after a moments consideration, I was glad. I bought Geromes photograph that very night.

"Gerome is a young man as you see by his photograph, that I have sent, not over 40. He has a beautiful eye and a splendid head. He dresses remarkably plain. I am delighted with Gerome.

"Gerome comes to each one, and unless there is absolute proof of the scholar's having been idle, he will look carefully and a long time at the model and then at the drawing, and then he will point out every fault. He treats all alike good and bad. What he wants to see is progress. Nothing escapes his attention. Often he draws for us. The oftener I see him the more I like him."

Thus began an admiration that was to last all Eakins' life. And Gérôme

seems to have noticed, beneath the provincial awkwardness of his pupil, something out of the ordinary, for he was said to have remarked that Eakins would either never learn to paint or become a very fine painter.

The École Impériale contrasted in every way with the Pennsylvania Academy. There were antique classes, but the foundation of the Beaux-Arts system was study of the nude, carried out with the utmost thoroughness. To produce an accurate, competent drawing or painting of the model was the chief aim. The artistic viewpoint was literal naturalistic representation. A strict, narrow discipline, within its limits it furnished the most basic academic training of the time. Its greatest deficiency, and a major one, was in the technique of painting. While students in Munich were beginning to learn free broad brushwork in the style of Frans Hals, at the Beaux-Arts the dictum of Ingres, "Drawing is the probity of art," was still gospel. The basis of a painting was a meticulous drawing, and the painting technique taught was dry and tight. For broader knowledge of the rich resources of the oil medium and the complex

9. Jean Léon Gérôme: AVE CAESAR, MORITURI TE SALUTANT
1859. Oil. 36⅝ × 57¼
Yale University Art Gallery; Gift of C. Ruxton Love, Jr., B.A. 1925

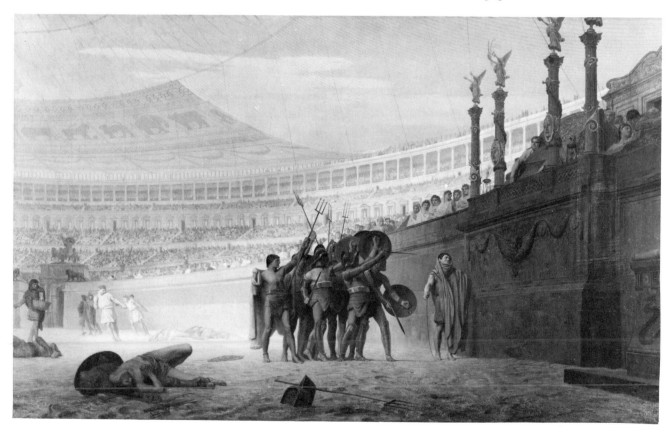

Thomas Eakins

methods of the old masters, a student would have to look beyond the school.

The Beaux-Arts system was personified in Jean Léon Gérôme. In his early forties, only three years a professor, he had already begun to achieve the status that was to make him the leading exponent of Beaux-Arts principles for the rest of his life. Within their limits he was a great teacher; few were so lucid, so rigorous in their standards, so relentless in pointing out faults, so just in recognizing good work. As a painter he was an outstanding figure in the conservative establishment. His scenes of Egypt and the Near East, based on extensive travels, and his reconstructions of events in Greece, imperial Rome, and seventeenth-century France, were impeccable in the accuracy of their exotic and historical details, their truth of character, their mastery of naturalistic vision, and the perfection of their craftsmanship. But something was lacking: a comprehension of the difference between literal representation and creative art, a sense of plastic form and design, a gift for transforming nature into the forms of art—lacks which he shared with other leaders of the French academic world. One has only to compare his art with that of his exemplar Ingres to see the difference between a superlatively accomplished illustrative painter and a great formal creator.

From the first, Eakins had been allowed to draw from the model, although there were also sessions of antique drawing. But for five months he was limited to drawing and not permitted to paint. "Gerome gives me the benefit of his criticisms twice a week," he wrote in March 1867. "Last time he made no change in my work, said it was not bad, had some middling good parts in it, but was a little barbarous yet. If barbarous and savage hold the same relation to one another in French that they do in English I have improved in his estimation. . . . 5 months!

"Only once he told me I was going backwards & that time I had made a poetical sort of an outline.

"The biggest compliment he ever paid me, was to say that he saw a feeling for bigness in my modelling (Il y a un sentiment de grandeur là dedans) and some times he says 'there now you are in the right track, now push.'"

Then, on March 21, 1867, he reported: "Gerome has at last told me I might get to painting & I commence Monday." Two weeks later: "I am working in color now and succeed in getting off some beastly things but hope to do better." Up to this time, when he was approaching twenty-three, Eakins evidently had never painted regularly. His art education, by present-day standards, had been unusual, to say the least. From a background of penmanship, mechanical drawing, and study of perspective, he had gone on to drawing from casts and then from the nude, plus intensive extracurricular study of medical anatomy. None of this prepared him for painting. And yet there was a kind of unintended logic about it. Constructing forms in three dimensions, and learning the structure of the human body, had come before problems of

10. STUDY OF A YOUNG GIRL
1867–1869. Oil. 17^9/$_{16}$ × 14^5/$_{16}$. G 25
Philadelphia Museum of Art; Gift of Mrs. Thomas Eakins
and Miss Mary Adeline Williams

light and color and the handling of oil paint. There had been no weakness in
any phase: from his teenage work, his drawings had shown unusual strength
and sureness. His coming difficulties in learning to paint were the result of
striving for a more fundamental understanding of painting technique than the
Beaux-Arts system could offer. Actually he was an intelligent learner, with
great powers of concentration, so that when he came to painting he was able to
master basic problems in two or three years of intense, often troubled study,
and his first finished pictures were to be unusually mature.

By late September 1867 he had come to realize that he would have to work
out for himself the difficulties of painting, so he rented a studio at 64 rue de
l'Ouest. "The studio will enable me to commence to practice composing and
to paint out of school which I could not do before," he wrote. "As soon as I can

get knowledge enough to enable me to paint quickly I will make pictures, but I have been only 4 months at the brush and can't do it yet."

Judging from this and following letters, by "composing" he did not mean making compositions in the usual sense, but experimenting with painting objects in light and color, instead of painting the model in class. Among the twelve oil studies probably done in Paris that have been preserved, the only ones not of models are two studies of casts of Greek or Roman heads and one of a ram's head; these may have been "compositions" done out of school. By "pictures" he evidently meant finished paintings as distinct from studies.

"This month I am working at my own studio," he wrote some days later. "I practice composition and color. Gerome told me before I left to paint some bright colored objects; lent me some of his Eastern stuffs which are very brilliant & I am learning something from them, faster than I could from the life studies. The colors are strong & near the ends of my scale of colors, such high & such low notes & this has taught me a good many things that I might not have paid attention to, if I had only been painting flesh, where the colors are not strong but very delicate & clean. I remember many a trouble that I have got into from trying to play my tunes before I tuned my fiddle up. This year will probably be the last that I will go to school regularly & I hope before next summer to be able to paint a life study, as well as anyone in the class. I think I can if nothing happens & I can keep my usual good health."

(Recurring references to his health, in this and other letters, do not mean that Eakins was a hypochondriac. A hundred years ago the mortality rate, even among the young, from diseases that now yield to modern drugs, was much higher than today—a fact that was to play a tragic part in his own life. And he was writing his family from three thousand miles away.)

"I am right well and hard at work but in the dumps the last of the week," he wrote in November, "for I made a drawing on my canvass according to Gerome's directions for Wednesday and then he said not bad, that will do, now I will mix your colors which you will put on. I have not been able to make them gee together and have got a devil of a muss and will get a good scolding tomorrow morning. . . .

"I am perfectly comfortable and would be happy if I could make pictures.

"About that I am not so down hearted as I have sometimes been. I see much more ahead of me than I used to, but I believe I am seeing a way to get at it and that is to do all I see from memory. I believe I am at least keeping my place in my class & have made friends with the best painters. Gerome is very kind to me & has much patience because he knows I am trying to learn & if I stay away he always asks after me & in spite of advice I always will stay away the antique week and I often wish now that I had never so much as seen a statue antique or modern till after I had been painting for some time."

In January 1868 he reported: "I am working now from memory & compos-

ing. I make very bad things but am not so downhearted as I have been at times when I was making a drawing from the model not good not bad but wishy washy generally. When you make a thing mighty bad & see how bad it is, you naturally hunt to improve it, & sometimes find a way but it keeps staring you in the face till you do. When after painting a model I paint it from memory & then go back & do it again, I see things the second time, I would not have seen if I had staid at school painting on the same canvass all the week & maybe getting more and more tired.

"Color is becoming little less of a mystery than it was & more of a study in proportion. When it ceases altogether to be a mystery and it must be very simple at the bottom, I trust I will soon be making pictures. One consolation is

11. STUDY OF A NUDE MAN
1867–1869. Oil. 21½ × 18¼. G 27
Philadelphia Museum of Art; Gift of Mrs. Thomas Eakins
and Miss Mary Adeline Williams

that I am composing. It was hard to begin, I felt I ought to know more, but now I am at it & whatever I can gain in it, is straight towards making a selling picture. Anyhow I think I am working now in the best way.

"Gerome did not scold me that day, you asked me about, but just painted my head right over again & this I take as an insult to my work, and tribute to my perseverance & obedience that week. I had a clean canvass, clean brushes, clean outline, clean everything, but I am sure I would have learned more slathering around. These things will be done so easy after knowing how to paint.

"A beginner in skating may learn faster by rolling over rough ice, than by very slowly studying out a complicated turn, which he may never be able to learn but which a good skater may easily do the first time he tries it."

He continued his anatomical studies, though to what extent there is no record. There was a dissecting room in the school, and students could also work in the Paris hospitals. For a time in the spring of 1868 he also studied under the elderly conservative sculptor Augustin Alexandre Dumont at the Beaux-Arts, not so much for the medium itself as to supplement painting. "I got admitted yesterday to the studio of Dumont the sculptor in our school," he wrote his father on March 6. "I am going to model in clay every once in a while. I think I will thus learn faster. When I am tired of painting I will go to the class and be fresh and I will see more models and choose. The sculptors are not so noisy as painters. They are heavier duller looking boys proverbially. I was well received and spent 15 francs on them to give them the welcome." "Dumont the sculptor is a stout old gentleman, much older than Gerome," he wrote in April. "He is like a father to us. He tells them 'work more with our fingers and brains and less with tools.'"

II

A few weeks after arriving in France Eakins had written his sister Frances: "The first thing a traveller does on reaching Paris is to visit the Louvre. I did so, and having no guide book I followed the English visitors and stopping when they stopped & going on when they went on I received the same benefit as if I had had one.

"First, I went to see the statues. They are made of real marble and I can't begin to tell you how much better they are than the miserable plaster imitations at Philadelphia. But I left right away. Statues make me shiver; they look so cold. No English lady ever enters a Statue Gallery. Half the figures are stark naked. I went next to the picture galleries. There must have been half a mile of them, and I walked all the way from one end to the other, and I never in my life saw such nice funny old pictures. I'm sure my taste has been much improved, and to show it, I'll make a point never to look hereafter on American Art except with disdain. After the pictures, came the curiosities and these are of great historical interest. . . . When you remember that history has been

from my earliest youth my greatest delight and dearest study, you may imagine perhaps my rapture." He then went on, in a vein of heavy-handed humor that reminds one of Mark Twain's *Innocents Abroad,* to describe "a tooth-pick composed entirely of diamonds used frequently by Charles IX," "a bible almost as good as new, said to have been very frequently used by Charles XII," and so forth.

That he revisited the Louvre several times is indicated by mentions in later letters. Also in 1866 he applied for and received permission to copy in the museum; but whether he did and what he may have copied are not known. But his scorn of the old masters continued for some time. His letters in general show little concern with aesthetic matters: they reveal a young artist too intensely concentrated on his own painting problems to give much thought to other art. His interests extended mostly to works which, by successfully solving the problems that troubled him, had something to teach him; and his comments on them were confined mostly to their technique.

In contemporary art his preferences were almost exclusively for the conservatives. The annual official Salons, which he visited regularly, supplied his chief contacts with contemporary French art. He revered Gérôme, not only as a teacher but as an artist. In letters and notes he referred, usually with approval, to Isabey, Troyon, Jacques, Couture, Meissonier, Doré, Bonnat, Robert-Fleury, Fortuny, Regnault. Sending his father a photograph of Carpeaux's sculpture for the new Opera, he said: "He probably models now better than any one in the world & is a graduate of our school."

But his preferences, though limited and oddly mixed, were his own. A provincial in the midst of the shams of official Second Empire art, he respected the artists who seemed to him most sound and genuine, not the most fashionable. For the typical Salon *machine,* with its saccharine portrayal of female nudity, he had nothing but contempt.

"I sent by last mail a catalogue of the Exhibition of Fine Arts [the Salon] for Shinn," he wrote his father in May 1868. "There are not more than twenty pictures in the whole lot that I would want. The great painters dont care to exhibit there at all. Couture Isabey Bonnat Meissonier have nothing. The rest of the painters make naked women, standing sitting lying down flying dancing doing nothing which they call Phrynes, Venuses, nymphs, hermaphrodites, houris & Greek proper names. The French court is become very decent since Eugenie had fig leaves put on all the statues in the Garden of the Tuilleries & when a man paints a naked woman he gives her less than poor Nature herself did. I can conceive of few circumstances wherin I would have to make a woman naked but if I did I wouldnt mutilate her for double the money. She is the most beautiful thing there is [in] the world except a naked man but I never yet saw a study of one exhibited. It would be a godsend to see a fine man model painted in a studio with the bare walls, alongside of the smiling smirk-

ing goddesses of waxy complexion amidst the delicious arsenic green trees and gentle wax flowers & purling streams a running melodious up & down the the hills especially up. I hate affectation & what you may stand in a child is unbearable in a man and so one is pleased to escape such a mass of trash & run back to the old Louvre pictures. You have no idea how bad the old so-called masters work often is, but travel was hard & they studied nature & did all they could in earnest, but if their names were not signed to their things nobody would think of buying them."

Ingres, the *chef d'école* of the Beaux-Arts, died in January 1867. Eakins' only recorded reference to him included him among the "classics" he detested. Even the great Ingres memorial exhibition at the École in 1867, containing 584 works, is not mentioned in his surviving letters. If he saw it—and it is hard to believe that he did not—one would think that his hostility would have been changed at least by Ingres' portraits, fully represented there.

Delacroix, who had died in 1863, was still anathema to the academicians, an opinion shared by Eakins, who wrote in a notebook in 1870: "L'instinct de couleur chez Delacroix le poussait involontairement à chercher les tons dans tout son tableau à la fois. Il le couvrait entierement chaque jour mais aussi il essayait de modeler tant que soit peu, mais c'était déjà trop, et ses tableaux sont abominable et géneralement d'un dessin impossible. Ses hommes sont des singes. Il n'avait pas de procédé et ce sont les embus et les difficultés purement mécaniques qui l'ont toujours vaincu et parfaitement vaincu." But giving the devil his due, he added: "On ne peut espérer sentir la couleur mieux que Delacroix," and concluded, with the self-assurance of youth: "Profitons de ses défauts pour aller beaucoup plus loin que lui."*

Of the living French independents, who for us today seem to include the most vital creative artists of the time, there is no mention in his surviving letters. The 1860s were a period of relative calm between storms, the romantic movement having passed, the impressionist not yet emerged. The Académie was in full control of the art world, and the few surviving older independents were still outside the pale. Corot and Millet, whom Eakins later came to appreciate, were living, but their names do not appear in his known Paris writings. Also still living but not mentioned were Daumier, Théodore Rousseau, and Daubigny. On the other hand, it has been said that he tried to study sculpture under Barye, but was put off by the reception given him by a young assistant. Later, to his own students, he expressed admiration for Barye.

[*] The instinct for color with Delacroix impelled him involuntarily to search for tones in his whole picture at once. He covered it entirely each day but also he tried to model ever so little, but everything was already too much, and his pictures are abominable and generally impossible in drawing. His men are monkeys. He had no method and it is the sunken-in areas and the purely mechanical difficulties which always defeated him and completely defeated him.

No one could hope to feel color better than Delacroix.

Let us profit by his faults to go much further than he.

Among the independents the one most in the public eye was Courbet. He was also the one whose naturalism was closest to that of Eakins; and he was to be among the painters whom the latter appreciated in future years. But there is no mention of him in Eakins' surviving writings from Paris. Courbet was, after all, the arch-revolutionist of the time, the most violent antagonist of the academic establishment in which Eakins existed.

Even when Courbet and Manet, having been rejected at the Exposition Universelle in the spring of 1867, showed their works in a building outside the grounds, Eakins' known letters did not mention them, or indeed any art in the exposition, although he visited it several times. In one long detailed letter to his father about the fair he devoted much space to the American products: "The Locomotive is by far the finest there. I can't tell you how mean the best English French and Belgian ones are alongside of it. . . . One of the most amusing things in the American department is the soda water fountains. The foreigners above all the French have begun to taste the ice cream soda water and its fame has spread. . . . No people will think of competing with the Americans for sewing machines. . . . I wish we had a steam squirt over here from Philadelphia just to put alongside of the English one. The worst one we had would answer the purpose. The English are strong in lighthouses." Then a discussion of the national restaurants and their "waiter girls" in native costumes. "The Russians have Georgian women in their restaurants and they are very beautiful. The Spanish girls have the gayest frocks of all. . . . The finest thing of all though was a single girl in a Romany restaurant. She was dressed in a perfectly plain frock of crimson and had a few green leaves in her black hair. She was the most beautiful woman I ever saw or ever expect to see. . . . I will never forget that long sad face with such clean firm modelling." But not a word about the art exhibitions—even the American one.

The impressionist movement was still in embryo. Manet and Degas, like Courbet, he could have seen sometimes in the Salons, and the younger impressionists occasionally, but his surviving letters did not mention any of them. (He later came to appreciate Manet and Degas.) The younger impressionists, most of whom were only a few years older than himself, were still a group of eccentrics who believed in painting in the open air; their first group exhibition was not to come until 1874, when the name "impressionist" was invented. And in any case Eakins would not have sympathized with them: his whole viewpoint, then and later, was fundamentally different.

His artistic philosophy at this time was literal naturalism, and his opinions of other art and artists were limited and naive. But he had done much firsthand thinking about the relation of art to nature. In early 1868 his father reported an argument with friends, in which they evidently contended that the artist was a creator not dependent on nature. Eakins wrote Benjamin a long reply, using the homely imagery of boating, familiar to both of them: "I cannot conceive that they should believe that an artist is a creator. I think Herbert Spencer will

set them right on painting. The big artist does not sit down monkey like and copy a coal scuttle or an ugly old woman like some Dutch painters have done nor a dung pile, but he keeps a sharp eye on Nature and steals her tools. He learns what she does with light the big tool and then color then form and appropriates them to his own use. Then he's got a canoe of his own smaller than Nature's but big enough for every purpose except to paint the midday sun which is not beautiful at all. It is plenty strong enough though to make midday sunlight or the setting sun if you know how to handle it. With this canoe he can sail parallel to Nature's sailing. He will soon be sailing only where he wants to selecting nice little coves and shady shores or storms to his own liking, but if ever he thinks he can sail another fashion from Nature or make a better shaped boat he'll capsize or stick in the mud and nobody will buy his pictures or sail with him in his old tub. If a big painter wants to draw a coal scuttle he can do it better than the man that has been doing nothing but coal scuttles all his life. That's sailing up Pig's run among mud and slops and back houses. The big painter sees the marks that Nature's big boat made in the mud and he understands them and profits by them. . . . Then the professors as they are called read Greek poetry for inspiration and talk classic and give out classic subjects and make a fellow draw antique not see how beautiful those simple hearted big men sailed but to observe their mud marks which are easier to see and measure than to understand. I love sunlight and children and beautiful women and men their heads and hands and most everything I see and someday I expect to paint them as I see them and even paint some that I remember or imagine make up from old memories of love and light and warmth etc., etc., but if I went to Greece to live there twenty years I could not paint a Greek subject for my head would be full of classics the nasty besmeared wooden hard gloomy tragic figures of the great French school of the last few centuries and Ingres and the Greek letters I learned at the High School with old Heaverstick and my mud marks of the antique statues. Heavens what will a fellow ever do that runs his boat a mean old tub in the marks not of nature but of another man that run after nature centuries ago. . . . No the big artists were the most timid of themselves and had the greatest confidence in Nature and when they made an unnatural thing they made it as Nature would have made it had she made it and thus they are really closer to Nature than the coal scuttle men painters ever suspect. In a big picture you can see what o'clock it is afternoon or morning if its hot or cold winter or summer and what kind of people are there and what they are doing and why they are doing it. The sentiments run beyond words. If a man makes a hot day he makes it like a hot day he once saw or is seeing, if a sweet face a face he once saw or which he imagines from old memories or parts of memories and his knowledge, and he combines and combines, never creates but at the very first combination no man and less of all himself could ever disentangle the feelings that animated him just then and refer each one to its right place."

During his years in Paris, Eakins lived on the Rive Gauche, within walking distance of the École, in far from luxurious quarters. In his first year he rented a room at 46 rue de Vaugirard, across the street from the Palais de Luxembourg, where "the soldiers woke me up at the right time in the morning with their trumpets and drums." His first studio at 64 rue de l'Ouest, to which he moved in September 1867, was across a courtyard from Lucien Crépon's; rent 650 francs a year. But it was on the ground floor and so wet and so hard to clean that in November he moved upstairs (for 200 francs more) to a drier but smaller studio, with a tiny bedroom over the entry reached by a ladder. Crépon's quarters were also so damp that "I asked him to stay with me . . . & he & his wife & child staid in my studio except to sleep & I was very glad to have them for company. I like to see a child playing about." In July 1868 Crépon found a larger studio with two bedrooms and a kitchen, at 116 rue d'Assas, and asked Eakins to come in with them, paying half the rent of 800 francs, which he was glad to do. When Bill Sartain came to Paris in March 1869 he also shared the studio. But by this time Crépon was earning more and wanted the whole place for himself and his family; so in early April 1869 the two Americans rented a smaller studio on the rue de Rennes near the church of St. Germain-des-Prés, and roomed together in the Hotel de Fleurus, 3 rue de Fleurus, until Sartain moved to another hotel in mid-October.

It did not take Eakins long to adjust to student life in Paris. His bookish French was soon replaced by fluent colloquial speech and student slang. His notebooks and personal accounts were written in French. As time passed he made firm friends in Gérôme's class, particularly Louis Cure, Achille Guédé, Gustave Courtois, Paul Marie Lenoir, Auguste Sauvage, Ernest Guille, and Pascal Dagnan-Bouveret, some of whom were to make their names in established art. Lenoir (not Albert Lenoir), one of Gérôme's favorite pupils, who accompanied the master on several of his visits to Egypt, was "one of my first and best friends at the studio."

Another good friend in the Gérôme class was Germain Bonheur, through whom Eakins met his older sister and brother, strong-minded, mannish Rosa, and Auguste, also an animal painter. "He was on terms of intimacy with the entire Bonheur family," wrote Gilbert S. Parker in 1917, "and many were the anecdotes that he could relate concerning Rosa and her brothers." Once when he was dining with them, he wrote to his mother, "I took my gun & pistol around to show their cousin who was there who is a good mechanic. He said he never saw such beautiful arms & so they are. America beats the world in machinery." Bill Sartain, who was present, recalled that "Tom was speaking of our national mechanical skill and to illustrate his point he pulled out from his pocket his Smith & Wesson revolver—(I know of no other person in Paris who

ever carried one!)—Rosa put *her* hand into her pocket and pulled out one of the same make."

His daily life was hardworking: nothing of the *vie de Bohème*. Classes at the École began at seven A.M., and he was always on time. On the other hand, soon after entering the school he wrote his father that he had spent an afternoon "with the French students & witnessed the trifles which make the greatest & perhaps the only difference between them and others. The whole afternoon that I spent with them, I dont consider altogether wasted. I saw more of new character & manners than I would ever have discovered by myself, nor am I either sorry or ashamed to have accompanied them to the place. But I would be ashamed if I had been in the least attracted by the vice I saw there."

But he was no prude; his letters home often contained broad humor and language; in one to his father he described in detail the Gallic comedy of an outdoor *café chantant* on the Champs Élysées, expressing amusement at an American acquaintance who asked whether it was respectable and if the police standing around would not stop it. "Respectable. Dear me. Fine looking old gentlemen stop there to rest and smoke their cigars, & have with them their daughters, & no married lady would hesitate an instant to stay there and applaud their wit. . . . If the man stopped of his own accord or shut up his place he would be put in jail. The Government of France has authority over every place of amusement. It is its duty to see that its subjects shall be kept gay." He enjoyed ribald student songs, and made copies of several before he left France.

He went frequently to the opera; one expense account sent to his father listed five operas in two months, usually in the two-franc seats—"principally to hear Adelina Patti and it is not probable I can ever hear such singing again." A ball at the Closerie de Lilas in early 1868 was explained: "The masked ball I was curious to see never having seen one and my companions going." There were visits to the circus—"the finest thing I know of in Paris. Men & horses in motion. Nothing can ever be finer. If Paradise is prettier than this part of the circus I want to see it." At one point he visited a gymnasium several days a week, mostly to wrestle.

"I am studying Spanish," he reported in March 1867, "which may be of use to me some time, or if of no use otherwise, as a benefit to my mind. My study of other languages has shown me the best way of attacking a new one"—to go to a teacher three times a week for a month, talking nothing but Spanish, then a lesson a week for some time. "The grammar is very simple and the verbs analogous with the Italian ones. . . . The Italian I judge to be the only tongue that can be learned without a teacher."

Philadelphia friends came to Paris. William Crowell arrived in early June 1867, and roomed with him. In late July they were joined by Bill Sartain, and the three high-school classmates went on a walking trip in Switzerland, partly

by rail, starting from Geneva, to Villeneuve, thence to Martigny; then into the Haute-Savoie in France toward Mont Blanc, to Chamonix; over the big glacier, the Mer de Glace, back to Martigny for a day's rest; then eastward to Zermatt, where rain forced them to stay. From there Eakins wrote his father that "Geneva and its lakes and mountains are beautiful and as far as French is spoken so are the people, as well as intelligent;" but then he launched into a diatribe against the German-speaking Swiss of Zermatt—because they were "filthy" and "cretins." Included in this blast were the English in the hotel, except the Australians and "the little girls too young to be prudish and English. . . . So different from the French."

Nevertheless, the young men continued their journey, mostly in German-speaking Switzerland, visiting fifteen or more places, including Interlaken, Lauterbrunnen, Andermatt, Weggis, Lucerne, Zurich, Saint Gall, Konstanz, Schaffhausen, Basel, and Freiburg. The whole trip, on foot and by rail and boat, lasted several weeks, perhaps a month. Their wanderings ended in Strasbourg, Alsace (still part of France), where they visited John Sartain's old friend, the painter Christian Schussele. Born in Alsace, Schussele had settled in Philadelphia and become a well-known genre and historical painter; but stricken with palsy, he had returned to his native province for a cure. He was later to play a considerable part in Eakins' life.

By September 2 the three friends were back in Paris. John Sartain also came to Paris, to see the Exposition Universelle. "Mr. Sartain is busy every day & all day at the exhibition," Eakins reported. "He went up in the balloon. He is right well." The older man took the younger to the opera (two nights running), to the Louvre, to tour the École with Albert Lenoir. "I have been so much with Mr. Sartain in the evening I have had no time [for a letter]," Eakins wrote his father. Sartain went on to Strasbourg to see Schussele, and arranged that his friend should return to Philadelphia to teach the classes of the Pennsylvania Academy.

IV

In the evenings Eakins would write home to his family and friends— usually long, detailed letters. The contents and tone varied with the recipient. For his mother he described French food, clothes, and customs, and his own daily life: in one eight-page letter soon after settling in Paris he gave her a minute description of his room on the rue de Vaugirard, with drawings of each piece of furniture. He told each of his sisters what he thought would interest them, according to their ages: for Maggy and little Caddy, mostly animals and fun. For his aunt Eliza, his mother's older sister, who was a needlewoman, he concentrated on Parisian clothes (not very knowledgeably).

To his father he wrote regularly once a week, on Thursday or Friday, reporting every stage of his work, and revealing his problems and struggles. And

12. Eakins' letter to his mother. Paris, November 8 and 9, 1866
Hirshhorn Museum and Sculpture Garden, Smithsonian Institution

his father evidently wrote frequently as well, although his letters have not been preserved. Benjamin paid his son a regular allowance to cover all his expenses in Paris, and every two or three months the son sent the father an itemized account of expenditures, recording every item down to the smallest, and explaining any that were out of the ordinary—such as his purchase for 1.75 francs, in March 1868, of a volume by Rabelais, "a writer priest doctor of medicine and hater of priesthood. He wrote a very fine book which I bought and am reading."

In May 1867 he wrote Benjamin: "Your offer of still more money to enable me to continue my studies reached me last week . . . & with a feeling between pride & humiliation I long for the time that may enable me to give them the other direction." In September of the same year: "Your letter to me has given me the greatest consolation in lifting from me my only great anxiety that from spending so much money even with strict economy, and so far passing the calculations I had made to myself, for prices have more than doubled in the short time Crepon has been here." In March 1868: "I have tried to act in moderation without being liberal like a poor man or mean as a rich one. Spending your money which came to you from hard work I am touched by the delicacy of not wanting the items but only the sum left, but I will nevertheless continue to give them as I have always done. . . . I could even now earn a respectable living I think in America painting heads but there are advantages here which could never be had in America for study."

In the beginning of his sojourn in Paris he had sometimes been homesick. But in reply to a letter from his father in the fall of 1867, urging him to come home for a visit, he wrote: "I do not know exactly what made me betray an uneasiness in my letter of which you speak. It was probably a rainy day or I had been seeing some disagreeable person or thing. But certainly it was a momentary affair like that, and not to a homesickness that could be dispelled by a momentary visit. I love my home as much as anybody and never see the sun set that I do not think of it and I often feel lonely, but I can learn faster here than at home, and stay content and would not think of wasting the expense of a voyage for a few weeks pleasure. You miss but one from the family. I miss all."

To his sister Frances he wrote almost as frequently as to his father, and even more fully; and she replied in kind. Four years younger, Fanny had been about eighteen when he left home—an intelligent, warmhearted, high-spirited girl, devoted to her brother, as he was to her. His letters to her, often very long—four, six, eight pages, sometimes more—are the most intimate that we have.

"My poor dear sister," he wrote after a year abroad, "how plain I see you miss me almost as much as I miss you. If I was home I would take you to see Joanna [Max Schmitt's sister] & we would have a good romp or we would get Harry Lewis & Aunt Tinnie in the kitchen & have a dance, or we would go

hear some music or have fun in a thousand ways. But never mind as soon as I learn to paint we will never be apart very long at a time."

The tone of his letters to her was big-brotherly, almost paternal, filled with instruction, advice, admonitions. They had many mutual friends of their generation, and Eakins' letters abounded with affectionate references to "Joanna, Ida, Amy," and other young women and men. "Give Joanna my best thanks [for her photograph] which is an additional proof of the goodness she has always shown me. . . . Be sure to go see Ida often and send me news of her continually." And there were as many mentions of older relatives and friends: their aunts and uncles, their parents' friends, their friends' parents.

In the spring of 1868 we find him advising her to sharpen her skates and grease them before putting them away for next winter. "You & Maggie ought to go to Jansens [swimming pool] & learn to swim this summer. . . . You boat so much that you ought to know how to swim. If you swim well maybe Poppy will take you sailing once to show you how nice that is for it is much better than rowing."

Sometimes he cautioned or reproved her, and the big-brother tone became domineering. Once he expressed the wish that she have nothing to do with a woman relative of Emily Sartain: "I do not care to tell you my reasons but they are all sufficient." This rightly infuriated Fanny, who replied: "If you have got good reasons why let me know them, if you have not say so and forever after hold your peace." To which he answered: "These reasons . . . were medical and as such I do not consider a modest virgin the proper person with whom to enter upon an explanation even if she is my sister"—a lofty attitude that must have enraged Fanny still more. But such differences were exceptional.

They shared many interests: reading, languages, poetry, music. Fanny was a serious girl, eager to learn, like himself; and her letters brought out the born teacher in him. She also was reading Dante in Italian, and he sent her exhaustive discussions of the poet's imagery, action, and language, stressing his concreteness and exactness. "Dante is mighty careful about the actions. Never does he betray a looseness in the most trifling details all that is done has its object."

From Dante he embarked on lengthy analyses of languages, English, French, Italian, Spanish, Latin, Greek: derivations of words; comparisons of words for the same thing in different languages; grammar, declensions, conjugations, and so on. These discussions, pages long and revealing remarkable philological appetite and knowledge, were evidently not over his sister's head. one of his replies began: "I have received your learned letter. . . . You are now getting too deep for me." But he went on to say: "This kind of knowledge you are getting will never desert you but will I am sure be some day of great service to you. It will enable you to appreciate the writings of good men & teach you to despise affectation & nonsense." He ended by urging simplic-

ity, including "slang." "By slang I mean the talk of sensible people who have ideas which they are eager to express in a short way & who are not making conversation. . . . Leave fanciful derivations to those who want to be brilliant & thought learned but store up for yourself solid things."

It was probably his reading of Rabelais that led him in October 1868 to write Fanny: "Je m'en vas t'escripre dans le bon vieulx francais," going on to indite three letters in sixteenth-century French.

Then there was music. Fanny was studying piano, and working hard. Receiving a "dolorous" letter about her progress, he wrote a six-page reply. "I dont know anything about music except it should be like other things that I do know and yet I will try to give you advice." He proceeded to draw a mathematical analogy, illustrated by a diagram, between the pursuit of perfection in piano-playing, and geometrical curves approaching a straight line but never reaching it. "Piano playing is made up of hundreds of things but the whole is motion & can of course be represented mathematically." Then another diagram, these curves representing a pianist with differing stages of skill, from playing trills to playing Mozart's and Beethoven's sonatas. "This man was very foolish to waste so much time on his trill. He ought to have started on the most important thing . . . [which] advances him in all the little things without his knowing it. . . . Dont think that you are the only one that has been down hearted. I have often wanted to die & I feel now plain it was my stupidity. I was playing my trills drawing from plaster casts." He urged her to experiment with different kinds of playing—from memory, from sight—things that "would help more than an hour of old fashioned work. Skating is a very very simple thing to music & how much do I not owe to fooling on skates, to skating over rough ice, to hopping on one foot to awkward unusual motions that none but the young undignified dare do." In other letters he told her about music he had heard: operas, orchestras, church music.

Eakins' letters to Fanny displayed more humor than to others, mocking people and things they felt the same way about, ridiculing pretense, falseness, and "nonsense"; often brutally frank, as when he called a mutual acquaintance "a contemptible little pimp." Sometimes he concocted elaborate burlesques, long-drawn-out, and a bit heavy-handed.

V

In the summer of 1868 Benjamin and Fanny came over to England, then to Paris. Fanny wrote home an account of their meeting her brother: "We left London and on the 4th of July saw Tom he was waiting at the station for us. He is much thinner than when he left home, but his complexion is clear and he looks right strong. The excitement of seeing us had kept him awake for a couple of nights and had made him pale, but by yesterday he had regained his color and looked fine. Anybody would take him for an Italian, his face and figure are so very Italian.

"Yesterday morning we went to his studio. He had not yet finished any of his paintings (that is lady's work he says) and of course they are rough looking but they are very strong and all the positions are fine, and drawing good. He thinks he understands something of color now, but says it was very discouraging at first, it was so hard to grasp. He has changed very little, he's just the same old Tom he used to be, and just as careless looking. His best hat (I don't know what his common one can be) is a great big grey felt steeple, looks like an ash-mans, his best coat is a brown sack, and his best pantaloons are light with the biggest grease spot on them you ever saw. And then he most always wears a colored shirt. But he's the finest looking fellow I've seen since I left Philadelphia. We told him he was a little careless looking and he evinced the greatest surprise. 'Good gracious' he said 'why I fixed up on purpose to see you, you ought to see me other days.' You ought to see him bow, imagine Tom making a French bow. But I tell you he does it like a native."

The three spent ten days together in Paris, with a visit to the Crépons in Fontainebleau and a swim in the Seine by father and son. On July 13 Benjamin and Fanny left to travel through Germany and Switzerland to Italy, where Tom was to meet them. The École was still in session, and he stayed on faithfully. "School breaks up tomorrow," he wrote his mother on the 24th, "& I am anxious to get off as things are lonely here. Nearly all my things are moved to Crepons new studio so I have little more than my bed & the bare walls, and my companions have all left me. I have painted every day at school but cant work in the afternoon for I keep thinking all the time of seeing Poppy & Fanny again. Nearly every night we have seen some one of our comrades off going to his home to see his father mother & sisters. . . . I suppose you would laugh to see us all a hugging & kissing one another good by but that is the French way. . . . When I start to Italy I spend about 40 hours or so in the railroad cars . . . but at the end of it I see Poppy & Fanny again."

Breaking his journey with a stop at Turin, where he visited the museum, he joined his father and sister in Genoa on August 1. From there they sailed for Naples, with stops at Leghorn and Pisa, arriving on the 5th at the southern city, where they visited Virgil's tomb, Vesuvius, and Pompeii. Then to Rome for three days of sightseeing; thence north again to Florence, Padua, Venice, and Verona. Then into Germany: Munich (where they visited at least one of the museums), Stuttgart, Heidelberg, Mainz, and Düsseldorf; and to Belgium: Brussels and Verviers. On August 31 they were back in Paris. After nine more days together, on September 9 Eakins saw his father and sister off at the Gare du Nord for Le Havre and the sea voyage home.

For Eakins these two summer months had included almost five weeks of travel, and visits to about twenty cities. Although most of the time had doubtless been devoted to sightseeing, he must have seen a good deal of art that was new to him, particularly in Italy. But of what he saw, and what he thought and felt about what he saw, he left no known record.

That winter, when Gérôme was away on another trip to Egypt and the Near East, and "there is mourning in France among the students," Eakins returned to Philadelphia for a visit, arriving in time for Christmas. (The Eakins family placed great stress on Christmas, Thanksgiving, and the Fourth of July; it had been on the Fourth that Benjamin and Fanny had met Tom in Paris.)

Before starting home, he wrote his father a letter about skates. He had lent Benjamin his pair and did not want to take them away; on the other hand, if he should use Benjamin's low ones, "I could not begin to do on them as well as I want to & I would be so far behind my old comrades that although I have the excuse of absense I would be ashamed for I was once at their head." So he gave instructions for making a pair of runners to fit shoes he already had, giving minute details and enclosing a drawing. "I would have everything simple & not a single ornament of any kind." To Fanny he wrote in old French, in a burlesque of Rabelais, about the Christmas dinner he looked forward to, listing all its ingredients, especially oysters: "les huictres contiennent vertus phosphoriques et aultres soubstances mirifiques dont est faicte la cervelle humaine," and so forth.*

Over two months were spent at home. On March 6, 1869, he sailed from New York, arriving at Brest on the 16th. Bill Sartain returned to Paris with him, to share his studio, and to study with Adolphe Yvon, and then Léon Bonnat.

VI

At the end of his first month in Paris, Eakins had written Emily Sartain: "Non ti muova a sdegno contro a me il lungo tempo che trapassera avanti di ricever il mio viglietto, e non ragionare di cio che dimenticata t'ho. Tutte le fiate che vedo il Dante, mi vienero alla memoria le belle sere avute teco l'inferno leggendo (benche non sia mestier di un libro per farlo), e lego sovente." He explained that he had not written her until he was admitted to the Beaux-Arts because "sperando io di giorno in giorno non ho che mala fortuna avieta se non venerdi passato e che non ho voluto che istorie triste ad una mia amica pervenissero."† (This tender communication was the last third of a three-part letter: in English to John Sartain, in French to Bill, and in Italian to Emily; so there was hardly anything private about it.)

Two weeks later, receiving a letter from her, and her photograph, he wrote —in English this time: "I cant begin to tell you the pleasure I had on receiving a letter from you and Willie. I was anxiously looking for my first one. . . .

* Oysters contain phosphoric virtues and other marvellous substances of which the human brain is made up.

† Let not the long time that will elapse before you receive my letter move you to scorn, and do not deduce therefrom that I have forgotten you. Every time I see the Dante, there come to memory the beautiful evenings spent with you reading the inferno (though a book is not needed for that), and I read often. . . . I kept hoping from day to day but had nothing but bad luck until last Friday and I did not want to have sad stories reach my friend.

Your photograph is far the best I have ever seen of you and I am very thankful for it. I will soon have mine taken and will send it to you. . . .

"I envy your drive along the Wissahickon among those beautiful hills with which are connected some of my most pleasant reminiscences. You say you had a slight sensation somewhat resembling pride in your native city. I feel like scolding you for such a weak avowal of your real sentiments. You should hear me tell the Frenchmen about Philadelphia. I feel 6 ft. & 6 inches high whenever I only say I am an American; but seriously speaking Emily Philadelphia is certainly a city to be proud of, and has advantages for happiness only to be fully appreciated after leaving it. . . . Many young men after living here a short time do not like America. I am sure they have not known as I have the many reasonable enjoyments to be had there, the skating, the boating on our river, the beautiful walks in every direction."

The exchange of letters continued, but on his part with less frequent and shorter letters, and few in Italian. Sometimes he excused himself because of lack of time (yet he was regularly writing long letters to his father and Fanny). Ardor was evidently cooling; absence was not making the heart grow fonder. On the other hand, his letters to Fanny spoke often of Emily, with appreciation of her qualities. "I am glad you have both found companions in one another," he wrote in May 1867. "Emily is a good girl with much feeling, intensely sensitive, & I think she has had but few friends."

But in his correspondence with Emily herself there were signs of growing differences. Just before Christmas 1867: "Happy New Year Emily to you & all the family. . . . If as you say you have felt hard sometimes towards me I have never returned that sentiment. . . . Some of your reproaches make me think you want me to answer them. . . . I always sent general news of your family to my family . . . in my home letters that any one can read. . . .

"I have thought over your reproach of my being cynical. I think it unjust. Understand me I do not think you unjust for making it, but am thankful to you for speaking so free. . . . What I hate is imposition & hypocrisy and affectation. . . . Dear Emily Please excuse me from writing more. I feel so stupid & prosy from having been sick & it is getting dark so I want to hurry to the post office. I'll try write you more at length next time. There is one thing though very funny in your letter, I insist that the duties & responsibilities of men & women are equal etc. Tell me truly how hard did you set down your pretty little foot after writing that. You never learned that from yourself Emily or my mother or your mother or next door at your sister Helen's. Happy New Year to you. Go to our house and eat a big piece of mince pie for me & an extra slice of plum pudding at your own house." One can imagine how insufferable Emily Sartain must have found this response to her proto-women's-liberation declaration. No wonder that he reported to Fanny a month later: "I sent Emily Sartain two letters a good while ago but the answer must have miscarried."

Then in March 1868 Fanny evidently asked him point-blank if he was engaged to Emily or if he planned to marry her at some future time. He replied: "I am not engaged to be married to Emily Sartain & never was, & had I felt disposed I should not have thought of doing so without consulting my father & mother.

"I hardly know what to tell you or how much you want to know not knowing myself what for. You show me very great concern in the manner of your writing to me.

"There was love between me & Emily which exists still on my part but it never had the intensity of my love for Mary [illegible] or Louise her cousin or Mary Adams or Marty Bowen & is about the same as I have for Johanna & Amy & Ida any of whom would be preferable perhaps as a wife.

"Emily had very often said she would never marry & she was much older than myself & I could afford to be more intimate with her than the others & her house being pleasant to go to I was oftener there than with the others.

"When Emily knew I was about to sail for Europe she wrote me a letter of sorrow at losing me but which gave me an indefinite idea that maybe if I would ask her to marry me she would say yes. I parted from her in New York she being there, with much sorrow augmented by my having left Mommy & every one else but Poppy whom I was to leave next day.

"After I got here she commenced writing me very kind letters about what was going on at home. Once she asked me not to marry a certain friend of ours but suggested she had no right to advise me as I was entirely free & my own master to which I replied that she was right, at the same time feeling a little annoyed at the seeming want that I should try & bind myself to her. This at once made me extremely cautious in what I wrote & she complained of great coldness in my letters which complaint was well founded. Soon after the same subject being introduced more pointedly I reminded her of her expressed determination never to marry & gave numerous reasons why I should not engage myself to anyone under any circumstances. To this I got a spiteful little note telling me to direct my letters to *Miss* Sartain & not Emily, for the sake of politeness.

"Soon after she again commenced writing me every once in a while about home & the people I knew & what she thought might interest me & this lagged on till a month before Christmas. I wrote immediately a letter in answer & another one the next week but I have received no answer & the correspondence seems stopped.

"It hurts me for Emily to have written that but it is better that I should do so than that you should demand those things from her and it is necessary to understand my answer to your second indefinite question whether I expected to engage myself to her at some future time she knowing that I unexpect. I do not have such expectation & having written very explicit that I would not en-

Thomas Eakins

gage myself the initiative must rest with me where it belongs. It has been a long time since marrying has run in my head & I can only deal in probabilities. If I ever marry it will likely be with a girl of southern feeling good impulses & heart healthy & able to bear strong beautiful children. I promise you only never to run after a New England she doctor but I might look hard at an Italian or Jersey farmer's daughter. But these are idle dreams. I must think of my painting.

"God grant, you write me, that what you wrote be not wrong. God grant that what I answer may not be wrong. Consider how studiously you should keep from every one this knowledge but your mother. Emily is very sensitive as much so as yourself and has already suffered much from it as I remember long long ago. . . .

"I never thought you knew Emily very well. Once you were very bitter against her which I hardly liked. Afterwards you had an extravagant admiration for her which I never encouraged. Her insanity is great people, her trouble smartness and her virtues you know as well as I do."

Three months later, when Emily was coming to Paris with friends, he wrote: "I will be very glad to see you so soon. It has been a long time since we were together. . . . I will meet you at the depot." But that fall, coolness turned into active resentment. She had evidently written to his father speaking highly of Schussele, with whom she and Bill were studying at the Pennsylvania Academy, and he suspected that she had said that Schussele was a better teacher than Gérôme, and Philadelphia a better place to study art than Paris. He wrote Fanny in old French: "Y ha des femmes qui veulent tout gouverner et en prime place les hommes et d'aultant plus qu'elles soient faibles et incapable de se diriger elles-mesmes."* And to his mother: "I am sorry to see . . . that Emily is at her old tricks again. . . . She has lost Fanny's friendship for always & that of the rest of the family. . . . She broke with me who was always a good friend to her."

This was the end of the affair, as far as we know. It is impossible not to sympathize with Emily Sartain, or to hold Eakins blameless. They had been in love, he had written her ardent letters; then with separation his ardor had cooled, and he had withdrawn. Yet, considered realistically, it is doubtful that their marriage would have worked. Apart from the difference in ages, there were temperamental differences. Emily might well have proved too intellectual, ambitious, and dominating for him; and she might have found his uncompromising convictions and unconventional ways hard to put up with. Also, at the time he was still a student, in his middle twenties, and as he said, "I must think of my painting."

* There are women who wish to govern everything and in the first place men and all the more because they are weak and incapable of directing themselves.

Emily was to go on to an active and successful career as an engraver and painter, art editor of *Our Continent,* and educator. In 1886 Eakins, who had just been through the bitter experience of his forced resignation as director of the Pennsylvania Academy schools, heard of the death of the principal of the Philadelphia School of Design for Women, and immediately wrote Emily offering his help if she wanted the position: "I consider you as better qualified than any one else to direct such a large school: for you have great and good influence over young people and old too." A few days later he placed in her hands a statement of his principles in the Academy controversy, writing: "I send you a statement which I leave entirely to your discretion." She was appointed head of the School of Design, and remained so until her death in 1927. In the 1890s Eakins painted two portraits of her—but neither was finished; an unkind mutual friend said that she was too "bossy." And indeed the pose is that of a woman accustomed to command.

Emily Sartain never married. She saved his letters to her; hers to him seem not to have been preserved. As for Eakins, his determination to marry "a girl of southern feeling good impulses & heart healthy & able to bear strong beautiful children . . . an Italian or Jersey farmer's daughter" proved to be far from the reality of his future life. The young woman to whom he was to become engaged six years later did not correspond in any way with this image; nor did the woman he was to marry sixteen years later.

VII

One day in 1868, while Benjamin and Fanny were in Paris, Eakins opened by mistake a letter addressed to his father by Billy Crowell and started reading it to Benjamin and Fanny. "I commenced reading it out loud," he wrote to Billy, "and got as far as I love Fanny & have done so for a long time when I quick shut it up, saw on the back Benjamin Eakins & felt embarassed at reading in my father's letter before him & Fanny what I took to be a first declaration of your love. . . . It taught me what I never even dreamed of. . . .

"It seems now to me very natural that you should love one another only it never before entered my mind, & I am sure no one can blame you to keep on loving each other all your lives.

"As for marriage that is another thing. Fanny is not yet fully formed & you yourself would probably not wish to marry before you had your profession. . . .

"When the time comes for Fanny marrying if you are both in good health, how much gladder I will be if she chooses an old friend to me than a stranger.

"Yet without disparaging love I look upon love & marriage as two very different things or one can purely & very tenderly love the wife of another as did Dante & Michael Angel & other good men. . . .

"The noblest & most beautiful sight in the world is the father & mother of

strong children & the most ignoble & contemptible a bride & bride-groom. . . .

"My greater age has habituated me to patronize Fanny & all she does or is interested in. In love I feel like Methusaleh for I feel my love days long over & they will never come again. Love has racked me & was tearing my heart when I was a boy & none suspected it, and if ever I marry it will be only for the delight of raising children for the love of children grows on me not to leave an unnatural void."

This strange statement was written when he was only twenty-four. The next day he had the sense to add a postscript: "What I wrote that last stuff about myself for I dont know, or what connection it had with the subject, but there was some connection & I was going to say something I now forget but it was so late & I was so sleepy that probably it is not worth remembering for drowsiness connects things queer miles apart. All I want to say is that anything I can do to promote the happiness of my old friend & beloved sister will not remain undone."

VIII

As a young man Eakins had strong personal opinions and prejudices, which were freely expressed in his letters to Fanny. "Today there was no meat to be had because it is good friday. . . . Most people think they will go to hell if they eat meat on good friday & others that dont believe in it at all . . . would rather take a dose of castor oil than a nice piece of beef. Of all religions the christian is the most intolerant & inconsistent & no one without living here can know what a frightful war it wages against everything that is good." And in another letter: "Fanny if you ever will make a habit of going to church I'll think less of you."

She sometimes passed on to him certain friends' criticisms of Gérôme. One that particularly stung, in March 1869, was from Billy Crowell, who had evidently objected to Gérôme's picturing of the evil and cruel side of the past, such as Roman gladiatorial scenes. This called forth a seventeen-page letter to Fanny, largely devoted to a panegyric of his master. Among all his known letters, this is unique in its fervid emotion and extravagant praise.

"Gerome has made a picture of Dante," he wrote. "No one else could have done it. . . . Some painters paint beautiful skin, some find happy bits of color [then a list of other specialties], but who can paint men like my dear master, the living thinking acting men, whose faces tell their life long story. . . . Has he painted cruel or wicked men or low ones. Yes often & good ones too. . . . Gerome has raised himself above his fellow men by his brain as man himself is raised above the swine. He has made himself a judge of men." He described the famous *Ave Caesar, Morituri Te Salutant* (ill. 9), its "cold cruel barbarians killing one another for love of fighting, . . . the fat hideous Cesar, the poor

dead men. . . . There is your Colyseum, there are the men that built it & used it. Dont you like them. . . . It is the fashion to paint certain Roman virtues. Such pictures have been made wholesale since classic academies were first started & will always be made I fear, but they were lies. . . . You wanted to know the Romans. There they are real. Gerome knows them. He knows all men. Maybe you would have prefered some pleasing little episode a Roman a playing chess or smoking a pipe. . . . Ah Meissonier was your man. . . . Oh the sweet little Meissonier. The buttons are even sharper considerably than in Nature & you can count them twice as easily. Look at the little veins in the hand & the smoke how nice it curls."

A violent attack on Rome followed: "The Romans never became civilized. They never invented anything, they never made a picture, they never were architects. Their statues were made by Greeks. . . . They were rich these Romans from stealing. . . . The Greeks were very much like ourselves good plain civilized people loving home & not going out to fight except when attacked."

Going on to Gérôme's Near East subjects, he praised the life and beliefs of the people. "Their religion a silent prayer to the unknown immense God. The sun is going down. The man of the desert stops his horse spreads out his little carpet sticks his spear up in the ground takes off his shoes, everything is silent there, he forgets he is of the world & prays to his Allah. . . . How simple & grand. How Christ like. Then think of the contemptible catholic religion"— and a diatribe against rituals, images, genuflections, and so on. "See the Coffee house Almee the fat dancing girl with a big belly. . . . There's the East. . . . Gerome has given us the people, the grand old people of the Bible & the Arabian nights.

"How would you like to hear a minister reading the Bible & omitting everything improper or coughing in its place."

Then a long emotional description, with a drawing, of Gérôme's *Dante*, which pictured the poet, saddened by his expulsion from Florence, walking away from the city through a meadow, amid groups of young people who stop their play and music, frightened by his tragic face. "A strange man passes down the path amongst them. . . . Everything has become quiet as the landscape. You feel it right away. The music stopped. . . . He must look queer to the little children. They have not seen many such men as Dante. . . . Way off in the distance comes a pair of lovers. . . . By the time they come along the children will be at play again & some will laugh again. . . . Some will forget the queer man that came along. . . .

"Gerome always makes me think of Couture they are so different. . . . I saw four little things by Couture here lately . . . the most beautiful color I ever saw. . . . What a grand talent. He is the Phidias of painting & drawing. Who that ever looked in a girl's eyes or run his fingers through her soft hair or

smoothed her cheek with his hand or kissed her lips or their corners that plexus of all that is beautiful in modelling but must love Couture for having shown us nature again & beauty on canvass. In his Decadence he has far exceeded all other painters. . . . His art & Gerome's can hardly be compared. They are giants & children each to the other, & they are at the very head of all art."

In considering this extraordinary letter we must remember that Eakins was only twenty-four, that he had been hurt by criticism of his master from his close friend and future brother-in-law, and that he wanted his sister to share his beliefs. "You are superior to any girl I know of Fanny," he wrote, "or I never would have written you here what I have, or wanted you to think of Gerome as I do."

But what is surprising is his focusing on Gérôme's subjects, without mentioning his artistic and technical qualities; and his acceptance of the historic and exotic character of these subjects. He was extolling his master's realism in depicting the historic and exotic, his fidelity to facts, his truthful representation of humanity in its evil, cruel, and sensual aspects, as well as its affirmative ones. Doubtless he had in mind the pseudoclassic, saccharine idealism of much Salon painting. But it is curious that there was not a word about Gérôme's lack of interest in the realities of the contemporary world, which was to be Eakins' own chief subject matter. In this respect his art was to be much closer to Courbet's, Manet's, and Degas' than to Gérôme's. This letter confirms the naïveté of his artistic opinions at this time, his imprisonment in the official French art world, and his obliviousness to the naturalistic trend of independent French painting.

A month later, in a long letter to his father, he expressed contempt for the type of artist who depended on social maneuvering to sell his work, apropos of Thomas Buchanan Read's *Sheridan's Ride* (now in the National Portrait Gallery, Washington): "I saw the other day a thing by T. Buchanan Read. It was a picture of his poem Sheridans Ride. The frame was very beautiful and had the poem cut out in it an American eagle on top and his own bust in relief on it and all gilt. The picture itself was shameful. I never in my life saw such pretension united with bad work. You could not sell such a picture in an old rubbish store in Paris for 3 francs. Yet the man actually makes money out of his painting. He plots the Americans in Rome where he stays. He uses all kinds of tricks. . . .

"The nest of American artists at Rome is an infection. Their aim is to get big prices heavier than those commanded from the greatest artist. . . . Pickpockets are better principled than such artists for pickpockets rob from strangers. . . .

"A good painting has a very high money value which it always brings and beyond that a fancy price that runs up and down very irregularly. This fancy price is gambling and an artist that pays attention to it instead of the real price

must lose in the end as sure as insurance. The big painters understand this and whether their aim is reputation or the comforts of money or even social position they look on painting as their heaviest tool and work through it. A prince or any one at all could not get in to Gerome or Meissonier or Couture at work. No one but a student can ever get in to Gerome. So every thing I see around me narrows my path and makes me more earnest and hard working. That Pettit or Read get big prices does not in the least affect me. If I had no hope of ever earning big prices I might be envious and now worthy painting is the only hope of my life and study."

His letters home were not entirely concerned with personal and artistic matters; French and European politics sometimes entered in. About the dispute between France and Prussia over the status of Luxembourg, in the spring of 1867, he had written Benjamin: "This European balance of power business hardly seems honest to an American. It is as if I cocked my pistol and went up to my friend and said, My dear fellow, you seem to have been a little successful in your business lately. There is some danger that you may indeed become richer than I am which you see my pride & position in society could not tolerate. I had the honor yesterday to ask you for your pocket-book, and you will hardly refuse for the sake of such a trifle. . . . Besides my honor is now at stake."

When Czar Alexander II came to Paris for the opening of the Exposition Universelle of 1867, "I happened to be on the boulevard when the Emperor Napoleon went out to the depot to receive Alexander. He was bowing to everybody. About a square behind him an undertaker driving a hearse at full gallop followed him he also bowing like the Emperor. Everybody laughed even the policemen." Later he almost witnessed the attempted assassination of Alexander. "I was on the spot with Billy Crowell about 5 minutes before the thing happened. When the Emperors discovered no one was hurt they immediately kissed one another. They came back to Paris at full gallop a regiment of Horsemen clearing the way. They are said to have looked very pale."

By the spring of 1869 the hollow, corrupt absolutism of the Second Empire was in its final year. The vacillating attempts of Napoleon III to placate the rising opposition to his government served only to inflame the revolutionary forces. The May elections saw bloody riots in Paris. Eakins' letters described in detail what was happening in the streets. "I intended to write about [my accounts] last night," he wrote his father on May 14, "but the streets were so interesting that I did [not] care to stay in but went out till near midnight. We kept within sight of the big crowd that marched through the streets howling the Marseilles Hymn breaking lamps and so forth. Night before last there were a good many killed and wounded. [A long description of incidents.] We have seen a Paris crowd and don't like it, so our party has resolved not to get into any of them and as we don't intend to assist either side we would run but

useless danger. So I'll stay at number three rue Fleurus if there is any serious fighting in the streets or go down to Brittany with Cure." And later: "A Paris crowd is ugly to deal with. They are half earnest half fun. . . . Its like we go a skating the first day. Some one goes on the ice at the edge. Soon another goes just a little farther then another one a little farther. . . . Sometimes people get a ducking."

3. France and Spain, 1868 to 1870

A N INCREASING SELF-CONFIDENCE appeared in Eakins' letters after he had been two years in Paris. "My hard work since I have been back here is telling on me & my studies are good," he wrote, probably after his travels with Benjamin and Fanny. "Since I am learning to work clean & bright & to understand some of the niceties of color. My anatomy studies & sculpture, especially the anatomy comes to bear on my work & I construct my men more solid & springy & strong. It makes me catch forms quicker & the slight movements of the model dont hinder or worry me, only show me plainer what I am doing. Although it is a good thing to work after the human figure a good deal, those who keep on doing nothing else, finish mostly by not being able to do anything else & not doing that better than the others. There is no doubt of the necessity of long studio work and that is the hardest of all work, but it is only one light and you ought no more to be accustomed to one light than to one model. Now I am going to give a great deal of my time to composition, working only after nature during the school hours. . . . So I am in good spirits."

But there were still plenty of problems. "When you first commence painting," he wrote his father in June 1869, "everything is in a muddle. Even the commonest colors seem to have the devil in them. . . . As these difficulties decrease or are entirely put away, then you have more time to look at the model and study, and your study becomes more regular and the works of other painters have an interest in showing you how they had the same troubles. I will push my study as far and fast as I can, now I am sure if I can keep my health I will make better pictures than most of the exhibition [the Salon]. One terrible anxiety is off my mind. I will never have to give up painting, for even now I could paint heads good enough to make a living anywhere in America. I hope not to be a drag on you a great while longer."

For a month, in August 1869, he worked in the private class of Léon Bonnat, where Bill Sartain was a student. But on September 8 he wrote Benjamin:

13. STUDY OF A NUDE MAN (THE STRONG MAN)
1867–1869. Oil. 21½ × 17⅝. G 26
Philadelphia Museum of Art; Gift of Mrs. Thomas Eakins
and Miss Mary Adeline Williams

"I have now given up going to Bonnat—he is in the country, his native town of Bayonne. . . . Bonnat is now a big man. . . . I am very glad to have gone to Bonnat & to have had his criticisms, but I like Gerome best I think. I will send you Bonnat's photograph. He has a queer shaped head & looks as if he might be anything at all from a philanthropist to a murderer. His forehead is very low but it is very wide & behind his head is high. He is the most timid man I ever saw in my life & has trouble to join three words together. If you ask him the simplest question about what he thinks the best way to do a thing, he wont tell you. He says do it just as you like. He will never impose any way of working on his boys. . . . He never finds fault with any thing but the result. [Then an account of Bonnat's early discouragements by his teachers.] Couture came near giving up painting on account of his masters & his conclusion is the best

thing a master can do is to let his pupils alone. Bonnat is still so young, his troubles are fresh in his mind & this is why he has no system." On the other hand, Eakins later admired Bonnat as an artist, almost as much as Gérôme.

Evidently his father urged him to return home again for a visit, but he replied in September 1869: "I might come home again this winter. But I would not on any account, much as I want to see you all for it would only put back a good deal further, the big day that I am always looking to now when I shall come home again to live. So a little more patience. I am all alone, and you are missing but one. Twenty days at least would have to be spent on the winter sea, and the thought of returning to France so soon, would not let me get regularly to work & the work could not be of the kind that I am most needing now. I think maybe my best plan would be to work at school till the rain begins, and then go over to Algiers in the sunlight & paint landscape. Open air painting is now important to me to strengthen my color & to study light."

Finally, in late autumn 1869, he wrote Benjamin: "I feel now that my school days are at last over and sooner than I dared hope, what I have come to France for is accomplished so let us look to the Fourth of July, as I once looked for it before & for Christmas after. I am as strong as any of Geromes pupils, and I have nothing now to gain by remaining. What I have learned I could not have learned at home, for beginning Paris is the best place. My attention to the living model even when I was doing my worst work has benefited me & improved my standard of beauty. It is bad to stay at school after being advanced as far as I am now. The French boys sometimes do & learn to make wonderful fine studies, but I notice those who make such studies seldom make good pictures, for to make these wonderful studies, they must make it their special trade, almost must stop learning & pay all their attention to what they are putting on their canvass rather than in their heads & their business becomes a different one from the painter's, who paints better even a study if he takes his time to it, than those who work in the schools to show off to catch a medal, to please a professor or catch the prize of Rome.

"I do not know if you understand. An attractive study is made from experience & calculations. The picture maker sets down his grand landmarks & lets them dry and never disturbs them, but the study maker must keep many of his landmarks entirely in his head for he must paint at the first lick & only part at a time & that must be entirely finished at once & so that a wonderful study is an accomplishment & not power. There are enough difficulties in painting itself, without multiplying them without searching what it is useless to vanquish & the best artists never make what is so often thought by the ignorant, to be flashing studies. A teacher can do very little for a pupil & should only be thankful if he dont hinder him & the greater the master, mostly the less he can say.

"What I have arrived to I have not gained, without any hard plodding work.

My studies & worries have made me thin. For a long time I did not hardly sleep at nights, but dreamed all the time about color & forms & often nearly always they were crazinesses in their queerness. So it seems to me almost new & strange now, that I do with great ease some things that I strained so hard for & sometimes thought impossible to accomplish. I have had the benefit of a good teacher with good classmates. Gerome is too great to impose much, but aside his overthrowing completely the ideas I had got before at home, & then telling me one or two little things in drawing, he has never been able to assist me much & oftener bothered me by mistaking my troubles. Sometimes in my spasmodic efforts to get my tones of color, the paint got thick & he would tell me that it was the thickness of the paint that was hindering me from delicate modelling or delicate changes. How I suffered in my doubtings & I would change again, make a fine drawing and rub weak sickly color on it & if my comrades or my teacher told me it was better, it almost drove me crazy, & again I would go back to my old instinct & make frightful work again. It made me doubt of myself, of my intelligence of everything & yet I thought things looked so beautiful & clean that I could not be mistaken. I think I tried every road possible. Sometimes I took all advice, sometimes I shut my ears & listened to none. My worst troubles are over, I know perfectly what I am doing and can run my modelling, without polishing or hiding or sneaking it away to the end. I can finish as far as I can see. What a relief to me when I saw everything falling in its place, as I always had an instinct that it would if I could ever get my bearings all correct only once."

II

But the strain of hard work and the gloom of Paris winters had their effect. "I have a cold that set me coughing today," Eakins wrote on November 5, 1869. "I will try to get it well. It has been raining now for two weeks every day and sometimes it pours and is very dark so that I feel anxious to get away. . . . Rain dampness and French fireplaces no color even in flesh nothing but dirty grays. If I had to live in water and cold mist I had rather be a cold blooded fish and not human. I made a good drawing at school this week, & if I can keep my health I think I can make a name as a painter for I am learning to make solid heavy work. I can construct the human figure now as well as any of Gerome's boys counting the old ones, and I am sure I can push my color farther so I keep working hard and thinking of the reward of my troubles and long studies. My attention will now be much divided from my school work to making up sketches and compositions now that I am getting such a good start. I have a good fire going that warms my back and I hold my feet up on a chair to keep them from the draught that blows in from under the doors and sashes and up the chimney. The French know no more about comfort than the man in the moon."

Three weeks later: "I am going to Spain. I have been pretty sick here in spite of my precautions against the weather & feel worn out. I will go straight to Madrid, stay a few days to see the pictures, & then go to Seville." (Bill Sartain had spent three weeks in Spain in 1867—"a great revelation to me"—and urged his friend to go there.)

Eakins left Paris on Monday night, November 29, "in a pouring rain of course," he wrote from Madrid on Thursday. "All my friends came to see me. . . . Tuesday afternoon at 2½ o'clock we started into Spain. It was still raining. The night was very cold in the mountains. At daylight we were crossing mountains with snow covering them all. At 10 minutes of seven we commenced descending. The sun got up in a clear sky a thing I had not seen for a very long while and at half past nine we were in Madrid. I was pretty weak and sick from my diarrhoea but the sight of the sun did a great deal to cure me and now I feel right well and almost as strong as ever. The sky here is a very deep blue the air is dry mountain air and the temperature 40 Fahrenheit. . . . My appetite which I had lost entirely is as entirely come back again. Tomorrow night I will start to Seville where I will try to stay some time. Madrid is the cleanest city I ever saw in my life. . . . I went to church this morning to hear mass. . . . Friday afternoon. The ladies of Madrid are very pretty, about the same or a little better than the Parisians but not so fine as the American girls. . . . I have been going all the time since I have been here and I know Madrid now better than I know Versailles or Germantown."

At the Prado he discovered Spanish painting. "I have seen big painting here," he said in the same letter. "When I had looked at all the paintings by all the masters I had known, I could not help saying to myself all the time, its very pretty but its not all yet. It ought to be better, but now I have seen what I always thought ought to have been done and what did not seem to me impossible. O what a satisfaction it gave me to see the good Spanish work so good so strong so reasonable so free from every affectation. It stands out like nature itself. . . . I have seen the big work every day and I will never forget it. It has given me more courage than anything else ever could."

III

After three days and two nights in Madrid, Eakins resumed his journey south to Seville, where he stayed first at the Fonda de Paris. Soon he was joined by his deaf-mute friend, Harry Moore.

"I am painting all the morning till three," he wrote on January 6. "Then I walk out into the country with Harry Moore. Then back to dinner & then we sit in the dining room by the fire & talk for I am the only one that can talk with him & he likes to talk very much. . . . I am very well & it seems to me when I breathe the dry warm air & look at the bright sun, that I never was so strong & I wonder if I can ever be sick or weak again. The Spaniards I like better than

any people I ever saw & so does Harry Moore. He notices things, more than ordinary people, & remarks the absence of every servility & at the same time a great watching for the comforts or feelings of others. He can see farther out of the corner of his eye than any one I ever knew, & he sees everywhere gentlemen repressing the curiosity of the little children at our queer motions, or at least trying to prevent its exhibition. We walk out every day into the country. One day we went up along the river. At every quarter of a mile there would be little groups of young men & women, much like our old picnic parties, family affairs, & they would be dancing. We stopped a long while with one party, the girls were so beautiful & one man came with a little pig skin full of very fine wine & gave us all to drink making us take first because we were strangers. How different a reception we would have got in England & even at home. I don't know if we would have liked to see two foreigners stop to look at our party because of its pretty girls."

In early January, Bill Sartain joined them, and the three friends enjoyed to the full the life of the ancient southern city. Sartain later wrote: "At the Fonda de Paris Tom and I had a splendid large room, looking out on two streets, and also on the hotel court yard which was planted with orange and other fruit trees, and had a fountain in its centre. In the morning before getting up we rang and said to the waiter who came what we would have for breakfast—and were offered any game or other delicacy that the markets afforded—generally having steak & game—and elaborate Spanish dishes. At six in the afternoon we had a superb table-d-hote of many courses and then there were four desserts. Our bill at this hotel was $1.50 per diem."

Eakins reported on January 16: "Harry Moore, Billy Sartain & I are all three in fine health & spirits, it is warm & bright. I know ever so many gypsies men & women, circus people, street dancers, theatre dancers and bull fighters. The bull fighters are quiet, gentle looking men." Ten days later: "I am forming a very desirable acquaintance at Seville. I speak Spanish enough every day to kill or deafen a Spaniard if my whole conversation of the day could be addressed to one person."

In the meantime he had embarked on his first complete composition, a large oil of street entertainers, a *compañía gymnástica:* the Requeña family— Augustín, Angelita, and their seven-year-old daughter, Carmelita. The girl is dancing in a sunlit street, while her father blows a horn and her mother beats a drum. The shadows of unseen spectators fall on the pavement, in a window a woman with a child in her arms is watching, over the wall can be seen the roof of a palacio, a palm tree, and the blue sky.

"My student life is over now & my regular work is commenced," Eakins wrote his father on January 26. "I have started the most difficult kind of a picture, making studies in the sunlight. The proprietor of the Hotel gave us permission to work up on top of the roof where we can study right in the sun.

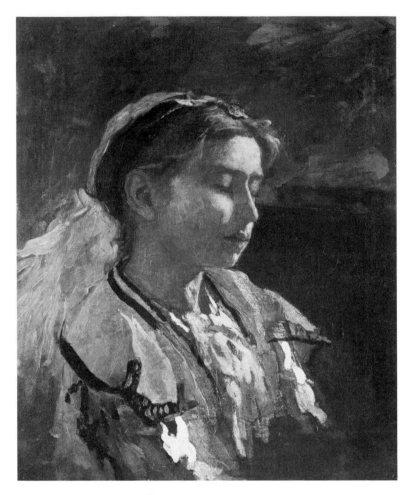

14. CARMELITA REQUEÑA
1869. Oil. 21 × 17. G 32
The Metropolitan Museum of Art;
Bequest of Mary Cushing Fosburgh, 1979

Something unforeseen may occur & my pictures may be failures, these first ones. I cannot make a picture fast yet, I want experience in my calculations. Sometimes I do a thing too soon & I have to do it all over again. Sometimes it takes me longer to do a thing than I thought it would & that interferes with something ahead & I have a good many botherations, but I am sure I am on the right road to good work & that is better than being far in a bad road. I am perfectly comfortable, have every facility for work especially sun shine, roof & beautiful models, good natured natural people desirous of pleasing me. If I get through with what I am at, I want a few weeks of morning sun light. Then I will make a bull fighter picture & maybe a gypsy one."

But "something unforeseen" did happen, and seven weeks later he wrote:

"The trouble of making a picture for the first time is something frightful. You are thrown off the track by the most contemptible little things that you never thought of & then there are your calculations all to the devil & your paint is wet & it dries slow, just to spite you, in the spot where you are the most hurried. However if we have blue sky, I think I can finish the picture & it wont be too bad if not too clumsy."

Two weeks later, excusing himself for not writing his father once a week: "I have been lately working very hard & often in much trouble & when night came I would be very lazy. Sometimes I am at work at 6 o'clock & except to take my two meals I work on till 6 at night & then eat my dinner & then after dinner, I don't feel like doing anything at all but going to bed.

"If all the work I have put on my picture could have been straight work I could have had a hundred pictures at least, but I had to change & bother, paint in & out. Picture making is new to me, there is the sun & gay colors & a hundred things you never see in a studio light & ever so many botherations that no one out of the trade could ever guess at. I hope to soon be over the worst part.

"We take a day most every week to do nothing, working on Sundays. Then we get horses and gallop off into the country & we mostly average 40 miles and that makes us sleep well. It is more pleasant than walking for we go so fast & far & then rest all the middle of the day & look at the sky & eat our dinner.

"The bull fights are the best two in Spain & the bull fighters are now arriving. They are very fine men. I like them extremely." (Sartain recalled: "Having on my previous visit to Spain seen a bull fight I did not care to go again—though the others did.")

At the end of April he was still working on his big picture. "My want of experience in picture making has made me lose weeks of time, but I am not in the least disheartened, as your last letter feared. I will know so much better how to go about another one. My picture will be an ordinary sort of picture, with good things here and there so that a painter can see it is at least earnest clumsiness."

A Street Scene in Seville evidences the long labor that went into it: the handling is tight and not completely certain; the paint is heavily laid on; and although the motionless figures of the man and woman are well and solidly realized, the action of the little dancer seems frozen, without movement. Yet the picture is an unusual performance for a young artist doing his first large composition. It is something seen firsthand and painted without studio formulas. Especially noteworthy is the handling of outdoor light: the sunlit figure of the dancer against the shadowed wall, and the two other figures in shadow except for small patches of sunlight on them. The prevailing grays are given value by a few notes of positive colors in the clothes: scarlet, blue, black, white. Eakins had set himself a difficult set of problems, and had at least partly resolved them.

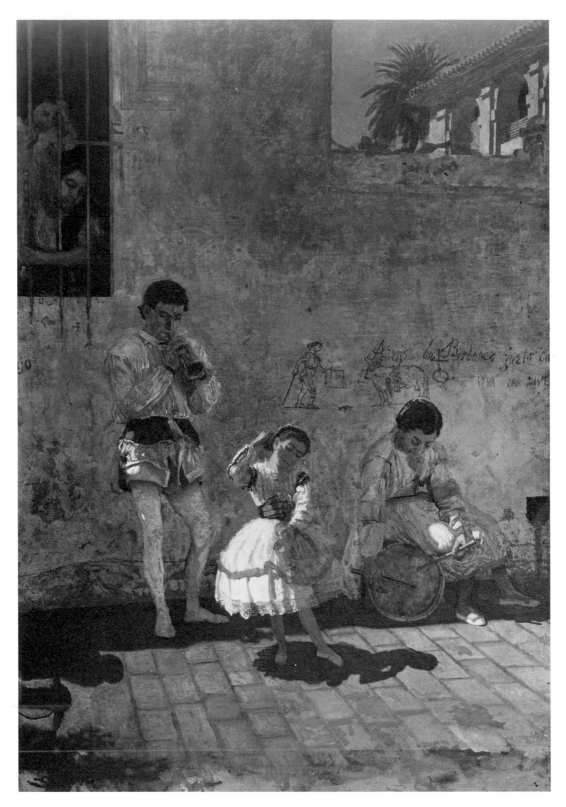

15. A STREET SCENE IN SEVILLE
1870. Oil. 62³/₄ × 42. G 33
Mrs. John Randolph Garrett, Sr., Roanoke, Virginia

Toward the end of their stay in Seville, probably in May, the three young Americans made a nine-day horseback journey to Ronda, about fifty miles southeast, in the rugged wilds of Andalusia. Sartain wrote later: "Attaching ourselves, but not too closely except when needed for finding our way or for safety, to the ordinario or expressman who carried his goods on the backs of mules we started on our journey. It took three days to arrive at Ronda, part of the way over mountains where there were no roads—only occasional tracks made in the previous journeys. It was thus for long stretches over hills & mountainsides, a vast solitary waste. At night we would sleep in the inns, consisting of one long cobble stone paved room—at the further end our horses and the mules & baggage, nearer the part devoted to cooking & eating. . . . At night they laid on the cobble stone floor for each of us a mattras not over five feet long, a foot wide & perhaps an inch thick—through which the stones were plainly felt." Three days were spent in Ronda with excursions into the surrounding country, then three more to return.

IV

In late May 1870, after six months in Spain, Eakins left Seville for Madrid and Paris with his two friends. This time he may have stayed longer in Madrid than he had in December and spent more time in the Prado, for in a small notebook he made full notes, which appear to have been written after leaving Seville, on paintings in the museum; they seem more extensive than he would have had time for in his previous short stay, especially with all the sightseeing he had done. These notes, almost all in French, give a more intensive view of his observations and opinions about painting than even his letters to his father and Fanny.

We have seen his emotions on encountering Spanish painting on his first stay in Madrid. In the 1860s it was still impossible to know the art of Spain in depth outside its native country. For several decades it had had an influence on certain French painters, notably Courbet and Manet, but mostly through the few examples in the Louvre, occasional exhibitions, and the visits of troupes of Spanish dancers, rather than by firsthand contact in the Prado. Courbet never visited Spain, and Manet, the painter who showed the most direct influence of Velázquez and Goya, did not go there until 1865, and for two weeks only. (On the other hand, Bonnat studied in Madrid in the 1850s.) Eakins was one of the first American artists to experience Spanish art in Spain. It came to him with an unexpectedness and impact that would have been impossible later.

His great discovery in the Prado was of course Velázquez. Here at last was an old master whose viewpoint corresponded with his own: portrayal of real life and real men and women, even in religious and mythological subjects; love of character more than ideal beauty; and a style closely related to visual

France and Spain, 1868 to 1870

reality. In his mastery of light and its effect on color and values, the Spaniard had solved all the problems with which Eakins had been struggling; and his consummate skill, the depth and richness of his technique, and his command of the brush were a revelation after the dry, tight methods of the Beaux-Arts. At the same time, Velázquez's fundamental austerity and simplification, and his deliberately reserved color harmonies, with their sensuous subtleties of grays, whites, blacks, and earth tones, coincided with the instinctive preferences of the young American. Here was the real world pictured as he saw and felt it, but with a superlative artistry and a grave splendor he had never before realized. Throughout Eakins' life, Velázquez was to hold the highest place in his pantheon, and his own art was to reveal an affinity with him more than with any other old master.

His second discovery among the Spaniards was the somber naturalist Ribera. Eakins' style was to be as close to his as to Velázquez's, though in less essential ways: in concentration on the individual figure, emphasis on anatomy, and dark, warm color. In Eakins' notes the names "Ribera and Velázquez" and "Ribera and Rembrandt" were often coupled, with no distinction between their relative artistic statures. It is typical of his lack of aesthetic sophistication that even though in 1868 he had spent several days in both Naples and Rome he seems to have remained unaware of Ribera's greater predecessor in naturalism, Caravaggio.

As for other Spanish painters, Zurbarán was not mentioned in his notes, nor El Greco. To the latter his reaction would undoubtedly have been violently negative. Of Goya he wrote: "I never saw more character in children's heads than his studies for a large family portrait" (probably *The Family of Charles IV*); but of the finished picture: "abominable stiff commonplace work. . . . He would have done better to have worked on his picture from nature." But later: "Goya avait le procedé de Gilbert Stuart. *Examiner les choses de Stuart pour voir s'il a jamais pu faire lumineux. Goya fait un dessin exquise comme un Stuart*."*

To the other national schools so richly represented in the museum he paid less attention than to the Spaniards. Titian's *Danae* was mentioned, but only with a comment that the paint in the figure's thigh had cracked in the light but not in the shadows, "qui sont très profondes et très coloriées."† Veronese and Tintoretto were commented on, only that their paintings had not cracked.

The third of the Prado's great trinity—Velázquez, Titian, Rubens—was not mentioned in his notes, but a long section of his letter of December 2 had been devoted to a diatribe against him: "I am glad to see the Rubens things that is the best he ever painted and to have them alongside the Spanish work. I

* Goya had the method of Gilbert Stuart. *Examine Stuart's things to see if he was ever able to make things luminous. Goya makes a drawing as exquisite as a Stuart.*
† . . . which are very profound and very colorful.

always hated his nasty vulgar work and now I have seen the best he ever did I can hate him too. The best picture he ever made stands by a Velasquez. His best quality that of light on flesh is knocked by Velasquez and that is Rubens' only quality while it is but the beginning of Velasquez's. Rubens is the nastiest most vulgar noisy painter that ever lived. His men are twisted to pieces. His modelling is always crooked and dropsical and no marking is ever in its right place or anything like what he sees in nature, his people never have bones, his color is dashing and flashy, his people must all be in the most violent action must use the strength of Hercules if a little watch is to be wound up, the wind must be blowing great guns even in a chamber or dining room, everything must be making a noise and tumbling about there must be monsters too for his men were not monstrous enough for him. His pictures always put me in mind of chamber pots and I would not be sorry if they were all burnt." So between Rubens, the exuberant master of the baroque, of plastic movement and dynamic design, and Velázquez, the austere, static naturalist, he chose the latter.

But most of his notebook observations were about technique. Examination of the older canvases in the Prado, particularly those of Velázquez, brought home to him the difference between direct painting, *au premier coup*, and the old masters' more complex, richer processes of underpainting and successive overpaintings and glazes, with the main forms and lighted areas built up in solid pigment, and the shadows and final details painted in translucent glazes —a technique that created the utmost substance and depth. By contrast, the *premier coup* method, to his mind, resulted in what he called *faiblesse d'aspect*—weakness of appearance, or lack of substance.

About one figure in Velázquez's *Las Hilanderas* (probably the young woman in the right foreground) he wrote: "Voici comme quoi je pense être peinte la femme filandiere de tapis, le plus beau morceau de peinture que j'ai vu de ma vie.

"Il l'a dessinée sans faire attention aux traits. Seulement il a mis sa tête et bras bien en place. Alors il l'a peinte très solidement sans chercher ou même marquer aucun plis des draperies, et peut-être a-t-il cherché ses harmonies de couleurs à plusieurs reprises peignant là-dessus car la couleur est excessivement épaisse sur le cou et toutes les parties delicates.

"Enfin il a frotté là-dessus quand tout était bien sec se servant de tons déjà preparés et alors seulement a-t-il fini son dessin indiquant les traits.

"Je crois Ribera et Rembrandt avoir procedé de cette même manière, la seule à mon avis qui puisse donner la delicatesse et la force en même temps.

"Les Vandyks à Madrid sont d'un dessin superbe mais sont très faibles d'aspect à côté les Ribera et Velasquez, parce que ils ont été peints au premier coup probablement et il n'a pas pu employer la pâte qui aurait détruit sa delicatesse de modelé.

"Voilà aussi pourquoi les études de tête de Goya sont si faibles d'aspect bien que modelées comme des Vandyks.

"Ce n'est pas un préjuge qui me fait croire que Velasquez n'a pas peint les plis du pourpoint blanc du premier coup, car on voit bien que les plis sont de simples frottis d'ombres sur le blanc.

"D'ailleurs c'est bien la manière de Bonnat et de Fortuny, et c'est là toujours que m'ont porté mes propres instincts. . . .

"Velasquez frotte beaucoup avec des couleurs tout à fait transparentes dans les ombres mais *le dessous est deja tres solidement peint.* . . .

"Faire solide tout-de-suite."*

As to the technique taught by Gérôme, although Eakins was always to retain his admiration for his master, he now realized how limited his methods were. One of his earliest notes was: "Il faut me décider de ne jamais peindre de la façon du patron. On ne peut guère espérer être plus fort que lui et il est loin de peindre comme les Ribera et les Velasquez quoiqu'il soit aussi fort qu'aucun frotteur." And later, speaking of Ribera's and Rembrandt's attention to texture: "Couture et Bonnat le savent bien. Gerome ne l'a jamais soupçonné à ce qu'il parait."†

By the beginning of June he was back in Paris, where he remained for a half-month, seeing the Salon and making notes on some of the pictures, in the same notebook he had kept in Spain. These comments, still in French, ex-

* Here is how I think the woman tapestry-weaver was painted, the most beautiful piece of painting that I have seen in my life.

He drew her without giving attention to details. Only he put her head and arm well in place. Then he painted her very solidly without seeking or even marking any folds of the draperies, and perhaps he sought for his color harmonies in several repetitions painting over, for the color is excessively thick on the neck and all the delicate parts.

Finally he glazed [or scumbled] over when everything was quite dry using tones already prepared and only then he finished his drawing indicating the details.

I believe that Ribera and Rembrandt proceeded in this same manner, the only one that in my opinion can give delicacy and strength at the same time.

The Vandyks at Madrid are superb in drawing but are very weak in appearance beside the works of Ribera and Velasquez, because they were painted *au premier coup* probably and he was not able to use impasto, which would have destroyed his delicacy of modeling.

That is also why the studies of heads by Goya are so weak in appearance although modeled like Vandyks.

It is not a prejudice which makes me believe that Velasquez did not paint the folds of the white doublet [he should have said "bodice"] *du premier coup,* for one sees well that the folds are simple glazes of shadows on the white.

Moreover this is clearly the manner of Bonnat and of Fortuny, and it is always toward this that my own instincts carried me. . . .

Velasquez glazes a great deal with entirely transparent colors in the shadows but *the undersurface is already very solidly painted.* . . .

Paint solidly at once.

† I must decide never to paint in the manner of the master. One can hardly hope to be stronger than he and he is far from painting like the Riberas and the Velasquezes although he is as strong as any *frotteur.* [The last word is ambiguous; it could mean either a painter who glazes or scumbles, or a floor polisher. Probably student slang.]

Couture and Bonnat know it well. Gerome has never suspected it, it appears.

panded into a long discussion of the handling of light in relation to color, and vice versa. Having for some years been used to the unchanging illumination of the studio, and having recently struggled with outdoor light in his big picture, he was concentrating on how to secure the widest possible range of color, while keeping within the widest range of lights and darks. For example, one should not allow a white or a brilliant color to appear in the strongest light, as this would make it necessary to lower all the other values and to limit the range of color. Of Eugène Giraud's *La Confession avant le combat* in the Salon he noted: "Il avait bien garde de ne mettre aucun objet colorié dans le soleil ce qui lui a permis d'étendre sa gamme beaucoup et de donner au costume du toreador toute la couleur qui lui convient." And he noted that in Henri Regnault's *Salome* (now in the Metropolitan Museum): "La femme est dans une demi teinte ce qui a permis au peintre de faire le plus grand contraste possible les cheveux excessivement noirs, la lumière jaune la couleur qui prête la plus à la lumiere et cela lui a laissé toutes les couleurs brillantes pour faire son costume et accessoires en demi teinte. Ainsi tous les autres tableaux autour paraissent t'ils [sic] très faible d'aspect.

"J'aurais dû peindre ma danse dans les rues d'une autre façon," he continued. "J'aurais dû peindre au premier coup un objet rouge quelconque au soleil et à droite de mes figures; le mur et le ciel et laisser sécher. Après j'aurais peint mes figures par dessus et enfin couvert les objets à droite qui m'aurait donné la note du rouge. J'aurais gagné énormément en temps et travail et mon tableau n'aurait pas été faible d'aspect. . . .

"Ribera s'est bien gardé dans son grand tableau à Madrid de laisser paraître du blanc dans la lumière."* (Probably *The Martyrdom of Saint Bartholomew.*)

After his half-month in Paris, in mid-June Eakins sailed for home, reaching Philadelphia in time for the Fourth of July, as he had promised. He brought with him his large Seville street scene and three small canvases painted in Spain. But of oils done in Paris, the products of almost three years' struggles in learning to paint, he seems to have brought back only about twelve or fourteen small works (unless he later destroyed others). Stranger still, out of the eight or

* He guarded himself well against putting any colored object in the sun which permitted him to extend his gamut a great deal and to give to the costume of the toreador all the color that suited it.

The woman is in a half-shade which permitted the painter to make the greatest possible contrast the excessively black hair, the yellow light the color that lends the most to light and this has left him all the brilliant colors to paint her costume and accessories in half-shade. So all the other pictures around it appear very weak in appearance.

I should have painted my dance in the streets in another way. I should have painted *au premier coup* any red object in the sun and at the right of my figures; the wall and the sky and let it dry. Afterward I should have painted my figures on top and at last covered the objects at the right which would have given the note of red. I would have gained enormously in time and work and my picture would not have been weak in appearance. . . .

Ribera guarded himself well in his big picture in Madrid against letting white appear in the light.

nine figure studies, none shows the complete figure—only the heads and shoulders of nude models, male and female, cut down from larger canvases. The most probable explanation is that he wanted to avoid problems with the United States customs. Even in their reduced state, these oil studies have a strength, a solidity and bigness, and a command of light and shadow that present a promise of future growth, and that make one regret the absence of the rest of the bodies.

Only a few weeks after Eakins left France the Franco-Prussian War broke out—that cataclysm which was to destroy the Parisian world of the Second Empire that he had known. In August his classmate Achille Guédé wrote him: "Je suis soldat dans la guerre contre la Prusse et je vais partir. Je ne sais pas quand ce sera fini, ni même si je reviendrai; je t'écrirai quand je pourrai et si tu ne reçois plus de lettre de moi, c'est que je serai tué."* (He was not.) And after the fall of France and the two sieges of Paris, Louis Cure wrote, on May 28, 1871, the day the Commune collapsed in the flaming city: "Guille est hors Paris, hors danger, il se porte bien. Je m'impresse de t'apprendre cette bonne nouvelle."†

For the rest of his life Eakins was never to forget Gérôme, his fellow students, and his years in France and Spain. But he was never to return.

* I am a soldier in the war against Prussia and I am about to leave. I do not know when this will be finished, nor even if I will return; I will write you when I can and if you do not receive any more letters from me, it will be because I have been killed.

† Guille is out of Paris, out of danger, he is well. I hasten to let you know this good news.

4. The Early 1870s

THE UNITED STATES to which Eakins returned in 1870 had entered the post-Civil-War era of tremendous material expansion. The phenomenal growth of industry, commerce, and railroad-building was producing the first great American fortunes. New wealth and leisure were awakening cultural aspirations. Contacts with Europe were closer. The new millionaires were beginning to plunder the old world for old masters to hang in their grand new mansions. More contemporary foreign art was being imported: mostly academic French, German, and Dutch, bought for record-making prices. Public awareness of the fine arts was growing. Museums were being established; art magazines were being launched (and foundering); the popular press was giving more space to art. Art schools were expanding, and more students were entering them, including a larger proportion of women; although most of the latter would abandon art for matrimony, the feminine influence on the American art world was becoming a powerful factor.

In consonance with the new spirit, architecture was displaying increased scale, ostentation, and eclecticism. Elaborate ornamentation was replacing the relative plainness of earlier days; furniture was heavier, intricately carved, highly upholstered; the dark interiors were filled with bric-a-brac and objets d'art; young ladies were decorating cozy corners with fishnets, shells, and gilded autumn leaves. While middle-class men had settled into the sartorial rut of dark suits and stiff white collars, women's clothes had evolved into ornate constructions of bustles, pleats, bows, loops, ruches, and flounces. It was an age in which structure was being concealed beneath what was fondly believed to be artistic embellishment.

In 1870 American painting was responding to the new expansive spirit, but still in the language of the past. The Hudson River School tradition was culminating in the grandiose canvases of Frederic E. Church, Albert Bierstadt, and Thomas Moran, depicting the natural marvels of the Western Hemisphere. The genre painters were picturing life in America in its sentimental or humorous aspects, with nostalgic fixation on country life and childhood. The

American city was ignored by all but illustrators and printmakers. Portraiture had declined from the high level of Copley, Charles Willson Peale, Stuart, Neagle, and Sully to a plateau of routine competence. Aside from a few idealized allegorical works, particularly in sculpture, the nude remained a questionable subject. The prevailing artistic philosophy was literal representation: the artist must picture nature faithfully, in full detail, without taking liberties. Except for a few heterodox individuals, artists showed little awareness of new developments in Europe: even the Barbizon School was considered revolutionary by established painters. The American art world was under the complete control of the older academicians, backed by patrons, critics, and the public. In spite of growing wealth and artistic aspirations, the 1870s were still a provincial period in American art.

In the artistic history of the period a key role was to be played by the huge Centennial Exhibition of 1876 in Philadelphia, the first major world's fair in this country. Bringing together not only the latest products of technology from all nations, but current European painting, sculpture, and decorative arts, it was to prove a landmark in the cultural evolution of the American people, making them more aware of international arts and, at the same time, of their own past.

II

Most young American artists returning from Europe in these years found the native scene uncivilized and crude, and hard to assimilate into art. But Eakins was of stronger fiber. As both artist and man, he fitted back into his environment as if he had never been away.

A top-floor room at the back of 1729 Mount Vernon Street was turned into a studio, with large windows giving north light. Benjamin fixed it up nicely, with curtains at the windows and comfortable furniture; and at first he would work there while his son painted, and Aunt Eliza would sew and knit. Finally Eakins could stand this no longer and had to tell them that he must work alone. They were much hurt, but after this the studio assumed the character that suited Eakins—that of a workshop. It was probably this episode that led to an agreement between father and son, made verbally in 1871, and put into writing in 1883: "In consideration of the sum of Twenty dollars per month (this until changed or broken by sufficient notice) paid by Thomas Eakins to Benjamin Eakins, Thomas Eakins receives his board, lodging, and the exclusive use of the 4th story studio. Thomas Eakins will have the right to bring to his studio his models, his pupils, his sitters, and whomsoever he will, and both Benjamin Eakins and Thomas Eakins recognizing the necessity and usage in a figure painter of professional secrecy it is understood that the coming of persons to the studio is not to be the subject of comment or question by the family."

In Eakins' first American paintings his most frequent subjects were his sisters, seen in their home and engaged in everyday occupations. These pictures were modest in size and entirely informal. In one Fanny is playing the piano, in a white dress with a red sash. In another she is playing while Maggy leans on the piano, listening. His second sister, now about seventeen, was also musical; in still another painting, later called *Home Scene*, she is seated at the piano but pauses to look down at little Caddy lying on the floor writing on a slate.

Maggy was also the subject of one of his earliest portraits, *Margaret in Skating Costume.* An outdoor girl, she had become a fit skating companion for him and Benjamin. In her rough corduroy jacket, with her blunt features and dark coloring she is far from a fashionable young lady.

Will Crowell had two younger sisters, Kathrin and Elizabeth, a little older and a little younger than Maggy, and the young people of the two families were becoming close friends. Eakins pictured Elizabeth as a girl in her teens sitting on the floor, her schoolbooks beside her, making her poodle beg for a cookie balanced on its nose.

In 1872 he painted his first full-scale, full-length portrait, of Kathrin, the older sister, in a white muslin dress, seated in an armchair, playing with a kitten. Three years later Elizabeth, now a young lady, was pictured in another full-scale painting, *Elizabeth at the Piano.* (How often these young women were shown making music!) Dressed in black, with a red rose in her hair, she is playing in a sort of indoor twilight. Her shadowed face, revealed by reflected light, is sensitive and sympathetic. A strange, unorthodox way to portray an attractive young woman; yet the muted light, the dark tonality, the limited but deep color, create a penetrating mood; one can almost hear the music. There is an undercurrent of deep feeling: for the woman, for music, for the quiet harmonies of domestic life.

In the small *Chess Players,* a year later, his father's two old friends, the painter George W. Holmes (at the right) and Bertrand Gardel, teacher of French, are playing, while Benjamin stands looking on. The concentration called for by the game is exactly conveyed: both players are studying the board, and Benjamin is equally absorbed. The comfortable wood-paneled room, the three glasses on the chess table, the decanter, wine bottles, and wine glasses on the small table, the family cat—all bespeak a solid middle-class home and an atmosphere of seasoned friendship. The inscription on the side of the chess table, BENJAMINI. EAKINS. FILIUS. PINXIT. 76, is a testimony to the artist's relation with his father.

In these domestic scenes Eakins was a complete realist. Every figure was someone he knew well, every room was a real one, every piece of furniture was actual—some of them still in 1729 Mount Vernon Street in the 1930s. These paintings differed from most American genre of the time. They told no

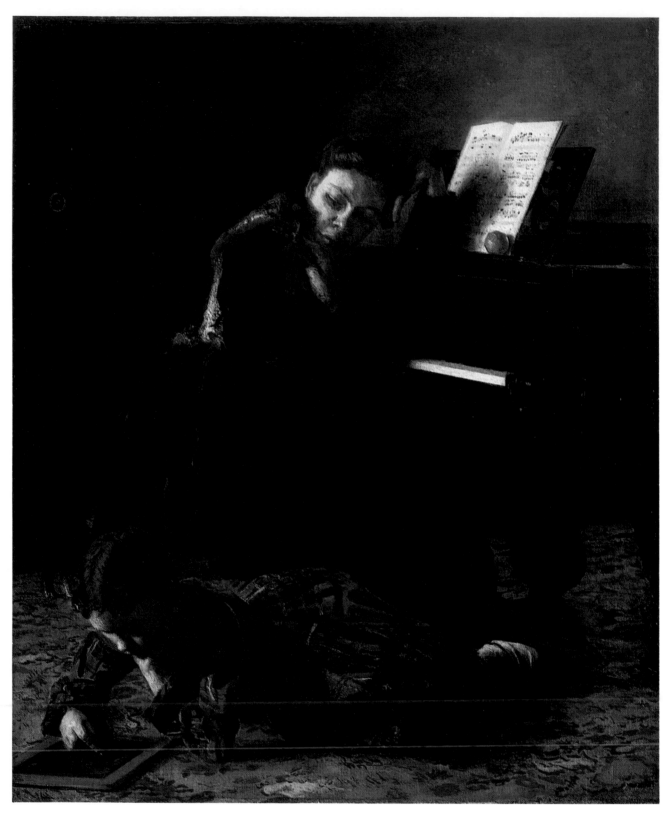

16. HOME SCENE
Early 1870s. Oil. 21¹¹/₁₆ × 18¹/₁₆. G 37
The Brooklyn Museum; Gift of George A. Hearn and others

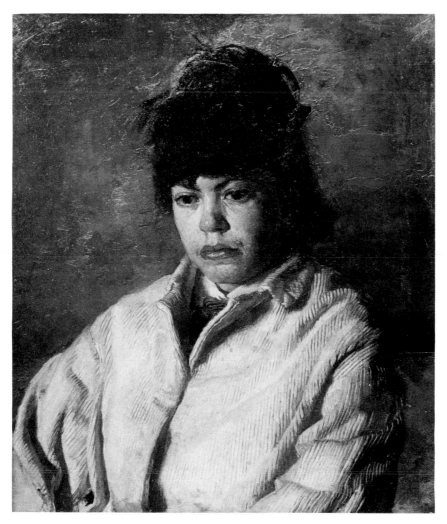

17. MARGARET IN SKATING COSTUME
Early 1870s. Oil. 24¹⁄₈ × 20¹⁄₈. G 39
Philadelphia Museum of Art; Gift of Mrs. Thomas Eakins
and Miss Mary Adeline Williams

stories, sentimental or humorous; they simply pictured women and men in their daily lives, with entire truthfulness. Individual character, in faces, bodies, hands, clothes, was portrayed honestly and exactly. None of the people, no matter how close to him, were flattered; even his beloved sister Fanny was shown as not conventionally pretty—a contrast to the idealization usual in picturing women in that day. The dark interiors of the period were depicted with equal veracity, but they were subordinated to the people. In this also, his works differed from most native genre. In Eastman Johnson's fine *Hatch Family,* for example, the room and its furnishings were almost as impor-

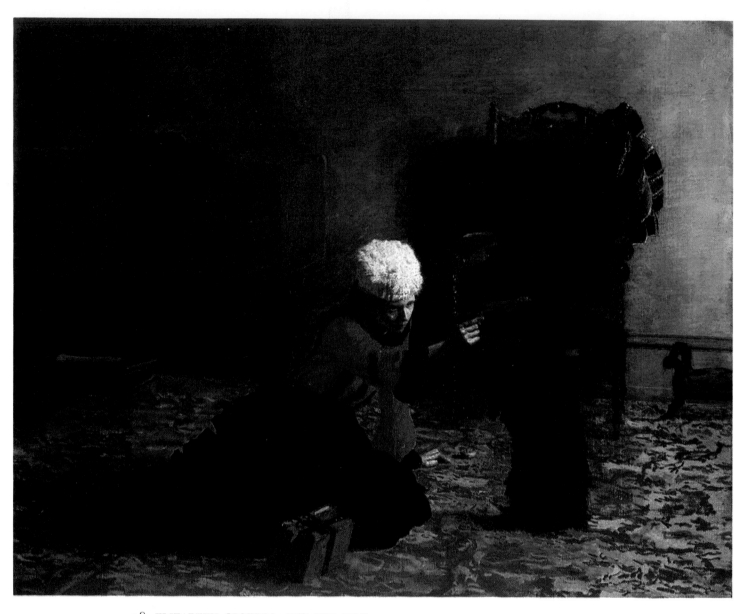

18. ELIZABETH CROWELL AND HER DOG
Early 1870s. Oil. 13³/₄ × 17. G 46
San Diego Museum of Art; Gift of Mr. and Mrs. Edwin S. Larsen

70
Thomas Eakins

tant as the human actors; whereas Eakins concentrated on the individual man or woman, for whom the setting remained a setting. His people were seen informally; they seemed not to be posing but to have been caught unawares, in natural attitudes, like Elizabeth with her poodle, or Caddy lying on the floor as children like to, her back to her sister. The utter authenticity of these domestic scenes gave them a flavor unique in American painting of the time. The artist's viewpoint was purely objective; there was no overt expression of subjective emotion. But his intimate relation to his subjects, and the truth and depth of his portrayal of them, created an undertone of reserved but intense feeling. These works had their own kind of sober poetry.

19. THE CHESS PLAYERS
1876. Oil. 11¾ × 16¾. G 96
The Metropolitan Museum of Art; Gift of the artist, 1881

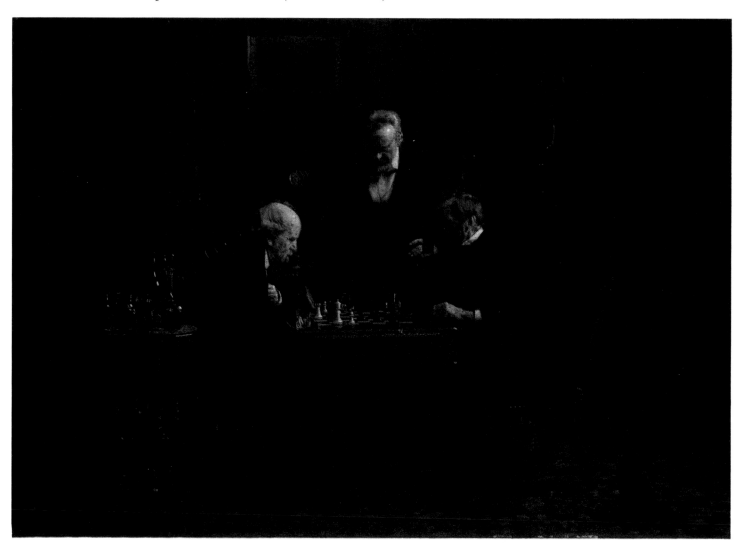

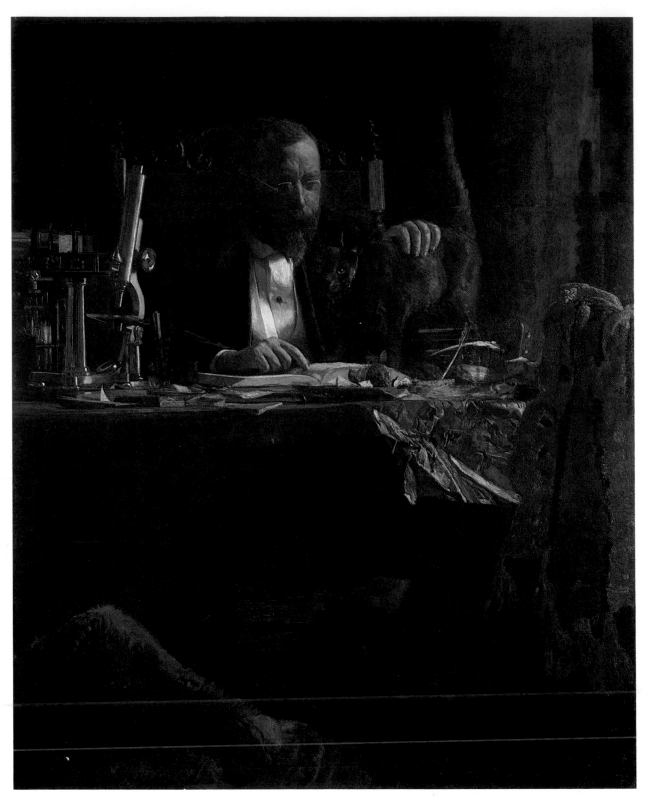

20. PROFESSOR BENJAMIN HOWARD RAND
1874. Oil. 60 × 48. G 85
Medical College of Thomas Jefferson University, Philadelphia

21. PROFESSOR BENJAMIN HOWARD RAND: DETAIL

In the middle 1870s Eakins embarked on portraits of persons other than his family and friends. These portraits were not commissioned: the sitters were prominent Philadelphians he knew and admired; he asked them to pose, and gave them the paintings. Often he borrowed them back for exhibitions. Doubtless he aimed in this way to launch himself as a portrait-painter.

His first such sitter was Benjamin H. Rand, who had taught chemistry at Central High School when Eakins was a student there, and who now, in 1874, was Professor of Chemistry at Jefferson Medical College. He is shown reading at his desk, pausing to stroke the cat that has invaded his study. The desk is crowded with objects: scientific instruments, test tubes, papers, and, in the midst of these, a red rose and the paper in which it had been wrapped. (Was it

His handling of light was somewhat like that of the Dutch Little Masters; but with Vermeer and Pieter de Hooch light was all-pervading, filling the whole picture, making the backgrounds prominent elements in the composition. Eakins' command of light was closer to Rembrandt's: concentration on the central forms, against backgrounds darker and subordinated. This principle was also close to that of Velázquez in his single figures; but in *Las Meninas* and *Las Hilanderas* there was a complex interplay of lights such as Eakins seldom attempted.

The color in these early interiors was dark, warm, and restricted in range. In these years before impressionism's chromatic revolution, most American painting was lower-keyed than it was to be from the 1880s on. For Eakins there was the example of the Spanish masters, with their palettes austere compared to the Italians and French. And his own character was attuned to a sober key: his seriousness, his concern with form, the somber emotional undertone revealed in some works—even his very complexion and coloring. In his palette the earth pigments predominated. Flesh tones tended to be swarthy, Latin. Grays and browns and neutral tones played considerable parts in his color harmonies. The purely decorative or emotionally expressive roles of color did not concern him; for him color was a function of light and form, a result of light on forms of various local colors; it was integrated with form and space, and played its part in creating them.

But actually Eakins had an inborn, deeply physical color sense. Within its dark range his color had a full-bodied strength and depth. Like all other elements in his art, it possessed substance, physical power. And sometimes, in paintings in which he gave himself greater chromatic freedom, such as *Professor Rand, Dr. Brinton,* and *Mrs. Brinton,* to name only works of the 1870s, he attained a richness comparable to Courbet and the pre-impressionist art of Manet, Degas, and Bazille. Such works revealed him as a profoundly sensuous colorist.

III

A few months after his return from abroad the first of a number of tragedies occurred in Eakins' personal life. His mother was stricken with mental illness, the exact nature of which is not clear; it was probably a form of manic-depressive psychosis, and she may have spent some time in a mental institution. In April 1871 Rebecca Fussell wrote her daughter: "Tom Eaken has been at home since July 4th. Since early autumn he has never spent an evening from home as it worried his Mother & since her return home they never leave her a minute." His letters to her had revealed how deeply attached to her he was, and during her illness he took his part in nursing her. She died on June 4, 1872, in her early fifties. The attending physician was affiliated with the Philadelphia Hospital for the Insane; the city register gave the cause of death as

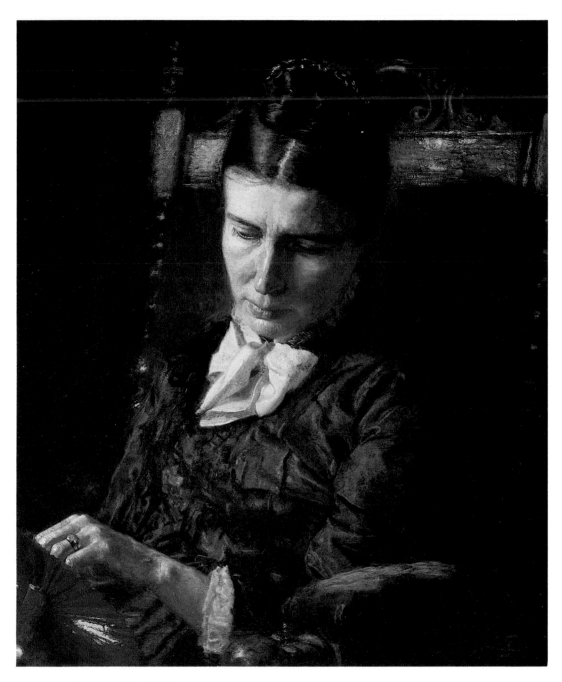

23. MRS. JOHN H. BRINTON
1878. Oil. 24¼ × 20⅛. G 126
Mrs. Rodolphe Meyer de Schauensee

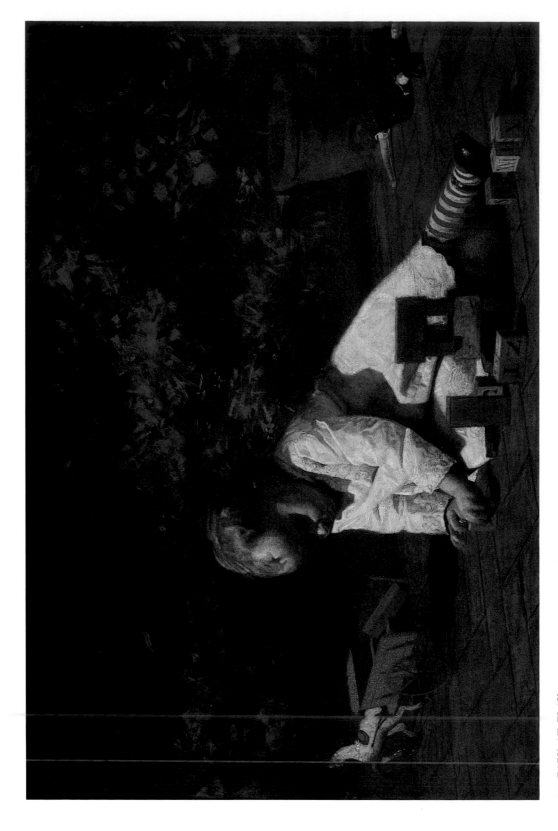

24. BABY AT PLAY
1876. Oil. 32¼ × 48. G 99
Collection of Mrs. John Hay Whitney

"exhaustion from mania." Following her death, her son was also ill from exhaustion, and it may well be that the tragic expression in his portrait photographs of this time was caused by this family tragedy. After her death he painted a portrait of her, from an old photograph (ill. 2). Benjamin was to survive her by twenty-seven years.

That year, on August 15, Frances Eakins married William Crowell, and the couple settled in the Mount Vernon Street house. Their first child, Ella, was born in December 1873. When she was about two and a half her uncle painted her sitting on the brick pavement of the backyard, playing with blocks and a toy horse and wagon. The painting is far from the usual baby picture—no prettifying, no rosy flesh. The child's face, looking down, is shadowed, almost somber. The picture is equally far from what an impressionist would have made of a child playing in sunlight. The figure is sunlit, but its warm tones against the red brick and green foliage create a color harmony that is deep and powerful, not brilliant. The painting has all of Eakins' usual substance; this baby is solid; she possesses avoirdupois. The last quality one would expect in a portrait of a two-year-old girl is monumentality, but this is the quality it has.

Ella was followed by another daughter in 1876 and a son in 1877. By this time the house must have become somewhat crowded. Will Crowell was studying law, and Benjamin promised him $5,000 when he finished law school. After he had done so, and the third child had arrived, Benjamin lent him $5,175, without interest, to buy a farm in Avondale, Chester County, Pennsylvania. Settling there for the rest of his and Fanny's lives, Will gave up the law for farming. Eventually they had ten children.

It had been in 1872 that Eakins painted his full-length portrait of Kathrin Crowell. Between them there was more than friendship, and in 1874 they became engaged, when he was thirty and she twenty-three. Many years later one of her best friends, Sallie Shaw, grandniece of Benjamin Eakins and a friend of Maggy, remembered Kathrin as small, with medium brown hair, not a tomboy like Sallie herself, enjoying fun though not creating much fun, and rather exclusive, "not associating with many." She was not artistic; she played the piano, but "nothing special"; "just a good decent girl." It has been written that Eakins wrote her "rather gentle, formal little letters," but they do not seem to have survived. She remains a dim and puzzling figure in his life, especially after his ardent relation with artistic, intellectual Emily Sartain, and after his declaration to Fanny in 1868: "If I ever marry it will likely be with a girl of southern feeling good impulses & heart healthy & able to bear strong beautiful children." Sallie Shaw said that Tom "associated" with so many girls that Benjamin put his foot down and told his son that he had to get engaged; she said that it was Benjamin who had really engineered the engagement to Kathrin. Rumor had it that it was her younger sister, Elizabeth, vivacious as well as pretty, whom he loved. (That there may have been some truth in all

25. KATHRIN
1872. Oil. 62³/₄ × 48¹/₄. G 45
Yale University Art Gallery; Bequest of Stephen Carlton Clark, B.A. 1903

this is suggested by his frequent affectionate references to a number of Philadelphia girls, in his letters to Fanny from abroad.)

Yet the fact that in 1872 he had chosen Kathrin as the subject of his first ambitious portrait shows that he was already attracted to her. But it is a strange portrait for a young man painting a girl to whom he was later to become engaged. In no way beautified, she sits with her head bowed, looking down at the kitten in her lap, so that one cannot see her eyes. The stark light leaves most of her face and figure in shadow; her skin is almost claylike in its lack of glow. With its dark earthy color, this is a sincere, somewhat labored, somber portrait.

The engagement was a long one; Eakins may have felt that he must be financially independent before marrying. Then, on April 6, 1879, Kathrin died of meningitis, at the age of twenty-eight.

Although her portrait was his first full-scale one, Eakins never exhibited it, as far as we know. He preserved their engagement ring, dated 1874. After his death, his widow gave it to Elizabeth.

He was to remain single for five more years, until he was almost forty.

I V

When he returned from abroad Eakins had resumed his active outdoor life, and it supplied many of his early subjects. In Philadelphia with its two rivers, rowing on the Schuylkill was a favorite sport. The reach of the river north of the Falls of Schuylkill Bridge was wide and the water was smooth, making it one of the best sculling courses in the country. Rowing, practiced by gentlemen of the city's upper class and by athletes of the less upper classes, was "a curious combination of athletic democracy and social exclusiveness," as Nathaniel Burt has written. The river banks were lined with the clubhouses of what was called, half-humorously, "The Schuylkill Navy." Eakins was an oarsman and belonged to a rowing club, probably the prestigious Pennsylvania Barge Club, of which Max Schmitt was a member. Eakins liked to watch the races, which provided one of the few opportunities in that day to see the at-least-partly unclothed human body in action.

His first recorded outdoor painting in America was *The Champion Single Sculls*, now titled *Max Schmitt in a Single Scull*. His boyhood friend had become one of the best amateur oarsmen on the river, winner of the Schuylkill Navy's first two single-scull races, in 1866 and 1867. The painting shows him in his shell *Josie*, resting on his oars, while in the distance the painter himself is rowing a shell with EAKINS 1871 on the stern. It is a clear day in late autumn or early spring, with glassy calm water; the afternoon sun strikes the rowers and shells, the brown trees, and the distant Girard Bridge. This was a scene completely familiar to the artist, observed firsthand, and recorded with fidelity to reality. The light and atmosphere were those of America: clear air, strong

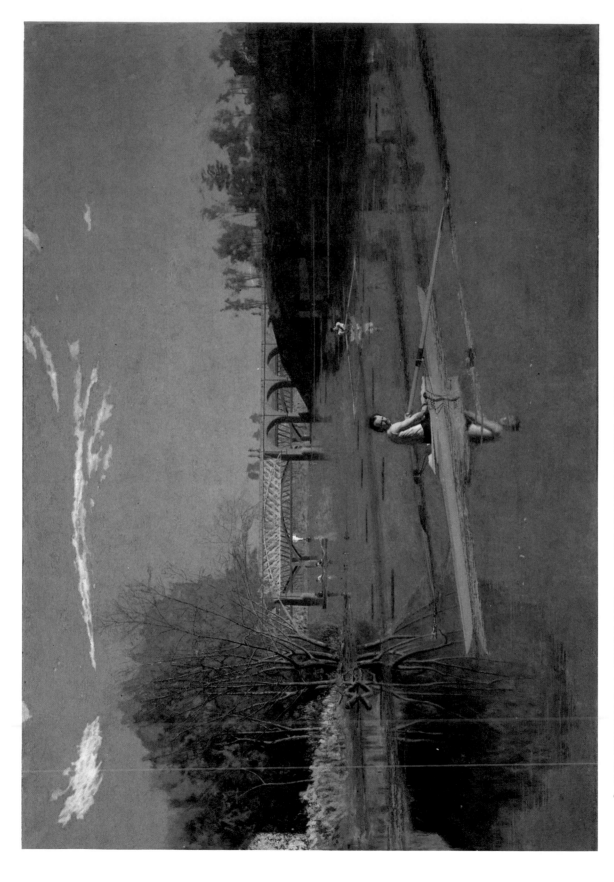

26. MAX SCHMITT IN A SINGLE SCULL, or THE CHAMPION SINGLE SCULLS
1871. Oil. 32¼ × 46¼. G 44
The Metropolitan Museum of Art; Purchase, 1934, Alfred N. Punnett Fund and gift of George D. Pratt, 1934

sunlight, high remote sky, brown trees and grass—things Eakins had never seen in Gérôme's class or in the Prado. There was no trace of a derived style. An original mind was dealing directly with actualities. The vision was photographically exact, crystal-clear. The three-dimensional space and the forms contained in it were well understood. The strong diagonal of Schmitt's shell in relation to the horizontal lines of the bridge and distant shore, created a finely conceived design. For an artist only twenty-six or twenty-seven years old, who little more than a year before had agonized over his first outdoor composition, the absolute sureness was remarkable.

Eakins' favorite professional oarsmen were the Biglin brothers, John and Bernard, of New York, among the top professionals in the country, who rowed a famous pair-oared race on the Schuylkill in May 1872 against Henry Coulter and Lewis Cavitt of Pittsburgh. "John and Barney Biglin have been long and favourably known to the boating community," said the Philadelphia *Press*. "They have rowed a great number of races and lost very few. . . . They are both dapper fellows, about the medium height, well formed, and with a very determined cast of countenance. . . . John is twenty-eight years old and Barney twenty-five. They are both in their prime, and have made the art of rowing a study most of their lives."

The Biglins arrived in Philadelphia several days before the race, and practiced on the Schuylkill. "Their rowing since their arrival here," the *Press* reported, "has been much admired for the grace and ease manifested in every motion, and the betting has been decidedly in their favor." In Eakins' painting *The Pair-oared Shell*, also called *Biglin Brothers Practising*, they are about to pass between the massive stone piers of the old Columbia Bridge; the time is just before sunset.

The race, on May 20, was between the Falls of Schuylkill Bridge and the Connecting Railroad Bridge, and return, a distance of five miles. Hours beforehand crowds had gathered on the shore and in boats. Wind and rain caused delays and the race did not start until late afternoon. At the turn the Biglins were three and a half lengths ahead, and at the finish, twenty lengths.

It was probably this race that provided the subject for Eakins' largest rowing picture, *The Biglin Brothers Turning the Stake*. The Biglins, wearing blue, have just turned their stake with a blue flag, while their competitors, wearing red, have not yet reached their red flag. In the left distance Eakins himself is seen in the stake boat, signaling with raised arm. The banks are crowded with spectators, afoot, on horseback, and in carriages, and the river is lined with craft of every size and kind. The Biglins are at about the middle point of their stroke, their oars biting into the water, and the muscular action of their arms and entire bodies is strongly portrayed. The sensation of physical energy and tension make this one of Eakins' most powerful representations of the male body.

27. MAX SCHMITT IN A SINGLE SCULL: DETAIL

Thomas Eakins

28. THE PAIR-OARED SHELL
1872. Oil. 24 × 36. G 49
Philadelphia Museum of Art; Gift of Mrs. Thomas Eakins
and Miss Mary Adeline Williams

29. THE BIGLIN BROTHERS TURNING THE STAKE
1873. Oil. 40¼ × 60¼. G 52
The Cleveland Museum of Art; Hinman B. Hurlbut Collection

30. THE BIGLIN BROTHERS TURNING THE STAKE: DETAIL

The Biglins remained his most frequent oarsmen models, even though their home base was New York. Probably from notes and memory, between 1872 and 1874 he pictured them, together and singly, in varying actions and settings, in at least nine oils and watercolors and six preparatory drawings. But there were other local oarsmen, nonprofessionals: his friends the Schreiber brothers; and the champion Pennsylvania Barge Club four, who included Max Schmitt, shown in a painting that hung for years in a clubhouse on the Schuyl-kill, probably a gift from the painter. Altogether, his rowing pictures formed the most numerous class of his outdoor subjects in the 1870s.

Another outdoor sport was sailboat racing on the Delaware River in its wide stretches east of the city. From boyhood Eakins had sailed his father's boat; he was at home on the river and knew all the river men. (In 1881 one of his best watercolors, *Starting out after Rail*, was owned by the boat-builder James C. Wignall, perhaps exchanged for a boat.)

31. SAILBOATS (HIKERS) RACING ON THE DELAWARE

1874. Oil. 24 × 36. G 76

Philadelphia Museum of Art; Gift of Mrs. Thomas Eakins and Miss Mary Adeline Williams

A favorite type of racing sailboat around Philadelphia was the "hiker," a small catboat with a tall mast, long boom, and a sail very big in relation to its hull—all of which made for speed, and a tendency to capsize. "When there is any more of a breeze than a cat's paw the fun commences," said *Harper's Weekly.* "The closest watchfulness, quickest decision, and nicest management are required of the sailing-master, and the crew must also be wide awake and active, ready instantly to obey the order to 'hike out'—to climb out to windward—when a 'tan-yarder jumps into her.' With all possible precautions, capsizes are frequent. . . . Such boats are very numerous at Philadelphia, and a regatta between them, with a stiff wind, is one of the most exciting spectacles imaginable."

Such a scene is pictured in *Sailboats (Hikers) Racing on the Delaware.* There is plenty of wind; the red-shirted skipper of the nearest boat bowling along is keeping his eye on the big sail, and three of his crew are leaning far out to windward. Farther away the river is alive with hikers on different tacks. It is a sunny day with a clear blue sky, and the picture is filled with sunlight, fresh wind, and lively movement. This is one of Eakins' happiest works.

A different kind of race is shown in three almost identical pictures (two small oils and a watercolor) called variously *Drifting; No Wind—Race Boats Drifting;* and *Waiting for a Breeze.* When the watercolor was exhibited in New York in 1875 Eakins wrote his friend and former Gérôme classmate Earl Shinn: "A drifting race. It is a still August morning 11 o'clock. The race has started down from Tony Brown's at Gloucester on the ebb tide.

"What wind there is from time to time is astern & the big sails flop out some one side & some the other. You can see a least little breeze this side of the vessels at anchor. It turns up the water enough to reflect the blue sky of the zenith. The row boats and clumsy sail boats in the fore ground are not the racers but starters and lookers on."

Still another outdoor pursuit was hunting railbirds in the wide marshes along the Delaware, where the Schuylkill joins the big river just below the city; or forty miles farther south on the New Jersey side, where the Cohansey Creek winds through the marshes. Benjamin Eakins and two old friends, George Morris and William R. Hallowell, owned a two-story boathouse near Fairton on the Cohansey, which they used for storing their boats and for sailing, fishing, hunting, and swimming. Morris was a wholesale clothing merchant in Philadelphia, a sturdy, jovial man of the English country-gentleman type, and a great gunner and sailor. Hallowell, member of an old Quaker family (there had been nine generations of William Hallowells in Pennsylvania), was a gentle little man who had been injured in the Civil War and was unable to work; he lived at Fairton on a bluff overlooking the creek. Both were good friends not only of Benjamin but of young Tom.

32. SAILBOATS (HIKERS) RACING ON THE DELAWARE: DETAIL

Their game was the clapper rail, a henlike creature of which it has been written: "The grass seems to swarm with them. It is ordinarily very difficult to flush them and one may wade or push a boat through the marsh for hours and never see one while all the time their tantalizing calls are heard near and far. . . . They are shot from small boats when the tide is high and the flooded marshes afford no shelter. . . . While one man poles the boat a second stands in the bow and fires at the slow-flying game as it rises from the scant cover."

In *The Artist and His Father Hunting Reed-birds* Benjamin stands forward in the boat, his gun at ready, while his son acts as pusher, poling the boat; the red-brown marshes stretch away into the distance. Inscribed on the boat's bow is the same signature as in *The Chess Players:* BENIAMINI EAKINS FILIUS PINXIT. Speaking to me of this painting in 1930, Margaret Eakins' friend Mary Adeline Williams, who as a girl had lived at Fairton and who used to sail and skate with Maggy, remembered that "the marshes looked just as they do in the picture, and Tom did also—big, slender and powerful." She recalled that near their house was a deep place in the creek, and on hot days the men, the dogs, and even the horses would go in bathing, the men without suits.

33. DRIFTING
1875. Watercolor. 10³/₄ × 16¹/₂. G 83
Mr. and Mrs. Elmer E. Pratt

34. THE ARTIST AND HIS FATHER HUNTING REED-BIRDS
c. 1874. Oil. 17¹/₈ × 26¹/₂. G 68
From the Collection of Mr. and Mrs. Paul Mellon

35. PUSHING FOR RAIL
1874. Oil. 13 × 30¹/₁₆. G 70
The Metropolitan Museum of Art; Arthur H. Hearn Fund, 1916

36. PUSHING FOR RAIL: DETAIL

The little oil *Pushing for Rail* shows three pairs of hunters and pushers: one hunter at the ready, one shooting, one reloading; in the distance are other pairs, and the sails of schooners on the Delaware, their hulls hidden by the reeds. In spite of the small scale of the figures, each is as exactly characterized as in a full-size portrait. They are far from the romantic sportsmen of painters like A. F. Tait and William T. Ranney; note the paunch of the middle-aged hunter at the left, and the shaggy, barefooted, ruffianly pusher at the right. Every detail of faces, bodies, clothes, and attitudes is delineated with miniaturelike fineness. But the whole scene is bathed in an autumnal mellowness of warm sunlight and hazy air. The six figures form a frieze against the distance and wide sky—a fine balance between specific forms and open space.

It was probably about *Pushing for Rail* that Eakins wrote a long letter in French to Gérôme, in 1874, explaining the subject: "a delightful hunt in my country. . . . I have chosen to show my old codgers in the season when the nights are fresh with autumn, and the falling stars come and the reeds dry out." He then went on to tell in detail just how the hunt was conducted. He evidently liked his old codgers, for two years later he took the right-hand hunter, in the same attitude and the same red shirt, and the Negro pusher at the left (in a different attitude), and put them together in *Will Schuster and Blackman Going Shooting.*

In these outdoor scenes as in his indoor ones, the figures were all specific persons. Max Schmitt was so precisely pictured that the painting was in one sense an outdoor portrait. In *Whistling Plover* the Negro hunter whistling to attract the birds was identified by the painter as "William Robinson of Back neck," and the picture was definitely a portrait, painted with almost microscopic precision. In the oil and watercolor versions of *Starting out after Rail* the two men were also named: the watercolor was originally titled *Harry Young, of Moyamensing, and Sam Helhower, "The Pusher," Going Rail Shooting*. Most of Eakins' subjects were local and personal, and some of his titles were equally so—a habit that must have amused his cosmopolitan colleagues.

At the same time, *Starting out after Rail* is one of his most abstract designs. The heeling boat with its geometric-shaped sail forms an obtuse-angle form against the flat water, the straight line of the distant shore, and the cloudless sky. The shore is exactly halfway between the top and bottom of the picture. The few distant boats keep the wide space from being monotonous. The style is severely simplified; there is not an unnecessary detail. The color scheme is equally simple, with only four main colors, yet so finely controlled that there is no lack of variety. Austerity of style is combined with purity of design.

In addition to rowing, sailing, and hunting, a newer sport appeared in one watercolor, *Baseball Players Practising*. "They are portraits of Athletic boys, a Philadelphia club," Eakins wrote Shinn. "I conceive that they are pretty well drawn.

"Ball players are very fine in their build. They are the same stuff as bull fighters only bull fighters are older and a trifle stronger perhaps. I think I will try make a base ball picture some day in oil. It will admit of fine figure painting." But this idea, like that in Seville for a bullfight picture, never got any further.

In all these outdoor pictures the central motifs are the men and their actions. But nature, although never the main motif, plays an essential part. In *Pushing for Rail* the hunters and the autumn marshes form a unified whole. In *Sailboats Racing* the focus is on the regatta, but the sunlit river and blue sky and breezy day are in complete harmony with the human action. In the finest of his outdoor paintings, *The Swimming Hole*, there is a perfect balance between the naked bathers and the secluded landscape setting.

Like his older contemporary Winslow Homer, Eakins was devoted to outdoor life and to picturing it; but their attitudes toward nature were very different. Homer loved nature for herself as much as for her relation to man; some of his major works, such as his marines, were without human figures. For Eakins nature was the environment for man and his occupations—a benign, harmonious environment, but never the principal actor. Among his finished paintings (aside from outdoor sketches) there is only one pure landscape, *The Meadows, Gloucester*—and it is by no means one of his most interesting works.

37 STARTING OUT AFTER RAIL
1874. Watercolor. 25 × 20. G 79
Wichita Art Museum, Wichita, Kansas; Roland P. Murdock Collection

The picturesque aspects of nature—mountains, forests, deserts, the sea—featured in most contemporary depiction of outdoor life in America, were absent from his work. His landscape was the environs of Philadelphia, its parks and rivers and marshes; the outdoor activities he pictured were those of city-dwellers. It is noteworthy that almost all these activities had to do with water: rowing, sailing, fishing, swimming, hunting in the marshes. It was inland water; Philadelphia, although a great port, is up the Delaware, fifty miles from the sea. The water was quiet, and its colors were not those of the ocean but of the two rivers: warm brown, green, and golden tones, with blues reflecting the sky. There was nothing in his paintings like the color and movement of Homer's marines of the stormy Atlantic on the Maine coast.

The infinitely changing life of nature—dawn, sunset, twilight, night, moonlight; storms, rain, and fog; the spectacle of varying skies; the whole visual drama of natural forces—all these phenomena that furnish the content of the landscape painter, had no part in Eakins' art. His hours were almost always those of broad daylight; his weather was usually clear and sunny. This had nothing to do with the idyllic viewpoint of the contemporary American impressionists; it was simply that the activities he painted were generally carried on in fair weather, and that he preferred meteorologic conditions that allowed things to be seen clearly. Nature's moods interested him less than her solid realities: the structure of earth and rocks and trees; the character of rivers and marshlands; the forms of man-made bridges; and the objective facts of season, time of day, wind, or calm.

Nevertheless, outdoor light was as thoroughly studied and realized as the tangible elements: its source, direction, intensity, and color; lights, halftones, and shadows; reflected lights. Figures and objects, seen in clear air and light, were represented with complete clarity, without veiling or softening. Lighted and shadowed areas were precisely defined. Often the principal light, as in his interiors, came from the side, illuminating one side of the forms.

The Biglin Brothers Turning the Stake demonstrates Eakins' study of outdoor light and color. Strong sunlight from the upper left and somewhat in front of us falls on the oarsmen's bodies and their shell, but leaves the sides toward us—the larger visible areas—in shadow. He has chosen a light that imposes the shadowed figures starkly against the sunlit water beyond them—an effective pictorial device. Lights and shadows are strongly contrasted; but the shadows are full of reflected lights, from the sky and from the water.

The sky is not blue (we are facing toward the sun), but warm grayed gold. The farther water is a similar warm hue, but bluer, reflecting both the sun and the higher sky; the foreground water is still bluer and darker, reflecting the sky at the zenith. The rowers' bodies in sunlight are light terracotta; in shadow, warm ruddy brown, but with cool blueish reflections: from the sky on their upper surfaces, from the water on their undersurfaces. These subtle

Thomas Eakins

variations reveal exact firsthand observation. The skillful use of complex lights and their different colors helps to achieve the roundness and substance that mark the picture, while the unveiled sunlight defining the men's straining muscles intensifies the sensation of physical energy.

With all its attention to outdoor light and color, the painting is far from impressionistic. Eakins shared with the impressionists a number of concepts: rejection of traditional classic and romantic subject matter; interest in contemporary life, including urban life; disregard of studio conventions in favor of direct observation of the real world, particularly the world of outdoors. But the impressionists were more concerned with purely visual sensations, with what the eye sees as much as with what the mind knows. Eakins' preoccupation with outdoor visual phenomena, although as intense as the impressionists', was differently motivated; he was concerned with outdoor light and color for their function in revealing form. Monet once said of his own art that he was painting not objects but the color of the air between him and them, but for Eakins the solid substance of the real world, and its pictorial equivalent in form, remained paramount. His vision was clear and precise, recognizing atmospheric envelopment but not emphasizing it. His paintings were constructed in black and white values as much as in color, and the range of values was wide, down to darks much darker than any in the impressionists' gamut. While the latter tended to dispense with gray and black, in Eakins' pictures, even his outdoor ones, neutral tones played a considerable part. His color was never to attain the brilliancy of fully developed impressionism. Some of his early outdoor canvases, such as *The Pair-oared Shell* and *The Biglin Brothers Racing*, were quite dark; and even in *Turning the Stake* the shadowed figures, the warm sky and distant shore, the relative absence of cool tones, and the full range of values were far from impressionism. The lightest and most colorful of his early works was *Sailboats Racing on the Delaware* with its sunlit cream-colored sails against the blue sky, the scarlet shirt of the nearest skipper, the varied bright colors of the flags on the distant ship. The picture was his closest to French impressionism, but its concern with the exact structural lines of the boats, its fineness of drawing, and its completely three-dimensional character were quite distinct from even the early works of the French school. Monet's early canvases were broader and looser in handling, heavier and richer in pigment, in one sense more "painterly." They showed more concern with two-dimensional values: elimination of halftones, deliberate flattening, abandonment of traditional concepts of three-dimensional design. By contrast, Eakins' paintings from the beginning had greater substance and depth, and more precision and refinement.

Most of the younger painters of Eakins' generation, not only the impressionists but the Sargent school, were concentrating on visual qualities at the expense of substance. Eakins, on the other hand, saw and felt the real world as

substantial forms. In this his art continued the tradition of pre-impressionist American naturalism—the tradition of the Colonial limners, of Feke and Copley, of Mount and Bingham, and of the Hudson River School in their more realistic works.

Specifically, his art can be seen as having a relation to the mid-century native tendency to which John I. H. Baur has given the name luminism. The luminists Fitz Hugh Lane and Martin Johnson Heade combined concentration on the object with intense absorption in light and its role in revealing and transforming the object. But between them and Eakins there were basic differences. The luminists' feeling for light was deeply poetic, with an affinity to transcendentalism—emotional values that were foreign to Eakins' naturalistic philosophy, just as his dominant interest in human beings and the physical life of the body was foreign to them. And in artistic qualities he was a more knowledgeable painter and a stronger master of form.

From the first, Eakins' vision was allied to photography, in its objectivity, exact recording of light, and reliance on black-and-white values. (This was of course long before color photography.) In the early 1880s he was to become an active photographer, but the stylistic affinity to photography appeared in his paintings ten years before we know of his using a camera. A manifestation of the naturalistic and scientific spirit of the period, it was appearing in the work of several other painters of the time. With Eakins the parallel to photography was in harmony with his whole artistic viewpoint; it involved neither a dependence on the photograph nor any loss of substance.

v

Eakins was exceptional among artists in his combination of artistic and scientific qualities. Next to painting, his chief interest was in certain fields of science. His studies at Jefferson Medical College and elsewhere had resulted in a knowledge of anatomy more thorough than that of any American painter. In his picturing of the human body in action, as in his rowing scenes, the figures had a vitality shown by no other figure painter in the country. But their anatomy was not stressed; there was no display of anatomical knowledge, no bulging muscles. The same vitality could be felt in his clothed figures.

He loved mathematics, and would sometimes relax his mind after painting by reading logarithms or working out problems in calculus. When he came to teach he would advise his students to study higher mathematics, which he said were "so much like painting." "In mathematics," he told them, "the complicated things are reduced to simple things. So it is in painting. You reduce the whole thing to simple factors. You establish these, and work out from them, pushing them toward one another. This will make strong work. The old masters worked this way." In his notes written abroad he had even applied similar principles to problems of pictorial light and color, concluding with the

38. PERSPECTIVE DRAWING FOR "THE PAIR-OARED SHELL"
1872. Pencil, ink, and watercolor. $31^{13}/_{16} \times 47^{9}/_{16}$. G 51
Philadelphia Museum of Art; Gift of Mrs. Thomas Eakins
and Miss Mary Adeline Williams

analogy: "Les mathematiciens n'ont pu mesurer le cercle qu'en commençant avec le carré dont on double continuellement le nombre de ses côtés."*

Perspective had absorbed him from high school days. For several of his paintings of the 1870s preparatory perspective drawings have survived, based on exact measurements and on mathematical computations, like the procedure of a mechanical draftsman. The ground plan of the composition was laid out in perspective, and on it the central forms were erected. For example, the perspective drawing for the watercolor *John Biglin in a Single Scull* (ill. 50) shows the water plotted in squares like a checkerboard, and drawn in perspective with lines receding to a vanishing point; the shell floating on this ground plan, complete in essentials, with the oars in exact positions; Biglin's figure;

* Mathematicians have not been able to measure the circle except by commencing with the square of which they double continually the number of its sides.

39. PERSPECTIVE DRAWING FOR "THE BIGLIN BROTHERS TURNING THE STAKE"
1873. Pen and ink, colored ink, and pencil. 31⁷/₈ × 47¹¹/₁₆. G 53
Hirshhorn Museum and Sculpture Garden, Smithsonian Institution

and the waves and the reflections in them precisely delineated. Occasionally details such as oarlocks or the pier of a bridge would be drawn separately in perspective. Often there would be mathematical notes, sometimes in French. These methods of construction were applied only to the main plan and the regular-shaped objects, not to the figures, which were drawn freehand. The completed drawing was the basis for the three-dimensional structure of the painting. Most of the existing perspective drawings are large (usually larger than the paintings), generally thirty-two by forty-eight inches. More were probably made but not preserved; a painting as finely designed in three dimensions as *Max Schmitt in a Single Scull* would almost certainly have been constructed in this way. These perspective drawings have a precise beauty of their own.

Similar methods seem to have been used in some indoor paintings, judging by the existing drawing for *The Chess Players* (ill. 19), in which the floor is divided into squares and drawn in perspective, and the central objects—the

Thomas Eakins

40. PERSPECTIVE DRAWING FOR "THE CHESS PLAYERS"
1876. Pencil and ink. 24 × 19. G 97
The Metropolitan Museum of Art; Fletcher Fund, 1942

chess table and the two players' chairs—are enclosed in rectangular boxes and positioned exactly on the floor plan. In a lecture on perspective that Eakins wrote later as a teacher, he recommended that objects of irregular form be constructed in this way, by enclosing them in boxes, dividing the surfaces of the boxes into small squares, tracing the outlines of the objects on the checkerboard of squares, and then removing the superfluous parts. "You need not imagine," he wrote, "there need be any want of accuracy in this method of copying by eye from one set of little squares to the other set, . . . for no matter if the eye itself should be so inaccurate that it would put a point in a little square as far as possible from its true place; yet by increasing the number of little squares, and so diminishing their size, a possible error can be made less than any given amount."

An example of the method was given in this lecture: "I know of no prettier problem in perspective than to draw a yacht sailing. Now it is not possible to prop her up on dry land, so as to draw her or photograph her, nor can she be made to hold still in the water in the position of sailing. Her lines, though, that is a mechanical drawing of her, can be had from her owner or her builder, and a draughtsman should be able to put her in perspective exactly.

"A vessel sailing will almost certainly have three different tilts. She will not likely be sailing in the direct plane of the picture. Then she will be tilted over sideways by the force of the wind, and she will most likely be riding up on a wave or pitching down into the next one. Now the way to draw her is to enclose her in a simple brick shaped form, to give in mechanical drawing the proper tilts one at a time, to the brick form, and finally to put the tilted brick into perspective and lop off the superabounding parts. . . .

"I advise you to take a real brick or a pasteboard box of similar shape, and letter the corners, and keep it by you while you draw it."

His own system, however, was more advanced than this, making use of higher mathematics, since he went on to say: "It is likely that an expert would not have got the tilts by drawing at all, but would have figured them out from trigonometric tables, but it is much easier for beginners to understand solid things than mere lines of direction."

Even the signatures in some of his more important portraits were inscribed in perspective on the floor instead of on the flat surface of the canvas. The signature was drawn flat, then squared off, redrawn in perspective, and transferred to the canvas. To such lengths would he go to insure that every element in the picture was three-dimensional.

A favorite problem in his rowing pictures was that of reflections in water, which so interested him that he later wrote an entire lecture on it, explaining the principles governing the different reflections on the near side of a wave, the far side, and the top—phenomena which to him were as susceptible to logical understanding as the structure of objects. These problems were close

41. JOHN BIGLIN IN A SINGLE SCULL
1874. Oil. 24¹/₁₆ × 16. G 59
Yale University Art Gallery, Whitney Collections of Sporting Art,
given in memory of Harry Payne Whitney, B.A. 1894, and
Payne Whitney, B.A. 1898, by Francis P. Garvan, B.A. 1897

42. THE BIGLIN BROTHERS RACING
Probably 1874. Oil. 24¹/₈ × 36¹/₈. G 61
National Gallery of Art; Gift of Mr. and Mrs. Cornelius Vanderbilt Whitney, 1953

to his recreations and his love of the water, and his exposition had a touch of poetry: "There is so much beauty in reflections that it is generally well worth while to get them right."

An example of his observation was: "Every one must have noticed on the sides of boats and wharves or rocks, when the sun is shining and the water in motion, never-ending processions of bright points and lines, the lines twisting into various shapes, now going slowly or in a stately manner, then dancing and interweaving in violent fashion.

"These points and lines are the reflections of the sun from the concave parts of the waves acting towards the sun as concave mirrors, focussing his rays now here, now there, according to the shifting concavities. . . .

"These bright points and lines are called caustics, and may, by knowing the cause of them, the general character of the waves at the time, and direction of the sun, be sufficiently well imitated by guess work."

In his perspective drawings for rowing pictures the reflections of figures, shells, and oars were exactly plotted. But it is noticeable that in the final paintings they were quite freely handled; in some pictures the broken colors of the reflections were among the richest passages in his early works.

Eakins' thoroughgoing, meticulous scientific procedures, exceptional even in his day, seem excessive to us today. Yet for him science remained subordinate to art. He was an artist using scientific methods, not a scientist practicing art. His studies were related to specific artistic problems: the anatomical structure of the body; human and animal locomotion; visual and optical phenomena; three-dimensional form and space. He reminds us of those early Renaissance masters who also lived in an age of scientific discoveries, and for whom art and science were inseparable; like Paolo Uccello he might have said: "What a sweet thing is this perspective!" His logical, inquiring mind worked naturally in scientific terms. There was nothing slavish in his use of scientific methods; he employed them but was not dependent on them. Actually, his innate grasp of the physical existence of figures and objects was so strong that if he had not used scientific procedures, the results would probably have been much the same. Certainly there was no coldness or lack of vitality in the final product. And it is undeniable that his rational study of the principles governing the physical world had much to do with the structural strength of his work from the very beginning.

Underlying his rationalism was the sensuous perception of physical reality that is the basis of all vital art. His understanding of reality was not merely intellectual, but deeply rooted in the senses. His work speaks in the direct sensory language of form and color, texture and pigment. Its sheer physical power is inescapable. The forms are absolutely solid, round, and weighty; they possess that rare quality, substance. His feeling for form was as deeply sensuous as the feeling for color more common among painters.

Eakins' technique was more complex than that of most of his contemporaries. Painters such as Manet, Sargent, Duveneck, and Chase were abandoning traditional methods in favor of direct painting *au premier coup.* The impressionists were developing a system of opaque pigment applied in separate touches. For Eakins, however, study of Velázquez and other old masters in the Prado had been a revelation of the complexity and richness of their technique, and of the limitations of *premier coup.* His usual procedure was to build his oils in underpainting and successive overpaintings and glazes. The forms in light were painted solidly and heavily, the shadows and recessions more translucently. The result was a combined substance and depth that could not be achieved by simple direct painting. He did not use transparent glazes as extensively or richly as the Venetians or Velázquez, but his adherence to a relatively traditional technique was exceptional in his time.

43. SAILING
c. 1875. Oil. 31⁷/₈ × 46¹/₄. G 77
Philadelphia Museum of Art; The Alex Simpson, Jr., Collection

Thomas Eakins

44. WILL SCHUSTER AND BLACKMAN GOING SHOOTING
1876. Oil. 22¹/₈ × 30¹/₄. G 104
Yale University Art Gallery;
Bequest of Stephen Carlton Clark, B.A. 1903

His paintings of the early and middle 1870s give evidence of considerable technical experimentation. Some oils, particularly his earliest figure paintings and portraits, were painted heavily and with more signs of labor than later works. Occasionally a palette knife was used, as in *Sailing*, or in particular passages like the sky in the oil study of *John Biglin in a Single Scull*. On the other hand, such early paintings as *Max Schmitt*, *The Biglin Brothers Turning the Stake*, and *Sailboats Racing* exhibit a technical command remarkable in so young a painter. In small pictures like *Pushing for Rail* and *The Chess Players* the handling is very delicate and fine, almost a miniature technique. In none of his canvases is there any display of brilliant brushwork in the manner of Sargent and many of the new generation. The brushwork is solid and firm, concerned with building forms, rather than with technical bravura.

Paradoxically, though a strong draftsman, he made few drawings, aside from his early studies of the nude and his perspective drawings. For drawing as a medium in itself he evidently cared little. He believed that the painter

should work in color and in oil pigment from the beginning of a picture. Instead of drawings, he painted small oil studies of the composition, in full color, giving just the main masses and tones. Such studies were usually squared off and enlarged onto the full-size canvas.

Although he frequently made small oil sketches outdoors, the finished paintings were executed in his studio. For more complex compositions his preparations were often elaborate. There would be separate oil studies of individual figures, some quite finished. Small wax models of the figures were sometimes made: for the 1877 version of *William Rush,* six such models; for *The Fairman Rogers Four-in-hand,* all four horses; for *The Swimming Hole,* the diver. Other models may have been made but not preserved. "When I came back from Paris," he told his students, "I painted those rowing pictures. I made a little boat out of a cigar box, and rag figures, with the red and white shirts, blue ribbons around the head, and I put them out into the sunlight on the roof and painted them, and tried to get the true tones."

Of some early compositions he produced several versions, with variations or in different mediums and sizes. Of *Starting out after Rail,* for example, there were an oil and a watercolor, practically identical; and with changes, a much larger oil, *Sailing.* There were watercolor and oil versions of *Whistling Plover;* and of *Drifting,* a watercolor and two oils. In the series of Biglin brothers pictures the figure of John, in almost identical pose and lighting, was repeated in two oils and a watercolor. As we have seen, a hunter and pusher in *Pushing for Rail* reappeared two years later in *Will Schuster and Blackman.* Evidently he felt that such products of thought and work should not be limited to one appearance. In this he was not alone: many artists' oeuvres reveal a similar economy.

VI

Eakins' watercolors are among the less familiar branches of his work. We usually think of him in terms of the weight and solidity of oil. His watercolors show a different aspect of his art. He began to use the medium in the early 1870s, and all but three of his twenty-seven known works in it were done in the ten years from 1873 to 1882. Their subjects paralleled the oils of these years; in fact, some were watercolor versions of the oils. In the 1870s there were scenes of rowing, sailing, and hunting; indoor genre; and his most complete and sympathetic picture of Negro life, *Negro Boy Dancing.* With the late 1870s came a series of historical subjects, and in the early 1880s of shad-fishing on the Delaware.

His watercolors were far from the spontaneous, on-the-spot works usually associated with the medium. They were as thoroughly planned as his oils. The perspective drawing for *John Biglin in a Single Scull* shows how completely the three-dimensional structure was worked out. The color studies for his wa-

45. WHISTLING PLOVER
1874. Watercolor. 11 × 16½. G 71
The Brooklyn Museum

46. NEGRO BOY DANCING
1878. Watercolor. 17⅝ × 22³/₁₆ sight. G 124
The Metropolitan Museum of Art; Fletcher Fund, 1925

tercolors, as for his oils, were in oil—a reversal of the usual procedure. (Winslow Homer, for example, often used his watercolors as source material for his oils.) One reason for his method may have been that it is more difficult to make changes in watercolor than in oil.

By these unusual methods Eakins produced watercolors that were as fully designed and realized as his oils, and as complete works of art, allowing for differences in scale and complexity. The physical nature of the lighter medium, of course, did not make possible the full substance and weightiness of his oils, but the watercolors had compensating qualities. Their color was always clearer and higher-keyed, because of the translucency of the water me-

47. STUDY FOR "NEGRO BOY DANCING": THE BANJO PLAYER
1878. Oil. 19 × 14³/₈. G 125
From the Collection of Mr. and Mrs. Paul Mellon

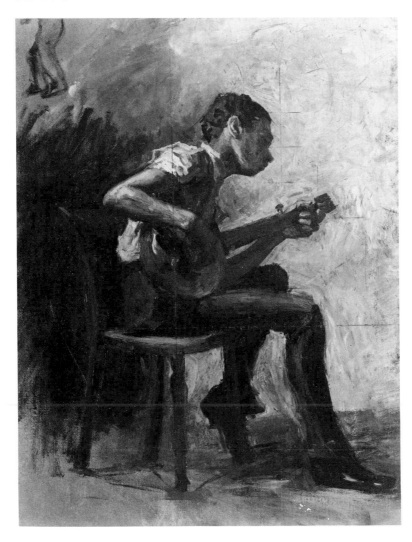

Thomas Eakins

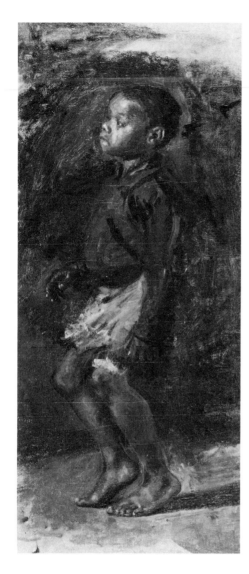

48. STUDY FOR "NEGRO BOY DANCING": THE BOY
1878. Oil. 21¹/₈ × 9¹/₈. G 125A
From the Collection of Mr. and Mrs. Paul Mellon

dium, with the white paper showing through the washes. The difference was particularly striking between watercolor and oil versions of the same composition, such as *Starting out after Rail.* (The same difference appears in the works of most artists who practice both mediums.) Though never brilliant, Eakins' watercolors had a quiet luminosity, a sense of pervading light, and a fine subtlety of color, especially in their grays. Their firm draftsmanship and skillful handling of washes made them among his most technically accomplished pictures. It is a testimony to his artistic range in these early years that, working on so small a scale and in so delicate a medium, he produced works of such quality. But a good many of his early oils, such as *Pushing for Rail* and *The Chess Players*, were also small compared to his later paintings, and were marked by refinement as well as strength.

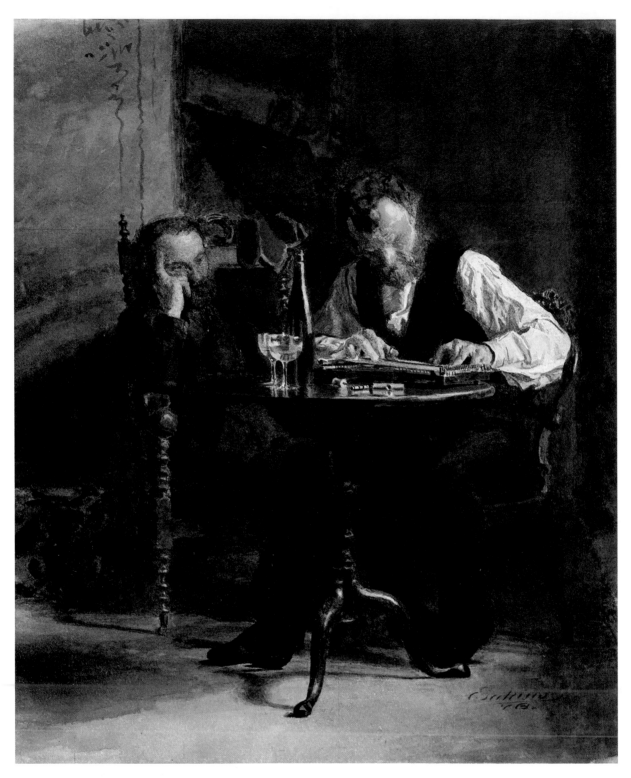

49. THE ZITHER PLAYER
1876. Watercolor. 12¹/₈ × 10¹/₂. G 94
The Art Institute of Chicago; Olivia Shaler Swan Memorial Collection

Eakins himself evidently considered his watercolors on a par with his oils: in the 1870s and early 1880s he exhibited them frequently, not only in water-color shows but in general shows; and he priced them not much lower than most of his oils. And it was two watercolors that he chose to send to his master Gérôme.

A tantalizing fact about his watercolors is that five of the twenty-seven re-corded have disappeared. Aside from the two he sent to Gérôme, three of those exhibited in the 1870s have so far not been found—including one that may have been among his most important, judging by its price and title, *The Pair-oared Race—John and Barney Biglin Turning the Stake,* probably a wa-tercolor version of the big oil. But inasmuch as two watercolors that were unlo-cated in 1933, when my catalogue list was published, have since turned up, there is hope that those still missing may be found.

A watercolor that definitely no longer exists was one of his few essays in fantasy, based on Longfellow's *Hiawatha.* (In 1867 he had written Fanny that Longfellow had produced "most beautiful poetry—far better than any En-glishman of today even Tennyson.") The subject was from "Hiawatha's Fast-ing": how he wrestled with Mondamin, the spirit of Indian corn, who died in the struggle, to be reborn as the corn plant. The watercolor showed the hero in a cornfield, standing over his opponent's body, silhouetted against a sunset sky with clouds shaped like animals. But in the end the subject proved too fanciful for Eakins. "I went seriously to work also at my Hiawatha," he wrote Earl Shinn in January 1875, "also to put into this exhibition intending to make a big water color. The corn angel was down & Hiawatha standing over & other angels as corn shocks were all around. And the sky was a corn field & a buffalo & deer & possum and squirrel & rabbit &c &c &c. It got so poetic at last that when Maggy would see it she would make as if it turned her stomach. I got so sick of it myself soon that I gave it up. I guess maybe my hair was getting too long for on having it cropped again I could not have been induced to finish it. I used to write poetry when I was a grammar school boy all about sweethearts. I guess they were madrigals. When I had them bad my mother used to give me vermifuge." In the 1940s this watercolor met a fate Eakins would have ap-proved of: it was ruined in an attempt to restore it.

Almost all Eakins' watercolors were products of his late twenties and early thirties. They had the varied, extroverted subject matter of those years before he abandoned the broader American scene to concentrate on portraiture.

VII

When Eakins had done work that he considered good enough to show to Gérôme, in the spring of 1873 he sent his master a watercolor of a rower (prob-ably John Biglin). Gérôme responded on May 10: "Mon cher Élève: J'ai reçu l'aquarelle que vous m'avez envoyé, je l'accepte avec plaisir et vous en remer-cie. Elle m'a été d'autant plus agréable que dans ce travail j'ai pu constater des

progrès singuliers et surtout une manière de procéder qui ne peut vous mener qu'à bien. Je ne vous cacherai pas que jadis à l'atelier je n'étais pas sans inquiétudes sur votre avenir de peintre, d'après les études que je vous voyais faire. Je suis bien enchanté que mes conseils, appliqués quoique tardivement, aient enfin portés leurs fruits, et je ne doute pas qu'avec de la persévérance, dans la bonne voie où vous êtes maintenant, vous n'arriviez à des résultats vraiment sérieuses. Je passe à la critique après avoir constaté les progrès. Le personnage qui est bien dessiné quant aux morceaux manque de mouvement dans l'ensemble, il est immobile et comme fixé sur l'eau; son attitude n'est pas je crois portée assez en avant, c'est à dire à la limite extrême du mouvement dans ce sens là. Il y a dans tout geste prolongé, comme l'action de ramer, une infinité de phases rapides, une infinité de points depuis le moment où le rameur, après s'être porté en avant, se ramene le haut du corps en arrière. Deux moments sont à choisir pour nous autres peintres, les deux phases extrêmes de l'action, soit quand il est porté en avant les rames étant en arrière, soit quand il est penché en arrière, les rames en avant: vous avez pris un point intermédiaire de là l'immobilité. La qualité generale du ton est très bonne le ciel est ferme et léger, les fonds bien à leur plan et l'eau est exécutée d'une façon charmante, très juste que je ne saurais trop louer. Ce qui me plaît surtout, et cela en prévision de l'avenir, c'est la construction et l'établissement joints à l'honnetêté qui a présidé à ce travail, c'est pourquoi je vous envoie mes compliments avec mes encouragements, et cela je suis très heureux de le faire. Tenez moi je vous prie en courant de vos travaux et consultez moi toutes les fois que vous croirez devoir le faire, car je m'intéresse beaucoup aux ouvrages de mes élèves et aux vôtres en particuliers.

"Je vous envoie avec mes cordiales salutations l'assurance de mon entier dévouement. J. L. Gérôme."*

Thomas Eakins

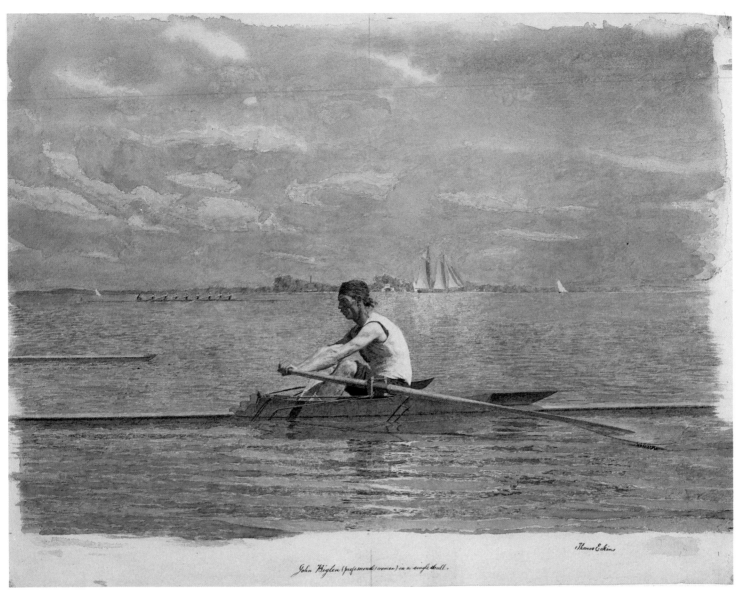

John Biglin (professional oarsman) in a single scull.

Thomas Eakins

50. JOHN BIGLIN IN A SINGLE SCULL
Probably 1874. Watercolor. 17¹/₈ × 23 sight. G 57
The Metropolitan Museum of Art; Fletcher Fund, 1924

Judging from this letter, the watercolor must have pictured the rower near the middle of his stroke, probably in the phase shown in the large oil of the Biglins turning the stake. Eakins evidently took Gérôme's criticism to heart and painted another watercolor to send his master. He also made a replica for himself, now called *John Biglin in a Single Scull* and owned by the Metropolitan Museum; it shows the rower at the end of his backward stroke, about to dip his oars in the water—a moment of pause between actions, as prescribed by Gérôme. The watercolor for Gérôme Eakins shipped to Paris in May 1874, together with two oils of hunting subjects to be submitted to the French dealer Goupil, Gérôme's father-in-law. This time the master replied, on September 18: "Mon cher Eakins, Je vous écrit bien tardivement, mais il y a les circonstances atténuantes à ma négligence que je vous prie d'excuser. J'ai reçu vos tableaux et j'ai trouvé un progrès très grand; je vous fais mes compliments et vous engage à continuer vos travaux dans cette voie sérieuse qui vous assure l'avenir d'un homme de talent. L'exécution est très bonne, peut-être un peu égale partout, défaut qu'il faut éviter car ce n'est qu'à l'aide de certains sacrifices qu'on arrive à donner de l'intérêt aux parties principales d'un tableau. Étant donné un sujet quelconque, tâchez d'en tirer tout l'intérêt possible, soit par le côté dramatique, soit par le côté plastique: ne faites pas la première choix mais retournez vôtre sujet dans tous les sens et choisissez la meilleure façon de le montrer au public: vous avez maintenant en main, le côté d'exécution, ce n'est plus qu'une question de choix et de goût. Votre aquarelle est entièrement bien et [je] suis bien content d'avoir dans le Nouveau Monde un élève tel que vous qui me fasse honneur.

"M. Goupil chez qui sont en ce moment vos ouvrages, a vu un de nos amis qui devrait revenir mais qu'il n'a pas revu encore: je ne sais si cela fera l'affaire de la maison, en deux mots, si cette espèce de peinture est commerciale, il me suffit de constater qu'elle est dans la bonne voie et l'avenir est là. Vôtre dévoué patron, M. Gérôme."*

Gérôme's criticism of the first watercolor seems to have had a lasting effect, for in most of Eakins' subsequent pictures of rowers the phase was either at

* My dear Eakins, I am writing you very tardily, but there are extenuating circumstances for my negligence which I beg you to excuse. I have received your pictures and I have found a very great progress; I give you my compliments and engage you to continue your work in this serious path which assures you the future of a man of talent. The execution is very good, perhaps a little equal all over, a fault which it is necessary to avoid for it is only with the aid of certain sacrifices that one succeeds in giving interest to the principal parts of a picture. Having been given any subject, try to draw from it all the interest possible, either by the dramatic side, or by the plastic side: do not take the first choice but turn your subject in all directions and choose the best fashion of showing it to the public: you now have in hand the side of execution, it is only a question of choice and of taste. Your watercolor is entirely good and I am very pleased to have in the New World a pupil such as you who does me honor.

M. Goupil with whom your works are at the moment, has seen one of our friends who should return but whom he has not yet seen again: I do not know if this will answer the firm's purpose, in two words, if this kind of painting is saleable, it is enough for me to state that it is in the good path and the future is there. Your devoted master, M. Gérôme.

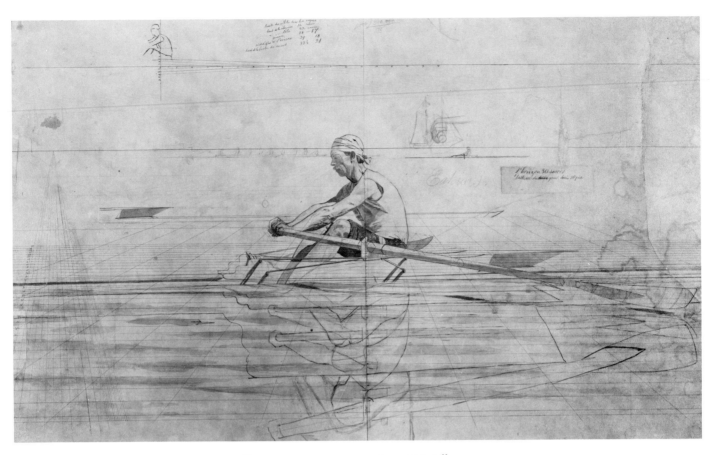

51. PERSPECTIVE DRAWING FOR "JOHN BIGLIN IN A SINGLE SCULL"
Probably 1874. Pencil, pen, and wash. 27³/₈ × 45³/₁₆. G 58
Museum of Fine Arts, Boston; Gift of Cornelius Vanderbilt Whitney

the end of the backward stroke or near the end of the forward stroke. The change was not all to the good. In the big oil, *The Biglin Brothers Turning the Stake,* the sensation that the men are in full action, pulling with all their strength, is much more intense than in the Metropolitan Museum watercolor or the related oil, *The Biglin Brothers Racing.* It is hard to find any artistic error in the large oil; on the contrary, it has the greatest energy of any of the rowing pictures. Gérôme, in stating that to show a rower in the middle of an action must result in immobility, was denying the possibility that a painter could represent movement—a limited conception, refuted by all the great masters of pictorial movement, a conception that revealed his own artistic limitations. One wishes that Eakins had paid no attention to this advice. As it was, his future development was more toward the static and monumental than toward plastic movement. This inclination was basic in his artistic character, but it must have been reinforced by Gérôme's criticism.

Eakins' fellow Gérôme student Earl Shinn, suffering from poor eyesight, had abandoned painting, on Gérôme's advice, and had become the art critic of *The Nation.* He shared Eakins' admiration of their former master and was later to write the text accompanying a hundred luxurious photogravures of his works. Eakins sent him Gérôme's first letter of 1873, which he used in a review. Another admiration they shared was for Bonnat, whose *Egyptian Fellah Woman and Child* had come to America. "Did you think to ask any picture men about that Femme Fellah de Bonnat," Eakins wrote Shinn in April 1874. "Bonnat a dit qu'il est à New York mais je ne me souvienne plus du nom du monsieur. I would like to go with you to see that picture." The painting, now in the Metropolitan Museum, had been purchased by the New York department store magnate Alexander T. Stewart, who had also bought Gérôme's famous Roman gladiatorial scene, *Pollice Verso.* In January 1875 Eakins wrote Shinn: "I can't come on today but I will soon, say next week or the week after. I want to see that Bonnat & to show my own pictures four oil pictures to the three or four principal N.Y. dealers & then ship them to Gerome from there. . . .

"The last letter Gerome wrote me he said that I had now in my own hands my trade le côté d'execution, ce n'est plus une question que de choix et de gout, etc. and one water color I sent him he found entirely to his taste, I will show it [the letter] to you when I come on. . . . I am going to write to Stewart & see if he won't let us see his pictures. I will tell him how Gerome used to get out his Pollice Verso to illustrate to me his principles of painting & how much therefore I ought to see it now that it is here & finished & how Gerome calls me his favorite pupil & is proud of having in the New World one doing him so much honor & if he dont let us in then he is a damned hog, (the same says you as he always was.)"

The two oils that Eakins had sent to Paris in May 1874 for submission to Goupil were probably *Pushing for Rail* and *Starting out after Rail.* In early 1875, as he told Shinn, he followed this by sending Gérôme four more oils for possible submission to the Salon, opening May 1. These were probably *Sailboats Racing on the Delaware; Drifting;* an oil version of *Whistling Plover;* and a rail-shooting picture, still unidentified. He wrote Gérôme and Bill Sartain, who was in Paris, informing them of the shipment. "But the box didn't come," he reported to Shinn on April 13. "As the time grew near for the last day of admittance to the saloon, the anxiety increased. Gerome himself feezed and sent to all the depots & express companies to see where it was detained. Gerome told Billy I was one of his most talented pupils and that he was most particularly anxious about me. At the last moment the box not arriving, Gerome ordered the old ones at Goupil's to be sent.

"Next day, Billy went up to Gerome's Sunday. The box had just arrived, and Gerome was opening it. There were two decorated artists there friends of

118

Thomas Eakins

Gerome that Billy did not know. Gerome pitched into the water of the big one said it was painted like the wall, also he feared (just fear) that the rail shooting sky was painted with the palette knife. The composition of this one they all found too regular. They all said the figures of all were splendid. The drifting race seemed to be liked by all very much. The nigger they had nothing against. Gerome said he would put in the saloon the rail shooters & the drifting race as the jury had not yet passed on them and he thought he could easily change them in explaining why. Next time, Billy went to Gerome he said he had changed his mind that he would leave the old ones in the saloon. They were not so good but the figures were larger, and Goupil wanted the four new ones for London. . . . Gerome said he was going to write me soon all he thought about my work. . . .

"Billy & Gerome are very truthful so I am very elated for I see by their reception that my little works have produced a good impression. But what elates me more is that I have just got a new picture blocked in & it is very far better than anything I have ever done. . . .

"I wouldn't send you such a damned egotist letter but I feel good, and I know you will be pleased at my progress."

Two paintings were accepted for the Salon, both being catalogued as *Une chasse aux États-Unis*. The critic of the *Revue des Deux Mondes* wrote: "Ces deux toiles, contenant chacune deux chasseurs dans un bateau, ressemblent tellement à des épreuves photographiques recouvertes d'une légère teinte locale à l'aquarelle, que l'on se demande si ce ne sont pas là les spécimens d'un procédé industriel encore inconnu, et que l'inventeur aurait malicieusement envoyés à Paris pour troubler M. Detaille et effrayer l'école française."*

Of the four oils sent in 1875, *Whistling Plover* was sold through Goupil's for $60 in gold. In future years Gérôme often inquired about Eakins of new American students; those who presented letters of introduction from his former pupil were assured of a cordial reception.

VIII

But in America things were different. Although Eakins had produced a good many pictures in his first few years at home, it was some time before he exhibited regularly. There were not many institutions in which a young artist could show. The National Academy of Design in New York did not welcome newcomers, and the Pennsylvania Academy was closed from 1870 to 1876 during construction of a new building. His first exhibition so far recorded was in April 1871, when the Union League of Philadelphia, trying to fill this gap,

* These two canvases, each containing two hunters in a boat, so much resemble photographic proofs covered over by a light local tint in watercolor, that one asks oneself if they are not specimens of an industrial process still unknown, and which the inventor has maliciously sent to Paris to trouble M. Detaille and frighten the French school.

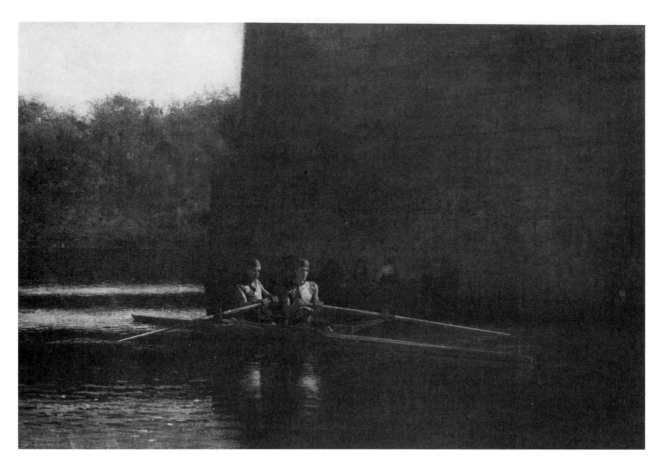

52. THE SCHREIBER BROTHERS
1874. Oil. 15 × 22. G 66
Collection of Mrs. John Hay Whitney

held its third Art Reception, which included two pictures by him: a portrait that has not yet been found, and *The Champion Single Sculls* [*Max Schmitt in a Single Scull;* ill. 26]. Of the latter a perceptive critic wrote that "though peculiar, [it] has more than ordinary interest. The artist, in dealing so boldly and broadly with the commonplace in nature, is working upon well-supported theories, and despite a somewhat scattered effect, gives promise of a conspicuous future."

It was by his watercolors, however, that Eakins was first represented on any scale in American exhibitions. In the annual shows in New York of the American Society of Painters in Water Colors (later the American Water Color Society), he had four in 1874, three in 1875, and one or two in five of the seven succeeding shows through 1882. (But he never became a member of the Society.)

By the mid-1870s he had made a connection with the Philadelphia dealer Charles F. Haseltine. And he occasionally took his pictures to New York to

show to dealers, though evidently without success. A record of sales written by him in 1880 reveals that until 1878 he had sold only two pictures. A watercolor, *The Sculler* or *John Biglin (Single Scull)*, probably a replica of the first one sent to Gérôme, was sold at the watercolor society's 1874 exhibition for $80; its present whereabouts is unknown. As already stated, the oil *Whistling Plover* was sold in Paris.

For teaching life classes at the Philadelphia Sketch Club in 1874 to 1876, and at the Pennsylvania Academy from 1876 to 1879, he asked for and received no pay. So until 1878 his total known income from his profession was $140. Fortunately, Benjamin Eakins had a moderate but secure income, and a house in which his son could live and paint. But the young man's financial dependence on his father was as great as it had been in his student years.

That he was by no means indifferent to having his pictures exhibited, well received, and sold is shown by a series of letters to Shinn in 1874 and 1875, in which he told about his works in progress, his plans for exhibiting and selling, and so on. (Parts of these letters have already been quoted in other contexts.)

In March 1875 he submitted a painting, probably for the first time, to the National Academy of Design annual exhibition. "I sent on my little picture" [evidently the oil *The Schreiber Brothers*], he wrote Shinn on March 26. "It is better than those Biglin ones. I did not care to exhibit the Biglin ones for that reason. They are clumsy & although pretty well drawn are wanting in distance & some other qualities.

"I feel to myself that I am going soon to do work so much better than anything that I have made yet, that if I had my own way entirely, I would destroy or keep to myself everything I have done this far, but there is no particular harm done by exhibiting if it calls any attention to my name or causes any expectations from me, or will bring me in a little money of my own.

"I did not varnish it. Artist exhibiters are admitted to varnish their pictures on April 6th from 10 A.M. to 4 P.M.

"If you are in the neighborhood and want an excuse to go in you can go rub a little linseed oil with your finger on any part of the shadows that are soaked in or on the whole of the picture except the light of the red handkerchiefs & the sky.

"I do not care at all for this being done, don't put yourself out. The picture don't please me altogether. I had it too long about I guess. The drawing of the boats & the figures the construction of the thing & the peculiar swing of the figures rowing pair oared the twist of the starboard oarsman to one the one side & the port to the other on account of the long sweeps are all better expressed than I see any New Yorkers doing but anyhow I am tired of it. I hope it will sell and I'll never see it again. I am doing far better work just now at least it is ten times better commenced."

But no work by him is recorded in the National Academy exhibition that year. This was undoubtedly the occasion for an indignant letter to Shinn: "The

reason my oil picture was not exhibited in New York I do not know. It was sent on in due time by Mr. Haseltine.

"About 2 weeks since I got a polite circular from T. Addison Richards president [of the Academy] saying he had dispatched my picture to my address. . . .

"I supposed the exhibition to be over but it had not commenced. I guess therefore my picture was simply refused.

"It is a much better figure picture than any one in N.Y. can paint.

"I conclude that those who judged it were incapable of judging or jealous of my work, or that there was no judgement at all on merit, the works being hung up in the order received or by lottery.

"Anyhow I am mulcted in the price of frame, & double expressage & boxing. . . .

"On receipt of your note I thought I would send on my picture that had just been refused at the Academy, but I believe it had better go to London. In selling things on merit only your object is to put them in comparison with the best ones in the largest market. I think by this course I will gain in the end.

"Besides, the anxiety I once had to sell is diminishing. My works are already up to the point where they are worth a good deal and pretty soon the money must come. Just now I am making rapid & heavy progress & old things of mine already made that would now bring less than they are worth for want of a reputation will soon fetch more than they are worth on account of the reputation that will have come.

"I dont like Englishmen but I would like to get their gold. I have seen artists bore their friends to buy their pictures but I had rather sell to my enemies.

"I will probably exhibit more things here in the Fall and again in N.Y. if they give me a chance, but next time I come on I won't take the trouble to carry any of my things to Schaus & other dealers. They will have to go see my things if they want to estimate their value. . . .

"My new work is still coming on all right.

"If you hear why I was refused, tell me. I will try find out next year if my things will be accepted before going to the expense of boxing them."

Reading this letter in the light of Eakins' future experiences with the artistic establishment, one does not know whether to smile or to weep at his unquestioning belief in his coming reputation and financial success, his naive assumption that he need only send his work to the National Academy to have it accepted, and his indignation at being actually rejected. But one can be happy for his self-confidence, recognition of his own worth, and elation at the progress of his new work.

Two years later, in 1877, he was first shown in the National Academy.

5. *The Gross Clinic*
and the Later 1870s

WRITING TO SHINN ON MARCH 26, 1875, about the painting submitted to the National Academy, Eakins had said: "I am doing far better work just now at least it is ten times better commenced." And on April 13: "What elates me more is that I have just got a new picture blocked in & it is very far better than anything I have ever done. As I spoil things less & less in finishing I have the greatest hopes of this one."

"This one" was undoubtedly *The Gross Clinic*. In 1873 and 1874 he had returned to Jefferson Medical College to continue studying anatomy. A leading figure at Jefferson at this time was Samuel D. Gross, one of the foremost American surgeons, author of the monumental *System of Surgery*, a magnetic teacher, and a man of strong character and impressive appearance. Watching him in the clinic amphitheater, operating before his students, Eakins conceived his largest and most ambitious painting so far. Dr. Gross is shown performing an operation on a young man for removal of a sequestrum (a piece of dead bone) in the thigh. The surgeon has paused, and stands, scalpel in hand, talking to his students. The assistant doctors (all of whom except one have been identified) are gathered around the patient; one is probing the incision, which is held open with retractors by two others; another is holding the patient's legs; the anesthetist keeps his cloth over the youth's face. Behind Dr. Gross sits a woman, presumably the patient's mother, shrinking from the sight and shielding her eyes. In the background the clinic clerk records Dr. Gross's comments, and in the entrance stand the surgeon's son, Dr. S. W. Gross, and an orderly. Above rise tiers of benches with dimly lit figures of students. Instead of the sanitary white of later surgery, all the doctors wear dark everyday clothes, customary in these days before modern antisepsis. The light falling from above illuminates the principal figures against the dark background of students.

Here was a subject seldom attempted in modern art, yet of vital importance in our age: medical science and its war against disease and death. Nothing like

it had been pictured in America, and little in nineteenth-century Europe. Baron Gros had shown Napoleon in the pesthouse at Jaffa, and Géricault had painted the dying and the dead in Paris hospitals; but since the romantics such subjects had been rare. The most famous historic prototypes were Rembrandt's two great *Anatomy Lessons*, but they depicted cadavers; *The Gross Clinic* shows an operation on a living man.

The realism of *The Gross Clinic* is total. No detail is spared: the wound, the blood, the imperturbability of the doctors. The viewpoint is completely objective; the hand that held the brush was as steady as the hand that held the scalpel. But there is no lack of humanity; rather, an acceptance of the grimmer aspects of human life—an acceptance like that of the scientist who devotes himself to disease and its treatment without evasion. The painting has both science's dedication to truth, and its humanity.

The Gross Clinic is at once a drama of real life and the portrait of a man. Dr. Gross dominates it, with his strong features, fine brow, and silvery hair catching the full force of the light. But every other individual is as fully characterized, from Dr. James M. Barton probing the incision, to Hughie O'Donnell, the orderly, in his shirtsleeves. It is a complex composition, made up of seven main elements: Gross, the patient, the group of assistant doctors, the woman, the clinic clerk, the two figures in the entrance, and the students; but all these components are organized into a unified whole. The design is pyramidal, with all elements culminating in the magnificent head of Dr. Gross. The principal figures have a sculptural roundness and solidity; they possess tremendous substance. The sheer physical presence of the painting is inescapable; it strikes one with the force and immediacy of a work of nature. This masterpiece of Eakins' early manhood, painted when he was only thirty to thirty-one, has a maturity, a power, and a depth that make it one of the greatest paintings of the nineteenth century.

With all its clarity, *The Gross Clinic* is not easily read at first glance; it has elements of enigma. The center of the action, the patient, is almost hidden; his face is covered by the anesthetist's cloth, and all that is visible of his body is his left buttock and thigh and his sock-covered feet; it takes a little time before one realizes what the doctors are working on. Also there is a half-hidden figure behind Dr. Gross; at the latter's left appears a hand holding a retractor in the incision, and on the surgeon's right are the elbow, thigh, and knee of this figure. These enigmatic features are part of Eakins' realism; a more superficial painter would have made things obvious, but Eakins knew that in an actual operation, involving six participants, everything is not clearly visible. (One is reminded of Tolstoi's account in *War and Peace* of how the Battle of Austerlitz seemed to witnesses.)

The light in *The Gross Clinic* is the most complex in any of Eakins' paintings, and it accounts for much of the pictorial drama. The central figures are in

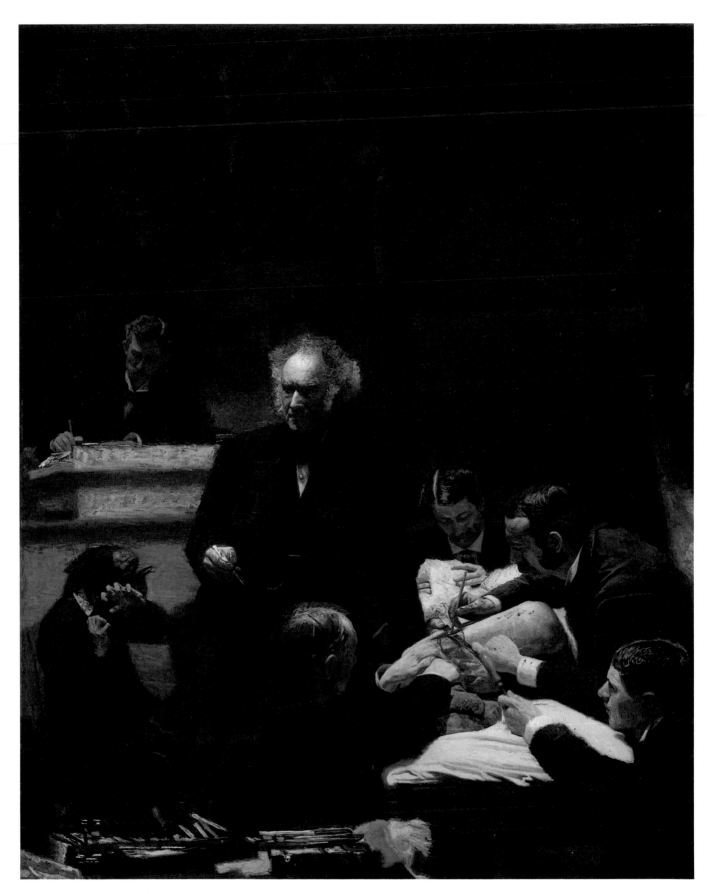

53. THE GROSS CLINIC
1875. Oil. 96 × 78. G 88
Medical College of Thomas Jefferson University, Philadelphia

strong overhead light; the patient's body and the white cloth he lies on are lit as if by a spotlight. Dr. Barton and the anesthetist are bending over the patient so that their faces are in shadow, yet luminous with reflected lights. But Dr. Gross's head receives the full strength of the light, which models it in sculptural relief, like the chiaroscuro in a Rembrandt portrait. This marmoreal head is the most powerful plastic form in the design. Eakins has wisely placed it against a relatively unmodulated background.

The central group stands out in full illumination against a background that is much darker, but not completely dark. The students are in half-light, subdued yet entirely clear. They seem ghostlike compared to the central figures. There is a marked difference in substance between these shadowed watchers and the doctors—a difference that adds to the complexity and richness of the painting. But the picture is not the representation of mere visual appearances; every figure and object has physical substance, in varying degrees.

There have been many color reproductions of the painting, but none of them quite capture the character of its color. It is not a brown picture, nor a green or blue one: its predominant tonality is black, gray, and white, balanced between warm and cool. It is one of Eakins' darkest paintings as a whole, but it is by no means monochromatic. In addition to its extreme contrast of darks and lights, there are strong positive colors throughout: in the glittering surgical instruments, the mahogany of the operating table, even the patient's gray-blue socks. These positive notes are given added intensity by the prevailing dark tonality. Within definite limits, the picture has great chromatic depth and power.

And there is the blood. Even under modern conditions, operations cannot be performed without shedding blood, and in *The Gross Clinic* it is on Dr. Gross's hand and scalpel, on Dr. Barton's hand, and on the cuff of the doctor holding the retractor; and it wells out of the incision. It is really red—one of the strongest colors in the painting. It is wet blood, shiny, with highlights, and it is painted with almost trompe-l'oeil realism.

Eakins was used to such surgical actualities, and it is doubtful whether he realized that to most laymen they would be horrifying. In his choice of the subject and his treatment of it there was an obliviousness to popular reaction that was both naive and admirable. But no wonder his contemporaries, used to the idealization of the day, were revolted. For *The Gross Clinic* unquestionably has its element of horror, as have many of the greatest paintings in the long history of art. Yet people who could look unmoved at physical violence in much historic religious art could not stomach the realistic portrayal of an operation performed for the purpose of healing.

The Gross Clinic is heavily painted, giving evidence of long work. When one examines it closely one is surprised at how lacking in elegance much of the handling is: there is no slick brushwork; things are put down with almost

54. THE GROSS CLINIC: DETAIL

brutal directness. There is less fineness of touch than in some smaller pictures like *The Chess Players;* with such a large canvas (eight by six and a half feet), Eakins was evidently thinking of the effect at a distance. But the handling throughout is strong and sure. The modeling of heads, hands, and the patient's body shows great technical command. The principal figures are in solid pigment, with some glazing. The students are painted much more thinly and delicately, and the two figures in the entrance are in translucent glazes over an undertone that shows through. In general the technique reveals a variety and mastery greater than in any of Eakins' previous paintings.

One fact not realized until recently is that there is a striking resemblance between a photograph of Gross by the Philadelphia photographer Frederick Gutekunst, and the doctor's head in the painting; not only in the position of his head but in the lights and shadows on it. Although the date of the photograph is uncertain, the similarity is so close that it seems likely that Eakins made use of it in selecting the pose and even the lighting.

Eakins had begun *The Gross Clinic* by late March 1875. For so large and complex a composition one would think that he would have made at least one perspective drawing, and oil studies of each figure; yet the only surviving works are a summary sketch of the composition, a masterly study of Gross's

The Gross Clinic and the Later 1870s

head, and a small study of a spectator. But obviously he must have induced the doctors to pose, and probably the students, all of whom are actual individuals. (Mrs. Eakins told me in 1930 that her husband said that Dr. Gross, after many poses, said, "Eakins, I wish you were dead!") In the summer of 1875, probably in August, John Sartain wrote Emily: "Tom Eakins is making excellent progress with his large portrait of Dr. Gross, and it bids fair to be a capital work." He was still adding to it on October 10 when he did a portrait sketch of the writer Robert C. V. Meyers for inclusion among the students. The finished picture is dated 1875. Only one other known oil is dated that year.

55. THE GROSS CLINIC: DETAIL

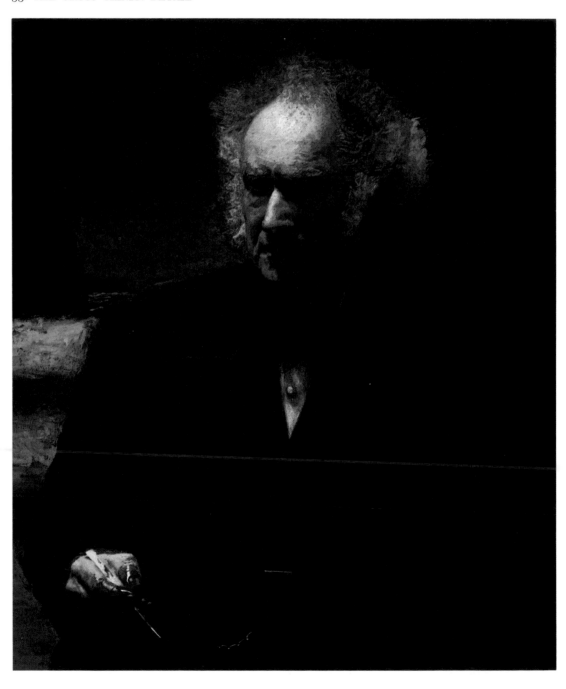

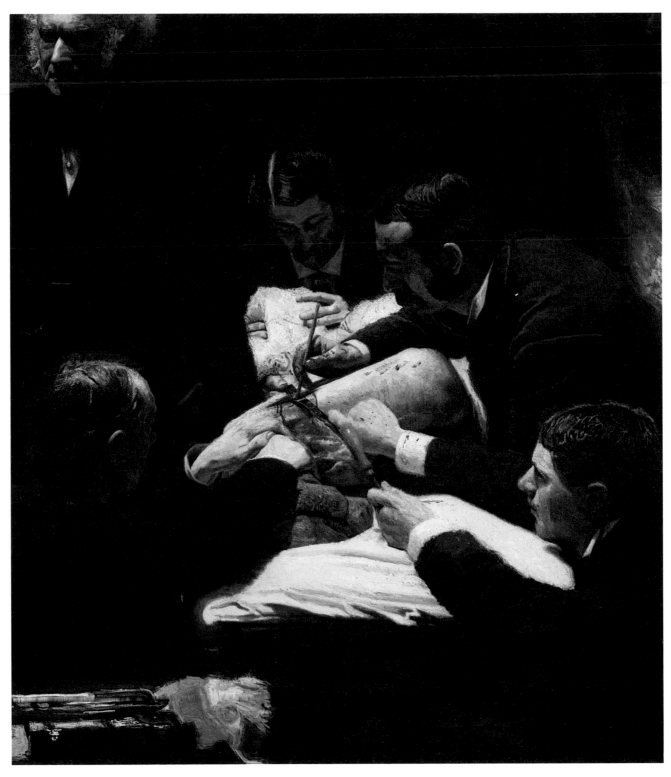

56. THE GROSS CLINIC: DETAIL

The Gross Clinic and the Later 1870s

Eakins' estimate of the picture's importance is shown by the fact that he arranged for the international publishers Adolph Braun et Cie. of Dornach, Alsace, to make a photomechanical reproduction, called an autotype or collotype, for exhibition and sale. For this he made a black and white copy in India ink, complete down to the last detail, since he felt that a photograph of a painting falsified the values. (Later he was to do the same for an illustration of his painting *The Fairman Rogers Four-in-hand*.) He exhibited the Braun autotype before the painting itself: at the Penn Club on March 7, 1876, and at the Pennsylvania Academy's first exhibition in its new building, opening April 22.

The Penn Club showing brought a comment from Eakins' friend William Clark, head of the Philadelphia Sketch Club, now critic of the Philadelphia *Daily Evening Telegraph:* "The original of this picture has never been out of the artist's studio, but reports of it have gone abroad and much curiosity has been excited in regard to it. It is a work of great learning and great dramatic power, and the exhibition of the photograph last night will certainly increase the general desire to have the picture itself placed on exhibition at an early day."

In creating *The Gross Clinic* Eakins intended it for the coming huge art exhibition of the Centennial Exhibition, due to open in Fairmount Park on May 10, 1876. His expectation of showing it first in the Centennial was probably his reason for exhibiting the Braun autotype, rather than the painting, at the Pennsylvania Academy. The Centennial's Committee of Selection, headed by John Sartain, began meeting in April. They accepted five pictures by Eakins: *Professor Rand, Elizabeth at the Piano, The Chess Players,* and two watercolors. But *The Gross Clinic* was rejected. The committee was conservative, as was Sartain, who made decisions without consulting them. Perhaps his earlier opinion of the picture was changed by the blood on Dr. Gross's hand.

This rejection undoubtedly was the reason Eakins exhibited the painting at his dealers, the Haseltine Galleries, in late April, about the time of the Academy opening and three weeks before that of the Centennial. This first public showing occasioned one of the most perceptive and prophetic reviews he was ever to receive, again by William Clark: "This picture until within a few days past has only been visible in the studio of the artist, but the reports of those who have seen it with regard to its many striking qualities have stimulated the curiosity not only of art lovers but of people who do not under ordinary circumstances take much interest in art matters. Mr. Eakins has been living and working in Philadelphia for the last four or five years—ever since his return from Europe, after completing his artistic education—but he has exhibited very seldom, and such of his works as have been placed on view here have not been of a character to attract general attention, although their great technical merits have received ample acknowledgment from competent judges. . . . The public of Philadelphia now have, for the first time, an oppor-

tunity to form something like an accurate judgement with regard to the qualities of an artist who in many important particulars is very far in advance of any of his American rivals. We know of no artist in this country who can at all compare with Mr. Eakins as a draughtsman, or who has the same thorough mastery of certain essential artistic principles. There are men who have a knack of choosing more popular and more pleasing subjects, who have a finer feeling for the quality that can best be described by the word picturesqueness, and who are more agreeable if not more correct in color. For these reasons it is not difficult to understand that the pictures of men who cannot pretend to rival Mr. Eakins as masters of technique should find more favor with the general American public than his have been able to do. . . . To say that this figure [of Gross] is a most admirable portrait of the distinguished surgeon would do it

57. THE GROSS CLINIC: DETAIL

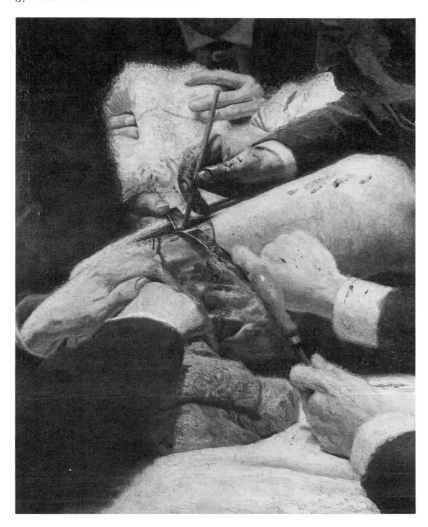

The Gross Clinic and the Later 1870s

scant justice; we know of nothing in the line of portraiture that has ever been attempted in this city, or indeed in this country, that in any way approaches it. The members of the clinical staff who are grouped around the patient, the students and other lookers-on, are all portraits, and very striking ones, although from the peculiar treatment adopted they do not command the eye of the spectator as does that of the chief personage. The work, however, is something more than a collection of fine portraits; it is intensely dramatic, and is such a vivid representation of such a scene as must frequently be witnessed in the amphitheatre of a medical school, as to be fairly open to the objection of being decidedly unpleasant to those who are not accustomed to such things. . . . Leaving out of consideration the subject, which will make this fine performance anything but pleasing to many people, the command of all the resources of a thoroughly trained artist, and the absolute knowledge of principles which lie at the base of all correct and profitable artistic practice, demand for it the cordial admiration of all lovers of art, and of all who desire to see the standard of American art raised above its present level of respectable mediocrity. This portrait of Dr. Gross is a great work—we know of nothing greater that has ever been executed in America."

Another Philadelphia newspaper critic had more reservations: "It seems scarcely creditable to the management of the Academy of Fine Arts that while half of its new galleries are filled with rubbish, we must go to a private gallery to see so notable a work as Mr. Thomas Eakins' picture of Dr. Gross at his clinic, which is on exhibition at Haseltine's. It is an unpleasant picture, it is true, but the Academy's own collection is full of horrors. . . . Subject aside, Mr. Eakins' picture is certainly one that would attract attention in any exhibition." The writer then proceeded to launch into criticisms: "It is not a subject to be thus vividly presented upon canvas. It is rather a subject to be engraved for a text-book on Surgery. This appears to us the fundamental fault of Mr. Eakins' picture, and its technical strength only makes its wrong conception more obtrusive.

"It is drawn with great skill. Especially admirable is the figure of Dr. Gross. . . . If we could cut this figure out of the canvas and wipe the blood from the hand, what an admirable portrait it would be! . . .

"The picture is painted in the modern French manner, with great mountains of paint. . . . Color there is none. We think we have never seen a more entirely achromatic picture. . . . Everything is as cold as though the sun had withdrawn his light. . . . We do not dwell upon these points ungraciously, there have been few pictures painted here lately that we should take the trouble to criticize thus, and in spite of his unfortunate subject, and of what appear to us faults in execution, Mr. Eakins has produced a work that is most creditable to himself and to the city. He has not been afraid to treat his subject in a realistic manner, boldly and vigorously, and the great strength of drawing and

handling that he has shown in this picture, as admirable as it is rare, mark him as an artist from whom we can expect very much."

In the end, *The Gross Clinic* was shown in the Centennial—among medical exhibits in the U.S. Army Post Hospital. Clark commented sardonically: "There is nothing so fine in the American section of the Art Department of the Exhibition, and it is a great pity that the squeamishness of the Selecting Committee compelled the artist to find a place for it in the United States Hospital building. It is rumored that the blood on Dr. Gross's fingers made some of the members of the committee sick, but judging from the quality of the works exhibited by them we fear that it was not the blood alone that made them sick. Artists have before now been known to sicken at the sight of pictures by younger men which they in their souls were compelled to acknowledge were beyond their emulation."

Quite aside from his pictures exhibited there, the Centennial attracted Eakins even more than the Paris exposition of 1867 had. His exhibitor's pass, still preserved in the Hirshhorn Museum, shows that he visited the exposition many times: for example, six days in September, five in October, and five in November. It is likely that in Philadelphia, as in Paris, the technological exhibits interested him as much as the artistic.

Eakins' record books state that after the close of the Centennial (November 10) *The Gross Clinic* was again exhibited at Haseltine's. Then it may have gone back to 1729 Mount Vernon Street, or to Dr. Gross, or on loan to Jefferson Medical College. It had not been commissioned, and Jefferson already had a conventional official head-and-bust portrait of Gross by Samuel Bell Waugh. But (we do not know how it was arranged) in 1878 the College bought *The Gross Clinic*—for two hundred dollars.

II

The middle 1870s saw the beginning of a revolt against conservative domination of the American art world. A younger generation was emerging to whom the art of their elders seemed old-fashioned and provincial. American art schools were inadequate; like Eakins, these younger men must study abroad, the favorite centers now being Paris and Munich. There they were exposed to viewpoints which, although not advanced, were far different from those back home. When they began to return in the second half of the 1870s they found themselves in growing opposition to the older art establishment. These innovators soon came to be called "The New Movement"—the first such in American art.

Eakins had been a forerunner of the New Movement. While about ten years younger than nonacademic independents such as La Farge, Homer, Vedder, Martin, and Wyant, he was older than any of the New Movement except Shirlaw, Sartain, and Warner. Of the younger men those nearest to his

age—Ryder, Dielman, Saint-Gaudens, Duveneck, Tiffany, Chase, Thayer, and Eaton—were three to five years his juniors; and the majority had been born in the 1850s. He had gone abroad several years before any of them, and had returned before most of them had even started. Although more devoted to the American scene than most of the new foreign-trained generation, and far more drastic in his realism, he came to be generally regarded as a member of the New Movement, and its leading representative in Philadelphia. Old John Sartain called him and his own son William "the two young firebrands from Paris."

In the 1877 annual exhibition of the National Academy of Design a number of the new men, including Eakins, were represented for the first time—too well represented and hung for the older members of the Academy, who adopted a rule that every Academician had a right to "seven feet on the line." Thereupon the New Movement artists revolted and formed their own association, the Society of American Artists. (William Sartain was one of the twenty-two original members.) The membership included not only the younger generation but several older independents. The Society was unique at the time in that members were not exempt from rejection by its exhibition juries. Although it had no building and no financial backing, for many years its annual exhibitions in New York were to be the most progressive in the country.

In the Society's first exhibition, in March 1878, Eakins showed two paintings; and he was included in its next five annuals, through 1883. In May 1880 he was elected a member, along with thirty-two others—the only national art organization he was to join for more than twenty years. But he still continued to be shown occasionally in the National Academy, though he was not elected a member until 1902. In Philadelphia he was out of the main current of the New Movement; in any case he was never concerned with art politics.

For the Society's second exhibition, in March 1879, he chose to borrow *The Gross Clinic* from the Jefferson Medical College. He was not yet a member of the Society, and the jury's courage in accepting the painting is noteworthy. This was the first time it had been seen in a national art exhibition, and the New York critics' reaction was far more violent and voluminous than the Philadelphians' three years earlier.

The New York *Daily Tribune*'s critic called the painting "one of the most powerful, horrible and yet fascinating pictures that has been painted anywhere in this century—a match, or more than a match, for David's 'Death of Marat' or for Géricault's 'Wreck of the Medusa.' But the more one praises it, the more one must condemn its admission to a gallery where men and women of weak nerves must be compelled to look at it. For not to look at it is impossible." Two weeks later the same critic really let himself go: "The more we study Mr. Thomas Eakins' 'Professor Gross,' No. 7, the more our wonder grows that it was ever painted, in the first place, and that it was ever exhibited,

in the second. As for the power with which it is painted, the intensity of its expression, and the skill of the drawing, we suppose that no one will deny that these qualities exist. . . . This is the subject of a picture of heroic size that has occupied the time of an artist it has often been our pleasure warmly to praise, and that a society of young artists thinks it proper to hang in a room where ladies, young and old, young girls and boys and little children, are expected to be visitors. It is a picture that even strong men find it difficult to look at long, if they can look at it at all, and as for people with nerves and stomachs, the scene is so real that they might as well go to a dissecting-room and have done with it.

"It is impossible to conceive, for ourselves, we mean, what good can be accomplished for art or for anything else by painting or exhibiting such a picture as this. . . . Here we have a horrible story—horrible to the layman, at least—told in all its details for the mere sake of telling it and telling it to those who have no need of hearing it. No purpose is gained by this morbid exhibition, no lesson taught—the painter shows his skill and the spectator's gorge rises—that is all."

The *New York Times*, objecting among other things to the patient's "ugly, naked, unreal thigh," said: "This violent and bloody scene shows that . . . the artist had no conception of where to stop, or how to hint a horrible thing if it must be said, or what the limits are between the beauty of the nude and the indecency of the naked. Power it has, but very little art." The New York *Herald* considered the picture "sickeningly real in all its gory details, though a startlingly life like and strong work."

On the other hand, the *Daily Graphic* published a line drawing of the painting and said: "The entire picture is a serious, thoughtful work, and we can readily understand what a fascination a subject like this must have for an artist who is himself a profound student of anatomy. There is thought and feeling of a high order in this painting, and in this respect it is in marked contrast with many of the works that surround it." But this was a minority opinion; almost all the New York newspaper critics damned the painting, not only for its whole subject but for details such as the inclusion of the patient's mother, the "puzzle" of the patient's body, confusing composition, monochromatic color, even alleged faults in perspective. One revealing fact, however, was the prominence and space that almost all the critics gave it. Even the *Tribune* writer who saw no reason "that it was ever painted, in the first place, and that it was ever exhibited, in the second," spoke of it before any other work in a large exhibition and devoted more than half his review to it.

The least hysterical and most intelligent review was by *The Nation's* critic (probably Earl Shinn). After discussing in detail Eakins' thorough methods of teaching anatomy, he said: "He sends to the exhibition a kind of challenge to Rembrandt, a modern 'Anatomy Lesson.' . . . It is simply a contemporary Dr. Tulp, explaining the secrets discovered by his scalpel to an audience of re-

spectful pupils. The picture . . . is no more amenable to questions of mere taste than Rembrandt's is. . . . The picture's scale is that of life, and at least twenty figures are included, the subordinate ones well subdued, though all connected with the central action by the most vivid expression of interest. The effect of the aged and quiet professor, in a sharp perpendicular light, as he demonstrates very calmly with a gesture of his reddened fingers, is intensely dramatic. Equally so is that of the horror-stricken mother. . . . These two figures, telling by their contrast of professional habitude and unaccustomed terror, are relieved with great constructive skill from the accessory groups, massed together by ingenious combinations or devices of shadow. Few professors have got themselves painted in so interesting a presentment for posterity. A tendency to blackness in the flesh-shades is the principal artistic infelicity in this curious and learned work."

Criticism of *The Gross Clinic* continued to appear in magazines and books. In *The Art Journal* Susan N. Carter wrote: "To sensitive and instinctively artistic natures such a treatment as this one, of such a subject, must be felt as a degradation of Art." "It ought never to have left the dissecting room," said *The Art Interchange*. "The scene is revolting in the last degree." "The horribleness taught nothing, reached no aim," said *Scribner's Monthly*. One of the country's most esteemed critics, S. G. W. Benjamin, a perfect exponent of the taste of the time, wrote in his book *Art in America:* "As to the propriety of introducing into our art a class of subjects hitherto confined to a few of the more brutal artists and races of the old world, the question may well be left to the decision of the public. If they demand such pictures, they will be painted, but if the innate delicacy of our people continues to assert itself there is no fear that it can be injured by an occasional display of the horrible in art, or that our painters will create many such works."

Eakins left no written record of his reactions to these attacks, but among the papers he preserved were clippings of most of the criticisms quoted above.

There were a few somewhat more understanding and temperate opinions, though not altogether favorable, from more mature critics. The knowledgeable literary and art critic William C. Brownell, in a thoughtful discussion of "The Younger Painters of America" in *Scribner's Monthly*, May 1880, wrote of *The Gross Clinic:* "So ably was the whole depicted that probably the reason why nine out of ten of those who were startled or shocked by it were thus affected, was its intense realism; the sense of actuality about it was more than impressive, it was oppressive. . . . His 'Surgical Operation' before-mentioned as a masterpiece of realism in point of technique, is equally a masterpiece of dramatic realism, in point of art. . . . The play of emotions which is going on is strong and vivid. . . . Very little in American painting has been done to surpass the power of this drama. But if the essence of fine art be poetic, an operation in practical surgery can hardly be said to be related to fine art at all. Many

persons thought this canvas, we remember, both horrible and disgusting; the truth is that it was simply unpoetic. The tragedy was as vivid as that of a battle-field, but it was, after all, a tragedy from which every element of ideality had been eliminated. The same thing is true, with obvious differences of degree, of most of Mr. Eakins's work. He is distinctly not enamored of beauty, unless it be considered, as very likely he would contend, that whatever is is beautiful."

The March 1879 exhibition of the Society of American Artists aroused so much interest that the directors of the Pennsylvania Academy invited the Society to send to Philadelphia, in April, as much as possible of the New York show, to be hung and catalogued as a unit. By this time Eakins was the most active teacher in the Academy school, had exhibited in the Academy annuals for three years, and was on this year's exhibition committee, which consisted of five layman directors and four artists, with a director, George S. Pepper, as chairman. But when the committee installed the show the Society's pictures were hung together in the largest gallery, while *The Gross Clinic* was hung by itself (doubtless over Eakins' protests) in the East Corridor at the opposite end of the building, flanked by galleries of watercolors and drawings and of students' works; and the committee gave the place of honor in the Society's section to a big canvas by Philadelphia's Thomas Moran, *Bringing Home the Cattle, Coast of Florida*, which had been rejected for the New York show.

The story found its way into the newspapers in New York and even Boston. "There is much dissatisfaction expressed by the members of the Society of American Artists at the treatment they have received," one New York paper reported. Eakins composed a letter to Pepper, a rough draft of which he preserved (whether it was actually sent is not known): "My Gross picture & Mr. Thos. Morans Florida picture having both of them an unfortunate notoriety I feel I must call your attention as Chairman of the Committee on Exhibitions to the bad feeling certain to be engendered by the present disposition of them & protest against it.

"The Directors asked for the exhibition of [the] Society.

"Mr. Moran's picture of Florida was rejected justly or unjustly by the Society whose exhibition you asked for. It now occupies the most prominent place in all the Academy among their work. . . .

"I feel that the Academy will be greatly blamed for what will seem to the Society a direct insult.

"The two pictures which have acquired the most unhappy notoriety in the Society are Mr. Moran's and mine. Mine accepted by them is removed from their exhibition & Mr. Moran's rejected by them has been given the place of honor in their collection here.

"It was the Academy directors who asked the Society for the loan of their pictures & the answer was yes if their pictures would be kept together & marked as the exhibit of their Society.

"Our committee must not judge the merits of their pictures.

"I regret exceedingly the difficulty of convincing some of the gentlemen of the exhibition committee that I have no cause for quarrel with them."

The Society's president, Walter Shirlaw, wrote the Academy protesting and stating that their entire exhibit would be withdrawn if it was not rearranged. Six days later William M. Chase and the sculptor William R. O'Donovan came to Philadelphia and met with the Academy's exhibition committee. It was agreed that the Moran should be removed from the Society's exhibit, but that *The Gross Clinic* should remain where it was. Whether Eakins acquiesced willingly in this compromise, there is no record.

Thus was Eakins' most important painting finally shown in Philadelphia's chief art institution. It should be added that the young Society deserved credit on three counts: for accepting the painting in the first place; for protesting its exclusion from their exhibit in Philadelphia; and for electing Eakins to membership the next year, in spite of attacks on his painting.

After the close of the Pennsylvania Academy exhibition *The Gross Clinic* went back to the Jefferson Medical College, where it was seldom seen by anyone from the art public. Its next known appearance in the art world was fourteen years later at the World's Fair in Chicago in 1893 (with a brief preliminary showing at the Pennsylvania Academy); then in 1904 it was shown at the Louisiana Purchase Exposition in St. Louis, where it finally received an award, almost thirty years after it was painted. These three exhibitions, and those in the 1870s, were the only ones in Eakins' lifetime. Occasionally the painting was illustrated or referred to in print, but not until after its creator's death was it to be seen more frequently by the general public.

Years later, in 1951, when the Philadelphia Museum of Art held its Diamond Jubilee exhibition, consisting of masterpieces of painting from all countries and periods, and from leading American public and private collections, *The Gross Clinic* was included. Visitors were asked to vote for their favorite picture in the show. Of 20,000 votes cast, the top three went to a Rubens with 3,500 votes, an El Greco with 2,700, and *The Gross Clinic* with 2,200.

III

Eakins' series of uncommissioned portraits of eminent men who interested him was continued, the year after *The Gross Clinic*, with a full-length portrait of another distinguished surgeon, Dr. John H. Brinton, also on the Jefferson faculty, and to become Dr. Gross's successor. During the Civil War he had been medical director of Grant's army in the field; and, later, editor of the *Medical and Surgical History of the War of the Rebellion*, and cofounder of the Army Medical Museum. Eakins was a friend of his, asked him to pose, and gave him the portrait; and two years later painted a half-length canvas of Mrs. Brinton (ill. 23), one of his most sympathetic portrayals of women. Unlike Dr. Gross, Dr. Brinton is shown seated in his study before an open book, sur-

58. DR. JOHN H. BRINTON
1876. Oil. 78³⁄₈ × 57¹⁄₈. G 101
Medical Museum of the Armed Forces Institute of Pathology;
on loan to the National Gallery of Art

59. DR. JOHN H. BRINTON: DETAIL

rounded by familiar possessions; on the wall is a portrait of an ancestor. (Eakins painted the picture in his own studio, but borrowed the doctor's furnishings, including the carpet.) There is none of the darkness and mystery of *Professor Rand;* Dr. Brinton is seen in an uncluttered room and in ordinary daylight, and the emphasis is on the strength of character shown in his face, body, and hands. While a more usual portrait than *Rand* or *Gross,* it is impressive in its solid structure and its range of robust color.

Next year, 1877, a sitter in quite a different field appeared: Archbishop James Frederick Wood, who two years earlier had been created first archbishop of Philadelphia. A native Philadelphian, a convert from Protestantism, an ex-banker, and an able, energetic administrator, as bishop he had strengthened his diocese financially, had completed the building of the Cathedral of Saints Peter and Paul, and had laid the foundations of the Seminary of St.

Charles Borromeo at Overbrook outside the city. Eakins' earlier anti-Catholicism seems to have abated; he knew and liked the archbishop, then in his middle sixties, and asked him to pose. His first idea was to picture him outdoors on the Cathedral steps, blessing his people, but the final portrait showed him seated indoors, clothed in his violet robes. The benevolent face, the strong old hands resting on his apron, the traditional richness of the vestments, give the portrait a mellow aura different from any of Eakins' previous portraits. It was the first of a long series of portraits of Catholic clergy; but they were not to resume until almost a quarter-century later.

In June 1877 came his first known commission for a portrait. Three months earlier President Rutherford B. Hayes had been inaugurated after a bitterly disputed election. The Union League of Philadelphia, stronghold of Republicanism and one of the city's most influential clubs, desired a portrait of the new President to add to the collection of historical portraits housed in its massive brick building on South Broad Street. How and why the club chose Eakins is not known, but he was commissioned to paint the portrait, for $400.

On behalf of the League, Colonel Samuel Bell wrote the President on June 5, 1877, requesting him to "name such a time as would suit your convenience to sit." The League committee evidently wanted the usual half-length portrait, but Eakins had his own ideas. On June 13 he wrote George D. McCreary, chairman of the committee: "It may at first sight seem ill befitting me to commence offering suggestions to those who have just gratified me so by their choice of me to paint the president, but I would nevertheless ask of you to represent to Col. Bell & your Committee one of my ideas with the excuse that I am even more anxious than they for the success of my portrait.

"I do not intend to use any photographs but the president must give me all the sittings I require. I will take a chance to watch him & learn his ways & movements and his disposition.

"If I find him pressed or impatient or judge that he can ill afford a great number of sittings I would like to confine myself to the head only, painting it with the greatest care, and this I could finish during a few hours in a week's time.

"If he is disposed however for a fullsized portrait similar to the Dr. Brinton composition I would undertake it with equal spirit but of myself I would not select the size you mentioned. A hand takes as long to paint as a head nearly and a man's hand no more looks like another mans hand than his head like another's, & so if the president chose to give me the time necessary to copy his head & then each of his two hands, (for I would not be induced to slight them) then it would seem a pity not to have the rest of him when I know how to paint the whole figure. The price in either case can remain the same as you mentioned. In comparison with the importance of the work the money & time do not count.

"So I would beg your influence with the gentlemen to urge postponement

of the question of size only, until I can get acquainted with the president himself and then I would want to consult with them before commencing. I wish very much to make them a picture which may do me credit in my city and which if I may be allowed to exhibit in France may not lessen the esteem I have gained there."

On August 4, Colonel Bell wrote a letter of introduction for the painter to the President: "It is with pleasure that I introduce to you Mr. Thomas Eakins of this city, the Artist selected to paint your portrait for presentation to the Union League of Philadelphia. . . . Mr. Eakins very justly ranks among the foremost Artists and I have no doubt will succeed in obtaining a picture creditable to the Artist and satisfactory to yourself and the gentlemen desiring it. The style of picture will be decided upon after Mr. Eakins has had an interview with you and he will consult your convenience as to times of setting &C."

But it was not until late September, after the President had returned from a trip to the South, that Eakins was able to see him. What happened on that occasion was told in a letter written in his old age, in 1912: "The portrait was far from the conventional. Mr. Hayes knew nothing of art and when I asked for time for sitting he told me that he had already sat for a distinguished artist who had required only 15 minutes of sitting. I saw work by the distinguished artist. His method was to make a rapid sketch for the color and then use the photograph altogether.

"I told Hayes this, but all I could get out of him was permission to be in the room with him as he attended affairs of state and received visitors.

"As I was very anxious to please my patrons, I accepted the President's terms foolishly perhaps, but determined to do my best.

"The President once posed, I never saw him in the same pose again. He wrote, took notes stood up, swung his chair around.

"In short, I had to construct him as I would a little animal."

Under the circumstances it was impossible to paint a full-length portrait. As William Clark of the *Evening Telegraph* wrote when the picture was first exhibited at the Haseltine Galleries, in December 1877: "The artist originally intended to make a full-length, but was unable to obtain the necessary sittings, and the work at present under consideration was painted with the expectation that opportunities in the future would be afforded for the execution of a larger work. While it is complete in itself, it is also a preliminary study, and the fact that it is a preliminary study accounts for the rather awkward introduction of the right arm and hand—the only feature that calls for unfavorable criticism. The President is represented as seated in an easy and unconstrained attitude, at his office table, but the pose is such a peculiar one that it needs a larger canvas than the one adopted to. account for it. In a full length, what now appears awkward in the picture would be easy, natural, and obvious. It is certainly much to be hoped that the artist will be able to carry out his intention of

painting a full-length of the President, for the portrait he has executed indicates that he will produce an even more masterly work than his admirable portrait of Dr. Gross."

A severer verdict was that of the critic of the Philadelphia *Press:* "As the picture almost needs a label to suggest the now familiar features of the new President, it utterly fails to meet the first requirements of the painter's art. Mr. Eakins is evidently a follower of Rembrandt's most extreme theories of chiaroscuro, and in this particular instance has quite lost sight of his model in his search for effect. It is not impossible that President Hayes, if seated in a darkened room, with one bright ray of light striking his right temple from behind, might look exactly as he does in this portrait, but as the general public have never seen him under such circumstances, they will, we fear, be quite unable to appreciate the final excellencies of the painting. These excellencies, by the way, are found to be many if we lose sight of the fact that we are gazing at a portrait. Long and conscientious labor, gained by rare talent for accurately distributing light and shade so as to naturally and effectively bring each object into strong relief, mark the entire work, and although the result is rather anatomical than artistic, it is, as we said before, worthy of study."

It is evident that the portrait, as Eakins said, "was far from the conventional," and that the manipulation of light had played as important a part in it as in most of his paintings. And that it was not idealized is clear from Clark's review: "The pre-eminently realistic qualities of Mr. Eakins' art are well known, and this portrait is one of the most severely literal works that he has yet produced. . . . This portrait gives a very different idea of the President from that given by any of the photographs of him or by any of the painted portraits that have yet come under our notice. Not only does it give a different idea, but it gives a much more favorable one, for Mr. Eakins has fixed upon his canvas the features of a man of very strong and very pronounced traits of character. . . . It would be a matter for congratulation indeed, did we have portraits of all the Presidents which, like this one would have stamped upon them an uncompromising truthfulness. . . . There is certainly nothing of the mock-heroic in this representation of the President in his old alpaca office coat, with the stump of a lead pencil in his fingers, and with his sunburned face glistening with summer perspiration."

After the exhibition of the portrait at Haseltine's in the winter of 1877–78, it went to the League, which accepted and paid for it, and hung it. But mounting criticism soon came from members, particularly on one point. The weather in Washington had been hot, and the President, like ordinary citizens, was flushed and perspiring: a fact that Eakins with his usual candor recorded. This detail was especially damaging in view of Mr. and Mrs. Hayes's well-known teetotalism; as the saying went, in the Hayes White House "water flowed like champagne." "The Union League," said the *Press* in June 1878, "has hung on its walls a portrait of President Hayes, which represents him with a rubicund

countenance far removed from that supposed to characterize a temperant, not to say a temperance man. As such a 'counterfeit presentment' is likely to create erroneous impressions, prejudicial to our Chief Magistrate, it is hoped that it will be either removed or 'turned to the wall,' at the earliest possible moment."

This pious wish was granted. In June 1880 A. Loudon Snowden, a prominent League member and a personal friend of Hayes, wrote the President: "I substituted some time since the likeness painted of you by W. Garl Brown [W. Garl Browne, Hayes's favorite portrait painter] for the Eakins portrait. . . . I had to handle the matter delicately as the friends of the latter artist were jealous lest the removal of the painting might injure his reputation. . . . What shall I do with the Eakins portrait,—shall I forward it to you or not? Whilst I would prize very highly your portrait, this work of Eakins is such a caricature, that it gives no pleasure to any of your friends." A month later Snowden sent Eakins' painting to Hayes, writing: "I fear when you receive it, Mrs. Hayes will banish it to the rubbish room." A recent thorough search of the Hayes memorabilia in the Rutherford B. Hayes Library in Fremont, Ohio, failed to find the picture. The Browne portrait, which had been painted from life in the White House in 1878, was presented to the League in September 1880 by "a number of gentlemen." It is a completely mediocre work by a mediocre artist.

The removal of the portrait was not imparted to Eakins or his friends or to the public. Through the years, in the absence of any information from the League about its whereabouts, there were periodical attempts by his friends and the press to locate it. One persistent legend, repeated even by those who should have known better, was that Eakins had painted the President in his shirtsleeves. In September 1912 Eakins wrote Charles Henry Hart, who was helping to form the Alexander Smith Cochran Collection of Presidential Portraits: "The portrait was finished accepted delivered paid for and hung and I never saw it again. [He then told of his experience with Hayes, described above.] I do not believe it was destroyed."

In 1912 or 1913 the Cochran Collection commissioned him to paint a second portrait of Hayes, and with considerable help from Mrs. Eakins, herself a gifted painter, he did a head and shoulders portrait, without hands, from a photograph. Although better than the Browne opus, it had little relation to the life portrait of 1877, which, aside from its historical interest, was probably, judging from contemporary descriptions, one of Eakins' more original works.

The only extant product of this first experience with a portrait commission is a small sketch of the view of Lafayette Park from a window in the White House, probably made when he was waiting for the President to appear or reappear.

To Eakins, as to many of the old masters, and some modern ones, the human figure was the central motif in art. Study of the human body had been the basis of his art education, and later was to be the basis of his own teaching. His personal attitude toward nudity was far franker than that of his time, and close to ours today. He liked to swim and boat and sail naked, and he cared little if others were shocked.

Yet he rarely painted the nude. There was a basic conflict between his interest in the nude and his realism. As an artist, for him the body and its pictorial possibilities were fundamental. But as a realist, he was concerned primarily with what he saw in the real world; and Philadelphia in the late nineteenth century was not Greece. The prudery of earlier America, which had objected to John Vanderlyn's chaste *Ariadne* and had accepted Hiram Powers' idealized *Greek Slave* only after approval by the clergy, had remained strong in Philadelphia, with its heritage of Quaker modesty. Even by the 1870s few American painters had pictured the nude, and it was not to become an accepted subject until the young men of the New Movement returned from Europe with their Continental ideas. Models who would pose naked were still difficult to find. Women's bodies were effectually concealed beneath voluminous garments that swathed them from high collar to ground-sweeping skirt. Only the semi-nude figures of male athletes were on public view in sports like rowing, prizefighting, and wrestling.

Eakins seldom attempted fantasy; like Courbet, who said he would paint an angel if anybody showed him one, he would picture the nude if it was visible in the real world—otherwise, only rarely. Remember his words as a student in Paris: "I can conceive of few circumstances wherin I would have to make a woman naked"—in spite of his belief that "she is the most beautiful thing there is in the world except a naked man." He even found a lack of reality in professional models; and in later years he often asked women who were sitting for portraits if they would also pose for him nude.

Among his few paintings of the female nude, the most complete were his various versions of the William Rush theme. Rush (1756–1833), one of the first American professional sculptors, and a Philadelphian, in 1809 had carved in wood an allegorical fountain figure for the city water-works in Centre Square: a nymph symbolizing the spirit of water, in a Grecian robe, bearing on her shoulder a shore bird, a bittern. (The statue in its original setting is shown in the painting by John Lewis Krimmel in the Pennsylvania Academy, *Fourth of July in Centre Square,* about 1810.) In 1854 a bronze cast had been made of the wood original, and placed in the waterworks park in Fairmount, one of Philadelphia's pleasantest, most popular spots.

Eakins admired Rush, whom he called "one of the earliest and one of the

best American sculptors," and he liked the story of his carving the statue, which he told in a written explanation of the painting: "William Rush was a celebrated Sculptor and Ship Carver of Philadelphia. His works were finished in wood, and consisted of figureheads and scrolls for vessels, ornamented statues and tobacco signs called Pompeys. When after the Revolution American ships began to go to London, crowds visited the wharves there to see the works of this Sculptor.

"When Philadelphia established its Water-works to supply Schuylkill water to the inhabitants, William Rush then a member of the Water Committee of Councils was asked to carve a suitable statue to commemorate the inauguration of the system. He made a female figure of wood to adorn Centre Square at Broad Street and Market, the site of the waterworks, the Schuylkill water coming to that place through wooden logs. The figure was afterwards removed to the forebay at Fairmount where it still stands. Some years ago a bronze copy was made and placed in old Fairmount near the Callowhill Street bridge. This copy enables the present generation to see the elegance and beauty of the statue, for the wooden original has been painted and sanded each year to preserve it. The bronze founders burned and removed the accumulation of paint before moulding. This done, and the bronze successfully poured, the original was again painted and restored to the forebay.

"Rush chose for his model, the daughter of his friend and colleague in the water committee, Mr. James Vanuxem, an esteemed merchant.

"The statue is an allegorical representation of the Schuylkill River. The woman holds aloft a bittern, a bird loving and much frequenting the quiet dark wooded river of those days. A withe of willow encircles her head, and willow binds her waist, and the wavelets of the wind-sheltered stream are shown in the delicate thin drapery, much after the manner of the French artists of that day whose influence was powerful in America. The idle and unobserving have called this statue Leda and the Swan and it is now generally so miscalled.

"The shop of William Rush was on Front Street just below Callowhill and I found several very old people who still remembered it and described it. The scrolls and the drawings on the walls are from an original sketch book of William Rush preserved by an apprentice and left to another ship carver.

"The figure of Washington seen in the background of the painting is in Independence Hall. Rush was a personal friend of Washington and served in the Revolution. Another figure of Rush's in the background now adorns the wheel house at Fairmount. It also is allegorical. A female figure seated on a piece of machinery turns with her hand a water wheel, and a pipe behind her pours water into a Greek vase."

In a shorter statement Eakins wrote: "The statue represents the River Schuylkill under the form of a woman. The drapery is very thin, to show by its numerous and tiny folds the character of the waves of a hill-surrounded stream. Her head and waist are bound with leafy withes of the willow—so

common to the Schuylkill—and she holds on her shoulder a bittern, a bird loving its quiet shady banks."

In this latter statement Eakins wrote that "a Philadelphia beauty is said to have consented to be [Rush's] model," and, in a still shorter piece, "a celebrated belle consented to pose for him." She was Louisa Van Uxem, then about twenty-eight. Her posing for Rush seems to have been looked on askance in the Philadelphia of 1809, and the statue was considered immodest because "the draperies revealed the human form beneath." Eakins' painting *William Rush Carving His Allegorical Figure of the Schuylkill River* shows her posing nude while Rush carves the statue.

The story as told by Eakins attracted him in several ways. It was connected with the history of his native city, with the Schuylkill River, and with an early Philadelphia artist whom he admired. It presented an opportunity to picture the nude female figure. And for him the story undoubtedly had a symbolical meaning, embodying his own attitude toward nudity, and his admiration for a woman who was not a professional model but who would consent to pose nude for an artist.

But as a matter of historical fact, no evidence has been found that Louisa Van Uxem posed nude. For her to do so in 1809 would have been highly unlikely. And Rush's statue itself is draped, although the clinging Greek robe

60. MODELS FOR "WILLIAM RUSH CARVING HIS ALLEGORICAL FIGURE
OF THE SCHUYLKILL RIVER"
Left to right: head of William Rush; head of the Water Nymph; George Washington;
Water Nymph and Bittern; the Schuylkill Freed
1876–1877. Pigmented wax. 9³/₄ to 4¹/₂ high. G 498
Philadelphia Museum of Art; Gift of Mrs. Thomas Eakins and Miss Mary Adeline Williams

does display the figure in a most graceful manner. It is revealing that, although Eakins showed the statue robed, he chose to picture the woman naked.

Indeed, the painting is as much a work of imagination as of strict historical reconstruction. Rush carved his nymph in 1809, but his statues of *Washington* and *The Schuylkill Freed,* which also appear in the picture, were not executed until 1815 and probably 1828. Eakins had done a remarkable piece of research on Rush, but he was not an art historian, and accurate information on the sculptor's works was not available in the 1870s. Also the *Nymph* was not specifically "an allegorical representation of the Schuylkill River," but probably of flowing water in general. The chaperon knitting beside Miss Van Uxem seems to have been an engaging invention of Eakins', although her presence would have been quite probable, even if the young woman were clothed.

In painting the final version of the picture, Eakins, no more than Rush, used a professional model. She was Anna W. Williams, known as Nannie, a good-looking eighteen-year-old schoolteacher, a friend of one of his sisters: blonde, blue-eyed, and with a fine figure. In 1876 the United States Mint in Philadelphia was planning the first new silver dollar since the 1840s, bearing a new head of Liberty. To design the coin they imported a young English engraver, George T. Morgan. Enrolling as a student in the Pennsylvania Academy, Morgan intended to adapt the profile of a Greek cast in the Academy. Eakins, then teaching at the school, persuaded him instead to work from a living woman, to wit, Nannie Williams.

At this time Miss Williams was an instructor in the Philadelphia House of Refuge, a home for "wayward" girls. At first she refused to act as Morgan's model, since for a woman teacher in those days any public appearance, even on United States coinage, could have cost her job. Finally, after pressure from Eakins and her friends, she consented, on condition that her identity would never be revealed. The sittings, five in number, took place in Eakins' studio. "Mr. Morgan was so enthusiastic," said one account, "that he declared Miss Williams' profile was the most nearly perfect he had seen in England or America." In his coin designs from 1877 to 1882 her handsome, strong-jawed face, transformed into the Greek ideal, appeared with varying hairdos, not only on silver dollars, but on half-dollars, quarters, dimes, and gold eagles; and she was to remain the standard image of the Goddess of Liberty well into the 1920s.

Morgan did his best to preserve her secret, writing the director of the Mint that he was studying ancient sculptures as models. But in 1878 the story began to leak out, at first that the head "was taken from life, and is a fair type of the beauty of one of our Philadelphia ladies, . . . who naturally objects to having her name published." Within a year or so her identity became known. But, instead of suffering ill consequences, Nannie Williams achieved considerable fame, and offers of public appearances on the stage—all of which she

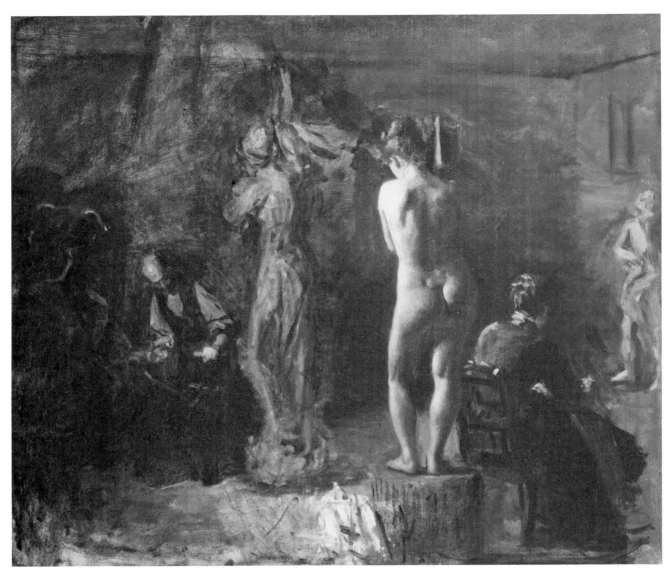

61. WILLIAM RUSH CARVING HIS ALLEGORICAL FIGURE OF THE SCHUYLKILL RIVER
First version. 1876. Oil. 20³/₁₆ × 24. G 111
Yale University Art Gallery; The James W. and Mary C. Fosburgh Collection

The Gross Clinic and the Later 1870s

62. ANNA W. WILLIAMS
Oil. 31 × 27
Private Collection

declined, remaining faithful to her career as a teacher, at sixty dollars a month. She went on to become principal of the School of Practice, Girls' Normal School of Philadelphia. In 1896 a New York newspaper, under the headline "To Marry a Goddess," said that she was about to be married, but this was evidently only a rumor, for she was a spinster when she died in 1926.

In the 1870s young Nannie Williams evidently had no such qualms about posing for Eakins, nude or clothed. In addition to the *William Rush* painting, she posed that year or next for *Courtship* (ill. 69), in an old-fashioned dress; in two small preliminary sketches she appeared both nude and clothed. Probably

Thomas Eakins

about the same time he painted one of his most sympathetic portraits, showing her reading, in contemporary dress. He photographed her in Greek robes, holding a lute, in front of a larger study of her for *Courtship;* and one of his photographs of a nude strongly resembles her.

The model for the elderly chaperon in *William Rush* was a relative of the Crowells, a Mrs. King, known as "Aunt Sally," who was to pose for several other works during the next six years or so, being paid for her time.

Eakins made thorough preparations for *William Rush.* Besides talking to old people who remembered Rush and his shop, and consulting Rush's

63. NUDE: STUDY FOR "WILLIAM RUSH"
1876. Oil. 14¼ × 11¼. G 113
The Art Institute of Chicago

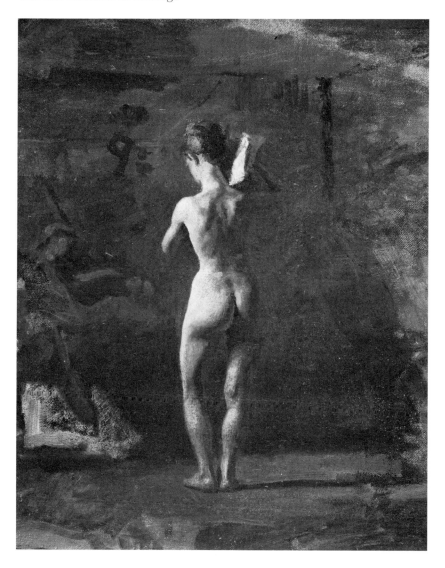

The Gross Clinic and the Later 1870s

64. WILLIAM RUSH CARVING HIS ALLEGORICAL FIGURE OF THE SCHUYLKILL RIVER
1877. Oil. 20⅛ × 26⅛. G 109
Philadelphia Museum of Art; Gift of Mrs. Thomas Eakins and Miss Mary Adeline Williams

sketchbook, he studied Krimmel's picture, copying a group of figures, and made detailed drawn and written notes on women's costumes from prints of the period. He modeled six small wax figures: the nude woman (now unfortunately lost), the statue of the nymph, its head, Rush's head, and the statues of *Washington* and *The Schuylkill Freed*.

In an unfinished version (ill. 61), dated 1876, the model is not Nannie Williams but a heavier figure; her back is turned squarely to us; her clothes, sketchily indicated, lie on the floor; the chaperon, dressed in the style of the 1870s, faces away from her. The only completed element is the woman's figure, one of Eakins' most masterly nudes.

A small study of the model alone (ill. 63), probably later, is of Nannie Williams: slenderer than the first model and with a narrower waist—an hourglass figure. (Mrs. Eakins, showing me the picture in 1930, commented acidly, "a corseted figure.")

The final version of *William Rush*, a small painting, only twenty by twenty-six inches, dated 1877, shows the sculptor's shop with Louisa Van Uxem standing on a block of wood and holding a big book on her shoulder instead of a bird. Her discarded clothes lie on a chair in the foreground. The chaperon sits beside her. In the left background Rush is carving his statue. Against the wall are his two other statues; on the floor are two carved scrolls.

This version reveals basic changes. The model is Nannie Williams; she faces more toward the left, so that her figure is seen more fully, though still from the back. Her pose is now that of Rush's *Nymph*, her left leg bent and her left hip dropped, giving more value to the lines of her body. Her clothes are on a chair in the foreground. The chaperon, in early-nineteenth-century dress, is again on her right but turned toward her—a more harmonious relation both humanly and compositionally. The young woman is slender and fine-boned, and the forms of her body have a rhythmic flow that one does not often see in Eakins' works. Yet, with all her grace, she is no idealized neoclassic goddess, but a naked woman of flesh and blood. The modeling of her figure is at once strong and delicate: one of Eakins' finest achievements, proving how the nude —even with the back turned—inspired him to full realization of his plastic gift.

The light falls full on the girl's left side, leaving her back in shadow; on her clothes; then more softly on the chaperon. The rest of the scene is in deep shadow; Rush himself is almost in the dark. This concentration of light on the woman, her clothes, and the chaperon is again Eakins' favorite device of illuminating the central elements against a dark background. The lighting of the woman's figure is especially skillful; although her back is shadowed, the shadows are luminous with varied reflected lights, such as the warm light on the inside of the buttocks, reflected from the chaperon's dress, contrasting with the dark shadow between the legs, where no light is reflected. The masterly handling of these direct and indirect lights accounts for much of the figure's

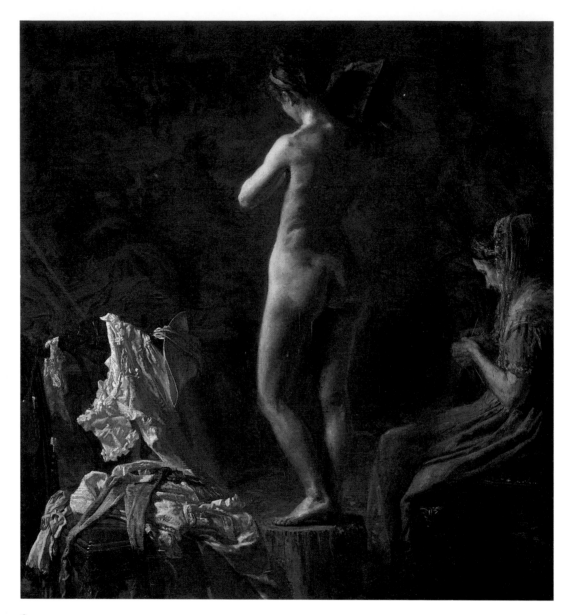

65. WILLIAM RUSH CARVING HIS ALLEGORICAL FIGURE OF THE SCHUYLKILL RIVER: DETAIL

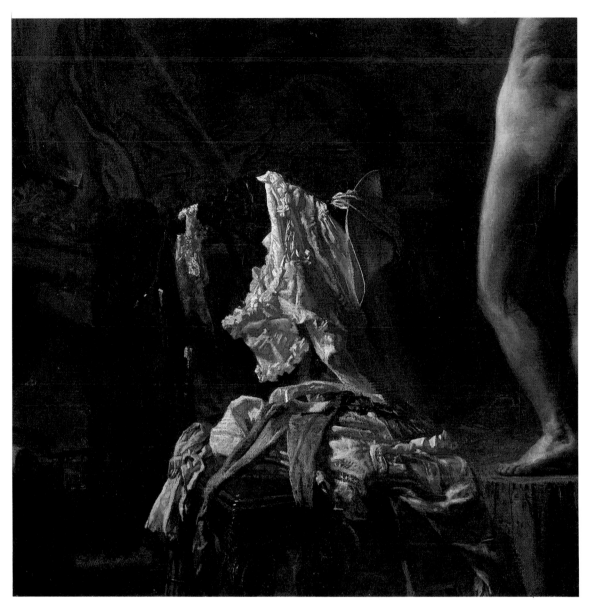

66. WILLIAM RUSH CARVING HIS ALLEGORICAL FIGURE OF THE SCHUYLKILL RIVER: DETAIL

roundness and sense of life. Throughout the picture, light plays a key role, creating a mellow richness, a kind of magic.

The discarded garments are a delightful invention; instead of being tucked away out of sight, they are in the immediate foreground, the nearest element in the composition. White short-sleeved dress and petticoat, straw bonnet with a scarf to tie it under the chin, a mantle, light blue stockings, elbow-length gloves, a green parasol—their varied colors are the most positive notes in the picture. Their seemingly casual but artfully designed shapes, with light catching their folds and creating intricate shadows and halftones, provide one of the finest passages in all Eakins' paintings—an enchanting still life in themselves.

This final version, compared with earlier ones, gives evidence of fully conscious design. The three central elements—the woman, the chaperon, and the clothes on the chair—form a pyramidal group, of which the woman's upright figure, a little to the right of center, is the dominating element. The sculptural forms of her body seem to radiate out toward the dark left half of the composition, creating a balanced relation between active forms and passive space. The clothes in the foreground, so immediate and precise, introduce a contrasting pattern, intricate and rococo, and add depth to the pictorial space. These elements, so different in the character of their forms but so finely related, produce a total harmony. This is one of Eakins' most perfectly realized designs.

The picture inevitably suggests Rembrandt, particularly the master's small-scale paintings featuring the female nude, such as the study for *Susanna and the Elders* in the Louvre, which Eakins may well have seen; but also others he could hardly have seen: the two finished *Susanna*s in Berlin and The Hague, or the *Bathsheba* now in the Metropolitan Museum, but in the 1870s still in European private collections. The only Rembrandt in the Prado in 1869 and 1870, *Sophonisba*, or *Artemesia*, has no relation to *William Rush* in subject or composition. Eakins' 1870 notebook proves that he admired the master as early as that, but his three references are short and general, and only about technical methods. In any case, with all its affinities to Rembrandt, which are incontestable, *William Rush* is as definitely based on direct relation to the real as Rembrandt's works were.

Eakins exhibited the picture three times in 1878, in Boston, New York, and Brooklyn; in Philadelphia in 1881; and in Chicago in 1882. When it was shown at the Society of American Artists in 1878 *The Nation* commented favorably on it, and Eakins' champion, William Clark of the Philadelphia *Telegraph*, wrote that "simply as a specimen of workmanship, there is not a picture in the display . . . that is at all up to [its] high standard"; and he quoted "a leading landscape artist of the old school" as saying that "he had not believed there was a man outside of Paris, certainly not one in America, who could do painting of the human figure like this." But most other critics found fault with it, chiefly on the ground that the model was ugly: one wrote that William Rush

"was no judge of the 'human form divine.'" The *New York Times* reached the nadir of idiocy: "What ruins the picture is much less the want of beauty in the model, (as has been suggested in the public prints) than the presence in the foreground of the clothes of the young woman, cast carelessly over a chair. This gives a shock which makes one think about the nudity—and at once the picture becomes improper!" There is no record that Eakins exhibited it again until 1914.

In spite of its early reception, and the fact that the painting never found a purchaser, the William Rush theme continued to interest him, and in his sixties he was to essay it again.

67. SEVENTY YEARS AGO
1877. Watercolor. $15^5/8 \times 11$. G 114
The Art Museum, Princeton University;
The Frank Jewett Mather, Jr., Collection

The Gross Clinic and the Later 1870s

The Rush subject ushered in a series of historical pictures which form a curious interlude in Eakins' evolution: five small oils and five watercolors, with studies for them, mostly single figures of women, young and old, in dresses of the early nineteenth century, sewing, knitting, or at spinning wheels. This surprising development on the part of the most drastic of American realists was probably a result of the Centennial Exhibition, which aroused widespread interest in everything early American. The Rush pictures themselves may well have been inspired by this awakened interest in the American past. (Even that other naturalistic painter of the contemporary native scene, Winslow Homer, in these same years went through a phase of picturing shepherdesses in eighteenth-century dress.)

Eakins' historical series began in 1876 with an oil, *In Grandmother's Time,* an elderly woman working at a spinning wheel. Next year came a watercolor, *Seventy Years Ago,* of Louisa Van Uxem's chaperon, seen from a different angle; and another watercolor, *Young Girl Meditating,* or *Fifty Years Ago,* of a girl in a long dress of the 1820s. In 1877 or 1878 a more ambitious oil composition appeared, *Courtship:* a couple in early-nineteenth-century clothes, the young man seated gazing at a young woman spinning (again Nannie Williams)—one of his few works with overt romantic sentiment. The series ended in 1881 with two fine watercolors of young women spinning, *Homespun* and *Spinning,* for which Margaret Eakins posed. (Two years later these subjects were to be revived, this time in sculpture.) For several pictures the elderly model was Aunt Sally, shown spinning, knitting, and sewing. Old dresses were brought down from trunks in the attic; the same or a very similar low-neck, short-sleeved, high-waisted, and long-skirted white dress appeared on young women in three oils and three watercolors. Recurring properties include a spinning wheel, a round-topped tip-table, and a Chippendale chair borrowed from the painter's friend Dr. S. Weir Mitchell.

Although historical in their subjects, these pictures were no different in essence from his former contemporary genre. Showing women of the past engaged in domestic occupations, they were marked by the same realism, intimacy, sense of individual character, and feeling for home life. In some there was a strain of revery, as in the small oil he titled *Meditation* (or simply *Study*), now called *Retrospection.* But of the whole series, only the two Rush paintings and *Courtship* told definite stories; and they avoided the anecdotal, fancy-dress, illustrative quality of historical works by Abbey, F. D. Millet, and E. L. Henry. This temporary focusing on the past involved no loss of the authenticity that marked his contemporary subjects.

68. YOUNG GIRL MEDITATING, or FIFTY YEARS AGO
1877. Watercolor. 9 × 5⁹/₁₆ sight. G 116
The Metropolitan Museum of Art; Fletcher Fund, 1925

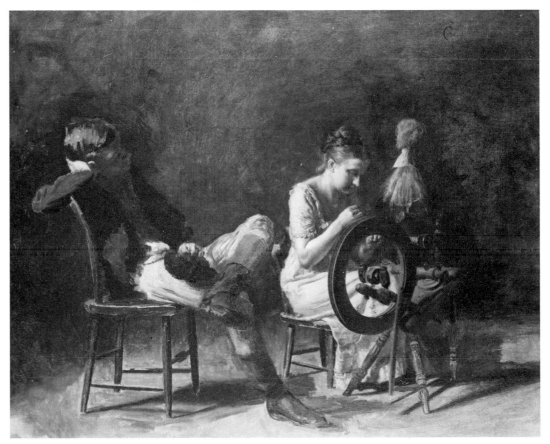

69. COURTSHIP
c. 1878. Oil. 20 × 24. G 119
The Fine Arts Museums of San Francisco, M. H. de Young Memorial Museum

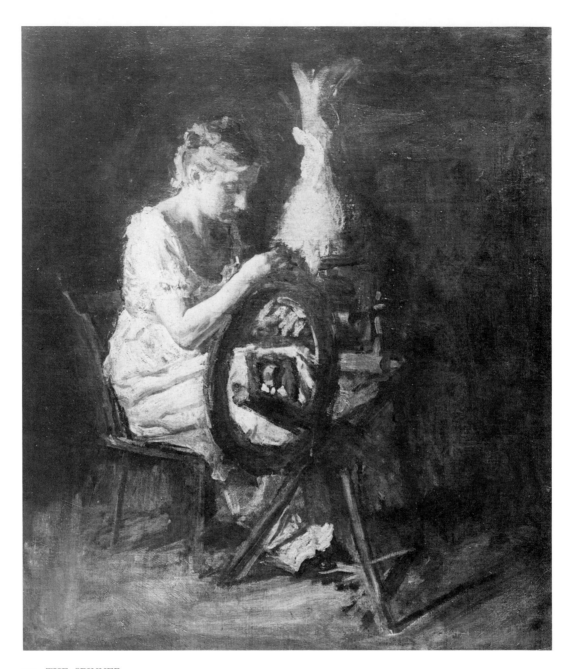

70. THE SPINNER
c. 1878. Oil. 30¼ × 25⅛. G 121
Worcester Art Museum

Thomas Eakins

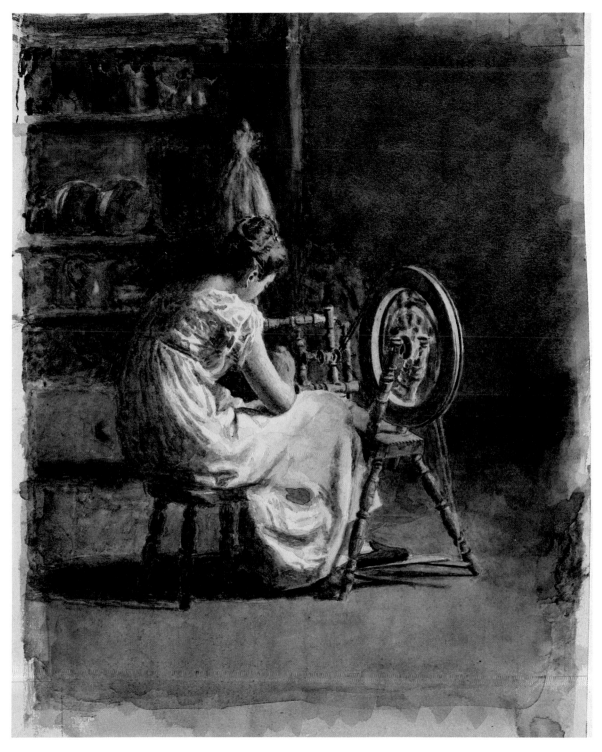

71. HOMESPUN
1881. Watercolor. 13³/₄ × 10³/₄ sheet size. G 146
The Metropolitan Museum of Art, Fletcher Fund; 1925

72. RETROSPECTION
1880. Oil. 14½ × 10⅛. G 140
Yale University Art Gallery;
Bequest of Stephen Carlton Clark, B.A. 1903

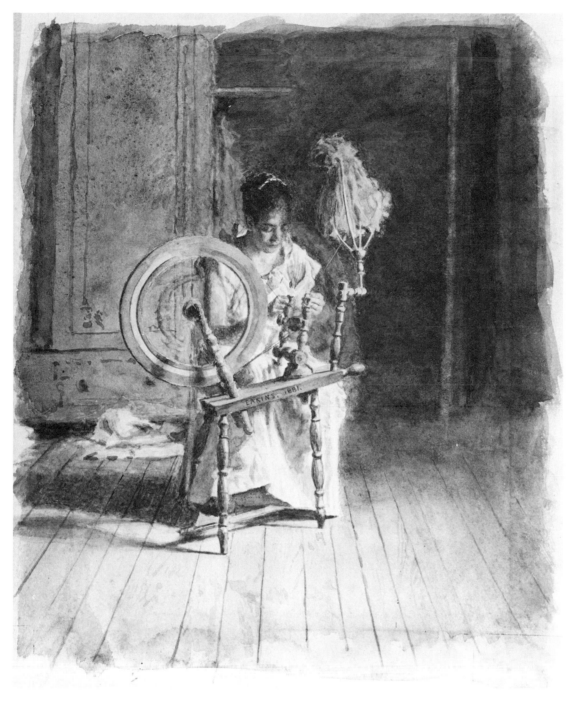

73. SPINNING
1881. Watercolor. 11 × 8 sight. G 144
Mrs. John Randolph Garrett, Sr., Roanoke, Virginia

From the middle 1870s to the middle 1880s Eakins was represented fairly regularly in the leading exhibitions of the country. At the Pennsylvania Academy his new paintings, often several of them, could be seen every year except one from 1876 through 1885. In New York he showed in every annual exhibition of the Society of American Artists from 1878 through 1883; of the National Academy from 1877 through 1882, except one year; and of the American Water Color Society from 1874 through 1882, except two years. Other channels through which an artist could reach the public were multiplying, and he and his dealer, Charles F. Haseltine, made diligent use of them, sending not only to the regular art organizations in other cities but to fairs, expositions, and such shows in the East and Midwest. It was at one of these, the 13th annual exhibition of the Massachusetts Charitable Mechanics Association in Boston, that he received in 1878 a silver medal for two watercolors—his first award, and the last for fifteen years.

How his pictures were hung, however, was another matter. Reviewers several times commented that they were skied or hung in dark corridors; as one said, "with the [National] Academy's usual hospitality to strangers."

The critical reception of his exhibits was mixed. The criticism of *The Gross Clinic* was exceptional, in both its virulence and the attention given the picture; never again was a work by him to be so violently attacked—or, unfortunately, to receive so much attention. American art criticism in the 1870s and 1880s, with a few exceptions, was at an abysmal level. Only one who has waded through the art magazines of the period can have any conception of the mass of sentimental, provincial, and backward trash that filled their pages, in both text and illustrations. Artists now happily forgotten were praised to the skies, while many we now value were condemned. The criteria were simple: the subject must be pleasing, ennobling, picturesque, or humorous; the style must be literal representation; the color must not be "queer"; and the picture must have "finish."

In the big national exhibitions Eakins' pictures were often passed over or given only brief mention, by contrast with the space devoted to popular favorites, and even to some older independents such as Hunt, Inness, Homer, and La Farge. Paintings that we now consider his best received scant attention. Yet when he was noticed, the criticism was not generally unfavorable. The most frequent charges against him were his lack of poetry and beauty, his concern with the commonplace, his dark or allegedly nonexistent color. But the critics usually respected his seriousness, scientific knowledge, and technical ability; and often they spoke of his influence and prestige as a teacher. Sometimes there was genuine perception and understanding, by writers such as Clarence Cook, Charles de Kay, William Clark, and Earl Shinn (the last also wrote under the pseudonyms of Edward Strahan and Sigma in *The Art Ama-*

teur and elsewhere). Clark and Shinn had both been artists, students of the Pennsylvania Academy, and they were personal friends of Eakins. Their critiques still read well today.

Eakins' recorded prices in the 1870s and early 1880s, as published in exhibition catalogues and two record books kept by him, were moderate enough. Watercolors were around $100 to $300; the top figure was $350 for *Negro Boy Dancing.* Often, as they found no purchasers, these prices were reduced from exhibition to exhibition, sometimes to as low as $50. Known actual sales figures for his watercolors were $80 for *John Biglin* in 1874, and $135 for *Seventy Years Ago* in 1878. After 1883 he seldom showed his watercolors. Several he gave away: aside from the two to Gérôme, he gave *Drifting* to a sale for the benefit of Christian Schussele's family; *Drawing the Seine* to the lawyer and collector John G. Johnson, in gratitude for legal advice; *Whistling Plover* to Dr. S. Weir Mitchell; and probably *Starting out after Rail* to the boat-builder James C. Wignall.

His oils in the 1870s were generally priced at $200 to $300, rarely more. The large *Biglin Brothers Turning the Stake* was exhibited for three years, 1878 through 1880, at $250 and $300—and found no buyer. The only exception to these low prices was *William Rush,* which he priced at $600 from its first showing in 1878, an indication of his estimate of it.

These were asking prices; what he actually received for the few sales made was something else. Goupil in Paris sold *Whistling Plover* about 1875 for $60. *In Grandmother's Time* was bought by President Seelye of Smith College directly from him in 1879 for $100. As we have seen, he was paid $200 for *The Gross Clinic* and $400 for the Hayes portrait. But some of his best oils had been given away: *Max Schmitt* to his old friend; the portraits of Rand, Brinton, Mrs. Brinton, and Archbishop Wood to the sitters; *Oarsmen on the Schuylkill* probably to a boat club; and *Will Schuster* to a sale in 1878 for the benefit of old George W. Holmes, who had become blind.

A list of sales drawn up by him in 1880, when he was thirty-six, shows that in the first ten years of his professional career, 1870 through 1879, he had sold three or four oils and two watercolors, and had been commissioned to paint one portrait: a total of six or seven pictures. In addition, he had received $100 for his illustrations and for illustrations of his paintings. For these ten years his entire income from art, aside from teaching, was $1,075.

But actually his prices were not so different from those of other nonacademic American painters of the time. Winslow Homer's oils of the 1870s, for example, were generally priced at about $200 to $500, except for the year 1879, when he raised the figures on three paintings to $1,500 each—and failed to sell any of them. His watercolors were priced at about $50 to $100, less than Eakins'. But Homer was a far more prolific artist, and his sales were considerably greater, though for low amounts.

The American paintings of the period that were fetching top prices were

the huge spectacular panoramas of the later Hudson River School: Church, Bierstadt, and Moran commanded prices of $10,000 or more. But these figures were dwarfed by those that the new millionaires were paying for academic European paintings: Rosa Bonheur's *Horse Fair,* $53,000, and Meissonier's *Friedland,* $60,000.

It is easy to see why *The Gross Clinic* was not popular, but harder to understand why Eakins' outdoor and sporting pictures failed to sell. Of the eighteen oils and nine watercolors of such subjects (not counting sketches) painted between 1871 and 1876, as far as we know only one oil was sold—in Paris—and one watercolor. For us today these works rank, along with Homer's similar subjects, as the most authentic and attractive pictorial records of outdoor life in America in the 1870s. But Eakins lacked Homer's combination of naturalism and idyllicism, just as both of them were far from the popular romanticism of painters like Tait and Ranney, and many others. Eakins was not picturing country life, summer resorts, the ocean, or the wilderness, but the sports and recreations of citydwellers, which must have seemed commonplace to a public interested in more picturesque themes. And his qualities of artistry, form and design would have little meaning for a public that looked in art only for pleasing subjects pleasantly pictured.

His letters to his father from Paris had expressed confidence in being able to make a living by his art: "I could even now earn a respectable living I think in America painting heads." His letters to Shinn in 1875 had shown unquestioning belief in his merit and his coming success: "My works are already up to the point where they are worth a good deal and pretty soon the money must come." By the end of the 1870s, however, he must have begun to realize that his confidence in financial success was groundless.

But he had his father's house to live and work in, and his father's income to keep him from poverty. He had complete belief in the strength of his art—a belief he was never to lose. And he had a second career, teaching.

6. Teaching, 1874 to 1886

EAKINS WAS A BORN TEACHER. The son of a teacher, his own pedagogical drive is manifest in his letters to Fanny. A realization of the inadequacy of his training in America had sent him abroad to study in one of the most rigorous schools in Europe.

His old school, the Pennsylvania Academy, cramped for space, had sold its building in 1870 and was to be inactive until its new building opened in 1876. The vacuum was partially filled by the Philadelphia Sketch Club, which held all-male evening classes in drawing from life twice a week, managed by William J. Clark. Earl Shinn proposed to Eakins that he give criticisms. On April 2, 1874, the latter replied: "If your friends of the Sketch Club really want my corrections of their drawings they can have them for the asking, that is, if the *majority* of the club desire them. I cannot of course act on the suggestion of one of them to my friend.

"I don't know them as you say. I only fear some of them are of the kind who would believe themselves more capable of teaching me than I them, but of this, you know best & I will make no account. It is always a pleasure to teach what you know to those who want to learn."

A year later he wrote Shinn: "My life school boys seem to be getting on very well considering the little time they have. Some are very earnest.

"But some continue to make the very worst drawing that ever was seen."

The Philadelphia *Press* reported in January 1876 that for two years, on Wednesday and Saturday evenings, Eakins had taught "large and interested" life classes at the club. In February, Clark said in the *Telegraph:* "If the rooms were four times as capacious as they were they would scarcely accommodate the students who are anxious to avail themselves of the facilities which the class affords." In 1884 Shinn recalled in *The Art Amateur:* "Mr. Eakins at once demonstrated not only that he was a thorough master of his subject, but that he had a distinct genius for teaching. His pupils developed that enthusiastic regard for him which zealous learners always feel for a master whose superior attainments they unqualifiedly respect, and such was the credit which the

class obtained that the applications for admission soon far exceeded the capacity of the rooms." For the two years that Eakins gave his criticisms, he did so without pay. A year or so after he stopped, the club on Clark's initiative made him an honorary member, one of only two in its history.

In the meantime, the Pennsylvania Academy's new building was under way. The Academy differed from New York art organizations such as the National Academy of Design in that it was owned and controlled not by artists but by laymen. It had been established in 1805 as a joint-stock institution by seventy-one public-spirited Philadelphians: businessmen, lawyers, and doctors, with only three artists; in the 1870s its board of directors and even its committees on the school and on exhibitions were still composed almost entirely of laymen. "These gentlemen are very unselfishly interested in the progress of art; and they pay for their enthusiasm liberally," wrote William C. Brownell, but "they do not permit even an artist so distinguished as Mr. Rothermel to have a voice in the management of what is distinctively *their* Academy."

An outstanding exception to lay control was John Sartain, who had been a director since the 1850s and for many years secretary of the board of directors, and chairman of the two key committees on instruction and exhibitions. In *The Reminiscences of a Very Old Man* he was to write that up to the late 1860s "there had never yet been in the Academy an organized school with regular paid instructors. . . . Students of art drew from the casts, and when sufficiently advanced were admitted into the life-class, a class carried on at their own expense, the Academy merely lending them the use of the room."

A close friend of Sartain's was Christian Schussele, the Alsatian-born artist, who had been schooled in the academic tradition by Paul Delaroche and Adolphe Yvon in Paris; he had settled in Philadelphia in 1848 and had become a successful, respected painter of storytelling genre, sentimental but lively, and of conscientious, highly finished historical scenes. Several of his paintings had been engraved by Sartain. In 1865, suffering from palsy, he had returned to Alsace for a cure. When Sartain was in Europe in 1867 he had gone to Strasbourg to see him. "I was pained to see that my friend's paralytic affliction had grown much worse," Sartain wrote. "The time could not be far distant when he would be unable to paint, but he would not be incapacitated for teaching, and I conceived a plan for establishing a proper art school at the Pennsylvania Academy, with Christian Schussele as professor." The two men reached an agreement, later ratified by the directors, and in 1868 the school was reorganized, with Schussele as Professor of Art.

Two years later the school was suspended for six years. Schussele continued teaching some students in his own home. A Building Committee, headed by Fairman Rogers and inevitably including Sartain, supervised the planning and construction of a new building at Broad and Cherry streets—the Acad-

emy's present home—which opened in April 1876. Designed by the gifted Philadelphia architect Frank Furness (only five years older than Eakins, it was his first important commission), eclectic, elaborately ornamental, but original and powerful, it is still one of the outstanding architectural monuments of the 1870s. The interior design of classrooms and galleries had been put in Sartain's hands. The building provided the largest space and most complete facilities of any American art school of the time. "The schools . . . are conducted upon a much more elaborate scale than those of the National Academy of Design," Brownell wrote in 1879. "The rooms in which the students draw and paint and model would not fail to excite the envy of New York art students. . . . Whereas the National Academy was designed chiefly for the exhibitions of pictures without much regard to the comfort and convenience of the classes, which are relegated to the basement, almost the entire ground floor of the much larger Philadelphia Academy is exclusively reserved for the use of the schools. . . . The main life class room [is] . . . probably the largest room in the country that is devoted to such a purpose."

Eakins had a hand in these new facilities: *The Nation* in May 1876 reported that "the professor of the Sketch-Club life-class, Mr. Eakins," had been asked for advice about the lighting of the largest life-class room. As he was the most active teacher of life drawing in the city, and a friend of Sartain, this would be natural. In January 1876 members of the Sketch Club had sent a petition to the Academy, drafted by William Clark, to have an evening life class, with Eakins as instructor, the students paying for models; and many of the club members joined the classes of the reborn Academy.

When the school opened in September 1876 Schussele headed it as Professor of Drawing and Painting. By this time he was half-paralyzed, and Eakins volunteered to help him by teaching the evening life classes, without pay; and also to serve as chief demonstrator of anatomy for the lecturer on anatomy, Dr. William W. Keen, again without pay. His offer was accepted. His personal relations with Schussele were friendly and helpful; but there was little agreement between them on methods of teaching. Schussele believed in traditional academic training: long discipline in drawing from the antique before study of the living model, and long drawing from the model before beginning to paint —methods to which Eakins was completely opposed.

The younger man soon showed that he had ideas of his own. In January 1877 he addressed a letter to the Committee on Instruction, which was headed by Sartain: "Gentlemen, The Life Schools are in great need of good female models.

"I desire that an advertisement similar to the following be inserted in the Public Ledger.

"'Wanted Female Models for the Life Schools of the Pennsylvania Academy of the Fine Arts.

"'Apply to the Curator at the Academy Broad & Cherry at the Cherry St. entrance.

"'Applicants should be of respectability and may on all occasions be accompanied by their mothers or other female relatives. Terms $1 per hour. John Sartain, Chairman of Com. on Instruction.'

"The privilege of wearing a mask might also be conceded & advertised.

"The publicity thus given in a reputable newspaper at the instance of an institution like the Academy will insure in these times a great number of applicants among whom will be found beautiful ones with forms fit to be studied.

"The old plan was for the students or officers to visit low houses of prostitution & bargain with the inmates.

"This course was degrading & would be unworthy of the present academy & its result was models coarse, flabby, ill formed & unfit in every way for the requirements of a school, nor was there sufficient change of models for the successful study of form."

Needless to say, there is no record of any such letter appearing in the newspapers. But the Committee on Instruction, meeting next day, decided that the decision as to whether female models should be masked and "be covered during her periods of rest" should be left to the model, "with a preference for entirely dispensing with the mask and other covering."

John Sartain called Eakins and his own son Bill "the young firebrands from Paris." Between the Academy directors and Eakins there were growing differences. "The relations between Mr. Schussele and his assistant were always cordial in the extreme," Shinn wrote in 1884, "but the younger and more progressive man was bitterly antagonized from the start by certain of the managers." In late March 1877 the advanced male students started a new life school, with Eakins as instructor. "Some of the Art-students, who are dissatisfied with the teachers and methods of the Academy-schools," reported *The Art Journal*, "have organized a society of their own, under the name of the Art-Students' Union, and taken a room on Juniper Street, above Arch Street. The principal causes of their dissatisfaction are said to have been the facts that only nine hours a week were devoted in the Academy to the study of models by daylight, and that Mr. Thomas Eakins, whose instruction they valued, had not found favor in the eyes of the directors. The Art-Students' Union allows twenty-seven hours of daylight study every week. The expenses are only two dollars for an entrance-fee, and one dollar a week thereafter. The organization is similar in origin, purpose, and method, to the Art-Students' League in New York. Its outlook is said to be very promising." Here, as at the Sketch Club and the Academy, Eakins gave his services without pay.

However, he evidently continued to teach the Academy's evening life classes, to the displeasure of the directors. On May 15, 1877, George Corliss,

170

Thomas Eakins

the Academy actuary (registrar and secretary), wrote Schussele: "At a stated meeting of the Board of Directors, held 14th inst., it was resolved: That Prof. Schussele be instructed that he will, from this date, be expected not to delegate his authority or duties to any other person; and that his personal attention to the instruction of regularly established evening classes will hereafter be necessary." On this rejection of his voluntary, unpaid assistance to Schussele, Eakins left the Academy's life classes and devoted himself to those of the Art-Students' Union. But he continued to assist Dr. Keen as his chief demonstrator of anatomy.

The École des Beaux-Arts had been for men only, and Eakins' students at the Philadelphia Sketch Club, and presumably at the Art-Students' Union, had been males. But the Pennsylvania Academy had been one of the first American art schools to admit women under the same conditions as men; during Eakins' association with it, females numbered almost as many as males. The women seem to have valued his teaching as much as the men did. In November 1877 the secretary of the women's life class, Susan Hannah Macdowell, wrote Fairman Rogers, who had succeeded Sartain as chairman of the Committee on Instruction: "We desire to submit the enclosed petition for an additional life class. . . . Our desire in having this class, is to offer an additional opportunity of studying from life at a very convenient time, for those students whose private work prevents them from having the full benefit of the early morning class, added to this the great advantages to all the students of having more opportunity to study from the nude.

"On presenting our petition to Mr. Claghorn [president of the Academy] we learned that Mr. Thomas Eakins has no longer a position as instructor in the Academy. We are sorry for this, as, his good work of last winter at the Academy, proved him to be an able instructor and a friend to all hard working students.

"Professor Schusselle's work at the Academy is already heavy. Therefore if this extra class be granted us, we desire the privilege of inviting both Professor Schusselle and Mr. Eakins to overlook our work, using their own judgement as to the amount of instruction necessary."

Two days later the Academy directors agreed to add an evening life class for women, but Eakins was not reinstated.

Fairman Rogers was exceptional among the lay directors of the Academy. Member of a wealthy Philadelphia family, he was a civil engineer, a former professor of civil engineering at the University of Pennsylvania, and now a trustee of the University. Intelligent, public-spirited, urbane, and genuinely democratic, he understood and respected professional worth in fields other than his own. He and Eakins were to become good friends, and allies in reshaping the Academy school.

Throughout the 1877–78 season Schussele's strength was failing, so that he

had to be helped around his classes, and attendance had fallen very low. Meanwhile Eakins was teaching large life classes at the Art-Students' Union. In March 1878 Rogers and his committee decided that Eakins was needed, and at their request he wrote the board of directors: "After having taken charge of several of your classes during last season with pleasure to myself and profit to the scholars, the following note was sent to the Professor. [He then quoted verbatim the actuary's letter of the preceding May to Schussele.]

"In view of the increased classes, and the proposed extension of one of the largest of them, your committee on instruction have desired me if convenient to again assist in the teaching. If you will kindly furnish the professor through the actuary with the necessary permission, I shall be happy to give him any assistance he may choose to avail himself of." A few days later the actuary informed Schussele that the directors had rescinded their resolution of the previous May, and that he was "authorized to avail himself of such assistance as he may consider desirable in any or all of the classes."

This curiously roundabout way of handling the affair, without mentioning Eakins' name, undoubtedly resulted from the strange situation that the school's best teacher was not being paid, and the directors were not to be placed in the position of asking him to come back.

That June the actuary wrote Eakins: "I take pleasure in expressing to you the thanks of the Board of Directors, for valuable services given freely as instructor in the life classes, during the Season just closed. / By order of the Board." And next fall, in the circular of the Committee on Instruction, Eakins was listed as Assistant Professor of Painting and Chief Demonstrator of Anatomy.

Schussele was now little more than a figurehead. By early 1879 his health had declined so much that the directors were thinking of inducing him to resign. At a special directors' meeting on January 30, "the chairman of the Committee on Instruction [Fairman Rogers] said that the question of discontinuing the salary of Professor Schussele had been considered; and that it apparently could not be accomplished without the loss of Mr. Eakins' services—he considering himself bound in honor to Professor Schussele, so that he could not continue his connection with the Academy, after Professor Schussele's resignation, if caused by any act of the Academy. The committee considered it a matter of vital importance to the schools to retain Mr. Eakins; and believed that he would be willing to serve for some [time] without compensation, if Professor Schussele should not be compelled to resign."

Schussele died on August 21, 1879. On September 9 Eakins wrote his favorite woman student, Susan Hannah Macdowell: "Dear Sue, I am just going off to Newport [to sketch Fairman Rogers' four-in-hand coach]. I learned this morning that the Directors on the recommendation of the Committee on Instruction have appointed me Professor of Drawing and Painting. They did this

last night & Mr. Rogers wanted me to wait here so as to give the first lesson. I found 4 antique fellows whom I instructed & introduced to Billy Sartain whom I substitute till I come back.

"When old Sartain learns not only that I have the place, but that the other young firebrand Billy is keeping it for me, I fear his rage may bring on a fit.

"I hope you are all well and having a mighty good time."

His salary was $600 a year—half of Schussele's $1,200.

Even when Schussele had been his titular superior, Eakins had been re-modeling the school along new and radical lines. American art schools of the time, with very few exceptions, were little more advanced than the Pennsylvania Academy had been when Eakins had studied there. Drawing from the antique was still the primary discipline; admission to life classes took a long time, and even in them only drawing was taught, although some students painted on their own.

A complete and intelligent account of the Pennsylvania Academy school as it existed in 1879 is given in an article by William C. Brownell in *Scribner's Monthly Illustrated Magazine,* September of that year. Brownell was primarily a literary critic, but also knowledgeable about art and artists. He had visited the Academy the preceding season when the school was in session, had toured it thoroughly, and had interviewed Eakins in depth. (Schussele was still living, but he is mentioned only in passing.) This article is not only the most complete picture of the Academy school in Eakins' time but one of the most comprehensive accounts of his philosophy of painting and teaching. It is confirmed by a long article by Fairman Rogers in 1881, evidently written in consultation with Eakins.

About drawing from the antique, Brownell said: "The collection of casts from the antique is larger than any in New York. One large room is entirely occupied by casts of the Parthenon and a few other marbles ranking next to these." We know that Eakins admired Greek sculpture and talked about it often to his students. But his viewpoint on drawing from casts was clearly expressed in his interview with Brownell, who asked: "All this quite leaves the antique out of consideration, does it not?"

"Mr. Eakins did not say 'the antique be hanged,' because though he is a radical he is also contained and dispassionate; but he managed to convey such an impression. 'I don't like a long study of casts,' he said, 'even of the sculptors of the best Greek period. At best, they are only imitations, and an imitation of imitations cannot have so much life as an imitation of nature itself. The Greeks did not study the antique: the "Theseus" and "Illyssus," and the draped figures in the Parthenon pediment were modeled from life, undoubtedly. And nature is just as varied and just as beautiful in our day as she was in the time of Phidias. You doubt if any such men as that Myron statue in the hall exist now, even if they ever existed? Well, they must have existed once or Myron would

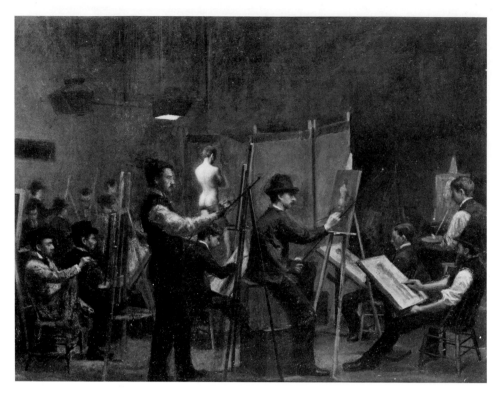

74. Walter M. Dunk: THE MALE LIFE CLASS
1879. Oil. 10¼ × 12¾
Pennsylvania Academy of the Fine Arts

never have made that, you may be sure. And they do now. Did you ever notice, by the way, those circus tumblers and jumpers—I don't mean the Hercules? They are almost absolutely beautiful, many of them. And our business is distinctly to do something for ourselves, not to copy Phidias. Practically, copying Phidias endlessly dulls and deadens a student's impulse and observation. He gets to fancying that all nature is run in the Greek mold; that he must arrange his model in certain classic attitudes, and paint its individuality out of it; he becomes prejudiced, and his work rigid and formal. The beginner can at the very outset get more from the living model in a given time than from study of the antique in twice that period. That at least has been my own experience; and all my observation confirms it.'"

In practice, students drew from the antique about six months before being admitted to the life classes. (There were of course separate life classes for men and women.) Once they were admitted, Eakins' policy was to encourage them to start right in painting in full color. Brownell reported: "Almost without exception they use the brush—which would excite wonder and possibly reprehension from the pupils of the National Academy. . . . Professor Schussele,

who is conservative, prefers a long apprenticeship in drawing with the point or stump. . . . Mr. Eakins, who is radical, prefers that the pupil should paint at once. . . . As is natural with ambitious students, most of these take Mr. Eakins's advice. That advice is almost revolutionary, of course. Mr. Eakins's master, Gérôme, insists on preliminary drawing; and insistence on it is so universal that it was natural to ask an explanation.

"'Don't you think a student should know how to draw before beginning to color?'

"'I think he should learn to draw with color,' was Mr. Eakins's reply. And then in answer to the stock objections he continued: 'The brush is a more powerful and rapid tool than the point or stump. Very often, practically, before the student has had time to get his broadest masses of light and shade with either of these, he has forgotten what he is after. . . . The main thing that the brush secures is the instant grasp of the grand construction of a figure. There are no lines in nature, as was found out long before Fortuny exhibited his detestation of them; there are only form and color. The least important, the most changeable, the most difficult thing to catch about a figure is the outline. The student drawing the outline of that model with a point is confused and lost if the model moves a hair's-breadth; already the whole outline has been changed, and you notice how often he has had to rub out and correct; meantime he will get discouraged and disgusted long before he has made any sort of portrait of the man. Moreover, the outline is not the man; the grand construction is. Once that is got, the details follow naturally. And as the tendency of the point or stump is, I think, to reverse this order, I prefer the brush. I don't at all share the old fear that the beauties of color will intoxicate the pupil, and cause him to neglect the form. I have never known anything of that kind to happen unless a student fancied he had mastered drawing before he began to paint. Certainly it is not likely to happen here. The first things to attend to in painting the model are the movement and the general color. The figure must balance, appear solid and of the right weight. The movement once understood, every detail of the action will be an integral part of the main continuous action; and every detail of color auxiliary to the main system of light and shade. The student should learn to block up his figure rapidly, and then give to any part of it the highest finish without injuring its unity. To these ends, I haven't the slightest hesitation in calling the brush and an immediate use of it, the best possible means.'"

Another special feature of the Academy was sculptural modeling from the nude, taught in connection with painting. "When Mr. Eakins finds any of his pupils, men or women, painting flat, losing sight of the solidity, weight and roundness of the figure," Brownell wrote, "he sends them across the hall to the modeling-room for a few weeks. There is now no professor of modeling, but as modeling is not pursued for the end of sculpture but of painting, the loss is not deeply felt. And Mr. Eakins is frequently present to give advice and ren-

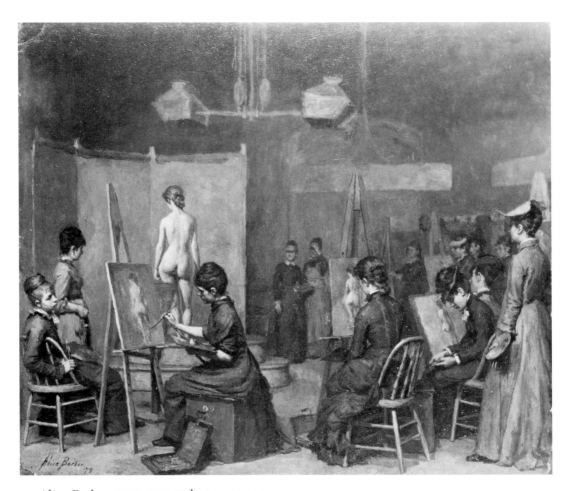

75. Alice Barber: THE WOMEN'S LIFE CLASS
(Susan Hannah Macdowell in the left foreground)
1879. Oil. 12 × 14
Pennsylvania Academy of the Fine Arts

der assistance." This practice, Rogers commented in his 1881 article, "is in accordance with the general theory of the school, that the students should gain accurate information rather than merely acquire the knack of representing something; and nothing increases more rapidly the knowledge of the figure than modelling it. The student studies it from all sides and sees the relation of the parts, and the effect of the pose upon the action of the muscles, much more distinctly than when painting from the one side of a model exposed to him from his fixed position in the painting class." Again, there were separate modeling classes for men and women. The works were in clay, in the round, and about twenty-two inches high.

The most radical feature of the Academy, which set it apart from other

schools not only in the United States but abroad, was the thorough teaching of anatomy, including dissection in the school's dissecting room. Eakins said: "To study anatomy out of a book is like learning to paint out of a book. It's a waste of time." In New York neither the National Academy nor Cooper Union taught anatomy, and the Art Students' League had lectures but not dissecting.

Since the reopening of the Pennsylvania Academy in 1876 there had been a Professor of Artistic Anatomy, Dr. William W. Keen, a leading surgeon and former head of the Philadelphia School of Anatomy, where he had given courses in anatomy for artists, attended by women as well as men. At the Academy he gave thirty to thirty-five evening lectures, two a week, open to all students including those in the antique class. Every part of the body was studied in detail, down to wrinkles in the skin; but with all this thoroughness, the course was designed for artists, not physicians. The lectures were illustrated by a skeleton; a manikin; plaster models painted red, blue, and white, to indicate muscles, tendons, and bones; and diagrams drawn on a blackboard; as well as by the living model, who was put through movements showing the functions and actions of the parts discussed, his muscles being called into play by weights, suspended rings, and other apparatus. Mild electric shocks were used to demonstrate certain muscles. Each lecture was accompanied in the dissecting room by dissections of the particular parts of the body. "It quite takes one's breath away, does it not?" Brownell commented. "Exhaustive is a faint word by which to characterize such a course of instruction."

76. Thomas Eakins: A WOMAN'S BACK: STUDY
1879. Oil. 10³/₈ × 14⁵/₈. G 202
Mr. and Mrs. Daniel W. Dietrich II

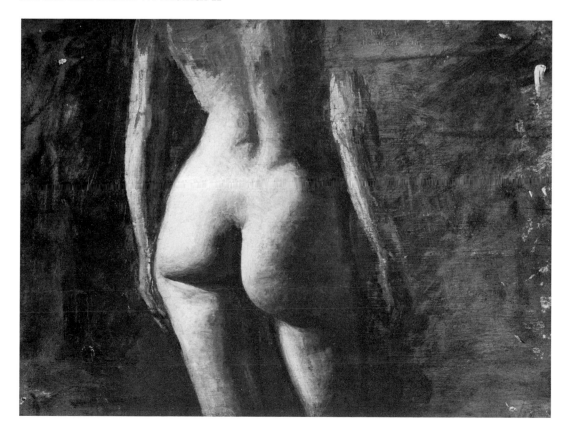

"In dissections presided over and directed by the professor of painting," he said, "the school of the Philadelphia Academy is, so far as I know, unique." For the first three years Eakins doubled as teacher of drawing and painting and Chief Demonstrator of Anatomy. The Chief Demonstrator, under the top supervision of Dr. Keen, was in charge of the dissecting room; under him were six or eight unpaid student Assistant Demonstrators, who made the prosections for the lectures and supervised the other students in their dissecting. From 1881 women also dissected, at different hours, and there were women demonstrators. All life-class students could use the dissecting room to study the parts being lectured on, and the majority did so. Horses and other animals were also dissected.

Brownell, visiting the dissecting room, asked Eakins: "Don't you find this sort of thing repulsive? At least, do not some of the pupils dislike it at first?"

"'I don't know of anyone who doesn't dislike it,' is the reply. 'Every fall,

77. James P. Kelly: THE MEN'S MODELING CLASS
1879. Oil. 10⅛ × 12¾
Pennsylvania Academy of the Fine Arts

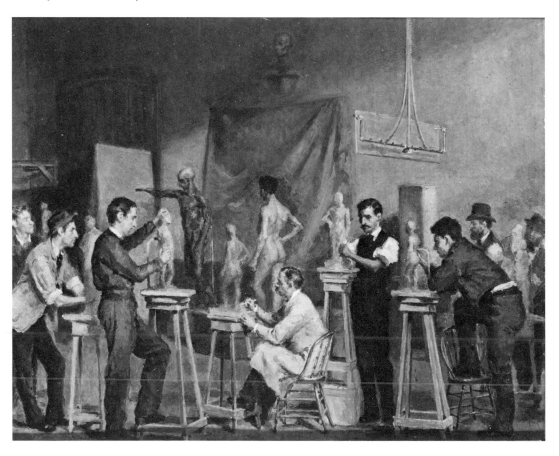

Thomas Eakins

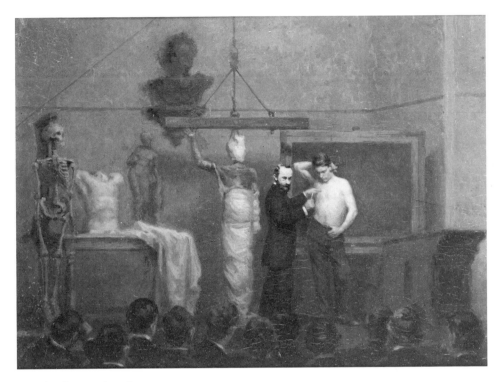

78. Charles H. Stephens: THE ANATOMICAL LECTURE
1879. Oil. 8⅝ × 11
Pennsylvania Academy of the Fine Arts

for my own part, I feel great reluctance to begin it. It is dirty enough work at the best, as you can see. Yes, we had one student who abstained a year ago, but this year, finding his fellows were getting along faster than himself, he changed his mind and is now dissecting diligently.'

"'But you find it interesting, nevertheless?'

"'Intensely,' says one of the students, with ardor.

"'And don't you find your interest becoming scientific in its nature, that you are interested in dissection as an end in itself, that curiosity leads you beyond the point at which the aesthetic usefulness of the work ceases? I don't see how you can help it.'

"'No,' replies Mr. Eakins, smiling, 'we turn out no physicians and surgeons. About the philosophy of aesthetics, to be sure, we do not greatly concern ourselves, but we are considerably concerned about learning how to paint. For anatomy, as such, we care nothing whatever. To draw the human figure it is necessary to know as much as possible about it, about its structure and its movements, its bones and muscles, how they are made, and how they act. You don't suppose we pay much attention to the viscera, or study the functions of the spleen, I trust.'

Teaching, 1874 to 1886

79. Thomas P. Anshutz: DISSECTING ROOM
1879. Oil. 10 × 12½
Pennsylvania Academy of the Fine Arts

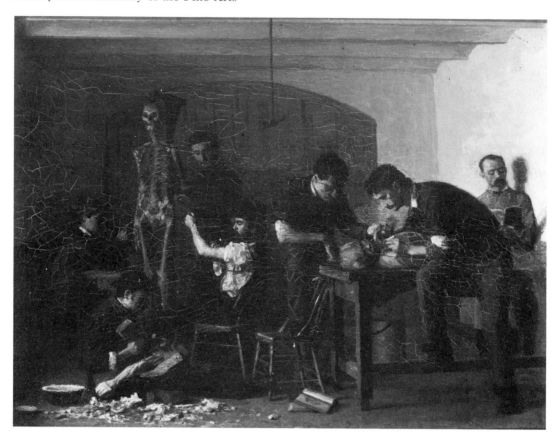

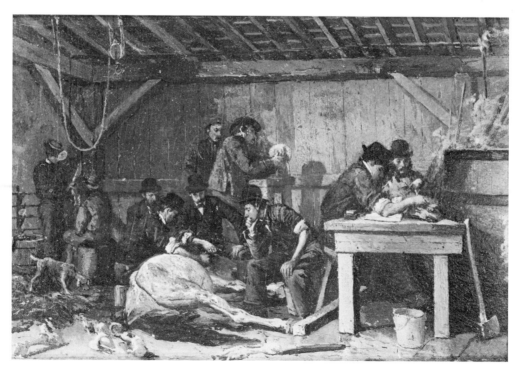

80. Charles L. Fussell: ANATOMICAL STUDIES
1879. Oil. 7⅜ × 10¼
Pennsylvania Academy of the Fine Arts

"'But the atmosphere of the place, the hideousness of the objects! I can't fancy anything more utterly—utterly—inartistic.'

"'Well, that's true enough. We should hardly defend it as a quickener of the aesthetic spirit, though there is a sense in which a study of the human organism is just that. If beauty resides in fitness to any extent, what can be more beautiful than this skeleton, or the perfection with which means and ends are reciprocally adapted to each other? But no one dissects to quicken his eye for, or his delight in, beauty. He dissects simply to increase his knowledge of how beautiful objects are put together to the end that he may be able to imitate them. Even to refine upon natural beauty—to idealize—one must understand what it is that he is idealizing; otherwise his idealization—I don't like the word, by the way—becomes distortion, and distortion is ugliness. This whole matter of dissection is not art at all, any more than grammar is poetry. It is work, and hard work, disagreeable work. No one, however, needs to be told that enthusiasm for one's end operates to lessen the disagreeableness of his patient working toward attainment of it. In itself I have no doubt the pupils consider it less pleasant than copying the frieze of the Parthenon. But they are learning the niceties of animal construction, providing against mistakes in drawing animals, and they are, I assure you, as enthusiastic over their "hideous" work as any decorator of china at South Kensington could be over hers. As for their artistic impulse, such work does not affect it in any way whatever. If they have any when they come here they do not lose it by learning how to exercise it; if not, of course, they will no more get it here than anywhere else. . . .

"'Of course, one can waste time over anatomy and dissection. I did myself, when I began to study; I not only learned much that was unnecessary, but much that it took me some time—time that I greatly begrudged—to unlearn; for a time, my attention to anatomy hampered me.'"

From the 1880–81 season on, a horse was used as a model in the modeling class for a six or seven weeks' pose. (In this case the men and women students were not separated.) At the same time a dead horse was dissected. "The horse enters so largely into the composition of pictures and statuary," Rogers wrote, "especially into works of the higher order, such as historical subjects, and is generally so badly drawn, even by those who profess to have made some study of the animal, that the work seems to be of value." Every winter or early spring Eakins took a class to a suburban bone-boiling factory where they dissected horses in the slaughterhouse, and in summer they continued with studies of the living animal, modeling and painting and studying its movements, at Rogers' farm. During the 1882–83 season the horse was succeeded as model for five weeks by a cow.

From time to time regular models were varied with athletes, trapeze-performers, and the like. At first more male than female models were used, but "because the male figure is more familiar to the male students, at least, than

that of the female," the sexes became equally represented. If the model was unusually good or had any interesting peculiarity of form or action, he or she was photographed, and a collection of these photos was built up for the students' use.

In talking to students Eakins emphasized character, in bodies as much as in faces. "Get the character of things," he once said. "I detest this average kind of work. There is not one in the class that has the character. It is all a medium between the average models. If a man's fat, make him fat. If a man's thin, make him thin. If a man's short, make him short. If a man's long, make him long." Again: "I'd rather see an exaggeration, although it is a weakness, than not enough. Go to the full extent of things." To Brownell he said: "We change the model as often as possible, because it is only by constant change that pupils learn that one model does not look at all like another. There is as much difference in bodies as in faces, and the character should be sought in its complete unity. On seeing a hand one should know instinctively what the foot must be. . . . Nature builds harmoniously." Brownell testified of the students' works: "I saw a sketch of none that was not individual, none whose ugliness was characterless. . . . Nowhere is there any effort at anything but individual portraiture—no attempt to make a Phidian statue from a scullion maid."

In addition to his insistence on character in life-class studies, Eakins started a portrait-painting class for the life students in 1879, with himself as teacher. And in 1883 he wrote the board of directors that he was "very anxious to have a still life painting class where color and tone experiments may be made on a greater scale than the gray tones of the flesh afford in the life class room. . . . The knowledge obtained from the study of strong colors is of very great importance." This recalls his own experiments in Paris in painting bright-colored textiles.

Among the objects to be painted were eggs. "There is nothing so like human flesh as an egg, for color, modeling, texture, and translucency," he told students. Again: "Paint an egg, as it teaches you to paint well. You know the form, and it's only painting." "Paint three eggs—one red, one black, one white. Paint the white and black ones first, then paint all three together. I turned myself some wooden ones, this shape, and I painted these in sunlight, in twilight, indoors—working with the light, and the light just skimming across them." "Take an egg or an orange, a piece of black cloth, and a piece of white paper, and try to get the light and color." "I cannot urge you too much to paint little simple studies. Take a lump of sugar, a piece of chalk, and get the texture. These things can be gained with paint. To get these things is not dexterity or a trick. No—it's knowledge." "These simple studies make strong painters."

The laws of perspective were taught as thoroughly as anatomy. In 1877 Eakins had volunteered to teach a course in perspective, but his offer was de-

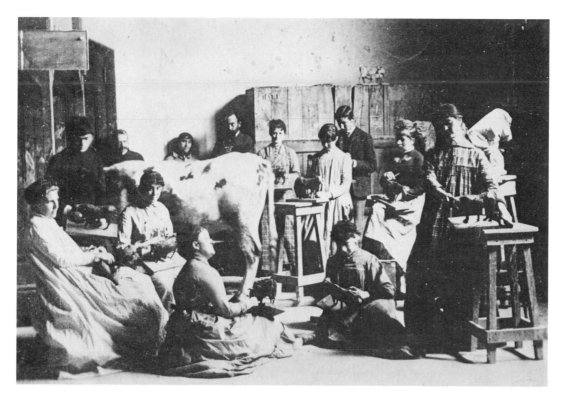

81. Modeling class at the Pennsylvania Academy of the Fine Arts. Early 1880s
Photographer unknown. (The bearded man in the center background may be Eakins.)
Philadelphia Museum of Art; Gift of Charles Bregler

clined; and it was not until three years later, after he had succeeded Schussele, that he gave his first regular lecture, on the evening of March 13, 1880. Every year thereafter he delivered a course of lectures on perspective, "illustrated by the lantern, and also by ingeniously constructed models on a large scale." The manuscript for the lectures is now owned by the Philadelphia Museum of Art; though some parts are missing and some repeated, it is a lucid exposition of a complex subject. Eakins evidently intended it for publication: the text calls for specific illustrations, and a few surviving drawings seem to be for this purpose; but like many of his projects, events prevented its realization.

The system was essentially that which he himself used. His students were given concrete problems to work out, using mechanical drawing methods. The final problem was his favorite one of a yacht sailing. A boat is the hardest thing I know of to put into perspective," he told his pupils. "It is so much like the human figure, there is something alive about it. It requires a heap of thinking and calculating to build a boat."

He also wrote papers on mechanical and isometric drawing, reflections in water, shadows, sculptured relief, focus of the eye, and "framing the picture,"

by which he meant the relation of the size of the subject pictured to the size of the picture. His original handwritten manuscripts for most of these are also now in the Philadelphia Museum. Whether they were actually delivered as lectures is not known; perhaps they all came under the head of "composition." Another long paper on refraction was probably for his own use, since it is almost entirely mathematical, without exposition. Students were frequently advised to study higher mathematics; to one he said: "You are young yet, and ought to learn it—it is *so much like painting.*"

No prizes were given in the school. "The true prizes," Rogers wrote, "are the acceptance of pictures by the various exhibition committees and the approval of the public. . . . This is the present theory of the school, and it is strongly supported by the Professor of Painting, who considers that working for any other prize is apt to distract the student." The only honor was Eakins' initialing the best studies, which were kept by the Academy.

Although he usually avoided working on students' pictures, he was not overly respectful of them; those that showed surface finish without sound construction were sometimes demolished in the process of pointing out faults. Henry O. Tanner, who had made a good start on a study but then stopped working on it for fear of spoiling it, was asked: "What have you been doing? Get it, get it better, or get it worse. No middle ground of compromise." A girl who said she "had her little ways" of solving problems was told: "There are no little ways." But he was seldom sarcastic at a student's expense. In fact, he did little unnecessary talking in the classroom. He would sometimes sit down in front of a pupil's work and study it intently, then rise without a word and go on to the next easel. On occasion this might happen to half the class, or an individual might not receive a criticism for weeks. Silence might be comment enough, or he might feel that some pupils were better off working things out on their own. They were always encouraged to think for themselves. "His methods made one very self-reliant," a former student said to me.

Charles Bregler, who studied with Eakins for several years, at the Academy and then at the Art Students' League of Philadelphia, made a practice during the years 1885 to 1887 of writing down his master's comments soon after he heard them. When Bregler published these, in 1931, he did not put them in any particular order; in the following and preceding quotations, which include all except a few, the order has been rearranged.

"Strain your brain more than your eye." "You can copy a thing to a certain limit. Then you must use intellect." "Paint a little piece of still life, paint hard. A half an hour is worth more than a whole week of careless work." "A few hours' intelligent study is better than a whole day of thoughtless plodding." "Don't paint when you are tired. A half an hour of work that you thoroughly feel will do more good than a whole day spent in copying."

"Picture making ought not to be put off too long." "There are men in Paris

in the schools, they paint day after day from the model. They never try to paint anything else. They are waiting until they know something. They are now old men. They cannot paint as well as they could twenty years ago."

"You notice a little boy learning to skate. They play, they pitch into a thing, and they learn much quicker than a big fellow."

"There is too much of this common, ordinary work. *Respectability in art is appalling.*"

"Don't copy. Feel the forms. Feel how much it swings, how much it slants —these are big factors. The more factors you have, the simpler will be your work."

"Get life into the middle line. If you get life into that, the rest will be easy to put on."

"Get the foot well planted on the floor. If you ever see any photograph of Gérôme's works, notice that he gets the foot flat on the floor better than any of them."

"Always think of the third dimension."

"You can't compare a flat thing with a round thing. You have to get it round as quickly as possible."

"The more planes you have to work by, the solider will be your work. One or two planes is little better than an outline."

"Think of the cross-sections of the parts of the body when you are painting."

"Get the profile of the head, then see how far back the cheek bone is, then paint the eye socket, then the eyeball, then the thin eyelashes on top of the eyeball. Always think of things in this way and you will do good work."

"Think of the weight. Get the portrait of the light, the kind of day it is, if it is cold or warm, gray or sunny day, and what time of the day it is. Think of these separately, and combine them in your work. These qualities make a strong painter."

"Get the thing built up as quickly as possible before you get tired. Get it standing, and in proportion in the first two days. Don't go at it as if you had four weeks ahead of you. Then model up a part as far as you can and take up another part. If you don't do this you keep going on correcting this part by that, and you get no further. You keep going around a ring."

"When finishing, paint a small piece, then don't go and finish another beside it. If you do you lose your drawing. But finish a piece some distance from it and then keep working the two points. For example, if I were painting an arm I would finish the elbow and then the wrist, then I would finish in between until the two ends met. Joints are always a good thing to start from."

"Feel the model. A sculptor when he is finishing has his hand almost continually on the model."

"Did you see those charcoal drawings by Degas? I saw one of a ballet girl

putting on her tights. He had that wriggle of the foot. The action was good. It was done with a few strokes of charcoal. That fellow knew what he was about."

He told Horatio Shaw that his drawing was very good, but "make it so it would look right in case you would go around to the sides and back of it." Urging A. Stirling Calder to start painting instead of drawing, he said: "Attack all your difficulties at once."

Judging from these statements, from Brownell's and Rogers' articles, and from what Eakins' former students told me in 1930 and 1931, he paid little attention to aesthetics or to art as formal design. His teaching was naturalistic, concentrating on the anatomical structure of human and animal bodies, on perspective, on light, and on color in relation to light. Rogers was evidently expressing Eakins' viewpoint as well as his own when he wrote: "The objection that the school does not sufficiently teach the students picture-making, may be met by saying that it is hardly within the province of a school to do so. It is better learned outside, in private studios, in the fields, from nature, by reading, from a careful study of other pictures, of engravings, of art exhibitions; and in the library, the print rooms and the exhibitions which are held in the galleries, all freely open to the student, the Academy does as much as it can in this direction." Indeed, for an art school of the time, the Academy did offer unusual material on older art. In addition to the antique casts there was a small library, "perhaps the most complete collection of carbon photographs [Braun autotypes] from old masters in the country (outside of the Braun agency)," and the John S. Phillips collection of etchings and engravings, one of the largest if not the most discriminating.

Former students with whom I talked agreed that although Eakins did not speak much about the art of the masters, old or modern, he did so occasionally. To the modeling class he often cited the Greek sculptors, especially Phidias. Of the old masters he spoke most frequently of Velázquez, Ribera, and Rembrandt. Among moderns he called Gérôme the greatest painter of the nineteenth century; but he also spoke of Corot, Millet, Barye, Courbet, Fortuny, Degas, Forain—an odd assortment. Even the old masters, however, were not exempt from criticism. Once when he and his students were looking at a reproduction of Rembrandt's early *Anatomy Lesson* in The Hague, and one of them, Thomas Eagan, remarked that it was not so good, Eakins said that Tommy was right, there were fine portraits in it, but the body didn't lie right. In general his comments were on technical not aesthetic qualities; if a picture was mentioned it was usually because it solved some specific technical problem; for example, he urged pupils to study William T. Dannat's *Quartette* in the Metropolitan Museum, for its handling of figures seen against light. But his kind of naturalistic teaching differed from that of most teachers of his time,

who stressed visual appearances and skill with the brush. Eakins' teaching was concerned with the more basic study of three-dimensional form and space —a concern rare in America.

In the large majority of his students he aroused enthusiasm and devotion. The president of the Art Students' League of New York, Frank Waller, wrote in 1880: "The relation between Mr. Eakins and the students is most intimate and friendly, and arises partially from the fact that Mr. Eakins is but little, if any, older than some in the school, partly because he has been there several years, but mainly on account of his ability, and the unquestioned assistance they actually receive from him. The relation is more like the family than that of master and scholars." Robert Henri, who entered the Academy shortly after Eakins left in 1886, said years later: "In those days it was an excitement to hear his pupils tell of him. They believed in him as a great master, and there were stories of his power, his will in the pursuit of study, his unswerving adherence to his ideals, his great willingness to give, to help, and the pleasure he had in seeing the original and worthy crop out in a student's work."

In the spring of 1882 came a major reorganization of the Academy school. Fairman Rogers, Eakins, and the Committee on Instruction had made a study of the faculties, salaries, classes, and tuition of nine art schools in the United States and two in Europe, including the National Academy, Art Students' League, and Cooper Union in New York, the Brooklyn Art Guild, Princeton and Yale, and the Boston Museum. As a result, Eakins drew up a three-page plan, headed "Reorganization of the Schools." Next fall's circular of the Committee on Instruction presented a forthright statement of the school's purposes and methods, written by him, beginning: "The object of the School is to afford facilities and instruction of the highest order to those persons—men and women—who intend to make painting or sculpture their profession. . . . The course of study is believed to be more thorough than that of any other existing school. Its basis is the nude human figure." The main features of Eakins' methods were outlined: the study of anatomy, human and animal, including dissection; modeling in clay; and lessons in perspective and composition.

In March 1882 Eakins was promoted from Professor of Drawing and Painting to Director of the Schools. His salary had been increased from $600 a year in 1879 to $1,200; now the directors agreed to double it again, "as soon and as rapidly as the income of the school will permit." Thomas P. Anshutz was appointed Assistant Professor of Painting and Drawing, at $30 a month. Dr. Keen continued as Professor of Artistic Anatomy, at his previous salary, assisted by John Laurie Wallace as Demonstrator of Anatomy, without salary.

The school had been a free one, but as part of the reorganization in 1882 the directors announced: "The financial condition of the Academy having made it necessary that the schools should be self-supporting, a moderate

charge will hereafter be made": $48 for the full eight-month season, $8 for a month. Attendance did not suffer. Throughout the years that Eakins was connected with the school, the number of students averaged somewhat more than 200, with usually a few more men than women. For the first season as a pay school, 1882–83, the total was 203. The students came from fourteen states: eight in the Northeast, six in the Midwest. Next year the directors' annual report said: "From a heavy tax upon the resources of the Academy [the school] has become largely self-supporting."

What with the antique class; separate life classes for men and women; modeling classes, also separate; night antique and life classes; the dissecting room; the portrait and still-life classes; and his own lectures (even with an assistant professor and a demonstrator of anatomy), Eakins must have been devoting a major part of his time to the school.

And he was teaching elsewhere. Widely recognized as a leading teacher and the foremost anatomist among American artists, he was being asked to instruct in schools in other cities. In the fall of 1881 he began to teach and to lecture on anatomy at the Students' Art Guild, the struggling free school of the Brooklyn Art Association, which had exhibited his pictures. Traveling to Brooklyn on Tuesdays and Fridays, he was paid $100 a month plus his travel expenses, which included sleeping cars and averaged about $45 a month. His teaching there continued probably through the 1884–85 season.

In the fall of 1885 the Art Students' League of New York, then ten years old, announced: "The League has secured for its lecturer on Artistic Anatomy Mr. THOMAS EAKINS, of Philadelphia (pupil of Gérôme), so widely known in connection with the Pennsylvania Academy of Fine Arts and Studies in Anatomy." He was to give twelve lectures, one a week, at 4:30 P.M., beginning November 10; they were to be "illustrated by the skeleton, anatomical figure, living model and set of casts taken by the Pennsylvania Academy with especial reference to such lectures." This series was to be followed by "the Perspective Lectures, which will be rendered both popular and instructive": twelve lectures on the same days and hours, beginning February 2, 1886. For each series he was paid $150, "this sum to include travel expenses." His perspective lectures were given in the spring of 1886, but not thereafter; his anatomy lectures were given in the four seasons of 1885–86 to 1888–89.

Contemporary accounts of his first League anatomy lectures in the fall of 1885, "before a large class of young men and young women," show that his method was far from that of drawing on a blackboard or paper, usual at the time, and even today. He used a skeleton suspended on a frame, an "anatomical figure," casts of different parts of the body, a living model, and a tub of modeling clay. "Seizing some modeling clay, he deftly modeled the muscles [of the arm] in his hands and attached them to the skeleton, at the same time

Thomas Eakins

showing the action of the tendons, and pointing out on the arm of the model the position of the muscle when in use and when at rest." Another writer commented: "A series of lectures unique in conception and character, and which, for practical utility, could not be improved upon. . . . The means by which he illustrated his remarks would have rendered the subject understandable to the least educated or intelligent person. . . . The hearers, instead of carrying away a few written notes, as is commonly the case in such a discourse, departed with a clear idea of the subject fixed upon their memories by a picturesque and lucid demonstration."

7. The Early 1880s

IN THE EARLY 1880s Eakins embarked on certain subjects more imaginative than his usual contemporary realism. In the 1870s there had been a few exceptions: *Hiawatha*, which turned out to be too sickeningly poetic to finish; the William Rush paintings; and the series of oils and watercolors based on the realities of everyday life in the past. In 1883 he produced a few Arcadian works, of which more later. Of unknown date there were studies for historical paintings never carried out: *Columbus in Prison* and *The Surrender of General Lee*.

None of these would prepare one for *The Crucifixion*, his only religious work, painted in 1880. Eakins was an agnostic, perhaps an atheist; he did not believe in the divinity of Christ, and in youth he had been strongly anticlerical. Yet he chose to represent this, the central image of Christianity. He may have been moved partly by an ambition to attempt a subject pictured by most of the old masters. (His painting has suggestive similarities to Ribera's *Martyrdom of Saint Bartholomew* in the Prado, on which he had commented in his 1870 notebook, though only about a technical point. And in 1876 his one-month teacher, Léon Bonnat, had painted a dramatic *Crucifixion*, from a cadaver nailed to a cross.) But he seems to have been motivated even more by his realism: he said he had never seen a picture of the Crucifixion in which the body was really hanging on the cross, or seemed to be in the open air. And there was his devotion to anatomy; the painting was his first full-scale nude since his student works. It was also his largest outdoor picture.

One of his favorite pupils, John Laurie Wallace, posed for it. He was an ideal model for the figure of Christ—thin, with a dark complexion, black hair, beard, and moustache, an aquiline nose, and Semitic-looking, though born of Scottish parents in Garvagh, Northern Ireland. He was only sixteen in the summer of 1880. When I met Wallace in 1938 he told me that Eakins made a cross, and they ferried over the Delaware to southern New Jersey, found a secluded spot and set up the cross, digging a hole for it. Wallace was beginning to pose on it, nude, when some hunters appeared; so they went to a still more

secluded spot, set up the cross again, and Wallace got up on it. "Eakins was thorough," he said, "he had a crown of thorns too." Naturally, Wallace was not nailed to the cross; he hung on by his hands. Eakins photographed him; and it was perhaps then that he painted a small study of the head and shoulders in sunlight. The large painting was executed in his studio in the Mount Vernon Street house, with Wallace strapped to the cross. (He told me that the cross was set up in the studio; other accounts, possibly apochryphal, say that the cross and Wallace were placed outdoors on the roof of the house, and Eakins painted them from his studio. If so, what did the neighbors think? One story is that they thought that Eakins had suspended a corpse on the roof. The truth may be that Wallace and the cross were placed outdoors and indoors at different times.)

The painting is far from traditional representations of the Crucifixion: there are no soldiers; no Virgin Mary, Saint John, or Mary Magdalene; no wound in the side; no apocalyptic storm or dramatic chiaroscuro. A dying Jew hangs alone on a cross on a desolate rocky hill, in the sunlight of every day, under an empty blue sky. His body is unquestionably hanging: the torso sags, the knees are bent, the arms are stretched taut, and the weight is borne by the nailed hands, clenched in agony. The legs are partly supported by the stand to which the feet are nailed, and one feels their feeble effort to relieve the strain on the hands. The head has fallen forward. This is a man in the last stages of physical suffering.

The figure occupies almost all the pictorial space; the top and bottom of the cross are not included. The concentration is on the body, one of Eakins' most masterly nudes. It is the body of a human being, down to the hair in the armpits. Blood has been running from the wounds; it runs down the arms, drips off the stand under the feet. The crown of thorns is no conventional symbol, but one of real thorns with sharp points. The loincloth is as precisely painted as a still-life; one can tell the kind of knot it is tied in.

The Crucifixion is a strictly objective portrayal of a human being in his last moments. Of customary religious feeling there is no trace; no sense of Christ as more than human, or of his death as the culmination of his life and teaching. Compared to representations of the subject by older masters, the religious content is nil. Yet in its unsparing realism the painting is more memorable than are conventional ecclesiastical works of the nineteenth century. Its naturalistic power and its expression of physical suffering and of purely human tragedy, as well as its technical qualities, make it one of Eakins' most impressive paintings.

Like *The Gross Clinic* and the later *Agnew Clinic*, *The Crucifixion* raises the question of whether there was an element of sadism in Eakins' realism. Certainly these works show a concern with bodily suffering, with wounds and blood, a somber strain that links him to the Spanish masters. Yet there is no

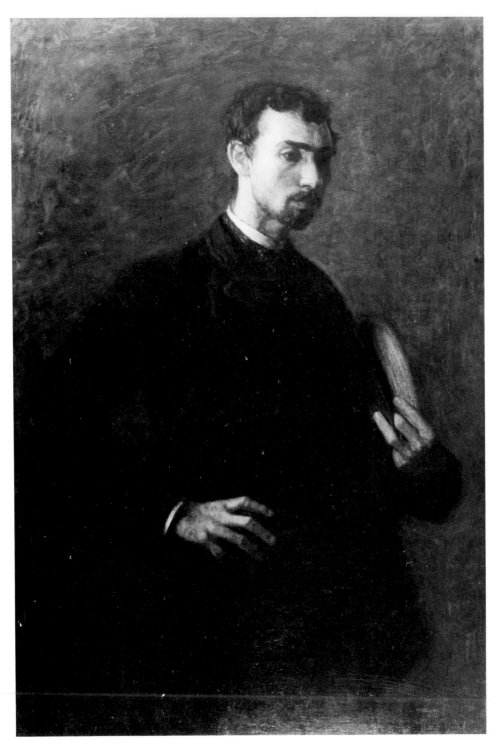

82. J. LAURIE WALLACE
c. 1883. Oil. 50¼ × 32½. G 206
Joslyn Art Museum, Omaha, Nebraska

overt cruelty in most of his subjects, unless we consider as cruel his lack of idealization in portraying people, his making some of them look older and homelier than they were. Rather than sadism, his uncompromising realism involved a lack of illusion, an inclination toward pessimism, a realization of the tragic in human life.

Originally the sky in *The Crucifixion* was a brilliant blue, against which the pale body and warm brown cross and crown of thorns stood out with startling effect. Recent scientific examination by Theodor Siegl of the Philadelphia Museum reveals that Eakins later (we do not know when or why) covered the sky with warm light gray paint applied with a palette knife—an unusual technique for him—and rubbed gray into the flesh. Today, with its subdued sky, grayed earthy flesh tones, and dun-colored rocky hillside, it is one of his least colorful works, with no strong positive notes. This severity is in harmony with the austerity of the image, but one cannot help regretting the original chromatic contrast.

The painting in its original color was submitted by Eakins to the Committee of Selection for the Society of American Artists' fifth annual exhibition in the early spring of 1882. The committee rejected it. But there were so many protests at the jury's actions that in May the Society held a supplementary exhibition—an American *salon de refusés*—in which *The Crucifixion* was included.

The critics' reactions were generally unfavorable. *The Art Amateur* said: "Mr. Eakins' 'Crucifixion' is of course a strong painting from the scientific side, but it is difficult to praise it from any other point of view. At this stage of the world there can be only one reason for an artist's choosing such a subject—he must treat it as a poet. The physical aspect of the case ought to be sunk; the mere presentation of a human body suspended from a cross and dying a slow death under an Eastern sun cannot do anybody any good, nor awaken thoughts that elevate the mind."

The Art Journal said it "is one of those works which it is well for an exhibition to be provided with, because it provokes discussion, although, in this case, one might wish it had been another subject. . . . The artist who undertakes anything of the kind should endeavor to present it in a reverential light. Of the spirit properly belonging to works of this class Holman Hunt's 'Shadow of the Cross' is an example. Mr. Eakins, on the other hand, paints as a student of the human body. . . . When the feet are reached and one remarks the idiosyncrasies of the toe-nails, the ideal which everyone holds is degraded, and we realize that, in an age tending so strongly toward realism, there are subjects which should be left untouched."

When the painting was shown at the Pennsylvania Academy that fall, William Clark of the *Telegraph* stated the problem more objectively and forthrightly: "This artist is the greatest draughtsman in America. He is a great

83. THE CRUCIFIXION: STUDY
1880. Oil. 22 × 18. G 143
Hirshhorn Museum and Sculpture Garden, Smithsonian Institution

anatomist as well. . . . [The picture] is a superb piece of drawing, while in brushwork, color, and other matters it is up to the artist's very best standard of excellence. But how does it figure the true sentiment of the theme? . . . What he has done primarily has been to conceive the Crucifixion as an actual event. . . . Whether or no Mr. Eakins' picture is not approved, in comparison with other treatments of the same subject, would appear to depend upon whether the spectator has ever conceived, or is willing to conceive, of the Crucifixion as an event which actually occurred under certain understood conditions. Certainly, if that event meant all that Christendom believes and has for centuries believed it to mean, it would seem that, if it is to be represented at all, the most realistic treatment ought to be the most impressive. It is undoubt-

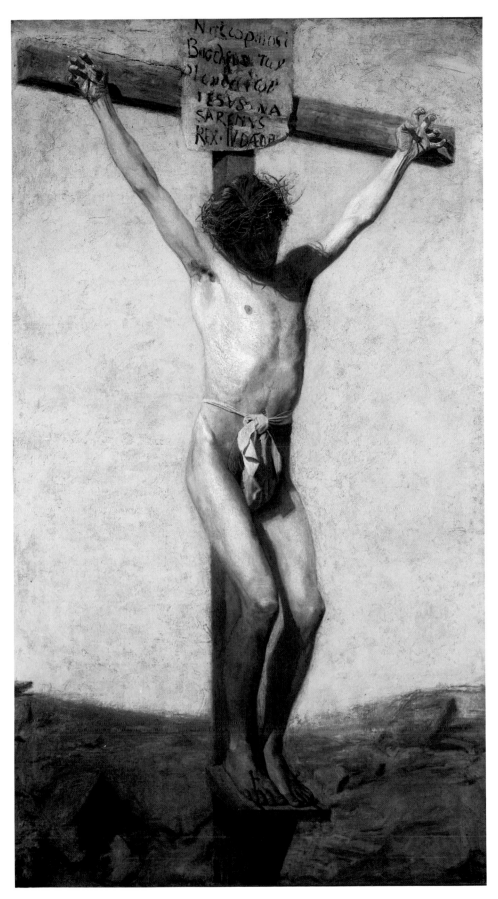

84. THE CRUCIFIXION
1880. Oil. 96 × 54. G 142
Philadelphia Museum of Art; Gift of Mrs. Thomas Eakins
and Miss Mary Adeline Williams

edly the case, however, that many who believe themselves to be good Christians fail altogether to appreciate their religion or the events upon which it is based as realistic; and to such, a picture like this has no message to deliver."

The most thoughtful review, and one of the longest, was that of a relatively young critic, Mariana G. Van Rensselaer, who after speaking of the absence of traditional features, said: "These things, however, . . . are but accessories which an artist may omit at will provided he gives us the essential idea— which is that of a *sacrifice*—and provided he uses his novel material to heighten the impression of terror or pathos at which he aims. This in my opinion, Mr. Eakins has done. I know there are some who see in the picture little but a most painful anatomical study: to me, however, it has an intensity of pathos touched with horror. . . . It is extremely difficult to put into words the impression made by such a picture, so strong, so repulsive in some ways, yet so deeply pathetic, partly by reason, perhaps, of that very repulsiveness. I can only speak for myself, when I say that after seeing a hundred crucifixions from modern hands this one seemed to me not only a quite original but a most impressive and haunted work."

It is noteworthy that the critics, in spite of their general disapproval, gave the painting more attention and space than most of Eakins' works, as they had *The Gross Clinic*.

The Crucifixion is the outstanding exception to Eakins' concentration on actualities, and one of his major works. On the other hand, the theme was foreign to his main interests, and he never painted another religious picture.

II

Mariana Griswold Van Rensselaer (Mrs. Schuyler Van Rensselaer) was a patrician, a member of the nation's older aristocracy. But she was also one of the few sensitive and perceptive American art critics of her time, contributing to leading art and general magazines. Even before she saw *The Crucifixion* she had been impressed by Eakins' works; and in May 1881, when she was only thirty, she suggested to the editor of *The American Art Review*, Sylvester R. Koehler, that she write an article on the Philadelphian. In preparation she visited Eakins in his Mount Vernon Street studio, on June 11, 1881. Knowing many artists of the New Movement, she had just published an article on the elegant, cosmopolitan William M. Chase, whom she had interviewed in his luxurious New York studio. Her reactions to Eakins and his habitat were expressed in a long report to Koehler.

"I went yesterday to Phil but fear I can give you little idea in words— especially written ones—of the strong contrast between the real Mr. Eakins & the one I had picture[d] to myself. He was very polite & pleasant, & ready to do all he could to further our wishes. But he was not the clever man I had anticipated in any thing outside of his immediate work. He seems to understand

his own aims and ideas & sort of work very well—as indeed, could hardly fail to be the case. But outside of that he is almost absurdly ignorant. He knew absolutely nothing about the black & white art of the country, had never heard of an American etcher except Ferris & in a vague way that there were some who did landscape work. Moreover, he did not know foreign artists, outside of Paris where he studied, even by name—Had never heard of Leibl, for instance, or of Lenbach, still more curious he was, not only not a gentleman in the popular acceptance of a 'swell,' but not even a man of tolerably good appearance or breeding. His home & surroundings & family were decidedly of the *lower* middle class, I should say, & he himself a big ungainly young man, very untidy to say the least, in his dress—a man whom one would not be likely to ask to dinner, in spite of the respect one has for his work! I used to wonder why he did not put better clothes and furniture into his pictures, but now I wonder how he even managed to see anything so good! His want of a sense of beauty apparent in his pictures is still more so in his surroundings. His studio was a garret room without one single object upon which the eye might rest with pleasure—the sole ornaments some skeletons & some models of the frame & muscles which looked, of course, like the contents of a butchers shop!"

Providing illustrations for the article would be a problem, since Eakins "says he destroyed all his academic studies & since that time has never worked at all in black & white even for the purpose of making notes . . . [yet] he said he should be glad to do some studies from life for our purpose tho' he was so unaccustomed to working in line that he did not know how he should succeed. . . . The American public does not seem to appreciate him at his proper worth. He has about all his pictures on hand in his rooms at present. . . . I was most interested in his explanation of the way in which he studied for the coach picture [*The Fairman Rogers Four-in-hand*] and the principle on which he painted the horses as he did."

The ambivalence of Mrs. Van Rensselaer's opinion of Eakins the man and Eakins the artist is shown in her urging Koehler to use *The Gross Clinic* as the large illustration for her article. "I hope you will. I do not see why it is so much worse than other things that are passed without comment and enjoyed—such as battle scenes to say nothing of crucifixions. The blood was the only unpleasant part in the canvas to me, & that does not offend, of course, in the reproduction. . . . It is much the most important picture he has painted—one of the very most important, it seems to me, we have yet produced."

Summing up her impressions for Koehler, she wrote: "He is most modest and unassuming, like a big, enthusiastic schoolboy about his work. I do not believe he knows how good it is or how peculiar. I am sure you could get him to make some studies of men in action that would be novel as well as good—baseball players, for example—& also of animals in motion. Anatomy is his

passion evidently & his one desire to paint human beings in motion. I believe that with proper encouragement he could do even better than he has done—that is if he had some one to order his pictures & some one to give him a little insight into the aesthetics of life & take him away from that 'milieu' where he now fin[d]s himself. I hope I have not given you a very disagreeable account of him. He is interesting in his way, but it was such a different way to the one I had imagined that I could not get used to it & fancied myself all the time talking to someone else tha[n] the real Mr. Eakins! Of course his pictures are none the less good in my eyes—indeed, they seem more remarkable when I consider the source & place of their production! . . . Do not understand me that he seemed at all unwilling to furnish us with whatever was wanted. On the contrary. He seems not to have much on hand just now & I doubt whether he is a prolific worker or works with an idea to making money or in an ambitious way of any sort. He seemed to me much more like an inventor working ou[t] curious & interesting problems for himself than like an average artist. His teaching occupies most of his time in the winter but now he will do whatever you want I am sure. I wonder how his photograph will look in your pages. He has a clever face in a way but a most extraordin[a]ry one. If you met him in the street you would say a clever but most eccentric looking mechanic!"

Unfortunately *The American Art Review* went bankrupt that fall, and Mrs. Van Rensselaer's article was never published. It would have been not only the first on Eakins as a painter, but the only one in his lifetime.

A few weeks after her visit to Eakins, Mrs. Van Rensselaer, apropos of *The Pathetic Song*, wrote a still ambivalent yet prophetic estimate of him in *The Atlantic Monthly:* "Of all American artists he is the most typically national, the most devoted to the actual life about him, the most given to recording it without gloss or alteration. That life is often ugly in its manifestations, no doubt; but this ugliness does not daunt Mr. Eakins, and his artistic skill is such that he can bring good results from the most unpromising materials. In spite of a deficient power of coloring, his brush-work is so clever, his insight into character so deep and his rendering of it so clear, his drawing is so firm, and his management of light so noteworthy that he makes delightful pictures out of whatsoever he will—even, as in this case, out of three homely figures with ugly clothes in an 'undecorative' interior. This Lady Singing a Pathetic Song was so impressive because it was admirably painted, and because it was at the same time absolutely true to nature—a perfect record of the life amid which the artist lives. The day will come, I believe, when Mr. Eakins will be rated, as he deserves, far above the painters of mere pretty effects, and a good way above even men of similar artistic skill who devote themselves to less characteristic and less vital themes. All possible renderings of Italian peasants and colonial damsels and pretty models cannot equal in importance to our growing art one such strong and real and artistic work as this one I have noted."

With all his emphasis on form, Eakins produced little graphic art. As far as is known, he never made a print—engraving, etching, lithograph, or wood engraving. But in the late 1870s and early 1880s he did produce a few works in a field new for him, illustrating. The five subjects he drew were for *Scribner's*, whose art editor, Alexander W. Drake, was endeavoring to raise its artistic level by commissioning the work of good artists. Eakins' first two illustrations, in November 1878, were for Bret Harte's humorous poem "The Spelling Bee at Angel's," which told how a group of California forty-niners, gathering in Angel's saloon, tried a new game, a spelling bee, which ended in a general massacre, with Harte's favorite character, Truthful James, in tattered clothes, shown shooting through a doorway: "the only gent that lived to tell about thet Spellin' Bee!"

The following June appeared a single illustration for a short story by Richard M. Johnston, "Mr. Neelus Peeler's Conditions," about a shiftless backwoods Georgia preacher and his wife. They were pictured in their shabby house, Neelus haranguing his patient, uncomprehending wife, who sits impassively sewing, while their child sprawls on the bare floor.

The last two illustrations, in July 1881, were for Maurice F. Egan's article "A Day in the Ma'sh," an account of the marshlands south of Philadelphia and their people, including the hunters of railbirds. It was a region well known to Eakins, and he did not need to originate anything for these illustrations, as he had for the earlier ones: for "Rail-shooting" he simply redrew his 1876 oil *Will Schuster and Blackman Going Shooting*, in practically identical form; and for "A Pusher" he took the Negro in the 1874 painting *Pushing for Rail*.

In these days before the general use of photomechanical halftones, illustrations were reproduced by wood engraving: a boxwood block was engraved by a craftsman who translated the artist's lines and tones into the relief lines of the block. By this time the old method, in which the artist drew directly on the block, so that his drawing was destroyed in the process of engraving, was being replaced by photographing the drawing and transferring the photo to the block. Eakins' drawings for three of the five illustrations have been found: monochrome wash drawings, larger than the printed illustrations, since *Scribner's* format was considerably smaller than that of pictorial magazines like *Harper's Weekly*. That these drawings were planned with his usual thoroughness is shown by a complete perspective plan for "Neelus Peeler" and an oil study of the man; and for the first "Spelling Bee" picture, an oil study of the central figure. Probably there were other studies that were not preserved.

The style of these illustrations was essentially that of Eakins' oils and watercolors: sober realism, honest portrayal of character, knowledgeable handling of light. Like his paintings, they were constructed in tone, without any

emphasis on line. The illustrations for Bret Harte's poem show no trace of graphic humor to match the humor of the words, none of the caricatural license of a Thomas Nast, or even of Eakins' own pupil A. B. Frost. For such a subject he seemed strangely miscast. His style was more appropriate for the realistic "Neelus Peeler" story, and still more, of course, for the rail-hunting scenes. But in none of his illustrations was there any concession to linear design, to the decorative values of flat pattern, or to the special qualities of wood engraving—characteristics that made Winslow Homer's illustrations among his most effective works in any medium. Eakins' five illustrations give no evidence of a bent for illustration or an interest in pursuing it. His pupil Joseph Pennell later wrote: "Illustrating, despised by the Professor, held in contempt by painters, looked down upon by the students . . ." But Pennell with his life-long touchiness had been offended by Eakins' decidedly negative reaction to his making a pen-and-ink drawing of the model instead of a painting; he had avoided further criticisms and soon left the Academy. Yet many of Eakins' pupils were to make their names as illustrators; aside from Pennell and Frost, they included Philip B. Hahs, Robert F. Blum, Alice Barber, Charles H. Stephens, and Alfred Brennan.

And Eakins became indirectly involved in illustration through his students. Brownell's article on the Academy was accompanied by ten illustrations by students, obviously chosen by their master. (Two were by Susan Hannah Macdowell, the only pupil represented by more than one.) For another favorite pupil, Alice Barber, who did the picture of the women's life class, Eakins painted a separate oil study of the nude female model's back. (In the foreground Susan Macdowell is seated painting.) Miss Barber, already an active engraver, engraved three of the illustrations. She also cut the blocks for "Neelus Peeler" and two reproductions of Eakins' paintings in *Scribner's* in May and June 1880: *The Chess Players* and *The Biglin Brothers Turning the Stake.* The latter, used with an article about spring around New York, was captioned "On the Harlem," which could not have pleased Eakins.

His income from all these illustrations was inconsiderable: $40 for the two Bret Harte drawings; $25 for "Neelus Peeler"; $50 for the two hunting subjects. In addition he received $10 each for the reproductions of his two paintings in *Scribner's,* and of a detail of *The Gross Clinic* in *Harper's New Monthly Magazine.* Total: $145.

Eakins' magazine illustrating stopped after July 1881. However, in the same years he drew a few illustrations of a different kind. Exhibition catalogues were beginning to be illustrated, not yet by halftones but by photomechanical linecuts of drawings made by the painters. Four such drawings, one in 1878 and three in 1881, were done by him, of two watercolors and two oils. The only original drawing that has been found, of *William Rush,* is in pen and ink without tone, translating the picture into pure line.

Eakins' portraits of the late 1870s and early 1880s included no such ambitious pictures of eminent persons as those of the earlier 1870s: Professor Rand, Dr. Gross, Archbishop Wood, or Dr. Brinton. Perhaps he was too busy teaching to ask such individuals to pose. However, these years did see three portraits commissioned, the first since the ill-fated *President Hayes*. In 1878 the trustees of the Mutual Assurance Company of Philadelphia engaged him to paint two portraits of the chairman of their board, General George Cadwalader, member of an old Philadelphia family whose portraits had been painted by Charles Willson Peale, Stuart, Sully, and others. He was a handsome man in his early seventies, with a strong, rugged face. One portrait, half-length, showed him in his uniform as a major general; the other, head and bust, in civilian clothes. The General died before they were completed, and Eakins used a photograph (by another photographer) in finishing them. Unlike the Hayes portrait, they seem to have satisfied his clients. The third commissioned portrait was of Mrs. William Shaw Ward, sister-in-law of Mrs. John H. Brinton, whom Eakins had painted in 1878. Begun in May 1884, it was not finished, as Mrs. Ward had to leave Philadelphia; but she paid half the agreed price and took the portrait.

The other portraits of these years were of his family and pupils. *The Writing Master* shows Benjamin engrossing a document, his firm benign face looking down at his work; his strong skilled hands are sunburned from outdoor activity. A human document, without idealization or sentimentality, it is one of Eakins' most sympathetic and mellow portraits.

A new category of sitters, beginning in the early 1880s, was that of his students, of whom he eventually painted about thirty portraits. The first, and one of the best, was of J. Laurie Wallace, who had posed for *The Crucifixion*. Eakins liked his looks and used him as a model for several other paintings, for sculptures, and for numerous photographs. In a small oil he is playing a zither while another student, George A. Reid, plays a guitar—a picture humorously titled *Professionals at Rehearsal*.

The series of genre scenes featuring women making music culminated in 1881 with the finest so far: *The Pathetic Song*. The singer was one of his pupils, Margaret Alexina Harrison, sister of the painters Alexander and Birge Harrison; the pianist was Susan Hannah Macdowell. This was Eakins' most ambitious domestic genre painting so far. The singer stands in clear strong light, and every detail of her figure and her elaborate dress is depicted with crystalline clarity and solid tangibility. The modeling of her face and hands is extremely subtle and refined; and the loving depiction of the ruffles and pleats of her gray-lavender gown, with the play of lights and reflected lights, creates a monument of intricate forms. By contrast with the salient relief of this domi-

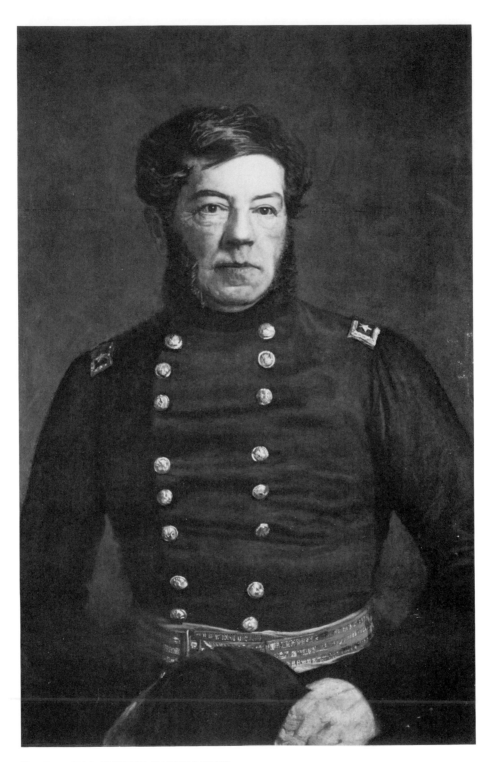

85. GENERAL GEORGE CADWALADER
1880. Oil. 38½ × 24½. G 138
The Butler Institute of American Art, Youngstown, Ohio

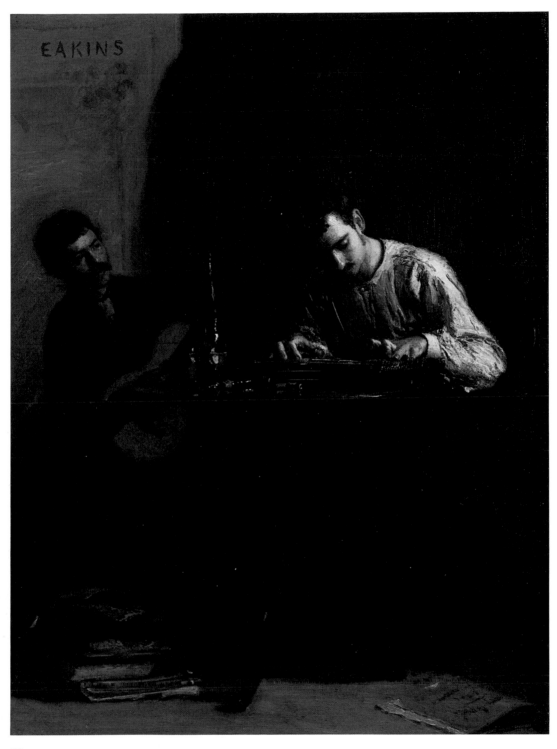

86. PROFESSIONALS AT REHEARSAL
1883. Oil. 16 × 12. G 207
Philadelphia Museum of Art; The John D. McIlhenny Collection

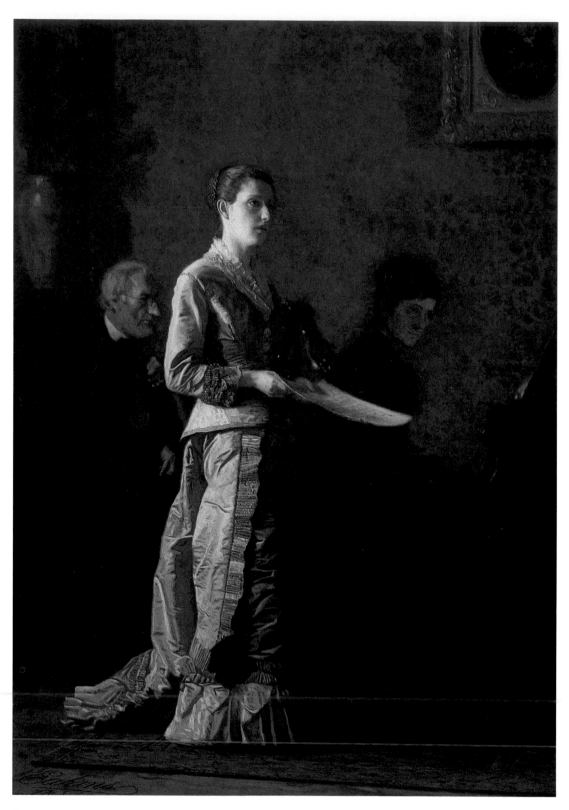

87. THE PATHETIC SONG
1881. Oil. 45 × 32¹/₂. G 148
The Corcoran Gallery of Art

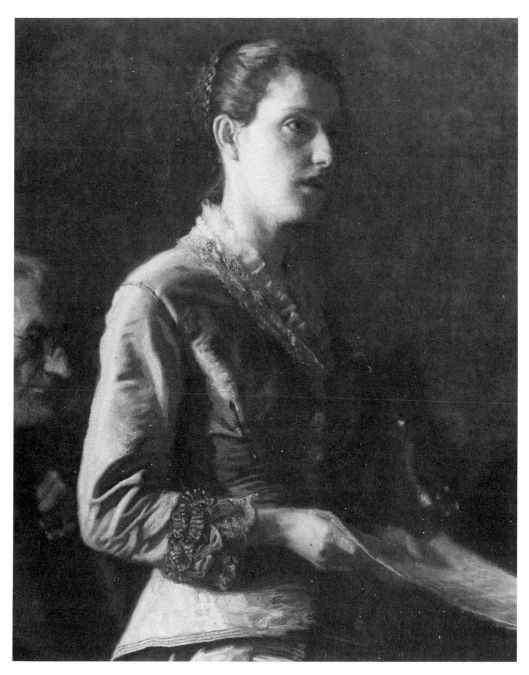

88. THE PATHETIC SONG: DETAIL

nant figure, the two shadowed accompanists are relatively insubstantial. This contrast in substance gives the singer's figure a sculptural roundness, an almost trompe-l'oeil physical existence.

For Miss Harrison's patience in posing, Eakins painted a watercolor replica and gave it to her.

V

One of the amenities of Philadelphia life in the nineteenth century was that the still-unpolluted Delaware River was an abundant source of shad. The fisheries across the river at Gloucester, New Jersey, were busy places in the spring and early summer. Unlike deep-sea fishing, shad fishing was carried on close to shore and could be watched by landsmen. The Eakinses and the Macdowells, Susan Hannah's family, would often cross over by ferry, watch the fishermen setting and pulling in their nets, and sit down to a meal of fresh-caught planked shad, with fixings.

Eakins' student A. B. Frost wrote his fiancée in early June 1882: "Mr. Macdowell [one of Susan's brothers] called to tell me the tribe of Eakins, will

89. TAKING UP THE NET
1881. Watercolor. $9^{1}/_{2} \times 14$. G 152
The Metropolitan Museum of Art; Fletcher Fund, 1925

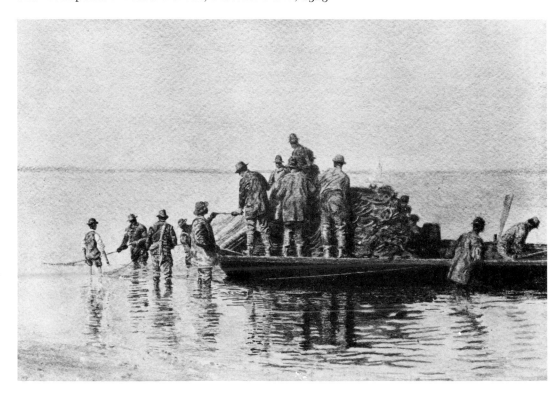

come forth from the wilderness and gather at the wharf called South, and taking unto themselves a boat (Ferry) will even cross the raging Delaware and go into the land of sand, called Jersey, then will they gaze on the hauling of the net and the catching of the toothsome shad, and having satisfied themselves that the fish are alive will sit themselves down to eat of the same cooked on a plank and eked out with waffles (called by the vulgar and flippant Undine men, 'door-mats') and coffee and radishes and such pleasant and indigestable edibles."

For Eakins these excursions resulted in four oils and three watercolors, painted in 1881 and 1882, picturing the gangs of fishermen paying out their nets from boats just offshore; hauling them in with the catch, by hand or with a capstan turned by men and horses; and mending the nets spread out on the meadows. His previous pictures of outdoor activities had been of sports: rowing, sailing, hunting. Here were men at work.

In the small oil *Shad Fishing at Gloucester on the Delaware River,* owned by the Philadelphia Museum, the fishermen are setting their net while a group of four persons—Benjamin, one or two of his daughters, and an older woman —and their dog Harry watch from the beach. The figures, with all their small scale, are painted with a fresh eye and delightful precision. The picture has a firsthand visual directness, with no trace of stylistic convention. Though by no means brilliant in color, it is one of his more luminous works; the river and beach are flooded with light. The figures, on the other hand, are somewhat darker, giving them more weight. Eakins did not adopt impressionism's drowning of all elements in luminous atmosphere, any more than Degas did. The vision, indeed, was close to the French painter's; for both of them, figures and their character were the essential features. One thing that makes this little oil so singularly satisfying is its design: the near group of onlookers balancing the boat and fishermen; the diagonal of the waterline in relation to the horizontal of the distant shore.

In the largest of the series, *Mending the Net,* the day is one of veiled, diffused light, with the figures standing in a patch of weak sunlight. The general tonality is quiet: gray in all the colors, no bright notes, but a subtle variety of local colors in the figures. The chief interest, as always, is in the figures: this row of seven fishermen silhouetted against the sky forms a frieze like the six hunters in *Pushing for Rail.* Each is an individual, exactly portrayed in body, clothes, and action. Their attitudes, unconventionalized and prosaic, have the authenticity of a photograph, the vision is closer to photography than in almost any other of Eakins' outdoor scenes. Such details as faces and hands are painted with the grasp of character shown in his full-scale portraits. Some of his most quietly accomplished, delicate yet strong painting is in these figures. The visual directness and the subtle grayed tonality remind one of Corot.

Like *The Crucifixion, Mending the Net* was not always so subdued in color.

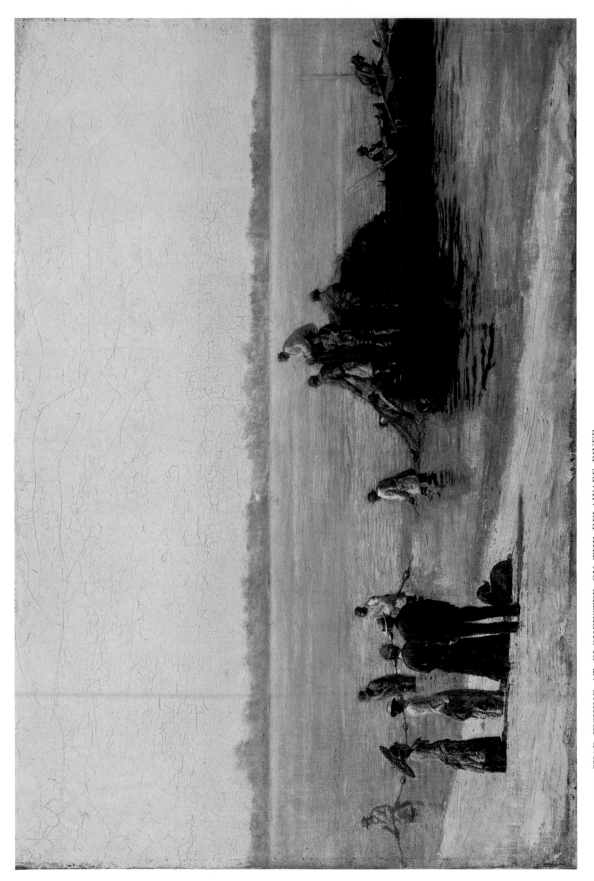

90. SHAD FISHING AT GLOUCESTER ON THE DELAWARE RIVER
1881. Oil. 12¹/₈ × 18¹/₈. G 152
Philadelphia Museum of Art; Gift of Mrs. Thomas Eakins
and Miss Mary Adeline Williams

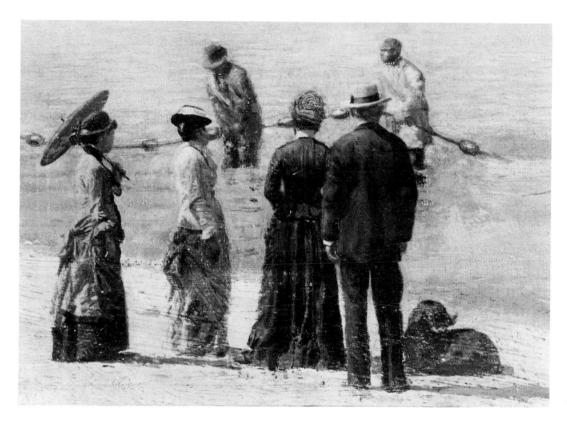

91. SHAD FISHING AT GLOUCESTER ON THE DELAWARE RIVER: DETAIL

A description in 1881 by Mariana Van Rensselaer described it as "a bright green landscape under a bright blue sky"; and technical examination by Theodor Siegl shows that at a later date, after the picture had been varnished, "the blue sky was toned down with a thin layer of opaque gray."

This group of shad fishing scenes reveals a new awareness of weather. Instead of the clear sunlight, unclouded skies, and calm water of his rowing pictures, some of these new works show gray days of fitful sunlight, cloud-filled skies, wind, cloud shadows on the water, waves breaking on the beaches—a feeling for nature's moving, changing aspects.

To these years, the early 1880s, belongs Eakins' only known full-scale pure landscape, *The Meadows, Gloucester:* fields, trees, cows grazing; a grayed sky and diffused light; a pastoral mood resembling the Barbizon school. In the absence of human actors and action, the painting, in spite of its fine tonal qualities, is somewhat on the dull side. Livelier is a series of small landscape sketches, probably done about this time in the Gloucester area. Twenty-six of them have been preserved: they are in oil on wood, cardboard, or canvas panels, in sizes to fit a sketchbox, and obviously painted on the spot. They pic-

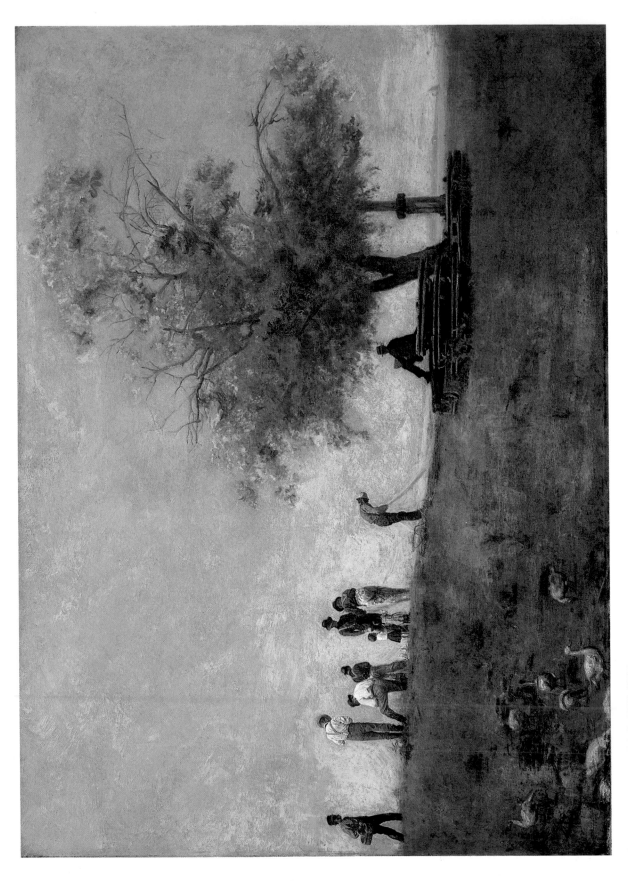

92. MENDING THE NET
1881. Oil. 32⅛ × 45⅛. G 155
Philadelphia Museum of Art; Gift of Mrs. Thomas Eakins
and Miss Mary Adeline Williams

93. MENDING THE NET: DETAIL

94. SHAD FISHING AT GLOUCESTER ON THE DELAWARE RIVER
1881. Oil. 12 × 18. G 154
Miss Elisabeth Ball

ture meadows, trees, beaches, glimpses of the Delaware, skies, clouds, even a sunset on the river. Summary, giving just the main masses, concentrating on outdoor light and color, and sometimes little more than color notes, they have a visual and chromatic freshness that did not always survive in his finished canvases. They suggest that he may have intended to paint more full-scale landscapes. (In a few he painted lines around the scene, framing it.) These sketches show an awakened interest that might have resulted in a new development in landscape painting. But this was not to happen.

VI

Since his brief study with Augustin Alexandre Dumont in the Beaux-Arts, Eakins had occasionally produced sculpture, not for itself but as an aid to painting: the small wax models of the six figures and statues in *William Rush* and of the four horses in *The Fairman Rogers Four-in-hand.* As part of his anatomical studies he had also made four anatomical reliefs of one of Fairman Rogers' horses, the mare "Josephine."

The problems presented by relief sculpture interested him particularly, and he wrote a lecture on the subject. The manuscript, now owned by the Philadelphia Museum, bears a note in his hand: "I believe this paper to be entirely original." The title, "Laws of Sculptured Relief," is followed by an "Argument," which begins: "A perspective in three dimensions. One more datum is required than in a picture perspective, before commencing the construction: to wit, the depth of relief."

"Relief holds a place between a painting or drawing on a flat surface and a piece of full sculpture," he wrote. It is governed, he said, by the same principles as plane perspective, except that the floor is tilted. "If the picture plane be tilted and considered as a picture of the floor, its feet marks would indicate in a relief the proper depth for the things resting on corresponding feet marks in nature, and vertical lines remaining vertical, the picture of square feet upon the tilting floor gives us a perspective scale in three dimensions almost as simple as that for a flat picture. . . ."

"We must determine arbitrarily the slope of our floor line. If we wish our relief to be very flat as in a coin, we choose a line nearly perpendicular. If we wish high relief, we slope our floor well. . . ."

"A relief should, I think, seldom be fuller than 1/2 nature; for if too full, it ceases to have a mechanical reason for being a relief, but had better be full sculpture.

"The best examples of relief sculpture are the ancient Greek.

"Where the subject of relief becomes complicated, as in the gates of Ghiberti at Florence, and distant landscape, architecture and other accessories are shown, the simple plan above is departed from. The near figures which are of

Thomas Eakins

the greatest interest are in full or nearly full relief, and the distant parts have a very flat relief, so that the level floor line if used to give us our scale would no longer be chosen a straight line, but a curved one.

"A great disadvantage in such relief as Ghiberti's is that when viewed in the light most favorable for showing the form, the near figures throw shadows on the distant landscape and other parts.

"This change of scale is a departure from the simplicity of the Greek frieze. The Greeks chose subjects for their reliefs exactly suited to their means of expression."

A scale, he continued, sometimes has to be modified here and there for mechanical reasons. "But the departure from the scale should never, in any place, be more than just necessary, and what departure is made, should be by easy gradients and the most gentle curves. I think that nine-tenths of the people looking at the frieze of the Parthenon would remember the figures as put upon a plane surface, which is not the case. . . .

"Modern sculptors do not generally understand the beauty of relief, and I have often seen an ear in a profile head as deep as all the rest of the head."

He then took "a simple problem"—a round tilt-top table, which he had previously drawn in plane perspective—and explained how to construct it in relief perspective. "Remember that the real table, any relief of the table, high or low relief, any plane picture of the table, should all cover each other exactly to the eye of the spectator."

To his students in class he said: "There are very few who understand the law that governs bas-relief, even good sculptors." "The frieze of the Parthenon by Phidias is the highest perfection of relief. . . . Those things by Phidias, with very little imagination you feel that they stand out full—yet when you get around to the side you see that they are very flat." "If you make the least error in a relief it won't look right. There is a limit in relief, if you keep inside of it it is a powerful instrument to work with. As soon as you do wild things, like the Fighting Gladiator coming toward you, it no longer has that strength."

Eakins' first independent sculptures, not connected with his paintings or anatomical studies, were two small oval reliefs of women in early-nineteenth-century dresses, spinning and knitting—a return to his historical subjects. They were commissioned, probably in early 1883, by James P. Scott, a wealthy Philadelphian, through his architect, Theophilus P. Chandler, as chimneypieces for his expensive new house at 2032 Walnut Street.

Spinning was a relief of a young woman in the same pose as in his 1881 watercolor *Homespun*, for which Margaret Eakins had posed. The model this time was his student Ellen W. Ahrens. The relief was very close to the watercolor, except for the elimination of objects in the background, but the girl was sitting in a more upright position, giving fuller value to the forms of her body.

95. SPINNING
1883. Bronze (cast 1930). 18¼ × 14⁷/₈ × 2³/₄. G 504
Philadelphia Museum of Art; Gift of Mrs. Thomas Eakins
and Miss Mary Adeline Williams

96. KNITTING
1883. Bronze (cast 1930). 18³/₈ × 15 × 3. G 505
Philadelphia Museum of Art; Gift of Mrs. Thomas Eakins
and Miss Mary Adeline Williams

Knitting was an elderly woman, based on the 1877 watercolor *Seventy Years Ago* and on the figure of the chaperon in the 1877 oil of *William Rush*. The model for all three works was Aunt Sally. In the relief the spinning wheel in the background of the watercolor was omitted, a round tilt-top table was added, and a cat disappearing under the chair. The woman's forearms were bare, her foot was exposed, and her figure was less concealed by her dress. The head was too large at first, and he modeled it three times before it satisfied him.

In these reliefs Eakins exemplified his own rules: the actual physical depth, though considerably deeper than in the Parthenon frieze, is never in the complete round; but the three-dimensional perspective has been so calculated that the nearest forms, approaching the round, establish for the whole relief a conviction of volume and substance. The style is consistent with that of his paintings and watercolors: realistic, characterful, with a sense of the bodies beneath the old-fashioned clothes. Far from the pseudoclassic idealism of much American sculpture of the time, these reliefs are closer to the homespun realism of the Rogers groups, but not to their unselective, nonartistic quality. Though modest in scale and subject, they reveal in Eakins a sculptural gift as natural as his gift for painting.

The final works were intended to be carved in stone. Eakins first modeled them in clay, then cast them in plaster. From the plasters he planned to have iron or bronze casts made, and from the latter to have the reliefs rough-carved in stone by a copying machine; and then to do the finished carving himself.

But when Scott saw the plasters he was not pleased. On June 18, 1883, Eakins wrote him: "In obedience to request through Mr. Chandler I sent to you the original panels. Your remark to me that the price seemed high for a thing you might not even use, requires of me an explanation. Mr. Chandler told me last summer that there was a great need for fine sculpture in this country now, that taste here had much improved, that architecture was very advanced, that gentlemen were building here such houses as had never been built before. I told him that good sculpture was much more expensive than pretty good sculpture, but he said that the expense was nothing to the rich men, if they got what they wanted, and the worth of their money. He wished me to undertake myself the ornamentation of the chimney piece and easily induced me, for the work was much to my taste. We settled that the price might be 3 or 4 hundred dollars for a figure.

"I have taken great pains to do my work well. I did not stint myself in the use of models, or of anything that might improve it.

"In the spinning panel after I had worked some weeks, the girl in learning to spin well became so much more graceful than when she had learned to spin only passably, that I tore down all my work and recommenced and since first showing you the knitting panel I have entirely remodelled the old lady's head which I felt I could improve.

"By consulting my expense book, I see I have paid the young spinning model at .75 per hour $128.95 equivalent to 172 hours, and the old lady at .50 per hour $67.12 or 134 hours, together 306 hours. For helping me cast Casani's bill to me is $8, and the dresses cost me about $4, besides which were a few incidental expenses. For every hour I have worked from the model directly I have probably worked two without the model, so you see my remuneration is not great for professional work.

"Nor am I an obscure artist.

"Relief work too has always been considered the most difficult composition and the one requiring the most learning. The mere geometric construction of the accessories in a perspective which is not projected on a single plane but in a variable third dimension is a puzzle beyond the sculptors whom I know.

"My interest in my work does not terminate with the receipt of my bill. Thus, I have heard with dismay that a stone cutter had offered to finish those panels each in a week's time.

"I have been twenty years studying the naked figure, modelling, painting, drawing, dissecting, teaching.

"How can any stone cutter unacquainted with the nude, follow my lines, especially, covered as they are, not obscured, by the light draperies? How could the life be retained?

"I want my panels cast in iron or bronze and reproduced in the N. York copying machine, so that good work and good money may not be thrown away.

"I should like to give at some time, a gelatine cast of the knitting panel with your permission to my friend Dr. Weir Mitchell who lent me his old chair and I should like also after their reproduction in stone to exhibit the originals at Mr. Fairman Rogers's, or at the Social Art Club, at the Society of American Artists in New York and at the Penna. Acad. of Fine Arts. There could be at these places no danger of reproduction.

"And lastly I should like to call upon you in reference to continuing or discontinuing the work sketched out."

Chandler asked him to give Scott figures for the entire cost of finishing the panels in stone and putting them in place, and also the cost of a third panel showing an old man reading. On July 11 Eakins sent Scott an estimate: casting in bronze; rough-carving in stone; finished carving by himself, again from the living model, at ten dollars a day for five days; and installing, would cost $130 per panel. The cost of a third panel would be $400 for modeling and $130 for carving in stone and installing.

"Although you were at first surprised at the cost of modelling," he wrote, "I do not think you imagined I had overcharged you after I had shown you the time consumed and expense I had put myself to upon the little things, but I do not agree with you that a less finished work would do almost as well.

"If you will stop at the Academy of Fine Arts, you can examine there casts

of the most celebrated reliefs in the world, those of the frieze of the Parthenon. Now this frieze, just twice as large as mine (linear measure), was placed on the temple nearly 40 feet high while my panel is not I think more than 3 feet above the eye. Hence to view the frieze at as favorable an angle as my panel you would have to go 12 times as far off.

"To make an analogy then, my panels should be finished $^{12}/_2$ just 6 times as much as the Phidias work.

"But the fact is that no one has ever yet equalled in finish the modelling of those frieze surfaces.

"And there are some little Greek reliefs at the Academy well worth your examination.

"Unfinished sketches by a good artist might fulfill the architectural requirements and would be appropriate in an artist's studio or his home, but hardly in a fine house like Mr. Scott's. If sketches were placed there you would come to wish them completed and so would your friends; and if you hung pictures on your walls I do not think you would choose unfinished studies."

Eakins exhibited the two plasters in the Pennsylvania Academy annual show in October 1883 as "panels in high relief, for open fire place," with no owner named. But Scott would not agree to have them carved in stone, nor even to pay in full for the work already done. He asked Eakins to take them back, which he did. The matter was still unsettled in the late spring of 1884, when Eakins wrote him: "When I last took the panels at your request it was with the notion that I should exhibit them at the usual spring exhibition of the Society of American Artists to be held in N.Y.

"I have just sent them the two panels, Knitting and Spinning.

"As the present uncertainty must be annoying to you as well as aggravating to me I would suggest as a termination that any mutual friend acquainted with the Fine Arts should by arbitration settle the affair laid in whole before him.

"I would rest entirely content with the judgment of either Mr. Edward H. Coates or of Mr. Fairman Rogers.

"Or you could name a gentleman and I could name one, who together would agree upon the right.

"Or if more agreeable to you (and less to me now) you might simply pay for the panels and I could have the price for them put in the catalogue of the coming exhibition in hopes they might be sold there and the money turned back to you, although I must not conceal that the refusal of a rich man like yourself to use a work made for him, would have the greatest influence in deterring other rich men from taking them, so little real confidence do I believe the average American picture buyer to have in his own judgment."

But then came another blow: the Society's jury rejected the reliefs. Augustus Saint-Gaudens, who had been a founder of the Society, wrote: "Dear

Aiken [sic], I write simply to say that I am in no way responsible for the rejection of your charming little reliefs. I was astonished that they were not received when I saw them after their rejection—I resigned from the jury two months ago." Will Sartain, also a member of the Society, reported to Eakins: "One of the hanging committee tells me St. Gaudens didn't serve—He resigned. St. Gaudens told Low that there were things in your bas relief that he would have been proud to have modelled. He says you did things that no sculptor would have attempted and that the effort to do them marred the effect of the work very much. The excessive reality of the chair and the wheel for instance demanded an unattainable perfection in the figure." Saint-Gaudens, in reply to a note from Eakins, wrote again: "I think I have already written you how great an injustice I think has been done by the rejection of your little reliefs. I do not see how there could have been a moment's hesitation about them. It's too bad there was no sculptor on the jury, they would then have been appreciated. I had not the time to serve. I resigned from the jury but not from the society and I hope you will not resign, so long as there is any hope in the organization. Come and see me when you come to the city."

A year later Scott still had made no payment. On May 5, 1885, Eakins again wrote him: "My last note to you some months since remains unanswered. I cannot believe you satisfied to do nothing, and as at our last interview we differed as to the money value and artistic value of the panels modelled for you, I hope you will consent to arbitration by disinterested persons. Mr. Edward H. Coates to whom I imparted some of the details of our transaction will kindly act in the matter and could easily I think come to an understanding either with you or with any expert friend of yours. Hoping to hear from you."

Coates, a director of the Pennsylvania Academy and its future president, met with Scott and Eakins in June; as a result, Scott finally paid $500 to Eakins, who retained the plasters. In early 1886 he had two bronzes of each made by Bureau Brothers of Philadelphia, for $120. Next year a set of the bronzes was exhibited at the Society of American Artists. Later that year Coates bought from Eakins two sets, in bronze and plaster, for $200, and gave the bronzes to the Pennsylvania Academy, which indicates that on this occasion at least, he had acted as deus ex machina.

Aside from Coates's intervention, Eakins' first project in creative sculpture had met with small encouragement, from either a rich "patron" or his fellow artists.

8. The Middle 1880s

AFTER THE DEATH of Caroline Cowperthwait Eakins in 1872 and the departure of Fanny and Will Crowell in 1877, the household at 1729 Mount Vernon Street consisted of Benjamin, his son, his daughters Margaret and Caroline, and his unmarried sister-in-law Eliza Cowperthwait.

Margaret, nine years younger than her brother, never married. His photographs of her and his best-known portrait, *Margaret in Skating Costume*, painted when she was eighteen, show her as no beauty: heavy-featured, with the dark coloring that both of them had inherited from Mark Cowperthwait. In the photographs she gazes at us with an unsmiling, dour, even hostile expression. In the oil *Home Scene* she is less forbidding, and in a small study she appears in a pensive, more sympathetic mood. Her brother as a young man had some of the same formidable look but finer features, a strong chin, and eyes alive and intelligent. But those who knew Margaret well remembered that she had a beautiful figure, strong and supple, resembling him in bodily freedom—"like an animal," said one. She sailed with him on the Delaware; and she was a graceful figure-skater—she and Benjamin were a sight to watch. She loved music and played the piano well. An existing cast of her hand made by her brother shows both strength and sensitivity. She was a favorite model for him: three oil portraits, and two paintings with her sisters; she also posed for his two 1881 watercolors of a girl spinning.

In December 1882 Benjamin, leaving for a trip to Canada, wanted her to go with him, but she did not feel like it, which was not like her. It was typhoid fever, and by the time Benjamin was called back it was too late for him to see her alive. She died on December 22, twenty-nine years old. For her brother her death was one of the greatest griefs of his life; years later he could not speak of her without showing strong emotion.

Now, of his three sisters only Caroline remained at home. In 1885, at twenty, she married a pupil of his, George Frank Stephens, and the couple left Mount Vernon Street.

97. MARGARET
Early 1870s. Oil. 18³⁄₈ × 15. G 40
Hirshhorn Museum and Sculpture Garden, Smithsonian Institution

II

Among Eakins' many women pupils the closest to him was Susan Hannah
Macdowell. Her parental background resembled his: her father, William H.
Macdowell, was an engraver of diplomas, certificates, invitations, and bank-
notes, and of lettering on prints by others, including John Sartain. Before he
and Benjamin Eakins knew each other, the latter sometimes engrossed names
on documents that Macdowell had engraved. Susan's family was even more
liberal than Thomas'. Her father was a fierce individualist, freethinker, atheist,
and admirer of Tom Paine. "Always a chess table, lively arguments," his
daughter recalled. He believed in freedom for his children and prompted
them to think and act for themselves.

The Macdowells had eight children, of whom Susan, born in Philadelphia on September 21, 1851, was the fifth, with three older brothers. She began to paint early; her father encouraged her and gave her a studio in the attic of their house at 2016 Race Street. She studied first with Schussele, in a school he conducted in his home when the Pennsylvania Academy was closed. When only twenty-four she exhibited in the Academy's inaugural exhibition in April 1876.

During our many conversations in the early 1930s Susan Macdowell Eakins told me that the first time she saw Thomas Eakins was when *The Gross Clinic* was being shown at the Haseltine Galleries in the spring of 1876. She thought it was one of the greatest paintings she had ever seen. She observed a tall, slender young man with a red sash around his waist, sitting on the edge of a table and talking to one of the gallery people. She was too shy to speak to him. One day later that spring, when she was leaving Schussele's class, Eakins called on the older painter. She was putting on her gloves; he came up to her and "made a French bow" and asked if he might button her glove. "I fell in love with him right then and there," she told me.

She asked him if he would criticize her work, in her home. Her handling under Schussele had been tight and smooth. "He made me break it up," she said. "His criticism crushed me for a while, but I realized he was right." That fall she entered the Academy's reopened school. She was to study there, first under Schussele and Eakins, then under Eakins, for seven years, from the season of 1876–77 to 1882–83; to exhibit in most of the Academy annuals through 1882; and to receive two prizes, one in 1879 for the best painting by a woman artist residing in Philadelphia, the second in 1882 for a work "showing the most accurate drawing."

It was Susan Macdowell who as class secretary in 1877 had presented the petition for an additional life class and for the reinstatement of Eakins. In Brownell's 1879 article she was the only student to have two illustrations (one a portrait of her father); and in Alice Barber's illustration of the women's life class (ill. 75) she appears in the immediate foreground, at her easel. Obviously an outstanding student, a leader among the students, and a favorite of the master's.

When Eakins was appointed successor to Schussele in September 1879, she was one of the first to be told the news; his letter to "Dear Sue" reveals close intimacy. (His fiancée, Kathrin Crowell, had died only the preceding April. Another enigma added to the puzzle of his long engagement.) Two years later Susan appeared as the pianist in *The Pathetic Song*. A photograph of the painting in unfinished condition reveals that the pianist had originally been another young woman, unidentified. By the early 1880s the Macdowell and Eakins families had become close friends, going on excursions together to the beaches of southern New Jersey. Susan and her sisters appear in many of

Eakins' photographs of these years, outdoors in their white summer dresses—among the most attractive of his early camera works.

On January 19, 1884, Thomas Eakins and Susan Hannah Macdowell were married, at the Macdowell home. He was thirty-nine and a half, she was thirty-two and a third, seven years younger. (She was born the same year as Kathrin Crowell.) For the next two and a half years the couple lived in A. B. Frost's former studio at 1330 Chestnut Street, on the top floor, up three or four flights of stairs. Frost had been a bachelor when he lived there, and the place could not have been very homelike. An itemized account book kept by Eakins from January 1883 through 1886 shows that he paid $25 a month rent, plus food, fuel, and light, as against the $20 a month for "board and lodging" on Mount Vernon Street that he had paid his father in accordance with their 1871 agreement. In January 1884 he paid $131.04 for "cook stove, tea kettle & wash boiler, bed, blankets, curtains, hardware, table linen, china, etc., etc." At the same time he spent $66.84 for a complete set of carpenter and machinist tools, including a lathe for $41, probably to replace those left behind in his father's house. "I have been carpentering and tinkering ever since I have been here," he wrote John Wallace on February 27, "but hope soon to get at pictures again." In March he hired a carpenter to "build a kitchen" for $72.32, and he bought window shades for $24.40 and a sewing machine for $35. However, his salary—$100—from the Academy came in regularly every month.

Susan Macdowell Eakins was small and slight (she could never have weighed more than a hundred pounds) but endowed with inexhaustible nervous energy. Intelligent and responsive, interested in all kinds of people and things, she was as liberal in her opinions as her father. She loved music and was an accomplished amateur pianist. She had a lively sense of humor and a gift for mimicry. Her buoyant nature was a complete foil to her husband's. Believing wholeheartedly in his art and his ideas, she was to give him throughout their married life the support of her intense faith and loyalty.

Eakins said that his wife was the best woman painter in America, and that he would rather have her opinion on his work than anyone's. She was indeed a gifted artist, in a strictly naturalistic style; a fresh eye, accurate drawing, skillful brushwork, fine handling of light, and complete honesty, free from either slickness or sentimentality. From her first encounter with Eakins her art was strongly influenced by his, and very close in vision and style. Her subject matter, like his, was mostly portraiture of family and friends; but also still-life, which he never attempted except as an element in portraits. At least once she painted a watercolor practically identical with one of his. It cannot be said—and she would have been the first to agree—that her work attained his power of form. His calling her the best American woman painter was pardonable exaggeration. But within her limits she was a genuine and able artist. Though after their marriage she found less time to paint, she continued to do so; his

account book lists four portraits (two of them copies) sold by her in 1884 to 1886: one for $75, three for $150 each.

Probably two years after they were married Eakins painted a portrait of her seated with an open Japanese picture book on her lap; beside her chair lies their red setter Harry. For a man picturing his fairly recent bride it is an unusual portrait. She was thirty-four or thirty-five, but she looks to be in her late forties. Under the clear overhead light, evidently from the skylight at 1330 Chestnut Street, her face appears thin and gaunt, her eyes deeply shadowed, her head somewhat drooping, her expression pensive. Her body is slight and angular, her hands bony and rather large in proportion, with prominent veins and strong wrists—hands used to work. She wears a light-blue silk dress, low-necked and high-waisted, down to her ankles—a simple dress, without the elaborateness of fashionable gowns of the day, but in fine taste, befitting an artist and the wife of an artist.

An intriguing fact about the portrait is that in a photogravure reproduction in *Book of American Figure Painters*, edited by Mariana Van Rensselaer, published in October 1886, the year the picture was probably painted, she appears younger. Her face is somewhat fuller, the bone structure not so visible, the eyes less sunken and shadowed, the mouth without the wrinkles at its corners. Her head is held a little more upright. Her hair is heavier, more piled-up, coming down to a point in front, and more elaborately arranged—altogether more modish. None of these differences are radical, but they add up to a definitely younger woman. On the other hand, the older face which looks at us in the portrait today has more individuality; note the breadth across the middle, from cheekbone to cheekbone.

There are also considerable differences in the folds of her dress and in the hanging behind her. It is evident that after the painting was photographed for reproduction Eakins worked further on it, in the process making his wife look somewhat older. When he did this is not known, for the picture is not signed or dated; it may have been before its first recorded exhibition, in May 1887, or the next one, in May 1889. The reworking is confirmed by the unusually heavy pigment.

Another curious feature is that X rays reveal that the picture is painted over another one, or the start of one, the other way up: a woman's head, much larger, in a different pose, and with no relation to Susan Eakins' head. The radiographs also reveal that even after this earlier painting was covered over by the portrait of Susan and Harry, Eakins made many changes before arriving at the version reproduced in the *Book of American Figure Painters*.

This is one of Eakins' very few portraits that are not life-size or nearly so. In color and handling it is one of his most richly painted works. There are more positive colors than usual: the strong blue of Susan's dress, the bright scarlet of her stocking, Harry's russet fur, the golden ocher of the hanging. The

98. THE ARTIST'S WIFE AND HIS SETTER DOG
Probably 1886. Oil. 30 × 23. G 213
The Metropolitan Museum of Art; Fletcher Fund, 1923

99, 100. THE ARTIST'S WIFE AND HIS SETTER DOG: DETAILS

Thomas Eakins

flesh tones are warm and varied, with a play of cool reflected lights from the dress. The left hand, ruddy in the light, cool in the shadows, and painted with masterful skill, is one of the most beautiful passages in all his work. The handling of pigment throughout is sensuous and rich. The painting is unusual for Eakins in being fully developed over its whole surface. Often his portraits concentrate on the figure, with the background relatively blank. But here the full-bodied color and pigment extend over the entire canvas. At the same time there is an intensity in the realization of the forms of face, body, and hands equal to that in his most complete large portraits. The overall design is finely conceived: the angular lines of the figure, from the pointed slipper to the culminating sculptural form of the head, are echoed by the curved lines of the chair, producing a counterpoint of linear rhythms. The central forms create a pyramid whose base is the floor, the rug and the dog, and its apex the head.

In spite of what may seem cruel candor in this portrait of his wife, Eakins devoted to it a fullness of realization that made it one of his richest chromatic and plastic creations, and one of his most penetrating portrayals of a human being.

III

In 1877 William and Frances Eakins Crowell had settled in Avondale, Pennsylvania. In the rich rolling farmland of Chester County they bought a 113-acre farm, with an ample early-eighteenth-century wood and stucco house. Avondale, thirty-five miles southwest of Philadelphia, was an hour's train ride from the city, or several hours by horse or bicycle.

Will Crowell had become an apprentice attorney in the city, but a distaste for legal work and a "heart condition" led him to abandon the profession and take to farming. He was far from the usual farmer, however; he had lived some time in France when Eakins was there, he liked literature, music, and art, and for Eakins he was a sympathetic former classmate, old friend, and brother-in-law.

When Will and Frances moved to Avondale they already had three young children: Eleanor (Ella), born December 1873; Margaret (Maggie), January 1876; and Benjamin, October 1877. From then on they produced child after child at intervals of two or sometimes three years: William James, Jr., 1879; Arthur, 1881; Thomas Eakins (named for his uncle), 1883; Kathrin, 1886; James W., 1888; Frances, 1890; and Caroline, 1893—a total of ten, five girls and five boys.

The Crowell farm was a busy one, and self-sufficient. There were twenty dairy cows whose milk was sold, sheep for nearby woolen mills, pigs, chickens, ducks, geese, and guinea fowls. There were two work horses and a pair of oxen. There were apple and peach orchards, and fields that yielded corn, wheat, oats, and timothy. Fanny's kitchen garden produced all their veg-

101. The Crowell family at Avondale. c. 1890. Photograph by Eakins
Mr. and Mrs. Barry L. Reinbold, in memory of Dr. Caroline Crowell
and William J. Crowell, Jr.

etables. Hired hands were only occasional; parents and children did the work. "With so many crops and so many mouths to feed," James Crowell wrote later, "Mother and the girls were kept busy filling bins in the cellar with apples, potatoes, and onions and stocking the shelves with canned fruits and vegetables. We boys also had our work cut out for us, working in the fields"—and milking the cows, chopping firewood, and many other chores, from before dawn to sunset. Plumbing, water supply, and heating were primitive.

But while living on this subsistence level, the family was not deprived culturally. The parents, though they had not been to college, were self-taught in literature, languages, and music. Will Crowell was a great reader, and regularly read aloud to the children—Dickens, Thackeray, Cooper, and so on—and every day after lunch, the newspapers. Fanny, long a serious musician, after eight years acquired a piano; every morning, from four o'clock on, she ran through her scales and played; and she taught her daughters, so that someone was always practicing or playing. There were family musicales, with the mother and a daughter playing four hands at the piano, Will playing the harmonium, and James, the only musical son, the violin.

Thomas Eakins

For the children there were other compensations for the hard work. There was a croquet lawn, and the barn and its haymow to play in. A brook, White Clay Creek, wound through the land, at one point forming a willow-lined pool in which they could wade and bathe. For Christmas a fine tree was cut on nearby public lands. But the greatest happening was the Fourth of July, when after dark "family, friends, and neighbors gathered on one side of the duck pond to watch the greatest show in Avondale." And on the Fourth there was ice cream, shipped from Philadelphia in a two-gallon container packed in ice and salt.

Eakins visited the farm regularly and often. To his nephews and nieces he was something of a hero. Will Crowell, Jr., wrote Margaret McHenry in the 1940s: "Uncle Tom was a frequent visitor, usually alone. He would come on an evening train and sleep on a blanket on the floor in the Sitting Room by the open door. I think of him as with horizons always his own and not of the Farm. Painting, modeling, riding, shooting, swimming, the study of anatomy, skinning and dissecting animals, treating the skins, throwing the lariat, throwing half hitches, splicing rope, tying knots, tricks with rope and string, making plaster casts of different hands, were of the things he did on the Farm with the children, particularly with Ella, Maggie and Ben.

"He delighted in congenial grown-up company and I think of him of an evening at the Farm sitting talking, sitting cross-legged on the floor like a Japanese, ultimately subsiding from the conversation and going to sleep still sitting cross-legged on the floor.

"At home on the Farm in the evening, unless we had guests, Papa read aloud to the family. If Uncle Tom was with us there was no evening reading and we loved Papa's reading. Uncle Tom had no use for novels but sometimes would apparently lose himself in one. I remember his doing this with one of the Cooper novels, I think Deerslayer, and then expressing himself as thinking little of it.

"Uncle Tom must have been with us during the 1888 March blizzard for I remember that he was sitting on the Dining Room stove while I had managed somehow to crowd in under it. We had wood stoves. The blizzard had begun with a warm rain and our wood-pile had been first soaked and then frozen to a solid mass from which frozen blocks of logs were dug with a pickax and brought into the house to thaw."

The Crowells were hospitable, and relatives and friends were constant visitors. Several summers Caroline Eakins Stephens and her children spent at least a month. Benjamin Eakins came frequently. Thomas Eakins often brought his students and friends to visit. The children loved the bohemian student Franklin Schenck, who skated with them and in the evening sang to their mother's and father's accompaniment on the piano and harmonium. Samuel Murray came often; the children remembered him as athletic, a fast runner, liking to jump and swim, and skillful with his hands.

By the early 1880s Eakins had taken up photography, and he made many photographs of Avondale and its people. Several show his nephews and nieces playing outdoors and bathing in the pool: the boys usually naked, for Fanny's children, at least the boys and the younger ones, seem to have been as uninhibited about nakedness as their uncle. The rich landscape of the farm—the fine big trees, the stream, and the pond—played a leading part in these photographs, which have an idyllic poetry rare in either his painting or his other photography.

Will Crowell built a studio for his brother-in-law on the third-floor rear of the house, reached by a separate stairway; the most isolated room in the house. Here, probably in the summer of 1883, two oils were painted, or at least conceived, now called *Arcadia* and *An Arcadian*. The settings of both were near the stream and the pool, and for both Eakins used outdoor sketches and his photographs. These paintings had a purely idyllic content that was new in his work, revealing the strong influence of Avondale's pastoral life.

For Eakins the Avondale world—his sister and his old schoolmate and companion, their children, the animals, the countryside—was a second home.

I V

A more purely imaginative kind of subject than Eakins had ever before essayed appeared in a group of Arcadian works created probably in 1883 and 1884: two paintings and four oil sketches for them, three sculpture reliefs, and a number of photographs. These works pictured an idyllic world akin to classic Greece, peopled by nude men and women outdoors, in natural settings.

Eakins' belief in the rightness and healthiness of nudity in nature was like that of his friend Walt Whitman, living in old age across the Delaware in Camden. In 1877, striving to recover from a paralytic stroke by the practice of sun-bathing, Whitman had written: "Sweet, sane still nakedness in Nature!—ah, if poor, sick, prurient humanity in cities might really know you once more! Is not nakedness then indecent? No, not inherently. It is your thought, your sophistication, your fear, your respectability, that is indecent. There come moods when these clothes of ours are not only too irksome to wear, but are themselves indecent. Perhaps indeed he or she to whom the free exhilarating ecstasy of nakedness in Nature has never been eligible (and how many thousands there are!) has not really known what purity is—nor what faith or art or health really is."

Eakins' Arcadian works form an unexpected phase in his art, seemingly at variance with his whole realistic philosophy. Yet they are consistent with his belief in the body and outdoor life, his emphasis on the nude in teaching, and his personal freedom from prudery. And they were linked to his admiration for Greek art, particularly Phidias and the sculptures of the Parthenon. There was nothing literary about these works: no mythological themes, no gods and god-

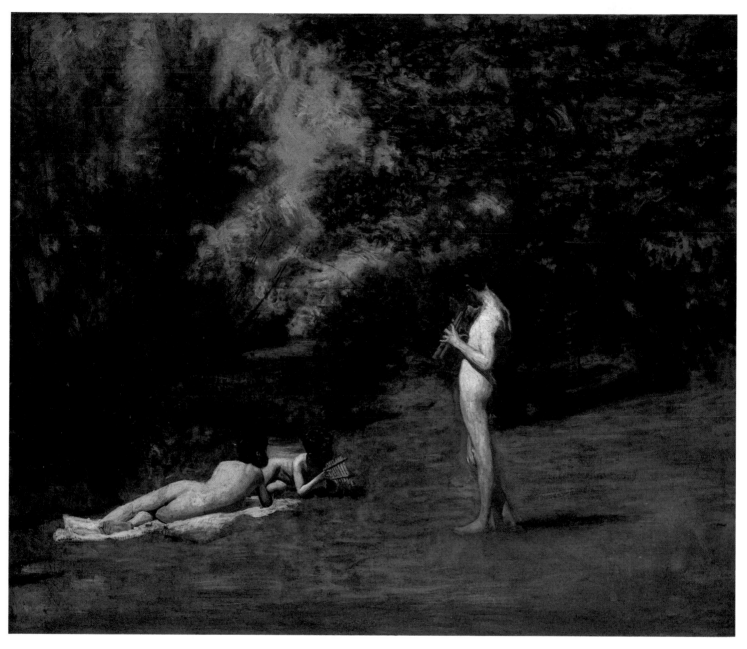

102. ARCADIA
Probably 1883. Oil. 38³/₄ × 45¹/₂. G 196
The Metropolitan Museum of Art,
Bequest of Miss Adelaide Milton de Groot, 1967

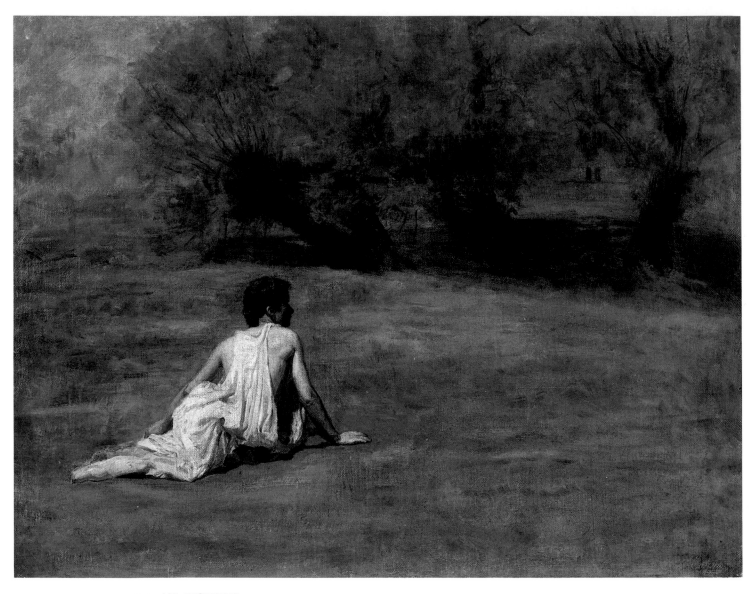

103. AN ARCADIAN
Probably 1883. Oil. 14 × 18. G 200
Mr. and Mrs. Lloyd Goodrich

desses, nymphs and satyrs, in the style of Bouguereau, Cabanel, and others; nor illustrations of Greek and Roman life a la Gérôme and Alma-Tadema. Eakins was trying to express the essential spirit of paganism, of bodily freedom in harmony with nature.

His most ambitious essay in this mode is the oil *Arcadia*, three naked figures in a sunlit glade beside a brook: a young man standing and a boy reclining, both playing pipes, and a young woman listening. (The place was evidently along the stream on the Crowell farm.) The figures are in relaxed, gentle poses, the handling is simple and direct, and the greens of meadow and trees are fresher and cooler than in most of his previous outdoor scenes. The painting is not entirely finished.

In the small oil *An Arcadian* a young woman is seated in a meadow with pollard willows in the background. (The actual spot was beside the pool on the Crowell farm.) She wears a white double chiton, a common Greek garment worn next to the skin, folded at the top to form a double covering above the waist, front and back, leaving the shoulders bare. Her back is toward us and she looks toward the right. When I first saw the painting in 1930 in Mrs. Eakins' house there were sketchy chalk marks at the right which indicated that Eakins planned to add a nude male seated, higher than the girl, facing her and playing pipes to which the girl would be listening—probably like the piper in the relief *Arcadia*. I admired the painting, and the next time I went to see Mrs. Eakins she presented it to me. She had had it cleaned, which removed the chalk marks—to my relief, for I would never have had the hardihood to do this. To me the painting has a Corot-like combination of realism, idyllic poetry, and visual freshness. The woman and her chiton are painted with the combined precision and largeness of form that the human body inspired in Eakins.

Photographs were used for both paintings.* For the standing youth in *Arcadia* John Wallace posed outdoors, naked, playing pipes (H 45); the boy was probably one of Eakins' Crowell nephews (H 48). There are also individual oil sketches of the two males in sunlight, evidently made at the same time as the photos, which would be possible since the poses were stationary. The photos are identical with the sketches and the painting (except for the backgrounds), down to details of light and shadows on the figures. No photo or sketch of the woman has been found. For *An Arcadian* there is a photograph of the meadow and willows (H 53), and an oil sketch of the woman but no photo.

Eakins also modeled three reliefs of similar subjects. In the largest, *Arcadia*, a seated youth is playing pipes, with a varied group of listeners, in proces-

* In this section and Chapter 9, the "H" numbers are those of illustrations in Gordon Hendricks' *The Photographs of Thomas Eakins* (New York, 1972); the "O" numbers are those of the Sotheby Parke Bernet sale, November 10, 1977, of the Olympia Galleries collection of Eakins photographs; and the "G" numbers are those of Eakins' paintings in the catalogue in my 1933 book on him.

sional order. The three women and the old man are clothed in chitons, the two young men are naked. (The young woman nearest the piper also appears alone in a small relief.) Again the model for the piper was long-suffering Wallace. A photo (H 47), evidently taken at the same time as the one used for the large oil, shows him outdoors, naked and playing pipes, but seated this time. In the relief he is more in profile, as a relief figure should be; he is sitting more upright, not slouched over as in the photo; and one leg is crossed over the other knee—all changes that create a stronger play of forms. His figure is the finest in the relief, and one of Eakins' finest nudes in any medium.

On the same occasion Eakins took two other nude photos of Wallace (H 46, 49), one with another nude youth. And someone photographed Eakins himself naked, also playing pipes (H 253). This, and another photo of him and Wallace, both nude (H 254), show him in comparison heavy, solid, and strong.

Three other photographs (H 62–65) are connected with the Arcadian works, though not as studies for them. In one (H 62) two unidentified young women in chitons, barefoot, stand indoors, probably in Eakins' studio, beside the plaster relief *Arcadia*. It seems probable that he photographed them with

104. ARCADIA
1883–1884. Bronze. 12½ × 25 × 2¼. G 506
The Collection of Jamie Wyeth

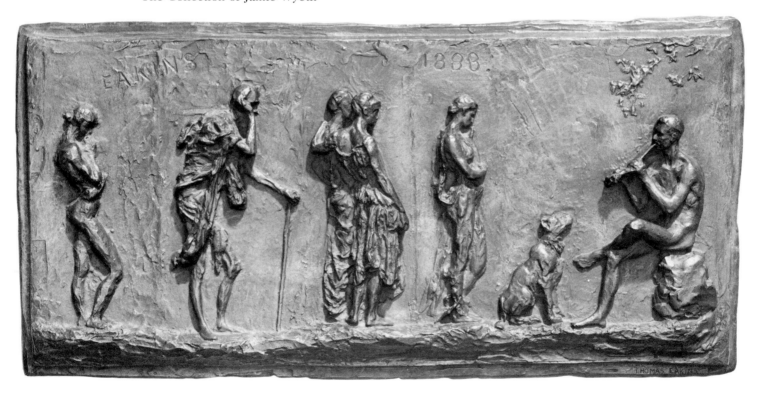

105. Two women in Greek costumes, beside a plaster cast of "Arcadia"
Photograph by Eakins. The Metropolitan Museum of Art;
David H. McAlpin Fund, 1943

the relief because they were models for it. The right-hand girl, in a double chiton, was probably also the figure in the small oil *An Arcadian,* in which she wears the same kind of garment. Mrs. Eakins told me that the model for this painting also posed for the large oil *Arcadia,* where she appears nude, lying on a white cloth which could be her discarded chiton. In the two reliefs and the photographs, as well as the smaller oil, she wears the double chiton. She was a pretty girl, and one would like to know who she was. That Eakins had a special feeling for the *Arcadia* relief is indicated not only by his photographing the two models beside it but by his including it in one of his most intimate paintings, *The Artist's Wife and His Setter Dog.*

It is noteworthy that in all the Arcadian works, only one of the women is nude, in the oil *Arcadia*—and she has her back to us—whereas all the men, except the old man in the *Arcadia* relief, are naked.

Three additional photographs (H 182–184) have Grecian themes. They are of Eakins' friends the young singer Weda Cook and her cousin Maud Cook, in chitons. In one (H 182) Maud is seated beside a cast of the nude torso of Aphrodite; in another (H 183) Weda stands beside the same torso, her hand on its shoulder. Related to the latter photo is a small oil sketch (G 267A) of Weda standing contemplating the statue. Such figure studies by Eakins were usually for planned paintings, and he was probably considering such a composition; but no larger picture has been found. The dates of the photos and the sketch are unknown. Weda Cook, who became a close friend of Eakins and in 1890 to 1892 posed for *The Concert Singer,* was only sixteen in 1883, but at that age she made her debut as a singer at the Philadelphia Academy of Music.

Also Greek in subject, of uncertain date, are two small oil studies for another painting never executed. One represents Phidias studying a scene for the frieze of the Parthenon; he is watching two youths in chlamyses on prancing white horses, in the same positions as in one of the reliefs in the frieze. The sculptor is pointing toward the horsemen, as if to command their movements or to indicate them to a nude young man beside him. The other study is of two nude men on prancing horses, also in Parthenon frieze attitudes. It is a sunny day with blue sky and white clouds and bright green earth. The sketches, though summary, are spirited in movement and fresh in color. Eakins was evidently planning a painting which would embody both his admiration of Greek sculpture and his recognition that it was based on actualities.

Mrs. Eakins told me that the critic Sadakichi Hartmann, a friend of Eakins, was interested in the subject. "I think Sadakichi Hartmann was around about the time when Walt Whitman was painted, say between 1886 and 1890, I do not feel sure," she wrote. "He was very enthusiastic about the work Mr. Eakins would like to do, had great ideas of a big space where horses and men, the naked figures could be moving, and Eakins could follow in the footsteps of Phidias. . . . [My husband] had a great wish for that kind of work, and those two little painted panels show what he was wanting to do."

As far as we know, Eakins did not exhibit any of his Arcadian paintings and sculptures. The only one listed in his record books is the *Arcadia* relief, entered by Mrs. Eakins as "Pastoral Sculpture." He later gave the oil *Arcadia* to William M. Chase. He himself does not seem to have used the words "Arcadia" and "Arcadian"; they were first applied by Mrs. Eakins in 1929, and by myself in 1930.

The Arcadian and Greek paintings, reliefs, and photographs form a curious interlude in Eakins' art: one of the few occasions when he departed from the

106. PHIDIAS STUDYING FOR THE FRIEZE OF THE PARTHENON
Oil. 10⅝ × 13¾. G 255
Private Collection

representation of actualities, present or past. They embodied an aspiration toward a freer, more pagan world than his actual environment, and a desire to expand his subject matter into more imaginative fields. But the question is whether such idyllic subjects were his forte. The most ambitious, the oil *Arcadia*, has its quality of poetic beauty, but it is not one of his strongest works; the woman's figure in particular is strangely formless for him. The picture's relative softness contrasts with the vitality of his paintings of contemporary physical action outdoors, especially the rowing pictures. An even more direct contrast is presented by his next important work, *The Swimming Hole:* a group of real young men bathing in a real place—a subject as idyllic as *Arcadia*, but straight out of reality.

107. THE SWIMMING HOLE
1884–1885. Oil. 27 × 36. G 190
The Fort Worth Art Museum

On August 25, 1884, Thomas Anshutz in Philadelphia wrote John Wallace in Texas: "Eakins is painting a picture for Mr. Coates of a party of boys in swimming." This is the oil now called *The Swimming Hole*. In the quiet water of a pond or river five naked young men are bathing, while Eakins himself is swimming, together with his setter Harry. Three of the men are his pupils, the other two are friends. The standing figure is Jesse Godley, who appears in many of Eakins' motion photographs of the time; the diver is George Reynolds, also a model for the motion photos; the redheaded boy half out of the water is Benjamin Fox, a painting student. The other two are unidentified friends. The party is bathing off a rude stone jetty, against a background of woods, and in the right distance, fields sloping down to the water. It is a sunny day, and the sunlit bodies stand out against the dark shadowed woods.

The figures are in the strongest relief of any of Eakins' outdoor paintings. They are completely in the round, solid, sculptural. Modeled with utmost precision, they have no trace of the softness of those in *Arcadia;* even at rest they give a sensation of vitality, of muscular energy. The composition, as in many of Eakins' more complex paintings, is pyramidal, with the standing man the apex. On the left the forms of the reclining figure lead to those of the seated one, whose upraised arm leads up to the standing one. On the right the diver's figure leads down to that of Eakins, who is the right base of the pyramid. The forms of all six bodies are interrelated in a complex rhythmic pattern more fully developed than in any of Eakins' previous works. The fact that the figures are naked, without distracting clothes, creates a plastic design whose purity and severity resemble a work of the Renaissance. The painting is Eakins' most masterful use of the nude, and the most finely designed of all his outdoor compositions. Compared to his pictures of half-naked oarsmen or his later prizefight pictures, *The Swimming Hole* gives the dominant role to the completely nude human body; it is pure creation in bodily forms. It reveals how portrayal of the nude could bring forth his full potentiality as a designer.

Although picturing sunlight, with the light and shadows on the bodies precisely delineated, the painting is far from impressionist. There is no envelopment of the scene in luminous atmosphere, no softening of edges. Compared to the impressionist palette, it is relatively dark and on the warm side; the darks are much darker than with the impressionists, or even Corot. The tonality is closer to that of Courbet than any other French realist of the period. But the painting has a direct visual realism, a precision, and a refinement that one does not find in Courbet; while on the other hand it does not have the Frenchman's amplitude of form, his heavy sensuality, his plastic voluptuousness. The whole vision is closely related to photography, but the forms have a solidity and weight greater than the camera can achieve.

108. THE SWIMMING HOLE: DETAIL

The Swimming Hole has complete unity: in forms, color, tonal values, and the relations of these elements to one another. The figures are perfectly related to their landscape setting. And the landscape itself has a subtlety and mellowness unusual with Eakins. The whole right-hand third, from the sky down through the distant woods and meadows to the beautifully painted water, is one of his richest pieces of painting. In a curious way it reminds one of a painter who was Eakins' complete opposite in almost every respect, Albert Ryder; it has a quality like the latter's most realistic work, *Weir's Orchard:* the sense of something seen in the real world, but transformed into the forms of art.

Several of Eakins' photographs are connected with *The Swimming Hole.* He evidently encouraged his male students to practice nakedness in nature:

Thomas Eakins

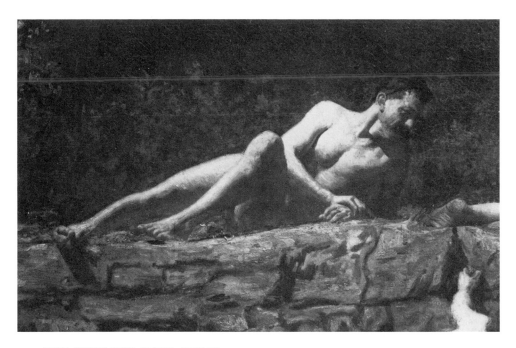

109. THE SWIMMING HOLE: DETAIL

seven photos (H 122–126, O 506, 510, 520, 521), obviously taken on a single occasion, show six or seven young men in a sunlit clearing in woods, wrestling, boxing (with gloves), having a tug-of-war, and evidently enjoying themselves thoroughly. They are completely naked. These instantaneous photos of fast action are remarkably clear. It must have been on this outing that the same number of naked youths (probably the same ones; one of them is recognizable) were photographed bathing at the site of *The Swimming Hole,* perhaps to cool off after their exercise. The three photos (H 42–44, O 516–518) show the place from the same angle as the painting; the men are standing on the jetty or diving or swimming; but none of them are in the same positions as in the painting. The relation between the photos and the painting is not like that in *Arcadia,* where the figures were stationary and posed; here they are photographed in action, and their attitudes are unplanned. There is nothing in the photos resembling *The Swimming Hole*'s deliberate composition, culminating in a single standing figure; two photos show three standing men. The similarities between photos and painting are in the place and the happening; but actually the differences are more revealing than the similarities, demonstrating the distinction between a raw slice of life and conscious design.

Eakins made a small oil study for the painting, adopting from the photos two figures which he later changed; and producing a composition closer to the final picture than any of the photos, though with many differences. He also

110. Students wrestling. Photograph by Eakins
The Metropolitan Museum of Art; Gift of Charles Bregler, 1961

111. Students at the site of "The Swimming Hole"
Photograph by Eakins. Olympia Galleries

painted four sketches of the landscape. Otherwise (unless there were sketches that were not preserved) he seems to have worked out the composition on the canvas. "The diving figure," Charles Bregler wrote, "being the most difficult to paint, was first modelled in wax." This wax model has not survived. Eakins worked a long time on the canvas, over a year off and on; the first mention of it in his accounts was in July 1884, the last in August 1885.

During the first half of the 1880s Eakins' art was expanding in several ways: in imaginative subjects such as *The Crucifixion* and the Arcadian subjects, even though they had no successors; in representing men at work in his shad-fishing pictures; in a new feeling for nature's changing aspects; in a freer use of the nude. And in *The Swimming Hole* his mastery of the human body and his feeling for nature were synthesized into his most completely realized outdoor composition.

9. Photography: Still and Motion

ONE FIELD OF EAKINS' ACTIVITIES neglected until recently is photography. When I was writing my book on him in the early 1930s, with Mrs. Eakins' cooperation, she did not call much attention to his photographs, nor did I see many in the Mount Vernon Street house; so that the book did not discuss this side of his work as much as it deserved. After her death in 1938, Eakins' former student Charles Bregler, who inherited much personal material from her, resurrected his master's prints and negatives, reprinted many of the latter, and rephotographed some of the original prints.

In 1969 Gordon Hendricks, who had been working on the subject for several years, organized an exhibition, "Thomas Eakins: His Photographic Works," at the Pennsylvania Academy. Three years later he published *The Photographs of Thomas Eakins*, which catalogued and reproduced almost all works then known, totaling about 240. Since then others have come to light, notably a group acquired by the Olympia Galleries, Philadelphia—of which more later.

Eakins had been interested in photography for several years before he began to practice it: in Paris he had exchanged portrait photos with his friends back home; he had sent home portraits of Gérôme, Bonnat, and others; he had purchased life studies, photographs from nature, and reproductions of works by artists he admired, especially Gérôme. Susan Macdowell and her sister Elizabeth had used a camera in the 1870s, possibly before they knew Eakins, and they continued to do so. Of the photographs included in the Eakins canon, some were definitely or probably taken by his family and pupils. But the large majority are unquestionably by him. It must of course be recognized that their authorship, unlike that of his paintings and sculpture, cannot be established by signatures, records, or technical qualities. Not being a professional photographer, he kept no record of his photographs, as he did of his paintings and sculptures; and only a very few were exhibited or illustrated in his lifetime. But the subjects and settings of most of them make his authorship either cer-

tain or highly probable. Indeed, it may well be that he made many more photographs than have survived. Smaller and less substantial than paintings, and in many cases purely personal, they were less likely to be preserved.

His camera, saved by Bregler and now in the Hirshhorn Museum, is an American Optical Company Scovill four-by-five-inch so-called view camera, which had become popular by about 1880, when he evidently began to take photographs. He added lenses that enabled him to do portraits and close-ups. Dry glass plates, which were replacing the cumbersome wet plates, were used. His equipment is described in detail in an inventory of his personal possessions in January 1883, in which he says that he has "many photographs and photographic studies."

A considerable proportion of his photographs are of his family, friends, and pupils: personal documents, like those taken by everybody who owns a camera. The outdoor scenes of his sisters and the young Macdowell women in their summer dresses are charming. A whole series records Fanny and her family at the Avondale farm. His students appear often, at work in class, in the Chestnut Street studio, or outdoors.

Portraits make up a large category: forty or more persons, equally divided between those he also painted and those he did not. He evidently liked to photograph men and women he knew, whether or not he intended to paint them. Often there are several photos of someone whose physiognomy appealed to him, such as his father-in-law William H. Macdowell and his pupils Franklin Schenck and Samuel Murray. On the other hand, only three of his better-known sitters are represented: Walt Whitman, Talcott Williams, and Frank Hamilton Cushing. Many other eminent sitters, the subjects of his major portraits, do not appear.

Eakins' photograph portraits had none of the professional portrait photographer's style—the formal clothes put on for the occasion, the studied poses, the studio properties, the staged backgrounds—nor, on the other hand, the soft-focus idealism of the more consciously artistic photographer. His portraits are utterly candid, concentrating on the character of faces, hands, bodies, and clothes. Little attention is paid to settings; his people are usually seated in his studio, against blank backgrounds, or in the backyard of 1729 Mount Vernon Street. The accessories that play essential parts in his more complex portrait paintings are absent. There is little manipulation of light and little concern with composition. Occasionally, as in his four portraits of Amelia Van Buren (herself a photographer), there is more deliberate posing and lighting. But always the concentration is on individual character, clearly revealed. By such direct, simple means he produced many realistic portraits that are among the strongest of his time.

The nude played a considerable part. The photographs catalogued by Hendricks included many male nudes: students, some posing for the life class of the Art Students' League of Philadelphia, but many more outdoors, wrestling,

112. Three male nudes. Early 1880s. Olympia Galleries

boxing, and swimming. The latter are remarkable examples of instantaneous photography. But in Hendricks' book there were only five female nudes, four of them indoors (H 70, 190–192). Two of the four had their backs turned, and one, seen from the front, was hiding her face; only the fourth (H 190), probably Nannie Williams, showed her face. There was only one woman outdoors, seated under trees (H 19). This small number of women was puzzling. But Seymour Adelman has recently written: "The reason Eakins' photographs of the female nude are now so rare is simplicity itself; scores of them were destroyed, soon after Mrs. Eakins' death in 1938, by a well-meaning but tragically misguided family friend."

The Pennsylvania Academy Committee on Instruction said in its 1882–83 report: "A number of photographs of models used in the Life Classes, were made in cases in which the model was unusually good, or had any peculiarity of form or action which would be instructive, and a collection of these photographs will thus be gradually made for the use of students." Yet no such collection was ever found at the Academy, and art historians have wondered what happened to them after Eakins left the Academy in 1886. Bregler did not pro-

duce any prints or negatives of nudes that could be identified as having been taken at the Academy.

In 1974 and 1978, however, two groups of photographs came to light, obviously taken at the Academy or during the time Eakins taught there. Totaling eighty-five, almost all previously unknown, they included many nudes, about equally divided between men and women. They were found in the safe-deposit box of Edward Hornor Coates, who was chairman of the Academy's Committee on Instruction during the last years of Eakins' tenure—the committee that forced his resignation in 1886. Why Coates secured and preserved these photographs is still unknown. It is unlikely that Eakins would have given them to him, especially since forty-two, of male and female nude figures, were evidently used in Eakins' lectures on anatomy in other schools. It seems most probable that after Eakins' departure Coates removed them from circulation on moral grounds. They were acquired by Joseph Seraphin of the Olympia Galleries, Philadelphia. An auction sale of the first group at Sotheby Parke Bernet in New York in 1977 fetched record prices; one composition of three female nudes brought $11,000, the highest auction price for a single photograph up to that time.

Five of these Academy photographs show three or two nude models posed together. Two (O 502, 503) represent three young men, some of whom have been tentatively identified as students, including Wallace. Three others (O 505, 513, 514) show nude young women. One woman wears a mask, one is hiding her face with her arm, and three have their backs to us; only two are facing us, and one of these has her head bowed and covered so that her face cannot be seen. All have youthful figures: and the fact that three or two of them appear together suggests that they, like the men, were not professional models but students, willing to expose their bodies but not their faces. (The men show no such modesty.) The women are so posed as to make effective compositions, in each case with one standing figure in the center.

More directly connected with Eakins' teaching is a series of twenty-six multiple photographs of individual nude models, fifteen men and eleven women. Each in the series shows seven (sometimes six) views of the same figure, standing, in different poses: three facing left, two full-face, and two with backs to us. Each of the seven views must have been photographed separately, the seven then being mounted together on heavy cardboard. Behind each model is a vertical stand, to insure that the figure stood in the same place. There are duplicate sets for sixteen of the twenty-six. Evidently these multiple photographs were made to be studied, and perhaps to be projected on a screen during Eakins' lectures on anatomy. It seems likely that they were intended to demonstrate what he called "the center line" of the figure: the line of the different centers of gravity in different positions. A diagram drawn by him, also mounted on cardboard in the same format, represents a male figure

in corresponding poses, with a written explanation, concluding: "Such lines form the only simple basis for a synthetic construction of the figure." A similar line drawing, including the center line, is attached to one multiple photograph of a woman. (He admonished his students in class: "Get life into the middle line. If you get life into that, the rest will be easy to put on.")

One sequence shows Eakins himself nude: a strong body. It seems likely that some, perhaps most, of the models were students. The diagram bears a notation: "1st position / Godley / Eakins / Wallace." One of the series is identifiably Wallace, and several have names written on the reverse of the mounts: among the women, "Laura," "Becky," and "Lillie." All but two of the eleven women wear masks; none of the men do. One series has been identified as being of Susan Hannah Macdowell, then a student, shown without a mask.

An entirely different series of Academy photographs is unique and mysterious: men students in classical costumes posed against backgrounds of Greek and Roman casts, including the Medici Venus and the "Three Fates" from the Parthenon pediment. With their staged poses, dramatic gestures, and strong overhead or side lights, these scenes are definitely theatrical. One is evidently a deathbed scene: a sorrowing figure seated beside a prone man. (The death of Socrates?) The purpose of these tableaux is still a mystery, which fuller research will doubtless clarify. In any case, they demonstrate Eakins' constant

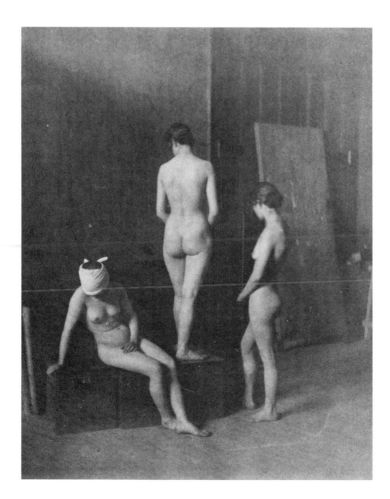

113. Three female nudes
Early 1880s
Olympia Galleries

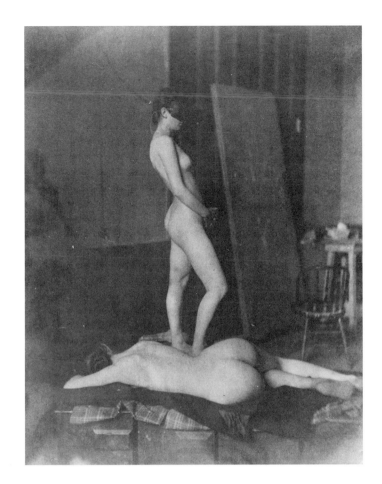

114. Two female nudes
Early 1880s
Olympia Galleries

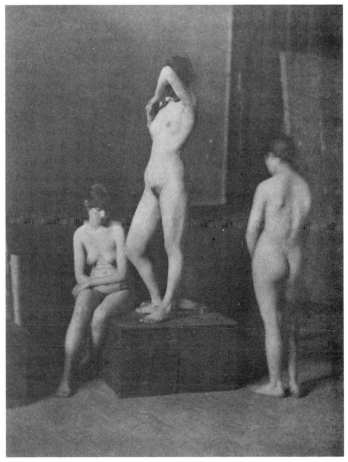

115. Three female nudes
Early 1880s
Olympia Galleries

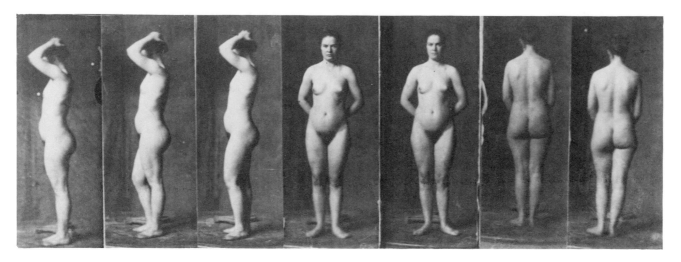

116. Female nude: seven poses. Early 1880s. Olympia Galleries

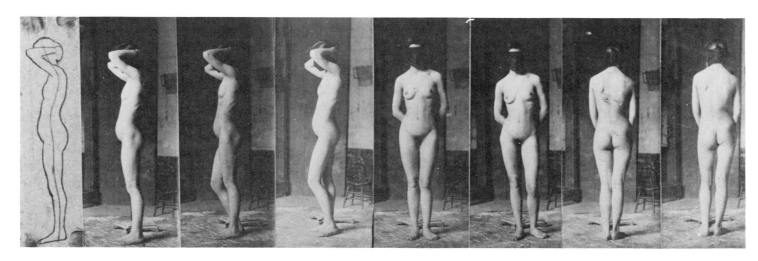

117. Female nude: seven poses, with drawing. Early 1880s. Olympia Galleries

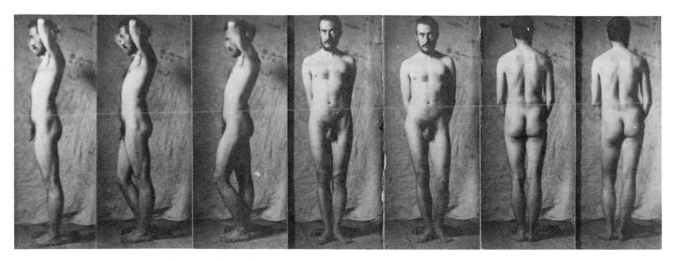

118. Eakins in the nude: seven poses. Early 1880s
Photographer unknown. Olympia Galleries

interest in Greek life and art—an interest also embodied in numerous other photographs not part of the group just described.

There were many subjects that Eakins painted but did not photograph, as far as we know: those before he acquired a camera, of course, including most of his outdoor subjects; almost all his major portraits; and such outstanding works as *The Pathetic Song, The Agnew Clinic, The Concert Singer, The Cello Player,* and the prizefight scenes. Although he painted about thirty of his students, he took camera portraits of only seven. On the other hand, he photographed many men and women and places that he did not paint. Only a minority of his photographs are related in their subjects to his paintings.

II

The relation of his photographs to specific paintings is less direct than has sometimes been stated. Among known photographs there are only a few cases in which one can say that he definitely copied one of them for an entire painting. The watercolor *Drawing the Seine* of 1882 (G 159) is an exact copy of a photo (H 31): the place, the fishermen, the horses, the sloop at anchor, and even details such as the breaking waves and the lights and shadows. Since the figures are in motion and in the same positions in photo and watercolor, he could not have painted the scene and then photographed it; it is obvious that he copied the photograph. Yet one would never suspect this from the watercolor, which is as fresh as anything he ever painted.

In the large 1899 oil *The Wrestlers* (G 317) the positions of the two men are almost identical to those in one of his photographs (H 229). In a small oil study (G 318) the top wrestler is in a somewhat different position, but the final version has reverted to the photo. The men could hardly have held their poses long enough for him to paint the large canvas, so again it is evident that he copied the photograph, with minor changes such as the addition of figures in the background. Perhaps this is one reason that the final painting is somewhat deficient in vitality compared to the two studies for it (G 318, 319), or to his prizefight pictures of the same period.

There are a few other cases in which Eakins copied parts of paintings and sculpture from his photographs. In the oil *Arcadia* (G 196) the two male figures were based on a photo of Wallace, outdoors, nude, playing pipes; and one of the nude reclining boy (H 45, 48); also on small oil sketches of each figure. In the sculpture relief *Arcadia* (G 506) the piper is based on a photo of Wallace, outdoors, nude, seated this time (H 47). In the oil *An Arcadian* (G 200) the landscape is that in a photo (H 53). And in the oil *Mending the Net* (G 155) a photo of a flock of geese (H 29) was used for some of those in the foreground.

The foregoing cases are ones in which we can state definitely that Eakins copied his photographs. There probably were other photos, now lost, which

119, 120. Three men in classical costumes. Early 1880s
Olympia Galleries

121. Two men in classical
costumes, with a cast of the
Medici Venus. Early 1880s
Olympia Galleries

122. Two men in classical costumes. Early 1880s. Olympia Galleries

123. Horses and fishermen in Gloucester, New Jersey. 1882
Mr. and Mrs. Daniel W. Dietrich II

124. DRAWING THE SEINE
1882. Watercolor. 11¼ × 16½. G 159
Philadelphia Museum of Art; John G. Johnson Collection

were used by him, but the small number of the above compared with the many which show no such relation, suggests that he seldom copied photos. (I am not including eleven portraits of sitters who were no longer living that he painted from photographs made by others.)

But there are interesting less direct relations between several photographed and painted portraits. In some cases Eakins had evidently photographed the person and in painting the portrait adopted the pose, the angle of vision, and other features, but changed everything else. For example, a photo (H 77) shows William H. Macdowell seated outdoors, probably in the backyard of 1729 Mount Vernon Street, in full daylight, wearing an overcoat and a broad-brimmed hat; the painted portrait (G 301) pictures him with the same hat but not the overcoat, seen from the same angle and with the same tilt of his head—but indoors, in a subdued light, against a dark background; this is one of Eakins' darkest, most Rembrandt-like paintings. Another photo of Macdowell (H 74) shows him on a porch with a leafy background, and in shirtsleeves; two painted portraits (G 254, 260) are so close in pose, the direction of the eyes, and the angle of vision, that it is evident that Eakins adopted these features of the photo but transferred his father-in-law indoors, had him put on a coat, and pictured him against a dark, objectless background, as in most of his head-and-bust portraits. In both cases it is more likely that the photographs came first than that he painted the portraits and afterward photographed Macdowell outdoors, in different light and differently clothed. A similar relation exists between a photo of Benjamin Eakins (H 200) in his backyard, reading a paper, and a head-and-bust portrait indoors (G 324); and between a photo of Eakins' brother-in-law Frank Macdowell outdoors (H 72) and two indoor portraits (G 218, 219).

Even when the photo and the portrait are both indoors, the same relation can sometimes be seen. Franklin Schenck, one of his favorite models for both camera and brush, in one photo (H 167) stands in shirt-sleeves beside his portrait bust by Samuel Murray, in cold studio light; in *The Bohemian* (G 243) he is shown in the same pose and from the same angle, but in a dark, romantic tonality. In most of these cases the lights and shadows on the faces are somewhat similar in photos and paintings, though never identical; but in other respects the similarities are too close to be coincidental. It seems evident that Eakins saw something in his photographs that he liked, and transformed them into canvases totally different in setting and tonality. He did not copy the photographs, nor can they be said to be studies for the paintings.

In several other cases the photo and the painting have certain points of resemblance—facial expression, direction of eyes, clothes, angle of vision, light (not all of these in each example)—so that it is clear that the photo was taken when the portrait was being painted, but no evidence that the photo came first, as in the preceding cases. Probably he took the photo as a record in another medium.

125. William H. Macdowell
The Metropolitan Museum of Art;
David H. McAlpin Fund, 1943

126. WILLIAM H. MACDOWELL WITH A HAT
Probably c. 1898. Oil. 28 × 21½. G 301
Mrs. Peggy Macdowell Thomas

127. William H. Macdowell
The Metropolitan Museum of Art;
David H. McAlpin Fund, 1943

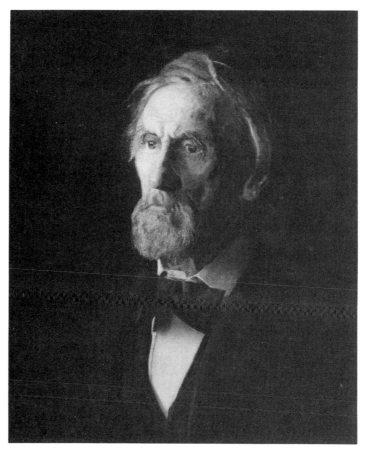

128. WILLIAM H. MACDOWELL
Probably c. 1890. Oil. 24 × 20. G 254
Yale University Art Gallery;
Bequest of Stephen Carlton Clark, B.A. 1903

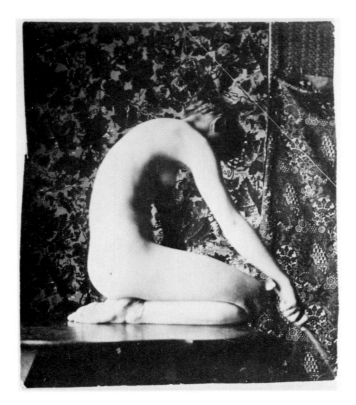

129. Female nude. Probably early 1880s
Seymour Adelman Collection

Aside from his use of the camera in teaching, photography for Eakins was a second medium of visual recording and expression, parallel to his painting and largely independent of it. In a small number of cases he actually copied his photos; in a somewhat larger number he adopted certain features of his photos, without copying; in still others, the photos were evidently taken at the same time, but with no closer relations. But in the large majority of cases there was no relation at all.

Not that there is anything shameful in an artist's using photographs, as is often believed. Recent studies such as Van Deren Coke's *The Painter and the Photograph* have shown that many nineteenth-century artists were much interested in the camera and its revelations, and that major figures, including Delacroix, Corot, Degas, and even Cézanne, sometimes used photographs as a new, additional source of visual material.

Among Eakins' finest camera portraits were four of Amelia C. Van Buren (H 176–179), whose painted portrait (G 263) is one of his major oils. The photographs are independent works, unconnected with the painting except through the sitter: different poses, dress, chair, background. They are carefully

composed as to setting and light, and technically excellent. Miss Van Buren must have interested him specially: a sensitive, introspective face. In the painting she looks older and thinner, the bone structure more revealed: in the photographs her face is rounder, softer, younger-looking. Even though the photos may date some years before the painting (as seems likely), the difference confirms that Eakins did tend to make his sitters look older than they were.

Miss Van Buren had studied with him at the Pennsylvania Academy in 1884 and 1885, but evidently only briefly. After returning home to Detroit, she remained a friend of Eakins and frequently stayed at Mount Vernon Street. She does not seem to have pursued the career of painting, but took up photography, exhibiting several works in the first three international Philadelphia Photographic Salons, in 1898, 1899, and 1900, and elsewhere.

A better-known photographer friend of hers was Eva Lawrence Watson, whom Eakins also photographed—one of his most engaging photo portraits. Like Amelia Van Buren, she studied painting with him at the Academy, from 1882 to 1884; and again at the Academy after he left, in 1887 and 1888. In the 1890s she took to photography, and became one of the pioneer art photographers who looked on photography not merely as a recording and documentary technique but as a fine art on a par with the other visual arts. A friend of Alfred Stieglitz, she joined his Photo-Secession movement in 1902 and was a member of its council.

In December 1899 the Camera Club in New York, dominated by Stieglitz, held an exhibition of photographs from eight private collections, including some works by Eakins, probably lent by Eva Watson. The Philadelphia representation also included Susan Macdowell Eakins, Elizabeth Macdowell Kenton, Samuel Murray, Amelia Van Buren, and a Miss Crowell, probably Maggie. As far as we know, this was the only time Eakins' photographs were exhibited during his lifetime, except for one motion photo that had been shown in 1886 (of which more later).

Unlike the new generation of the Photo-Secession, Eakins the photographer like Eakins the painter was a pure realist. Since he was not a professional photographer, his subjects were almost entirely personal. In his photographs as in his paintings, his main interest was in the human body, clothed or nude; and in his portraits, the human face. His emphasis was on character, recorded without softening or glamorizing. His light was plain daylight, indoors or outdoors; no known works reveal the use of artificial light, so essential for later photographers. The handling of lights and shadows and reflected lights that played so important a part in his paintings was comparatively direct and simple in his photographs. There was no use of soft focus, no idealization of the body and face, no attempt to simulate paintings, no Whistlerian effects. In general he showed little concern for deliberate composition or for the complex

design that he achieved in his major paintings; there were no photographic equivalents for *The Gross Clinic* or *William Rush*.

These generalizations apply to the majority of his photographs, but there were exceptions which showed more conscious artistic intent. The Avondale scenes of figures in nature displayed a feeling for landscape that appeared in few of his other photographs; and in some examples, a fine pictorial sense. His studies of male nudes outdoors for the Arcadian paintings and sculpture were artfully posed, and had an idyllic poetry, as did the indoor pictures of young women in Greek costumes, posing beside his *Arcadia* relief or the cast of Aphrodite. The few group photographs of female nudes taken in the Academy were thoughtfully composed, each with a standing figure as the apex of a pyramidal design. Without soft focus or artiness, the figures were revealed in clear light, with concentration on the rhythmic forms of the female body. The perfection of these few photographs makes one regret even more the prudishness that destroyed most of them. Entirely different but as consciously composed were the theatrical tableaux of male students in classical robes amid casts of antique sculpture—startling exceptions to the predominant realism of Eakins' photographs.

For Eakins photography was a medium that paralleled but did not rival his major mediums, painting and sculpture. But no other American artist of his time practiced photography so assiduously, or produced such an original and extensive body of works.

III

In this automobile-dominated day we may not realize the importance of the horse a hundred years ago: man's strongest and swiftest servant, and his commonest means of transportation. The horse played a major role in pictorial art, and his anatomy and muscular actions were subjects of scientific and artistic study second only to those of man. In the 1870s and 1880s the traditional representation of the gallop, with all four legs extended like a hobbyhorse, was giving way to scientific investigation. Because the movements of the legs were too rapid to be apprehended by the eye, instantaneous photography was being called upon. In California former Governor Leland Stanford, millionaire owner of a famous stock farm, commissioned the British-born photographer Eadweard Muybridge to record the animal's gaits. At Stanford's farm in Palo Alto in the summer of 1878 Muybridge, with the technical assistance of Stanford's engineers, devised a battery of twelve cameras (later increased to twenty-four) ranged side-by-side along a track, and set off one-by-one as the horse moved past, producing a series of photographs of its successive positions. Muybridge's photographs, published immediately (he had a gift for publicity), aroused wide interest in this country and abroad and proved that most past conceptions of the gallop, the canter, and the trot had been inaccurate.

130. THE MARE "JOSEPHINE"
1878. Bronze (cast 1930). 22⅛ × 27¼ × 4 G 499
Philadelphia Museum of Art; Gift of Mrs. Thomas Eakins
and Miss Mary Adeline Williams

131. THE MARE "JOSEPHINE": SKELETON
1878. Bronze. 11¼ × 14¼. G 500
The Butler Institute of American Art, Youngstown, Ohio

132. THE FAIRMAN ROGERS FOUR-IN-HAND, or A MAY MORNING IN THE PARK
1879. Oil. 23³/₄ × 36. G 133
Philadelphia Museum of Art; Gift of William Alexander Dick

Equine anatomy absorbed Eakins almost as much as human anatomy and was a feature of his teaching. He was particularly interested in the processes of animal locomotion. This interest was shared by Fairman Rogers, who was both a horseman and an amateur photographer. When Muybridge's published photographs first became available to them, in 1878, Rogers obtained six of them, and Eakins, in his friend's words, "took them up for examination." Rogers constructed a zoetrope, a popular device by which motion drawings or photographs, mounted inside a revolving cylinder and viewed through slits in the cylinder, were synthesized into simulated movement—a crude ancestor of the motion picture. "The photographs themselves," Rogers wrote in 1879, "are not exactly adapted for immediate use in the zoetrope. . . . Drawings must be made based upon the information given by the photographs. To do this, Mr. Eakins plotted carefully with due attention to all the conditions of the problem, the successive positions of the photographs and constructed, most ingeniously, the trajectories, or paths, of a number of points of the animal, such as each foot, the elbow, hock, centre of gravity, cantle of the saddle, point of cap of the rider, &/c. Having these paths, and marking the beginning of the stride and the exact point at the other end of the diagram where the beginning of the next stride occurs, the whole stride can be divided into an exactly equal number of parts; . . . and the exact position of each point of the body determined for each of the twelve positions."

By 1879 Eakins was in direct communication with Muybridge, who wrote him on May 7: "I am much pleased to hear the few experimental photos we made last year, have afforded you so much pleasure, and notwithstanding their imperfections have been so serviceable. I shall commence with the new experiments next week and we shall hope to give you something better." He went on to describe technical improvements, including a scale of measurements placed behind the horse's track.

But Eakins believed that this method of measurement was misleading, necessitating a calculation in perspective, and he wrote Muybridge a letter whose draft (with rough sketches) reads: "Dear Muybridge, I pray you to dispense with your lines back of the horse in future experiments. I am very glad you are going to draw out the trajectories of the different parts of the horse in motion as I have.

"Have one perpend. centre line only behind the horse marked on your photographic plate. Then after you have run your horse and have photographed him go hold up a measure perpendicularly right over the centre of his track and photograph it with one of the cameras just used.

"Do you not find that in your old way the perspective [is] very troublesome. The lines being further off than the horse a calculation was necessary to establish the size of your measure. The horses being a little nearer or a little farther off from the reflecting screen deranged and complicated the calculation each time."

One wonders how Muybridge reacted to this unsolicited proposal by a painter, fourteen years his junior. In any case, the photographer continued to use his own system of measurements throughout his future motion photography.

Fairman Rogers was an authority on coaching, and one of the first in Philadelphia to own and drive a four-in-hand, which he transported in summer to his Newport mansion "Fairholm" on Ochre Point. He was later to write a definitive *Manual of Coaching*. In the spring of 1879 he commissioned Eakins to do a painting of the coach being driven by him in Fairmount Park. In the picture Rogers is on the box, Mrs. Rogers beside him; on the seat behind them, her brother and sister and their spouses, Mr. and Mrs. George Gilpin and Mr. and Mrs. Franklin A. Dick; and on the rear seat, two grooms. All but one of the men, including the grooms, wear top hats; one of the ladies carries a red parasol; the horses are glossy bays; their harness sparkles; the coach is black and bright red; it is a sunny spring morning. Eakins' title for the painting was *A May Morning in the Park*.

The vision is photographically precise; every person is a portrait, every horse is in an exact different position, every detail of the coach is clearly rendered. The picture shows close observation of sunlight and shadows; it is one of Eakins' most varicolored outdoor scenes, with the rich chestnut of the horses, the subtle hues of Mrs. Rogers' clothes, the fresh warm greens of foliage and grass, and the sunlight striking through the scarlet parasol, an effective high note. The general tonality, however, is far from brilliant; darker and warmer than the impressionist gamut, as one can see by comparing it with Childe Hassam's *Le Jour du Grand Prix* of nine years later.

Eakins' studies for the painting were extensive and thorough, even for him. He had the coach driven before him; he made sketches of Mrs. Rogers, of the park background, and of the particular spot in the park; he went to Newport to paint a study of the coach being driven there. He modeled small wax figures of each of the four horses, in their exact trotting attitudes, as shown in the Muybridge photographs. He painted at least seven small oil studies of parts of the animals' bodies, especially their legs, in their individual positions, seen from the same angles as in the painting. Since he could scarcely have had the horses pose in these trotting positions, he probably used the wax models in painting the studies. For the final work he probably grouped all four wax figures together. Of few other of his paintings are there so many extant preparatory studies.

In selecting the positions of the individual horses he profited by Muybridge's published sequence photographs of Stanford's horse "Abe Edgington" trotting; in fact, he used the four consecutive positions shown in the photos, which together represent the full cycle of the trot—a fact that probably determined him and Rogers to choose this particular series of photos. It is worth noting that in the small oil sketch of the coach being driven in Newport,

although the coach is headed in the opposite direction from that in the finished painting, nevertheless the attitudes of all four horses are the same as in the wax models, the seven oil studies of individual horses, and the final painting. To such an extent had he planned every detail, even before the Newport sketch.

A May Morning in the Park may well be one of the first paintings produced anywhere in which the gaits of trotting horses are accurately represented. As representation of motion, down to such details as the blurring of the turning wheels, the picture records motion with complete truth. Yet it is arrested motion, naturalistically rendered, not movement in the forms themselves, as created by the masters of plastic movement. Eakins' own small Newport sketch conveys more sensation of movement, perhaps because it is more freely and broadly handled.

133. THE FAIRMAN ROGERS FOUR-IN-HAND: DETAIL

134. SKETCH FOR "THE FAIRMAN ROGERS FOUR-IN-HAND"
1879. Oil. 10¼ × 14½. G 134
The Philadelphia Museum of Art; Gift of Mrs. Thomas Eakins
and Miss Mary Adeline Williams

Eakins' erstwhile pupil Joseph Pennell, who never forgot a grudge, said some true things (and some untrue) in a talk years later to the London Camera Club. "If you photograph an object in motion, all feeling of motion is lost, and the object at once stands still. A most curious example of this occurred to a painter just after the first appearance in America of Mr. Muybridge's photographs of horses in action. This painter wished to show a drag coming along the road at a rapid trot. He drew and redrew, and photographed and rephotographed the horses until he had gotten their action apparently approximately right. Their legs had been studied and painted in the most marvellous manner. He then put on the drag. He drew every spoke in the wheels, and the whole affair looked as if it had been instantaneously petrified or arrested. There was no action in it. He then blurred the spokes, giving the drag the appearance of motion. The result was that it seemed to be on the point of running right over the horses, which were standing still."

When the painting was first exhibited, in 1880, the critics showed much interest and devoted much space to it, but almost unanimously condemned it. For some, the horses' gaits were incredible: as one wrote: "The effect of the picture as a whole it is impossible to accept as true, unless it be that Mr. Eakins' perceptions are right and those of everybody else are wrong." Others

 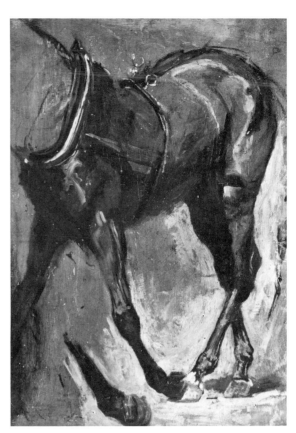

(*left*) 135. STUDY OF A HORSE FOR "THE FAIRMAN ROGERS FOUR-IN-HAND"
1879. Oil. 14⅝ × 10⅜. G 199A
Hirshhorn Museum and Sculpture Garden, Smithsonian Institution

(*right*) 136. STUDY OF A HORSE FOR "THE FAIRMAN ROGERS FOUR-IN-HAND"
1879. Oil. 14⅝ × 10¼. G 137
Hirshhorn Museum and Sculpture Garden, Smithsonian Institution

137. MODELS OF HORSES FOR "THE FAIRMAN ROGERS FOUR-IN-HAND"
1879. Bronze, marble bases. Each about 9½ × 12 × 2¾. G 503
Philadelphia Museum of Art; Bequest of Mr. and Mrs. William M. Elkins

accepted the scientific truth of the motions, as revealed by photography, but thought it was a mistake to represent them in a painting. "The fact is that the human eye cannot follow the swiftly moving limbs of the horse," said one, "and any attempt to arrest them on canvas can but result in disaster."

<div align="center">IV</div>

Muybridge's photographing at Palo Alto ended with the summer of 1879, and he devoted himself to publishing the results, and to lecturing in America and Europe, showing his photographs by means of a projecting zoetrope which he called a zoopraxiscope.

In France the physiologist Etienne-Jules Marey (1830–1904) had for several years been analyzing human and animal motion, though not yet by photography. His researches, published from the 1860s on, had aroused much interest and some disbelief, particularly among artists who had pictured horses in motion, such as Meissonier. Marey, reading of Muybridge's work, had communicated with him, and when the photographer came to Paris in 1881 the physiologist arranged to have him present his discoveries before an audience of distinguished scientists. Meissonier arranged a similar presentation before two hundred leading artists, including Gérôme, Bonnat, Detaille, and Cabanel. From then on Marey used the camera in his researches, originating his own technical methods and apparatus.

In 1882 came a rupture between Stanford and Muybridge; thereafter the latter tried, at first without success, to secure financial support for continuing his experiments. In February 1883, invited by Fairman Rogers, he lectured twice at the Pennsylvania Academy, and at the Academy of Music and the Franklin Institute in Philadelphia. It was probably these lectures that led to a decision in August by the University of Pennsylvania, of which Rogers was a former professor and presently a trustee, to sponsor further photographic work by Muybridge. "[He] had long cherished the desire of making a new and greatly extended study of the subject, but had been deterred by the want of means," wrote the university provost, Dr. William Pepper. "An extensive photographic plant, elaborate electrical and mechanical apparatus, access to typical animals of many kinds, much space for the erection of laboratories, and a large fund for current expenses were needed. It was represented to the Trustees of the University that several individuals, appreciating the importance of the proposed work to art and science, would unite in guaranteeing all expenses connected with the investigation if a University Commission should be appointed to supervise the entire affair, and thus insure its thoroughly scientific character." The commission, appointed in March 1884, consisted of seven university professors eminent in medicine, anatomy, physiology, and engineering; and for the Pennsylvania Academy, Edward Hornor Coates as chairman, and Eakins.

An outdoor studio was built on the grounds of the University Hospital, consisting of a battery of twenty-four cameras, a track for the moving subject, and behind the track a long shed painted black inside, with a network of white threads for measurements. The moving figures were photographed in sunlight against this background. The equipment was much more elaborate than at Palo Alto and included two additional movable twelve-camera batteries to photograph the figures from diagonal angles, and for use outside the university grounds. Available to Muybridge were university athletes, male and female models, thoroughbred horses at the Gentlemen's Driving Park, and animals and birds at the Zoological Gardens. He began work in the late spring of 1884.

From the beginning Eakins took an active part in the program, and as early as June 18 he himself was trying motion photography, using Muybridge's track and shed. But his technical methods were not those of Muybridge's camera batteries. In the latter, each exposure was made from a different viewpoint; the separate cameras could not exactly follow the speed of the subject, which could not except by coincidence be directly in front of the lens; so that exact scientific comparison between the images was not possible.

In 1882 Marey had devised a radically different system: photographing from a single camera, through a single lens, and on a single photographic plate. He had designed a camera with a perforated disk revolving in front of or behind the lens; as the openings in the disk passed the lens, successive images of the moving subject were recorded on the plate. The viewpoint remaining the same, the time intervals being regulated exactly by the revolving disk, and the movements being recorded on a single plate, the images could be compared with mathematical exactness. This was a definite advance over Muybridge's camera batteries, and a forerunner of the modern motion picture camera.

Marey had published his apparatus in 1882 in both scientific and popular French journals, and Muybridge had corresponded with him about it. There is eyewitness evidence that Muybridge and Eakins were using Marey-wheel cameras in the early summer of 1884. One of Eakins' helpers in his photographic work at the University was his Assistant Professor of Painting and Drawing at the Pennsylvania Academy, Thomas Anshutz, who had himself practiced photography and used it for his paintings. In a series of letters still extant Anshutz reported the progress of the work to John Wallace, who had left Philadelphia for Texas. On June 18, 1884, Anshutz reported that Muybridge, in addition to his camera batteries, "has also a machine for taking views on one plate," with a camera that had "two large disks with openings cut around their circumference. They run in opposite directions and are geared to run very fast, the exposure is while two openings meet." This was evidently a Marey-wheel camera, improved by using two disks instead of one, probably for reduced dimensions, more speed, and greater accuracy of timing.

138. A man walking. Marey-wheel photograph by Eakins. 1885
Philadelphia Museum of Art; Gift of Charles Bregler

Eakins, too, had a Marey-wheel camera, but with only one disk. Anshutz wrote in his June 18 letter: "Eakins, Godley and I were out there [at the University] yesterday trying a machine Eakins had made of the above design [as Muybridge's two-disk camera] except he had only one wheel. We sewed some bright balls on Godley and ran him down the track. The result was not very good. . . . But afterwards Muybridge took him with his machine and got a very good result."

During the summer of 1884 Eakins continued his own experiments, using his students as nude models. A record he kept listed the dates of August 16 and 21, and September 6 and 11; the experiments were numbered from 1 to 63. He described the actions as "run, running jump, walk, swinging bright ball out of doors, throwing base ball," and once "swinging bright ball in Prof. Barker's room in sun shine." He used Muybridge's track and shed, but had technical troubles. Several times he noted failures because of mechanical defects in his apparatus or because he forgot something; he did not have Muybridge's professional expertise. His worst problem was with reflected lights that fogged the images. On August 21 he noted: "The fog in the above from 34–39 are from reflections. The great improvement over all the last work was from getting back into the shed and shutting off as much extraneous light as possible by opening but one window and then shutting up with cloths all the

139. A man running and jumping. Marey-wheel photograph by Eakins. 1885
Philadelphia Museum of Art; Gift of Charles Bregler

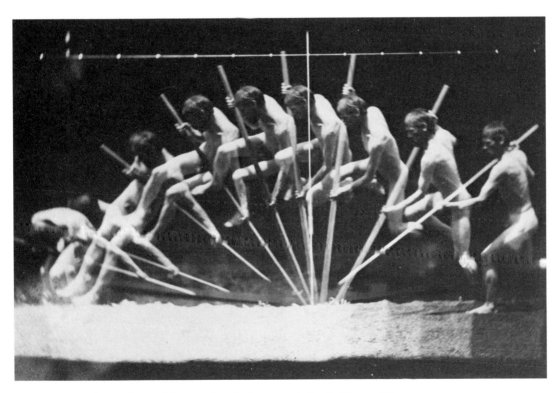

140. A man pole-vaulting. Marey-wheel photograph by Eakins. 1885
Philadelphia Museum of Art; Gift of Charles Bregler

opening except the part needed. The result would be still better if we could shut out all light except what falls on the figure." Anshutz corroborated this in a letter of August 25: "The correct way and I think the only way to get good results, is to have the whole yard roofed over and hung with black velvet or something similar, and then admit the sunlight through a broad slit just where the figure is. In this case there would be nothing to fog the plate which could be exposed on a running figure."

In late September, Eakins submitted a request to the commission to have a small shed built for his own work, inside the hospital enclosure, to be paid for by the commission. The expenditure was authorized; it amounted to $209.56. In the meantime he had designed a camera similar to Muybridge's Marey-wheel one, with two fenestrated disks, one revolving eight times as fast as the other and capable of sixty revolutions to the second. His drawings for the disks were given on August 20 to a watchmaker, who made them for $65. On November 5 he recorded: "64. 65. Made with new machine in our new house. Weather very cold and windy and sun already low. Did not dare put up our curtains on acct. of wind." The work had to be suspended for the winter because the models were naked.

In late March 1885 he was authorized to again set up his small shed in the University Hospital enclosure. No record of this year's work has been found, but all or most of the known photographs must have been taken that summer in his shed, since the backgrounds are plain black without the network of measuring strings in Muybridge's shed. The subjects were mostly young men, his students at the Academy, including Jesse Godley and George Reynolds, shown naked, walking, running, broad-jumping, high-jumping, pole-vaulting, throwing a ball. In one sequence Eakins himself appears, nude, running. In only one case is the subject female: four sequences of a nude professional model walking. While Muybridge was photographing not only men, women, and children but horses, dogs, and wild animals in the zoo, Eakins was concentrating on the human figure. Although his involvement in motion photography had begun with his interest in equine movements, there is only one horse (H 118) among his known motion photos.

In the Marey-wheel camera with a stationary plate, if the subject was moving from one place to another, as in walking, running or jumping, the images, though sometimes overlapping, cleared each other enough to be distinguished. But in movements taking place on one spot, such as throwing a ball, the images would be superimposed. To cope with this problem Eakins designed another two-disk camera in which the plate also was revolved, producing separated images on the same plate. In 1881–82 Marey had invented what he called a *fusil photographique* or photographic gun, a two-disk camera with a revolving plate that took twelve exposures. A hand-held machine, shaped like a gun, it was intended particularly for photographing birds in flight. The

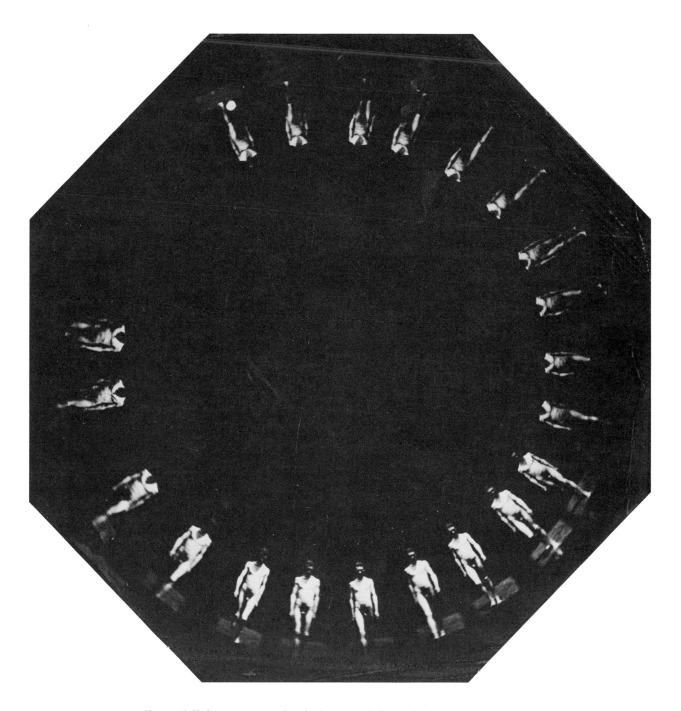

141. A man walking, full-face. Marey-wheel photograph by Eakins;
21 exposures on a revolving octagonal plate. 1885
The Franklin Institute Science Museum, Philadelphia

images were small, marred by vibrations, and mere silhouettes without depth or detail. Marey himself realized these limitations and experimented with a larger machine based on the same principle, but he ran into technical difficulties and abandoned the plan.

Marey had published descriptions of his *fusil* in 1882; his article in *La Nature* in April of that year had a detailed drawing of it. Eakins' revolving-plate camera embodied the same principle, but was a larger, more stable machine with a rotating octagonal glass plate about ten inches in diameter, allowing up

142. A man jumping horizontally. Marey-wheel photograph by Eakins, with his notations 1885. Hirshhorn Museum and Sculpture Garden, Smithsonian Institution

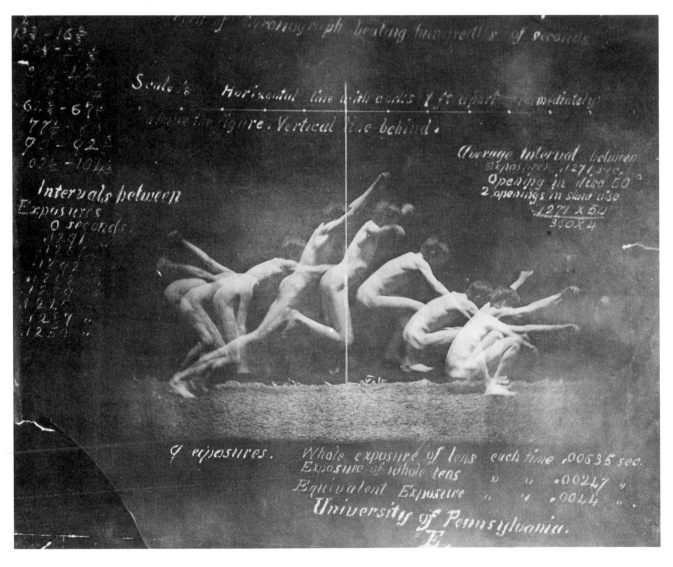

to twenty-four successive separate images. In its feature of a moving plate it can be said to have been a closer forerunner of the motion picture camera than Marey's, Muybridge's, or Eakins' own fixed-plate machines; and in its size and stability, than Marey's *fusil*.

Eakins' technical methods seem to have met with approval from the university commission; Coates wrote him on June 19, 1885: "All were interested in seeing the arrangements you have made for photography by the Marey process, which is undoubtedly well adapted for certain lines of study, and Dr. Pepper suggests that you should furnish to Dr. Parker, who is writing the treatise on the Muybridge work, drawings or photographs of the apparatus with plates which you deem most interesting.

"After having seen the time method in use at the Muybridge studio I should be pleased to have you advise me of any improvements which you think might be advantageously made. This is most important now, as Mr. Muybridge must finish all plates by the end of the summer.

"In reference to the building erected by you for your work and Dr. Allen's, Dr. Pepper thinks it should remain for the present at least, and this will afford you opportunity for any work you have in hand."

On October 2 Anshutz wrote Wallace: "The outcome of our photographic work this summer has I hear, been satisfactory to the University. The work of Muybridge being lacking in the correct time of exposure." This may have been merely pro-Eakins bias. On October 15 Pepper wrote Eakins that at a commission meeting next day, "you are expected to have all the results of your photographic work this Summer before the Committee." That the reaction was favorable is suggested in a letter from the provost to Eakins a month later: "In case it should be possible to continue the work of photography as a special feature of University work, what would be your opinion as to the desirability of keeping a certain number of the Muybridge lenses? Are they thoroughly well adapted to the work? and how many of them would be necessary?" At the same time he cautioned Eakins not to distribute "that photograph of a lad leaping, which I saw at Mr. Rogers," because the university planned to publish "a volume" on its photographic project, and a special fund had to be raised, and "it would endanger my success . . . if the freshness and novelty of the work should be at all impaired." The photograph, of a nude young man making a broad jump (ill. 142), had been taken on Eakins' fixed-plate Marey-wheel camera, and was the only motion photograph by him illustrated during his lifetime.

The cost of Muybridge's project totaled about $40,000, a considerable sum in the 1880s. The cost of Eakins' work, including photographic apparatus and the shed, seems to have been $814.85, reimbursed to him by the university commission on October 10, 1885.

The results of Muybridge's work were published by the university in 1887 under the title *Animal Locomotion: An Electrophotographic Investigation of Consecutive Phases of Animal Movements*—eleven huge folio volumes of illustrations, sumptuously printed in photogravure; 781 plates with more than 20,000 images. Two volumes were devoted to nude men, two to nude women, and one each to men with a "pelvis cloth," women and children, men and women "draped," abnormal movements, horses, domestic animals, and wild animals and birds. Almost all the successive movements were in sequences of twelve exposures, seen from three angles. The photographs were well lighted and clear, technically much better than Eakins'. There was no text, not even an introduction. *Animal Locomotion* was a set of superb picture books, and still one of the historic monuments of photography. It created enormous interest among scientists and artists in America and Europe. Because of its great cost and the limited edition, the price was high. The list of subscribers, proudly published by Muybridge, was an extraordinary roster of famous names: among European artists, Meissonier, Gérôme, Bonnat, Bouguereau, Detaille, Puvis de Chavannes, Rodin, Menzel, Lenbach, Watts, Millais, Holman Hunt; among Americans, Thomas Moran, Eastman Johnson, J. G. Brown, F. D. Millet, Louis C. Tiffany, Saint-Gaudens, Whistler, La Farge, Vedder, and the architect Henry H. Richardson.

The volumes contained no explanation of the photographic processes or analysis of the results. The original plan had been to accompany the plates with essays by Harrison Allen, Emeritus Professor of Physiology; George F. Barker, Professor of Physics; and Eakins on technical methods, including illustrations of his photographs. Coates had written Pepper about the coming publication, in September 1886: "Will Mr. Eakins be ready with his treatise and the plates made? The latter are certainly of value in themselves." But this plan was abandoned, and in 1888 the University published a modest volume, *Animal Locomotion: The Muybridge Work at the University of Pennsylvania: The Method and the Result*, with essays by William D. Marks, Whitney Professor of Dynamical Engineering; Professor Allen; and Francis X. Dercum, Instructor in Nervous Diseases. Marks's essay began with a detailed description of Eakins' methods and apparatus, written by Eakins himself, at Marks's request, in the summer of 1887.

"In the brief description of Professor Eakins's apparatus, hereafter given," Marks's essay said, "we have all that Marey has used. . . . His apparatus will be of great interest. He chose as his principal means the photographic method of Professor Marey. . . . Instead of one large disk, as in Professor Marey's apparatus, he used two small ones on the same arbor, but geared at different rates of speed,—namely, one to eight. [There followed a detailed description

of Eakins' two cameras, the stationary plate one and the revolving plate one.] It is to be regretted that Professor Eakins's admirable work is not yet sufficiently complete for publication as a whole. [Then an illustration of Eakins' photograph of a young man leaping.] The reproduction of a boy jumping horizontally, shown above, which Professor Eakins has photographed on a single plate by means of his adaptation of the Marey wheel, is of exceedingly great interest, because, in this picture, each impression occurred at exact intervals. The velocity of motion can be determined, by measurement of the spaces separating the successive figures, with very great precision, as also the relative motions of the various members of the body. The advantages arising from this method of photography would seem to render its further prosecution desirable, as yielding a means of measurement as near scientifically exact and free from sources of error as we can hope to reach."

There are some peculiar things about this essay, especially in view of the fact that Eakins helped to write it. It says that in Eakins' apparatus "we have all that Marey has used, with additions perfecting it greatly. . . . Instead of one large disk, as in Professor Marey's apparatus, he used two small ones." But in June 1884, according to Anshutz's contemporary account, Muybridge was using a two-disk camera, while Eakins was using a one-disk one and getting poor results compared to Muybridge's. Eakins finished designing his two-disk machine in August 1884 and first used it in November. Why did the essay credit Eakins with "perfecting" Marey's camera, without mentioning Muybridge's earlier two-disk camera? And in the description of Eakins' revolving-plate machine there was no mention of Marey's *fusil photographique*, which he had invented in 1881–82 and published in 1882. In this case, however, Eakins does seem to have definitely improved on Marey's apparatus, and evidently without depending on any improvements by Marey.

Perhaps it was Marks who added the credits for Eakins. Perhaps, on both their parts, there was some feeling about the elaborateness and expense of Muybridge's system, its relative lack of scientific exactness, and the scale and prestige of Muybridge's eleven volumes. And in Eakins' case, there may have been the trauma of his recent forced resignation as head of the Pennsylvania Academy school, an event in which Edward Hornor Coates had played a leading part.

As to Muybridge, in subsequent numerous writings about his work in Philadelphia he made no mention of Eakins, Marks, or Fairman Rogers. In fact, Marks's essay, with its single illustration, was the only account of Eakins' two years of work that was published during his lifetime.

Most of Eakins' motion photographs do not seem to have survived. His 1884 record lists sixty-five exposures, including failures, and he evidently did much further photographing in 1885, with better results. Yet only thirty-two existing photographs, all or most taken in 1885, are recorded by Hendricks.

Even allowing for failures, this seems a small number for two years' work. Even more puzzling is the fact that of the thirty-two, only two (127 and 128) are on the octagonal plates of the revolving-plate camera. Glass plates might have been broken, or thrown away. Perhaps some were left with the University or the Academy and not preserved by them. Charles Bregler, who had the negatives of most of those extant, wrote Henri Marceau of the Philadelphia Museum in 1943: "I do not have any other negatives, except the one of enclosed print. Whatever became of the other negatives is not known to me. There is a possibility they were destroyed, by some person ignorant of their value, having been left at the Academy when Eakins resigned."

Muybridge's university photography ended with the summer of 1885; and, as far as we know, so did Eakins'. He was not a professional photographer but a scientist-artist, interested in the processes of human and animal locomotion, and in recording them accurately by the camera. He had no urge to popularize his work, as Muybridge spent the rest of his life doing.

It has been written that Eakins was a pioneer in the development of the motion picture. It is true that Muybridge's elaborate methods were not continued, and that Marey's and Eakins' system of photographing through a single lens was to be the path of the future. But Eakins' experiments remained practically unknown and had no influence on the evolution of the motion picture, which was the product of experiments by a long line of individuals in several countries, sometimes paralleling one another, sometimes building on one another's work. In the late 1880s came George Eastman's invention of flexible film, which revolutionized the whole process and made possible the modern movie camera.

10. Teaching, 1886 to 1895: The Academy and the League

IN THE MIDDLE 1880s Eakins' artistic production decreased for several years, doubtless because of his duties as director of the Pennsylvania Academy school, his lectures in Brooklyn and New York, and his work with the Muybridge committee. Up to 1884 his pictures had been seen quite regularly in the Pennsylvania Academy (more there than elsewhere), the National Academy of Design, the Society of American Artists, and exhibitions in other cities. Many of these works were earlier ones, still unsold, going back as far as *The Pair-oared Shell* of 1872. But after 1884 he exhibited little for several years.

The critical tone continued much as before. His realistic strength and technical ability were generally recognized, his lack of beauty and poetry deplored. Occasionally a controversial picture such as *A May Morning in the Park* or *The Crucifixion* received considerable attention and space, but only exceptional approval. Generally, however, his standing as a teacher and an anatomist was given credit; his statements quoted in Brownell's article were sometimes cited at length. In Philadelphia his most perceptive critic and constant champion, from the 1870s into the 1880s, was William Clark of the *Evening Telegraph*.

The asking prices for most of his pictures at first remained at the same levels as in the 1870s. But in 1881 he began to raise the prices on his best oils, new and old. The highest recorded figures in the early 1880s were $1,200 for *The Crucifixion* and *The Pathetic Song;* $800 for *The Biglin Brothers Turning the Stake* (previously priced at $250 and $300), *Mending the Net,* and *Sailboats Racing* (later reduced to $600); and $600 for *William Rush.* He probably felt that his position in the teaching world justified the increases. In any case, only one of these pictures found a buyer: *The Pathetic Song.* Most of his other oils remained at $200 to $400, with some at $500.

There were some actual commissions and sales in the early 1880s. In 1880 Fairman Rogers paid $500 for *A May Morning in the Park,* the largest amount

Eakins had received so far, and the Mutual Assurance Society paid $250 each for two portraits of its chairman, General George Cadwalader. In 1883 he painted the fine small oil *Professionals at Rehearsal* for the pioneer collector of contemporary American art Thomas B. Clarke of New York, "to his order," for $300 less the cost of a frame, $30. (In the Clarke auction in 1899, which was to set record prices for Eakins' contemporaries Inness, Martin, Homer, and even Ryder, it was to fetch only $150.) In 1884 for the unfinished portrait of Mrs. Ward he accepted $150, half the agreed price. That year Edward Hornor Coates commissioned *The Swimming Hole;* but when he lent it to the Pennsylvania Academy annual exhibition in October 1885 (before paying for it), he decided that he preferred the 1881 *Pathetic Song,* for which he paid Eakins $800, reduced from $1,200, but still the highest known price Eakins had received. (Perhaps the nudity of the young men in *The Swimming Hole,* by contrast with the voluminous covering of the singer in the earlier picture, bothered Coates.) As we have seen, in 1885 Eakins received $500 in settlement from James P. Scott for his work on the reliefs *Spinning* and *Knitting* and retained the plasters; in 1887 Coates paid him $200 for casts in plaster and bronze. In 1885 he received $500 for a portrait of Edwin M. Lewis. Adding estimated returns from two probable sales in 1883 ($150 for the 1875 watercolor *Baseball Players* and $300 for an 1881 shad-fishing oil), the total for the six years from 1880 through 1885 would be $3,870—better than the $1,075 for the whole decade of the 1870s but hardly enough to support him and his wife without his Pennsylvania Academy salary, fees from the Brooklyn Students' Guild, and financial help from his father.

One of Eakins' favorites among his early paintings was *The Chess Players,* intimately connected with his father and two old friends. He exhibited it frequently, but always as owned by Benjamin Eakins and not for sale. In 1880 he lent it to the Metropolitan Museum for a year, and next year gave it to them—his second work to enter a museum.

On January 1, 1883, starting his journal for the year, he wrote this inventory of his possessions: "I own as personal property, my clothes, a good silver watch, a worn out gold watch (from my mother, she had it from my Uncle Tom), a gun, 2 rifles, pistols, an aneiroid barometer. I have a horse's skeleton & a good set of human bones (both carefully marked as to muscular insertions.) I have many good casts made principally by myself from dissections of the man, horse, dog, cat, etc. and many from parts of the human figure. I have as photographic apparatus a camera 4 × 5, American Optical Co.; a Ross portrait tube marked No. 2 C d V #23193, a view or landscape tube of long focus marked 8 × 5 S. A. doublet 17375, also by Ross of London, 14 double backs for dry plates, small trunk for carrying them, tripod, & accessories. Also a solar camera & accessories, and chemicals.

"I have plaster and carving tools, and a paint box & sketching box, a French

easel, many photographs & photographic studies, and many pictures and painted studies unsold, and many frames.

"I shall not credit to myself the supposed value of my work, but wait until sold and then credit to Profit what is sold. Neither shall I put into my account my other above personal property.

"I have also $300 in 4 per cent. Consols of the United States.

"I have also the ¼th part of a $1000 Mortgage & the ¼th part of a $400 Mortgage.

"I have 60 fr. in French money & $212.00 in cash."

II

In November 1883 Eakins lost his best ally in the Pennsylvania Academy school. Fairman Rogers wrote him: "I suppose that you will not be pleased when I tell you that I have resigned from the Board of Direction of the Penna. Academy of the Fine Arts. I have had for several years past altogether too many occupations and interests and I am determined to diminish their number and to have my time more at my own disposal.

"I leave the Academy with regret as I have many pleasant associations with my work there—not the least among them the hours spent with you."

By the 1884–85 season the number of pupils had increased to 224: 120 men, 104 women. But Eakins had not received the raise in salary from $1,200 to double that, which had been promised him in 1882. On April 8, 1885, he wrote the board of directors: "At the reorganization of the school as a pay school of which I was made the director, my salary was fixed at $2500, but as there were many doubts as to the probable number of scholars under the pay system, I was asked to temporarily serve at a much reduced salary. The chairman of the Instruction Committee Mr. Rogers, confident of the success of the new plan, assured me he believed my temporary salary would be much raised during the first year and probably paid in full thereafter, and that it was not contemplated that the expenses of the whole school would be paid by the pupils, the price for tuition being kept very low.

"The number of classes has increased, the school is full, probably as full as it should be, its pupils are becoming known, its reputation is wide, and its standard of work is very high. My promised salary was a large factor in my determination to remain in Philadelphia."

He did not receive the increase.

By the middle 1880s Eakins occupied a prominent but peculiar position in the American art world. His work was not popular, the critical reception was unfavorable on the whole, sales and commissions were few. On the other hand, he was widely recognized as an innovating teacher and the foremost anatomist among American artists. He had lectured in Brooklyn and was beginning to lecture at the progressive Art Students' League in New York. His

photographic work on the Muybridge committee had earned him the respect of eminent scientists in Philadelphia. He was director of one of the country's leading art schools, and he had a devoted body of students.

Beneath the surface, however, there was growing opposition. The Academy directors were laymen, public-spirited but conservative, and not necessarily in agreement with Eakins' innovations. As Brownell had said, it was "distinctively *their* Academy." Eakins was strong-willed; to the directors the school was becoming too much a one-man affair. With Fairman Rogers' resignation he had lost his strongest supporter. Rogers' successor as chairman of the Committee on Instruction, Edward Hornor Coates, was less liberal. He had been treasurer of the Academy for several years and was much concerned about its finances. The school, which the directors had stated in 1884 was "largely self-supporting," was still running a deficit of $6,000 or $7,000 a year. A campaign to raise an endowment of $100,000 had been started. Eakins' letter reminding the directors of their promise to double his salary could not have pleased them.

There is no question that the Academy under Eakins' directorship required far more thoroughgoing, rigorous study than any other art school in America, and perhaps abroad: exhaustive anatomical study of the human and animal body, with dissections performed in the school; concentration on fundamental form; intensive courses in perspective, involving mathematics; disregard of the pleasant routine of copying antique casts; immediate introduction to painting with all its problems. And on the negative side, little attention to aesthetics, study of the old masters, or "picture-making." It was a severe discipline, deep but narrow.

Also there was the dominant emphasis on the nude. About half the student body were women. Most of them seem to have been sensible, broad-minded young persons, but there was a minority who were more conventional. And then there were their parents. An incredible document is preserved in the Academy archives: a letter to its president, James L. Claghorn, April 11, 1882, signed "R.S."—probably the mother of a female student or prospective student:

"I know you will be surprised and perhaps astonished at the courage of a lady to address the 'President of the Academy of Fine Arts' in reference to a subject which just at this time seems to be so popular. . . . I acknowledge that every effort should be made and sustained with enthusiasm that promotes true Art. By *true art* I mean, the Art that enobles and purifies the mind, elevates the whole intellect, increases the love of the beautiful, and as nothing can be beautiful that is not pure and holy, that so elevates humanity that it becomes better fit to enjoy that purity and holiness, that belongs to immortality. Now I

appeal to you as a Christian gentleman, educated amidst the pure and holy teaching of our beloved Church, and where the exhortations to purity of mind and body were amongst your earliest *home* teachings, to consider for a moment the effect of the teaching of the Academy, on the young and sensitive minds of both the male and female students. I allude to the Life Class studies, and I know where of I speak. Would you be willing to take a young daughter of your own into the Academy Life Class, to the study of the *nude figure* of a woman, whom you would shudder to have sit in your parlor clothed and converse with your daughter? Would you be willing to sit there with your daughter, or know she was sitting there with a dozen others, *studying* a nude figure, while the professor walked around criticising that nudity, as to her *roundness in this part*, and swell of the muscles in another? That daughter at home had been shielded from every thought that might lead her young mind from the most rigid chastity. Her mother had never allowed her to see her young naked brothers, hardly her sisters after their babyhood and yet at the age of eighteen, or nineteen, for the culture of *high Art,* she had entered a class where both *male* and female figures stood before her in their horrid nakedness. This is no imaginary picture. I know at this time two young ladies of culture, refined families, enthusiastic students of painting, whose parents, after earnest entreaties of patrons of Art and assurances that Art could *only be studied* successfully BY ENTERING such a class, consented, with the assurance from their daughters that if they found the study as improper as their parents feared they would desist. They entered, and from their own lips I heard the statement of the terrible shock to their feelings *at first,* how they trembled when the professor came, one stating she thought she should faint. Her fellow students, who had been in the class for some time, assured her that she would soon *get over that,* and not mind it at all! She persevered, and now 'don't mind seeing a naked man or woman in the least.' She has learned to consider it the only road to *high Art,* and has become so interested she never sees a fine looking person without thinking what a fine *nude study* they would make! What has become of her *womanly* refinement and delicacy? . . .

"Now, Mr. Claghorn, does this pay? Does it pay, for a young lady of refined, godly household to be urged as the only way of obtaining a knowledge of true Art, to enter a class where every feeling of *maidenly* delicacy is violated, where she becomes so hardened to indelicate sights and words, so familiar with the persons of degraded women and the sight of nude males that *no possible* art can restore her lost treasure of *chaste and delicate thoughts!* There is no use in saying that she must look upon the study as she would that of a wooden figure! That is an *utter impossibility.* Living, moving flesh and blood, is not, cannot, be studied thus. The stifling heat of the room, adds to the excitement, and what might be a cool unimpassioned study in a room at 35 degrees, at 85 degrees or even higher is dreadful.

"Then with this dreadful exposure of body and mind, not one in a dozen could make a respectable *draped* figure. Spending two years in life study of *flesh color*, that a decent artist would never need, and then have to begin over again for the draped figure. Where is the elevating enobling influence of the beautiful art of painting in these studies? The study of the beautiful in landscape and draped figures, and the exquisitely beautiful in the flowers that the Heavenly Father has decked and beautified the world with, is ignored, sneered at, and that only made the grand object of the ambition of the student of Art, that comes unholy thoughts with it, that the Heavenly Father Himself covered from the sight of his fallen children.

"Pray excuse this liberty in writing to you but I have been made to feel that the subject is one of such vital importance to the morals of our young students I could not refrain."

There was also opposition within the Academy from a small group of Eakins' own staff and ex-students: in particular, Thomas Anshutz, James P. Kelly, Charles H. Stephens, George Frank Stephens, and Colin Campbell Cooper, Jr. All five had studied under him, and to some he had given positions of responsibility in the school. Anshutz, Kelly, and Charles Stephens had been in the Philadelphia Sketch Club's evening life class, which Eakins had taught from 1874 to 1876; they had joined in the club members' petition to the Academy for an evening life class with Eakins as instructor; entering the Academy, they had worked under him; and he and Dr. Keen had chosen them as demonstrators of anatomy. Anshutz, only seven years younger than Eakins, had succeeded him as Chief Demonstrator of Anatomy in 1881, and on the reorganization of the school in 1882 had been appointed Assistant Professor of Painting and Drawing, second in command to Eakins. He had played an active part in the motion photography project, and his letters to John Wallace had shown a respectful, friendly relation with his former teacher. But he was not in full agreement with Eakins' emphasis on anatomy, dissection, perspective, and early use of the brush, favoring longer drawing of the antique, study of costume models, and more traditional methods in general. The whole group probably resented Eakins' authority and his uncompromising insistence on basic disciplines. Charles Stephens' younger cousin Frank, in addition, had some kind of personal animus against Eakins; he had recently married Caroline Eakins, and had succeeded in turning her against her brother.

Eakins' training in medical schools and his anatomical studies had given him an attitude toward the human body as uninhibited as a physician's. His disregard of customary taboos brought about a number of occurrences that offended the more proper students and furnished ammunition to his enemies. The photographing of students in the nude must have shocked some. Male and female models were sometimes posed together for study of comparative anatomy. Men students sometimes posed nude for each other and for Eakins.

To save models' fees some of the women formed a sketch class and took turns posing nude. According to one account (perhaps apocryphal), a young woman who had an unusual talent for catching a likeness carelessly left her sketchbook in the classroom, where it was found by the incoming men's class, to their scandal and enjoyment. Some of the sketch class girls asked Eakins to criticize their drawings of each other, which he did, shocking the more conventional ones. Very rarely, women students posed nude for him, with their mothers' consent. All such happenings increased the tension between the liberal majority and the conservative minority in the school.

In early 1886 the conflicting viewpoints and interests within the school—artistic, pedagogic, moral, financial, and personal—produced a crisis. There were several versions, during and after the event, of what brought it on. The most probable is that the immediate issue was Eakins' exposure of the completely nude male model in the women's life class. If so, his reasons for such action were stated two years later in a letter to the Art Students' League of New York, which had asked him to continue his lectures on anatomy. "In lecturing upon the pelvis which is in an artistic sense the very basis of the movement and balance of the figure, I should use the nude model. To describe and show an important muscle as arising from some exact origin to insert itself in some indefinite manner under the breech clout is so trifling & undignified that I shall never again attempt it.

"The smaller bag tied with tapes or thongs, hitherto used at the League is to my mind extremely indecent, and has been more than once a source of embarrassment and mischief.

"I am sure that the study of anatomy is not going to benefit any grown person who is not willing to see or be seen seeing the naked figure and my lectures are only for serious students wishing to become painters or sculptors.

"Adverse criticism could be avoided by announcement of when I should use the naked model.

"Those not wishing to come to such lecture could stay away or withdraw and lose nothing they could make use of, but would not hinder others wishing to learn."

(In most art schools today, the common practice in life classes of both sexes is for the male model to pose without covering.)

It seems probable that some of the women students, backed by Anshutz, Kelly, Cooper, and the two Stephenses, complained to the Academy directors about this exposure, and that the Committee on Instruction took under advisement this and other complaints against Eakins. On February 8, 1886, the committee reported to the directors that they had had "under serious consideration for some time a change in the management of the schools, and had finally concluded that it would be well to ask for the resignation of the present Director." On a motion by Charles Henry Hart the committee was authorized to do

The men's petition, dated February 15, read: "We the undersigned students of the Academy of Fine Arts, have heard with regret of the resignation of Thomas Eakins, as head instructor of the school.

"We have perfect confidence in Mr. Eakins competency as an instructor, and, as an artist; and his personal relations with us have always been of the most pleasant character.

"We therefore respectfully and earnestly request the Board of Directors to prevail upon Mr. Eakins to withdraw his resignation, and continue to confer upon us the benefit of his instruction." The petition was signed by fifty-five students, including four or five women.

In reply to this mild statement, the directors told the press that they would not reconsider their action. One of them was quoted as saying: "We will not ask Mr. Eakins to come back. The whole matter is settled, and that is all there is about it. The idea of allowing a lot of students to run the Academy is ridiculous. All this talk about a majority of them leaving the school amounts to nothing. Let them leave if they want to. If all left we could close the school and save money. Why, we have an annual deficiency of about $7,000, and are now endeavouring to raise an endowment fund of $100,000, which it is hoped will keep the school running without a loss. There are 172 pupils on the roll, of whom eighty-two are males and ninety females. They pay from four dollars a month to forty-eight dollars for a season of eight months, so you can readily see that the school is not self-supporting. This very fact makes it presumptuous on the part of the students to tell us what to do. If any of them left it would be their loss, not ours." This enlightened statement was repeated in several other papers.

In all this agitation Eakins had taken no public part. On the 17th he denied to a reporter that he had offered to teach the students outside the Academy. "I could not give them the same advantages they have at the Academy," he said. "Of course, if a new school was organized, and I was requested to take charge, I would take a business-like view of the matter and probably accept. But I would take no steps to organize such a school. That I can say positively, and I don't believe any will be organized."

On learning of the directors' refusal, the leaders of the pro-Eakins students called a meeting for Thursday the 18th to consider withdrawing from the Academy and forming a new school, to be called the Art Students' League. "The meeting was held in one of the rooms in the College of Physicians," the *Press* reported, "and nearly forty students were present, and it was announced that many were absent whose hearts were in the movement, but had been detained by other engagements. It is expected to gain a total of fifty or more out of the eighty odd members of the class.

"H. C. Cresson, a fellow-student of Professor Eakins under Gerome, called the meeting to order. He said that the charges against Professor Eakins were that he was too much devoted to the nude and made unnecessary exposures of

Thomas Eakins

subjects in the anatomical class. As the students were studying art for art's sake he did not think it right that they should be hampered in the pursuit by prudishness and false modesty. . . . He announced that if the league was formed he could say that Professor Eakins would give his services as instructor free of charge for the first year. . . . He then referred to the necessity in the study of true art for absolute nudity in models, and commended Professor Eakins as a faithful and conscientious exponent of that theory. It was then formally agreed by a rising vote that a league should be formed, and it was further decided that a room should be procured. The calculation was made that the expenses will not amount to more than $25. a year per member, and even less as the number increases. The cost of tuition at the Academy is $48. a year."

Cresson, elected the League's president, in a long letter of the 22nd to the Philadelphia *Evening Item,* made still more explicit the seceders' attitude: "They desire to study THE ENTIRE NUDE FIGURE. . . . Gerome, Cabanel, Bouguereau—in fact any French professor—would scoff at the idea of any one attending a 'Life Model Class' if the 'points' so necessary in gaining the correct movement, proportion and swing of the figure, were covered. . . . Mr. Eakins insisted on the exposure of the entire figure at the Academy, because he . . . felt that he ought to give an *honest criticism* of the nude figure to his pupils—had he deceived and led them into *error* by attempting a criticism of the nude when covered at the loins, then he would have been dishonest."

On February 22, the Art Students' League of Philadelphia held its first session. Its name was obviously based on the Art Students' League of New York, which ten years earlier had been founded by former students of the National Academy of Design, and which, quite unlike the Pennsylvania Academy, was controlled entirely by its student members.

The conservative judgment on the affair was summed up in the leading editorial in the *Evening Bulletin* on the 19th: "Mr. Eakins' resignation and the foolish proposition of some of the young men of the School to form an independent class under that gentleman's tuition . . . grow out of a failure to appreciate the fact that the Life School of the Academy is a benefaction established by the directors for the good of the students and absolutely under the directors' control. Mr. Eakins holds one class of views on the subject of the work of Life Schools and the directors hold another. In any such difference of opinion, the will and judgment of the directors is supreme. It is their school and nobody's else. It is for them to determine what shall and what shall not be done in it. The persons whom they employ are their subordinates and are as much bound to accept their directions as is any other subordinate. With the pupils the directors are to deal through the instructors and through such general rules as they may prescribe. It is for the pupils to accept these rules or to study elsewhere; the directors are responsible only to their constituents.

"The general facts which have led to the present difficulty are these: Mr.

Eakins has for a long time entertained and strongly inculcated the most 'advanced' views, as they are often called, regarding the methods of study in life schools. Teaching large classes of women, as well as of men, he holds that, both as to the living model in the drawing-room and the dead subject in the anatomical lecture and dissecting room, Art knows no sex. He has pressed this always-disputed doctrine with much zeal and with much success, until he has impressed it so strongly upon a majority of the young men that they have sided with him when he has pushed his views to their last logical illustration by compelling or seeking to compel the women entrusted to his direction to face the absolute nude both as to the living and the dead subject.

"The directors gave Mr. Eakins the opportunity to retrace these most unwise steps, and he refused, preferring to resign rather than surrender to the judgment and authority of the directors. They could not do otherwise than accept the resignation, without putting themselves in a position both toward their teacher and the public which they could not possibly maintain. To have conceded the right to introduce such an innovation would have been to ignore all responsibility and would have led to the speedy disruption of the Life School.

"That the women of the Life School should have revolted at the tests forced upon them was inevitable. They appreciate the value of the privileges afforded by the Academy so highly that there is probably not one among them who would have made open protest against any of its methods if there had been any legitimate room for two opinions on the subject. A woman is never entitled to any special praise for following her womanly instincts, as she is never entitled to much consideration when she ignores them. With a few abnormal exceptions the women at the Life School recognized the fact that much as they might risk in coming in conflict with the Academy authorities, they would risk infinitely more by accepting the conditions that Mr. Eakins proposed to force upon them. As things have turned out, they have lost nothing by their attitude. The directors have stood by them and made it understood that the same limitations are to be preserved in the work of the Life School in Philadelphia that are observed in the schools of the same class in other parts of the country and generally among the best schools in Europe. To have done anything else would have been to drive these ninety women out of the School and to have put the Academy of the Fine Arts in a position which it would have found it very difficult to occupy." (Ninety was the total number of women students enrolled in all classes from October 1885 to February 1886; the number in the life class at this time must have been less. Of these, "all but a dozen" signed the women's petition for Eakins' return, according to the *Evening Bulletin* of February 16.)

An opposite and more accurate viewpoint was that of the New York weekly *Art Interchange*, whose "Philadelphia Letter," possibly by William Clark, said: "Professor Thomas Eakins . . . has resigned his position, much to the

regret of the majority of his pupils. It seems that there is a small faction of students in the professor's classes who are opposed to his methods of study, and they have been eagerly seeking for an opportunity to place their own favorites in power. Gratitude for the good results which have been attained by Mr. Eakins does not seem to have been thought of by his opponents, and a feeble charge was trumped up that he had insisted upon an excess of nudity in study from the life model, and made an unnecessary exposure of the 'subject' in the anatomical class! Art students who attend the classes at the Pennsylvania Academy are supposed to understand that it is a school intended for professionals and those amateurs who may have the good sense to avail themselves of the advantages of study from the nude model. If Mr. Eakins offended the modesty of the women and men of his class by an excess of realism, it was intended for their benefit, and they should not have overlooked the well-known fact that he always had their welfare at heart. . . . The best wishes of all who love truthful study will attend the formation of the students' class."

From Chicago, John Wallace wrote Eakins what must have been a letter of support, for he replied: "My dear Johnny, Your good letter came to me betimes, and I thank you very much for it. Your confidence in me and my good intentions has not been misplaced. I have often thought differently from others, but my heart was open to my friends.

"I have never deceived anyone or tried to. I have put myself out to help along in their work my worthy students. Such as you have always known me, such I am now and will be."

IV

The cabal which had helped to oust Eakins had themselves come under attack; on March 12 they sent a statement to the Academy board of directors, written by Frank Stephens and signed by Anshutz, Cooper, Kelly, and the Stephenses: "In the absence of any official statement as to the cause of Mr. Eakins' resignation from the Academy rumors have been spread, of which the enclosed clipping is a specimen, resulting in the general belief that he has suffered without cause.

"This is unjust to those who have brought Mr. Eakins' offences to the notice of your Board and still more to those who come under his influence now, or may hereafter, believing that he is, as he claims, the innocent victim of a conspiracy.

"We who are acquainted with the case cannot defend ourselves except by detailing the facts and that being in every sense undesirable we bring the matter to the attention of your Honorable body & appeal, most earnestly, for an official statement from your Board to the effect that Mr. Eakins' dismissal was due to the abuse of his authority and not the malice of his personal or professional enemies."

The clipping enclosed was the February 15 Press account, already quoted,

in which a director had said that Eakins "had a number of enemies who made trouble for him." What the "facts" could have been, beyond what is clear from the newspaper reports, there is no clue. In any case, the directors, as far as we know, did not issue any further public statement.

The cabal, not content with helping to force Eakins out of the Academy, now moved against him at the Philadelphia Sketch Club, where in the 1870s he had taught the life classes without pay and which in gratitude had made him an honorary member. On March 6 Anshutz and the two Stephenses, all members, wrote: "We hereby charge Mr. Thomas Eakins with conduct unworthy of a gentleman and discreditable to this organization and ask his expulsion from the Club." The moving spirit in this vindictive action was Eakins' brother-in-law George Frank Stephens.

The club president, John V. Sears, communicated this accusation to Eakins, who replied in a long letter, reading in part: "I know of no circumstances in relation to which any persons have a right to make charges against me to the Sketch Club, nor of any right of the Sketch Club to constitute itself a tribunal to hear and try charges.

"The action of the club in advising me as it has done, without stating what the charges are, or by whom they are preferred, is so inconsistent with the principles of plain and fair dealing that I can only regret that the club has permitted itself to be put in such an equivocal position.

"It is evident that there is an organized movement to do me mischief. . . .

"The methods are such as can proceed from only private motives, seeking their expression through malicious acts. . . .

"Until a full submission is made of the statements against me, with an equally candid advice of the names of persons making and discussing the charges, I must decline to consider the matter further."

Sears appointed a committee of three club members to deal with the matter. In response to a request to appear before them, Eakins wrote in part: "In making me a so-called honorary member, the Sketch Club presumably wished to convey a compliment which I did not seek. The compliment did not in any sense constitute me an ordinary member of the club, my relations to which are practically the same as if I had never heard of it. An action of expulsion cannot therefore be in question. The only action possible could be one withdrawing the previous action by erasing the compliment. Anything further would be gratuitous and malicious. . . .

"It would be folly for me to appear before your committee to answer an indictment the points of which I am not permitted to know in advance. . . .

"I could come to no conclusion until something specific is placed before me, a written statement properly signed, giving the detail of occurrences as to times, places, and persons witnessing the same."

In view of Eakins' attitude, Anshutz and Charles Stephens had second

thoughts. "[They] feel that they have made a mistake in making the charges in the first place," a member of the committee reported to Sears, "as they did not appreciate the fact that their assertions would have to be backed by absolute evidence, which they are unwilling to give for reasons you will know. It seems now to be conclusive that Mr. Eakins will make a fight. . . . Mr. A. and Mr. C.S. feel that they would not be doing the right thing in pressing the matter, as more or less publicity would be the result, a thing which they wish to guard against. On the other hand, Frank Stephens insists in pushing the thing to the utmost, regardless of any impropriety he may be guilty of in so doing. The first mentioned gentlemen are willing to withdraw the charges in preference to calling in new evidence, having absolutely refused to give anything further if the details are to be made public in the club. But they feel that they cannot make or persuade Frank to take that view of it, and, in the absence of any power to prevent him from carrying out his views, they feel that they are tied unwillingly to him."

In spite of the misgivings of Anshutz and Charles Stephens, and Eakins' refusal to cooperate in his own censure, the Sketch Club proceeded with the farce. An unpublished history of the club records that the committee of three "painstakingly and conscientiously investigated" the charges, "examining a number of witnesses. Finally, making a report in a very long and carefully worded document, with full specifications, on April 17th they found the member guilty of the charges preferred and recommended his expulsion from the Club. All former privileges granted this member were withdrawn and his name erased from the Club roll." (The "document" does not seem to have been preserved.)

Eakins, who in the midst of the Academy affair had offered to help Emily Sartain be appointed principal of the Philadelphia School of Design for Women, wrote her in late March: "Dear Emily, I send you a statement which I leave entirely to your discretion. It is comprehensive, & shown to some persons might do a deal of good. It is carefully written & covers all the ground.

"Anshutz is teaching in all my classes at the Academy, having given one class to Kelly the class formerly taught by himself."

The statement, dated March 25, 1886, read: "In pursuance of my business and professional studies, I use the naked model.

"A number of my women pupils have for economy studied from each others' figures, and of these some have obtained from time to time my criticism on their work.

"I have frequently used as models for myself my male pupils: very rarely female pupils and then only with the knowledge and consent of their mothers.

"One of the women pupils, some years ago gave to her lover who communicated it to Mr. Frank Stephens a list of these pupils as far as she knew them, and since that time Mr. Frank Stephens has boasted to witnesses of the power

which this knowledge gave him to turn me out of the Academy, the Philadelphia Sketch Club, & the Academy Art Club, and of his intention to drive me from the city."

The reasons for Frank Stephens' insensate hatred of his brother-in-law are not known. Aside from his public actions, he persuaded his young wife Caroline that her brother was immoral, and she had nothing to do with him the rest of her short life. After only five years of marriage, and after bearing three children, she died on November 30, 1889, aged twenty-four years and ten months—like Margaret, of typhoid fever. Stephens survived her by forty-six years.

"As regards the infamous lies that were circulated," Eakins wrote John Wallace, "and which imposed upon some people who should have known better, any of them are easily disproved to any one who takes the trouble to find out."

<center>V</center>

The next annual report of the Pennsylvania Academy directors, February 1887, began by calling the past year "one of the most eventful in the history of the institution. . . . During the year a number of changes have been made in the School Department, which, it is believed, will be in every way of advantage. For some time prior to the year just closed, the Committee of Instruction were of the opinion that better results would be obtained, and a broader teaching follow, from the influence of several minds in the school rather than from the influence of one. In the early part of the year Mr. Thomas Eakins presented his resignation, and the office of Director of the Schools, previously held by him, was abolished." The report also announced that the $100,000 endowment fund campaign had been successfully completed.

The circular of the Committee on Instruction for the 1886–87 season omitted the statement written by Eakins: "The course of study is believed to be more thorough than that of any other existing school. Its basis is the nude human figure." Instruction was now divided among several teachers: Anshutz and Kelly, the popular genre painter Thomas Hovenden, and Bernhard Uhle as instructor in portrait painting. The antique was reestablished as an essential discipline, and drawings showing "greater proficiency" must be submitted for admission to the school and the several classes. Although there was no prohibition on the nude in life classes, the rigorous concentration on anatomy and dissection was relaxed. The Committee on Instruction tightened its control of operations. Within a few years Anshutz emerged as the leading faculty member, continuing Eakins' realistic tradition in less thoroughgoing form, and eventually becoming one of the most popular teachers of the period. As the years passed, the Academy evolved into a conventional school, of which Eakins wrote in 1906 to a student asking about where to study: "My advice would be contrary to nearly all the teaching there."

The Academy debacle was the severest blow of Eakins' professional career. For ten years the school had been a large part of his life; he had given it time, energy, and the best of this thinking about art. Even the loyalty of many of his pupils could not entirely compensate for the loss of his position as head of the country's leading progressive art school. The attacks on his professional and personal morals left permanent scars; hereafter he was looked at askance by the respectable members of Philadelphia society. The break with the Academy injured his reputation as an artist, a portrait painter, a leader in the Philadelphia art world, and a man. Thenceforth he was always to some extent an outlaw in his own community.

<center>VI</center>

On the evening of Washington's Birthday, February 22, 1886, the Art Students' League of Philadelphia held its first class in temporary quarters at 1429 Market Street. "This association is composed," the Philadelphia *Record* reported facetiously, "of artists who desire to make a study of the human form in the garb of nature, which has been forbidden by the Academy of the Fine Arts. About thirty names have been enrolled." The first model was the newsboy on the corner. Publicity about the supposed immorality of master and pupils led a New York newspaper to send a reporter to enroll as a student and get the inside story. After struggling with art for a while, he confessed his purpose, said he had never seen a more serious group, and was allowed to depart in peace.

The League's announcement for the following fall began with a statement written by Eakins: "The Art Students' League is an association formed for the study of Drawing, Painting, and Sculpture. The basis of its study is the nude human figure. It is to be controlled entirely by the Artists and Art Students who are working members of the League." Eakins was given as Instructor—the only one.

Unlike the established Academy, the League left few records. But its longtime president, Edward W. Boulton, one of the original seceders from the Academy, kept a record book in which he wrote the League's constitution and listed the names of the students through the 1890–91 season. Some surviving circulars contain information about courses, lectures, fees, and so forth. And there were the memories of former students interviewed in the 1930s by myself and in the 1940s by Margaret McHenry. (I talked with Charles Bregler, Thomas J. Eagan, Frank B. A. Linton, Samuel Murray, James L. Wood, and Francis J. Ziegler.) From these sources it is possible to piece together a necessarily incomplete history of the school.

The League's organization was modeled on that of the New York Art Students' League. It was governed by its student members, who elected a Board of Control consisting of the four officers—president, vice-president, treasurer, and secretary—plus the chairmen of committees and three members not holding other official positions. There were two standing committees: the House

Committee, responsible for procuring and maintaining the school's quarters; and the Model Committee, for securing "suitable models." Annual members' meetings were held in April. The constitution, written out in full detail, provided for every contingency. Who drew it up and when, and how closely it was adhered to, we do not know.

The courses consisted of day classes in drawing and painting every afternoon, one to four (later changed to mornings, nine to twelve); modeling, three mornings (later, afternoons); and portrait (later dropped). Night classes were in drawing and painting, three evenings, and modeling, three evenings. (Eakins' insistence on modeling for painters as well as sculptors was continuing.) There were no antique classes. Lectures on artistic anatomy and on perspective were given by him and were open to nonmembers. Special arrangements were made for dissecting in medical schools. Tuition for the day classes was $40 for the season and $7 per month (later increased to $50 and $8); for the night classes, $20 for the season (increased to $25) and $4 per month. These fees included all lectures; for nonmembers the charge was $5 for each course of lectures. The season ran from late September or early October to early June, about eight months.

For Eakins this was a heavy teaching schedule, perhaps as heavy as at the Academy, where he had had assistants. He carried it on without taking any salary during the years of the school's existence. Indeed, he helped some of the students financially, usually by paying them for posing for him.

The League had no permanent home. After about two months at 1429 Market Street it moved to 1338 Chestnut Street, a few doors from Eakins' studio, where it remained for two seasons, through 1887–88. Then to 1816 Market Street for two seasons, 1888–89 and 1889–90. Here, Bregler told me, the school flourished; "they had electric light." The last known home was at 46 North 12th Street, 1890–91 to 1892–93.

At the end of the short first season, on June 1, 1886, the students wrote Eakins: "We, the undersigned, have assembled this day, to thank you for your appreciation and kindness shown us during the past school season." This was signed by sixteen men students, all but two of whom had signed the February petition to the Academy directors. If these comprised the total enrollment, as presumably they did, it is evident that not as many had seceded from the Academy as their leaders had expected.

"The Art Students' League, of Philadelphia," the friendly *Art Interchange* reported in June, "has closed its first quarter, which was a most successful one. . . . Professor Eakins states that he feels proud of the progress, made by Philadelphia's new art school and that his pupils have more than fulfilled his most earnest hopes." To John Wallace, Eakins wrote in October 1888: "I hear that at our old Academy they do not paint at all any more. They only draw outlines and shade them up occasionally. My own little school has gone into good

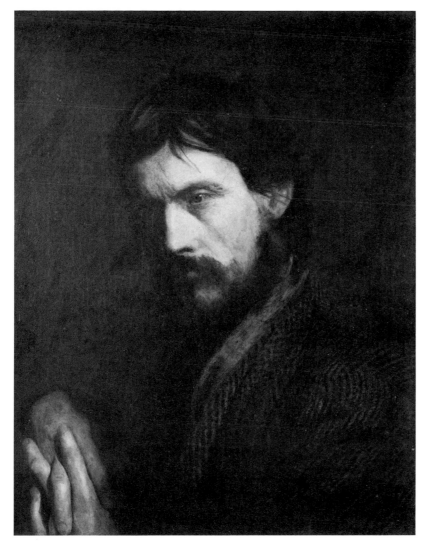

143. THE VETERAN
Portrait of George Reynolds. c. 1886. Oil. 22¹/₄ × 15. G 211
Yale University Art Gallery; Bequest of Stephen Carlton Clark, B.A. 1903

quarters at 1816 Market St., and is exempt from all impertinent interference of the ignorant.''

The low enrollment of the first short season continued into the next one, 1886–87; but then the number of students almost doubled: to twenty-five in 1887–88, twenty-nine in 1888–89, twenty-seven in 1889–90, and twenty-seven in 1890–91, the last year of the Boulton record. A little more than half were in the day classes, the rest in the night ones. Almost all the students were men, but there were a few women: Susan Eakins, the only one in 1887–88; four, in-

Teaching, 1886 to 1895

cluding her, in 1888–89; two in 1889–90; and three in the last recorded season, 1890–91, including Eakins' young nieces Ella and Margaret Crowell. All the women studied in the day classes. The male models, both professionals and students, posed completely nude, even when female students were present.

There were some hard times, when there was not enough money to pay for professional models, and the students would pose for the class: first the president, to set the example, Samuel Murray told me, then the vice-president, secretary, treasurer, and curator. Only one student always refused to take off his clothes. Murray said that from posing he learned a lot about bodily stresses and strains.

At the League, Eakins could give his students more personal attention than at the Academy, and the relationship between them, cemented by their loyalty during the Academy revolt, was close. They were like part of his family; they were often invited to his house, and his studio was always open to them. Occasionally they would assist him by painting the simple parts of large pictures, such as the leg of a chair—"something that didn't require much art," one of them said. The connection did not end with their schooling; he continued to follow their progress and would visit their studios to see their work. Among the most sympathetic of his portraits are the many he painted of them (and of his former Academy students), sometimes years after they had left the schools. More than one of them said to me: "He was my best friend."

The atmosphere of the League was more democratic and free-and-easy than the Academy's. Eakins' students were "the boys," and he was "The Boss." Every Washington's Birthday, on the school's anniversary, there was a costume party, featuring a burlesque concert, with a printed program full of excruciating youthful humor. For the "Third Annual Riot" in 1889 it was announced that "the entire Opera of Faust will be given, with an augmented Orchestra, and Chorus of 1000, on a scale of magnificence never before attempted north of South Street." At one party Eakins appeared as Little Lord Fauntleroy; at another as the popular Scottish singer Harry Lauder, with a whitewash brush for a pouch, when he performed a Scotch sword dance; and at the "Sixth Annual Round-up," in 1891, as an Italian organ-grinder, when the program listed: "FINALE. By special request the 'Boss' will give an organ recital, supported by the whole orchestra and connived at by the audience." But sometimes there was real music; in 1889 the program announced "Miss Weda Cook, the Favorite Contralto, has kindly promised to sing for us."

The League's first curator, in charge of the premises, was George Reynolds. Older than the other students, he had served as a cavalry officer in the Civil War; his wife had died in 1882. About four years later Eakins painted him as *The Veteran*, a somber and moving portrait. He appeared in *The Swimming Hole* and in several motion photographs; in 1886 he had been a ringleader in the secession from the Academy.

When Reynolds left the League after the second season, his place as curator was taken by Franklin L. Schenck. A genuine bohemian, poetic and completely unworldly, he had no money, lived and slept in the League quarters, and was half-starved much of the time. Eakins would bring him food and pay him for posing. Schenck called himself Pythagoras, after the Greek mystic-mathematician-philosopher, and he composed burlesque histories of the League, which he recited at the anniversary parties. Gifted musically, he played the guitar and banjo, sang in English and German, and was a devotee of

144. THE BOHEMIAN
Portrait of Franklin L. Schenck. c. 1890. Oil. 23⅞ × 19¾. G 243
Philadelphia Museum of Art; Gift of Mrs. Thomas Eakins
and Miss Mary Adeline Williams

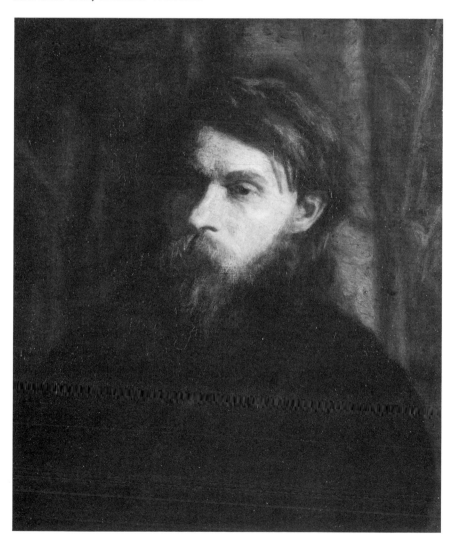

the opera. His fellow students loved him, as did Eakins. With abundant disorderly auburn hair and full beard, he was very paintable; Eakins portrayed him in six oils and a watercolor, and several photographs. In *The Bohemian*, one of Eakins' most romantic portraits, Rembrandt-like in tonality and color, his brooding air and dreamy eyes give him a curious resemblance to Paul Verlaine.

Many stories about Schenck were recalled by fellow students. At one of the anniversary parties he dressed as a dancer, with a ballet skirt, his feet squeezed into tight gold slippers. Quite drunk by the end of the party, he went to the street door to say goodnight to the others; as he stepped out, the door swung shut and locked, leaving him outdoors on one of the coldest nights of the winter. His friends wrapped him in an overcoat, took him up to Eakins' house, and put him to bed.

As the League's curator he was unpredictable. Once he hoisted the stove ashes to the roof and poured them down neighboring chimneys. When the Eakinses donated a discarded bathtub to the school, Schenck stuffed the wastehole with newspapers and filled the tub; which resulted in the bathwater's descending into the feedstore below.

After he left Philadelphia, Schenck settled in the country on Long Island, where like Thoreau he built his own house, lived alone, raised his own food, and painted romantic landscapes rather like Blakelock's. As his friend the poet Edwin Arlington Robinson wrote, the relation between him and Eakins was "an illustration of the broad-mindedness of the realist and the independence of the dreamer."

Out of the League came Eakins' closest friendship, with Samuel Murray, who joined the school in the fall of 1886 at the age of seventeen. Son of an Irish immigrant stonecutter, he showed such aptitude for modeling that he concentrated on sculpture. He soon became Eakins' favorite pupil, and in two or three years began to work in the Chestnut Street studio, first as Eakins' painting assistant, then as a sculptor in his own right. In 1891 he was elected vice-president of the League, and in the fall of 1892 Eakins made him his assistant in teaching. Sharing Eakins' studio for ten or eleven years, seeing him daily, and joining in his professional and personal life, Murray became like a son to the older man.

For Eakins the trauma of the break with the Pennsylvania Academy was too deep to be forgotten or forgiven. To his League pupils he often spoke bitterly about the institution and its directors, especially Coates, and about its methods of teaching. He enjoyed anti-Academy stories, particularly the one about Mrs. William P. Wilstach, a wealthy collector who planned to bequeath her collection and a large purchase fund to the Academy. As a stockholder she was entitled to free admission, but once the aged Academy secretary, for some pettifogging reason, refused to let her in unless she paid the twenty-five-cent

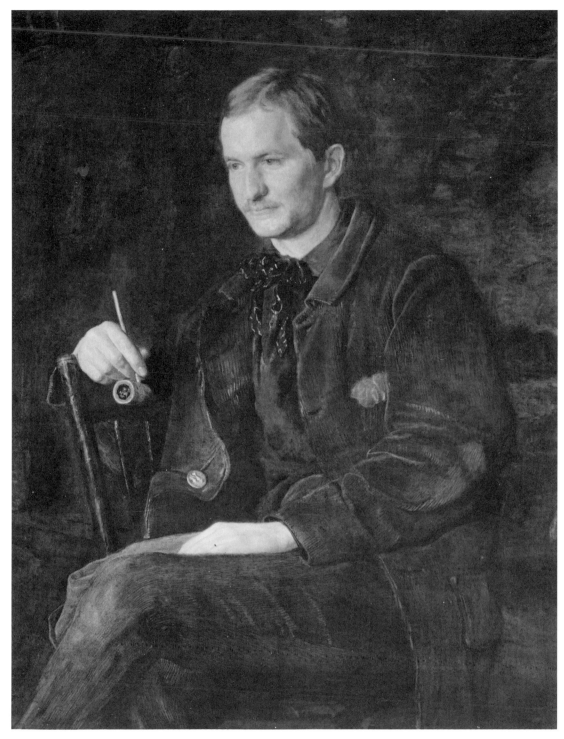

145. THE ART STUDENT
Portrait of James Wright. 1890. Oil. 42 × 32. G 258
Private Collection

in addition to his regular classes at the Pennsylvania Academy or the Philadelphia Art Students' League. The height of his activity was from the fall of 1885 through the spring of 1895.

For the Art Students' League of New York, during his second series of lectures, in December 1886, he offered to give a course of supplementary anatomy lectures with dissections. The League declined with thanks, because of lack of facilities for dissection. His basic anatomy course continued until, in the spring of 1888, the school, attempting to economize, arranged for another artist to take over the anatomy lectures and also teach a modeling class. But when the other artist broke the agreement in the fall, the League asked Eakins to resume his lectures. He replied: "The National Academy of Design has asked me to lecture. I am awaiting an answer to my terms and conditions. I should be glad to lecture at the League also if I can arrange convenient hours." In the rest of his letter (quoted earlier) he stated his intention to have a completely nude male model in lectures on the pelvis. The League Board of Control accepted his conditions and asked him to resume the lectures, which he did, probably in December. But the minutes of the board meeting of December 28 recorded the receipt of "a letter from Mrs. J. H. Tyndale complaining of the method of conducting the Anatomy Lectures. The Pres. reported on interview with Mr. Eakins in regard to this complaint to which Mr. Eakins replied by letter addressed to Board declining to change his methods." The following May it was "moved and seconded that the Anatomy lectures be discontinued for the coming year, but that in case enough applications are received to support the class that it be re-established." The school circular for the 1889–90 season said: "Artistic Anatomy. A course of lectures by a competent instructor will be arranged for if a sufficient number signify their desire to attend such a course." There is no record of Eakins' lecturing at the school that season or thereafter. Perhaps the students' interest in anatomy was not strong enough; or perhaps even the liberal League had its prudish element. (Next year in Augustus Saint-Gaudens' modeling class there was a question "as to the propriety of both sexes working from the same [nude] model." The League's president, after interviewing the sculptor, reported that the latter "had expressed the hope that the present arrangement would not be changed, but if it was thought best as a matter of expediency to do so, he would not oppose the Board." A different response from Eakins'.)

In his first lectures at the National Academy of Design, in discussing the pelvic region Eakins had held separate lectures for men and women, with a male model for the men and a female for the women. But in 1893 he did not divide the classes, lecturing on the pelvis before both men and women, with a completely nude male model. "At the lecture preceding the one in which the man was to appear nude," the New York *Sun* wrote two years later, "he warned the women of the fact, telling them that they might stay away if they

desired. He added that they would make a mistake if they did, as it was necessary to have the entire human figure displayed to give a proper understanding of its anatomy. There was nothing immoral in the sight of a nude figure, and he added that no one with a true desire for improvement would stay away. Several women did stay away from the lectures at which the model was nude in spite of his remarks, but there was no open outbreak at his departure, although a good deal of adverse comment was caused by it.

"Prof. Eakins is lecturing at the Academy this year [March 1895], as usual, with a model nude at certain lectures. Scarcely more than two or three women are present at these lectures. . . .

"Prof. Eakins's lectures are said to be the only ones in town at which nude models appear before both men and women."

But there had been repercussions. On December 19, 1894, Edwin Howland Blashfield, who as a student in Paris under Bonnat had known Eakins, and who was now chairman of the National Academy school committee, wrote: "Dear Eakins, The Council of the National Academy of Design have asked me to see or write to you before your next Anatomy Lecture in reference to the same. Some member (or members) of the council has been informed that certain scholars have felt offended at something in the matter or the manner of one of the lectures.

"The council appreciating the sincerity of your point of view, and the enthusiasm with which you treat your subject, is convinced that you will willingly avoid hurting anyone's feelings, and will be considerate of the point of view of any of your scholars if it differs from yours. This is simply a friendly request made to you, through me, by the council and school committee. . . . I feel pretty sure that if I can have a half hours talk with you we shall all agree. I wish you could also see Maynard (the former chairman) as we have talked together and agree almost entirely. You lecture on Thursday I think—Can you not come up and lunch with me on that day at my studio . . . at any hour you please or if you've no time to come up will you lunch with me near the Academy or at any rate will you let me know at what hour your train arrives (in case you can't meet me for lunch) and I will come to the cars and talk the matter over on the way to New York—I will stand just by the head of the train—I say this because I have grown old since you saw me and am not recognizable as the eighteen year old student who sat with you in the top gallery at the Grand Opera and who still has a Descartes which you once gave him."

Eakins replied: "Dear Blashfield, My next lecture comes on January 8th, and I shall be delighted on that day to come up to your studio from the Cooper arriving a little before 1 o'clock.

"I had no intention surely of hurting the feelings of any one & do not see just where can arise between me and my pupils, any serious or offensive difference of opinion in elemental descriptive anatomy.

"However, that we may know exactly what we are to discuss I would have you request the offended one [in his draft he crossed out "the lady" and "it must be a lady" and substituted "the offended one"] to write down carefully for us the exact offense.

"I do not expect to be in New York before my next lecture, and therefore cannot see Maynard in the meantime but I am always so glad to see him, and any arrangement you might make for all three of us meeting anywhere in New York would be very agreeable to me.

"I feel sure you will find there has been an entire mistake and nothing will remain of the incident but my renewal of an old friendship which I feel very warmly & of which I have so many very pleasant recollections."

There is a certain humor in this confrontation between Eakins the realist and the two representatives of academe, creators of highly idealized images of womanhood. In spite of the friendly tone of the letters, and the fact that Eakins was still lecturing at the Academy in the spring of 1895, this was the last season that he did so.

In early 1895 the Drexel Institute of Art, Science and Industry in Philadelphia engaged him to give twelve lectures on anatomy before the art class, consisting of about thirty young women and a dozen or more young men. With the third lecture, in mid-March, came trouble. "It is a rule of the school that nude models should not be exhibited to the young women," the New York *Sun* reported on March 18, "but whether this rule was made clear to Prof. Eakins when he was engaged is a matter of dispute. . . .

"Another custom among the students which played a part in this misunderstanding is their habit of referring to a model attired in a breech clout as 'nude.' Prof. Eakins uses the term literally as the dictionary gives it. On Thursday of last week, when the Professor, at the conclusion of his second lecture, announced that he would illustrate his third lecture on Monday with a nude model the students did not understand that the breech clout was to be dispensed with. Monday's lecture opened with no apparent falling off in the attendance of women students.

"The Professor, somewhat surprised at this, repeated his statement that he would exhibit an entirely nude boy in the course of the lecture. Some of the young women went out of the room, but the majority still seemed to misunderstand the situation. The model, a handsome young Italian of about 15 years, with a well-developed figure, was then introduced. He wore plenty of clothes when he first came on, but as the lecture proceeded one garment after another was removed.

"Miss Lyndalls, a teacher, who was in the lecture room in the capacity of a chaperone, becoming uneasy at the excited whispering among the young women, went over to the Professor and whispered a few words in his ear. The Professor looked surprised, and turning to the class reiterated his intention to

exhibit the model entirely nude. Still the young women seemed to misunderstand. . . . [When Eakins removed the model's robe], the boy stood before the class a nude model, as the Professor understood the expression. Very little attention was paid to the lecture after that, but the Professor went on in the most matter of fact way.

"The next day the young women and Miss Lyndalls drew up a complaint against the Professor and submitted it to President MacAlister. As a consequence, when the Professor, in ignorance of the indignation he had aroused, appeared at the institute to-day to deliver his fourth lecture he was told that the lectures would be indefinitely postponed.

"Prof. Eakins was very much surprised.

"'I have not used a draped model in ten years,' he said today, 'and I lecture right along before a mixed class at the National Academy of Design in New York. I gave explicit notice that I was going to exhibit the model entirely nude. There are always some ladies in a class like this one who are a little squeamish or over-modest, but it's not always the young and pretty ones, I can assure you. I only followed out my usual methods and have nothing to say in defence of those methods. Persons in a class like that must expect the model in the nude. It is necessary to have them so.'"

A Philadelphia newspaper played up the story, reporting that all the girls had left in a body. Eakins' friend Riter Fitzgerald, art and music critic of the Philadelphia *Item*, came to his defense: "Thanks to the enterprise of one of our journals, that talented artist and very modest gentleman, Professor Thomas Eakins, is the centre of attraction. He is accused of having, during his lectures on artistic Anatomy at the Drexel Institute, displayed a nude model before the horror-stricken gaze of the innocent male and female students, who had come there to study the Nude. . . . Professor Eakins had announced in advance on several occasions, that he would lecture on the Nude with an entirely nude model. . . . Yet the women came to the lecture, and only one left the class. . . . However, there are always timid people and foolish people. In this class I include the Trustees of the Drexel Institute as well as Mr. MacAlister. . . . If the Trustees . . . are going to 'play propriety' with Art, what kind of artists do they expect to turn out? . . . As it is, his dismissal by Mr. MacAlister was a very silly and unjust thing. . . .

"Professor Eakins tells me positively that there was never any arrangement with him forbidding the introduction of a nude model. 'I would not have consented to deliver the lectures had such a proposition been made,' he said. 'I never discovered that the Nude could be studied in any except the way I have adopted. All the muscles must be pointed out. To do this all drapery must be removed.'"

On the other hand, MacAlister told the Philadelphia *Times:* "It was distinctly understood between us that no model should be exhibited nude. We

will not allow the nude even when the classes are not mixed, as this one was."

What strikes one about these incidents is not only Eakins' persistence in showing the completely nude male model at certain lectures, but that in spite of his confrontations with the Pennsylvania Academy in 1886, and later with the Art Students' League and the National Academy in New York, he displayed innocent surprise each time the inevitable reaction occurred. To read his letter to Blashfield and his interviews about the Drexel Institute affair, one would think that the reaction had never happened before. This was of a piece with his disregard of popular opinion in painting such subjects as *The Gross Clinic, The Agnew Clinic,* and *The Crucifixion,* and with the uncompromising realism of his portraits. In his fifties he was as unyielding in adherence to his own principles as he had been at the beginning of his career.

Probably because of these confrontations, his lecturing ceased after the 1894–95 season, as far as we know, except at Cooper Union, where his class was made up entirely of women and the models were female; he continued to lecture there until 1898. The Art Students' League of Philadelphia had died in the early 1890s. Thus, as Eakins entered his fifties, his teaching, to which he had given so much time and energy for over twenty years, came almost entirely to an end.

From first to last Eakins' teaching was strictly naturalistic: anticlassical and antiromantic, concerned with the realities of the physical world. Rebelling against the outworn routine of the antique, it centered on the living human body, studied thoroughly, both scientifically and artistically—the most comprehensive artistic anatomical teaching of the time. As against pseudoclassic idealization, individual character was emphasized. The physical substance of figures and objects was stressed: their roundness, solidity, and weight, not merely their visual appearance. Intensive study of perspective aimed at precise understanding of three-dimensional space and the forms situated in it. Study of natural light and color was linked with their translation into pictorial light and color. By insistence on early painting as against drawing, students were encouraged to tackle all their problems at once: form, space, light, color, and technique. This naturalistic discipline was the most thorough teaching in America of the period, and in many ways more basic and vital than that of the École des Beaux-Arts.

The strengths of Eakins' teaching were bounded by its limitations. It was deep but not broad. Its concentration on naturalistic truths excluded many other elements of the work of art. There was no attention to the role of form, line, and color in creating design. There was little study of great art, past or present. The artists of the past whom he held up as examples (aside from the Greeks) were almost exclusively the seventeenth-century naturalists, particularly those of Spain. In nineteenth-century art his commendation, with some exceptions, was for the academics. He showed little awareness of current Eu-

ropean trends; in any case, he would probably have opposed them. And his observations on other art were confined mostly to technical matters. His students were given a thoroughgoing naturalistic education; what they made of it was up to them. Most of them, as was inevitable, absorbed the naturalistic truths, but missed the qualities of form and design that made his own art vital, but which he did not formulate—perhaps even to himself.

Looking over the list of his students, one finds a considerable number who later made reputations. Also, as with any teacher, a much larger number who did not. No teacher can create talent, let alone genius. Nevertheless, in the broader sense Eakins' influence on American art education was strong, salutary, and long-lasting; he helped to get rid of outworn concepts and methods, to establish study of the fundamentals of nature, and to stimulate an interest in contemporary realities.

Even though the Pennsylvania Academy, after he left, relaxed his thorough methods, his tradition was carried on by teachers who had been his pupils. Particularly through Anshutz, his naturalistic viewpoint was transmitted to Robert Henri and his younger colleagues George Luks, William Glackens, John Sloan, and Everett Shinn, all of whom studied with Anshutz at the Academy, and who later pioneered in the realistic revolt against academicism in the early 1900s. In their various ways these men looked upon him as an artistic ancestor.

In Eakins' own life, teaching had played an essential part. It had provided stimulus and outlet for his thinking about art. It had given him contacts with many young people, lasting friendships, and in the ten years at the Pennsylvania Academy, a position of responsibility and prominence in the art worlds of Philadelphia and the nation.

On the other hand, it had taken much of his time and energy, and at the height of his activity at the Academy, it had decreased his creative production. Lecturing on anatomy for two decades or more was a service to art education but taught him little that he did not know before. And the break with the Academy was a traumatic experience that had permanent effects on his life and his art.

The net result of Eakins' teaching on his art would be difficult to estimate; as with any dedicated teacher, it was a combination of positive and negative. But in any case, teaching obviously answered a basic need of his mind. It would be as hard to imagine him not a teacher, imparting knowledge to young men and women, as to imagine Winslow Homer not a solitary on the Maine coast, or Albert Ryder not a hermit in the city of New York.

Notes

When I was writing *Thomas Eakins: His Life and Work* (1933), in 1930 to 1932, Susan Macdowell Eakins made available much biographical material and information. Some information she gave me in conversations, of which I wrote records at the time. Some she wrote in numerous letters to me. She lent me many of Eakins' original letters, especially those to his father from France and Spain in 1866 to 1870; also his drafts and copies of later letters. All of these I copied. In other cases she copied his letters for me. Comparison of her copies with some original letters that have since become available shows that she sometimes omitted portions, or made minor changes in wording. Whenever an original letter has become available, I have quoted from it. Mrs. Eakins also lent me many original letters to her husband from other persons; these I copied.

All of the above-mentioned material, preserved by me, has been used in writing this book.

Designations for the kinds of information and documents furnished by Susan Macdowell Eakins are:

SME 1 Conversations with her
SME 2 Letters from her
SME 3 Eakins' original letters
SME 4 Her copies of his letters
SME 5 Letters from other persons.

After Mrs. Eakins' death in 1938 most of the original letters by her husband came into the possession of his former student Charles Bregler. Some of those owned by Bregler are quoted in Margaret McHenry's *Thomas Eakins who painted* (1946).

When I wrote my 1933 book I did not have access to Eakins' letters from Paris to his sister Frances, later Mrs. William J. Crowell. After her death these letters were divided among her children. One group of twenty was inherited by her daughter Dr. Caroline Crowell, who gave them to the Archives of American Art in 1974.

Another group is now in the collection of the Wyeth Endowment for American Art. Some individual letters had been divided so that some pages are in the AAA group, other pages in the Wyeth Endowment group. In almost all cases I have been able to reunite them.

Mrs. Eakins in 1930 had two notebooks in which Eakins, and after their marriage, she herself, kept a record of his works, with titles, dates, exhibitions, prices, and sales (if any). The first part of each notebook was in his hand, the later part in hers. In many cases both records gave the same information, and it is not known why Eakins made two of them. Together they listed most of his works, though not all; and the information about exhibitions was not complete. Mrs. Eakins lent me these notebooks, and I copied them in toto. Their present whereabouts is not known. In the following Notes these records are referred to when the information is needed for the text. The one designated "Record Book 1" was the longest, listing many more works. The other is designated "Record Book 2."

Between 1883 and 1887 Eakins kept itemized accounts of his income and expenses. These are now owned by Mr. and Mrs. Daniel W. Dietrich II, who generously made them available for copying by the Philadelphia Museum of Art. References to them are designated "Dietrich account books."

"G" numbers refer to Eakins' works listed in the catalogue in my 1933 book.

ABBREVIATIONS

Names of People

BE Benjamin Eakins
FE Frances Eakins
SME Susan Macdowell Eakins
TE Thomas Eakins

Institutions

AAA	Archives of American Art, Smithsonian Institution
AWCS	American Water Color Society
FHL	Friends Historical Library of Swarthmore College, Richard Tapper Cadbury Collection
Hirshhorn	Hirshhorn Museum and Sculpture Garden, Smithsonian Institution
MMA	Metropolitan Museum of Art
NAD	National Academy of Design
PAFA	Pennsylvania Academy of the Fine Arts
PMA	Philadelphia Museum of Art
SAA	Society of American Artists
WC	Wallace Collection, Joslyn Art Museum, Omaha
Wyeth	Wyeth Endowment for American Art

Publications

Hendricks Gordon Hendricks, *The Life and Works of Thomas Eakins*. New York, 1974.

Hendricks, *Photographs* Gordon Hendricks, *The Photographs of Thomas Eakins*. New York, 1972.

Hirshhorn *T.E. Coll.* *The Thomas Eakins Collection of the Hirshhorn Museum and Sculpture Garden*. Introduction and text by Phyllis D. Rosenzweig. Washington, D.C., 1977.

McHenry Margaret McHenry, *Thomas Eakins who painted*. Privately printed, 1946.

PMA *T.E. Coll.* Theodor Siegl, *The Thomas Eakins Collection*. Introduction by Evan H. Turner. Philadelphia Museum of Art, 1978.

Schendler Sylvan Schendler, *Eakins*. Boston, 1967.

Publications cited were published in New York unless otherwise indicated.

In the following Notes, references to the text are specified as follows: the first number is that of the page; the numbers following the colon are those of the lines on the page.

1. Childhood and Youth

1:23–26 Hendricks spelled "Cowperthwait" with a final "e". However, in the account books now owned by Mr. and Mrs. Daniel W. Dietrich II, TE included the name many times, always without the "e"; also SME in her letters to me. TE retained "Cowperthwait" or "C." until about 1870, occasionally omitting them in letters; he dropped them thereafter. He did not use them in signing his works, from 1870 on.

1:23 to 4:9 Chief sources: TE letter, 1893, probably to the *National Cyclopedia of American Biography;* SME 2, Aug. 29, 1931, and undated letters, 1930–31; interviews with Mrs. William J. Crowell, May 1931, and David Wilson Jordan, May 1930.

2:8–9 Joseph E. Haines, *A History of Friends' Central School*, Philadelphia, 1938, p. 39, 55–56.

4:15–16 Gordon Hendricks, "Eakins Slept Here," *Art News*, Jan. 1973, p. 71. Hendricks, p. 1, 4–5.

4:17–20 The statement in my 1933 book that the family moved to 1729 Mount Vernon Street when TE was about two years old, was based on information from SME, but is incorrect. The land was bought in 1853 for $289.50 by David C. Moore, bricklayer, who presumably built the house; house and land were sold on July 11, 1857, to Benjamin Eakins, "teacher of writing," for $4,800 (information from Seymour Adelman, 1970).

5:7–23 Letter from John L. Haney, President, Central High School, Dec. 18, 1930: "Thomas Cowperthwait Eakins was admitted to the Central High School in July, 1857, from the Zane Street Grammar School as a member of the 38th Class and completed the four years in the Principal Course, receiving the degree of A.B. in July, 1861. His name appeared regularly on the school records as Tom C. Eakins throughout the four years and he was graduated under that name.

"Interest will center in his work done as a school boy in the field of art. His teacher of Drawing at Central High School was Alexander Jay MacNeill (1832–1862) himself a graduate of the school who resigned in 1862 to accept a commission in the Navy and who died in the same year. During the eight

terms that Eakins came under the instruction of Prof. MacNeill the youth invariably received an average of 100 for his work.

"During his Freshman year he had a rating of excellent in Algebra and Phonography, good in Physiology and History, but only fair in English. His average for the year was 87.2, which was relatively a high rating and gave him a rank of #4 in a class of 42. During the Sophomore year he took up Latin, Geometry and Natural Philosophy, making high grades in all three. His averages during the two terms of that year were 87.5 and 93.7, winning him the rank of 8 and 5 in the respective periods. His English ratings improved during that term and he likewise achieved an average of 98 in a course in French.

"In the first term of his Junior year Eakins slipped back somewhat, especially in English, Latin and Mathematics. His average was 84.7, giving him a rank of #5 in a class of 30. As for conduct, he ranked #10 during that term. In the following term he improved materially in all subjects except Latin. His average of 88.4 won for him a rank of #4 in a class of 22; his conduct was so much improved that he was ranked No. 3.

"The Senior year was slightly disappointing. The low ratings in Latin continued, though he achieved 71 in the final term. The English marks were better. His Senior averages were 87.7 and 92.8 in the respective terms and his rank was 6 in the first term and 7 in the second. His final average was 88.4 and his graduating rank was No. 5. Only 14 members of the class were graduated."

5:12–14 *General Catalog of the Central High School of Philadelphia, from 1838 to 1890,* Philadelphia, 1890.

5:25–42 The drawings of gears and of Benjamin's lathe, and two of the romantic drawings, are now owned by the Hirshhorn Museum; the one of a camel and rider by Mr. and Mrs. Daniel W. Dietrich II. In addition, in 1930 SME owned the three drawings of an icosahedron, of a pump, and of the Crawford statue, on all of which I made notes; their present ownership is unknown.

7:2–4. 8:2–9 SME 1.

7:22–27 SME 1, and Mary Adeline Williams, 1930.

7:30–36 Letter, Schmitt to TE, May 1, 1866. Hirshhorn.

8:25–27 Nicholas B. Wainwright, "Education of an Artist," *Pennsylvania Magazine of History and Biography,* Oct. 1973, p. 509.

8:27–28 SME 1.

8:33 to 9:1 SME 1. The outdoor drawings referred to were owned by SME in 1930, and seen and noted by me; present whereabouts unknown.

9:3–4 SME 1. The Fussell painting, owned by SME in 1930, is now in the PMA.

9:7 ff The most complete and accurate account of the PAFA school and TE's relation to it is Maria Chamberlin-Hellman's doctoral dissertation, "Thomas Eakins as a Teacher." I am indebted to Mrs. Chamberlin-Hellman for her generous permission to read her dissertation and to draw on it for a number of facts.

19:19–28 E. V. Lucas, *Edwin Austin Abbey,* 1921, vol. 1, p. 11, 13.

9:35–38. 10:8–9 Sigma [Earl Shinn], "A Philadelphia Art School," *Art Amateur,* Jan. 1884, p. 32.

10:2–5 McHenry, p. 41, 49, and Hendricks, p. xxv, 13, 15–16, 27, 42, 94, 104, 121, stated that Christian Schussele was TE's teacher at the PAFA. This has been repeated in other publications. But John Sartain, chairman of the Committee on Instruction for many years, and Schussele's close friend, wrote in *The Reminiscences of a Very Old Man,* 1899, p. 250: "There had never yet been [previous to 1868] in the Academy an organized school with regular paid instructors." Schussele, born in Europe, returned there in 1865 and remained until 1868, when by arrangement with Sartain he was appointed Professor of Drawing and Painting in the school. TE was abroad from 1866 to July 1870, and after he returned, the school was suspended from 1870 to 1876. In biographical accounts of Schussele I have found no statement that he was a teacher at the school before 1868. The 74th Annual Report of the PAFA, for 1878–1880, recording Schussele's death in August 1879, said that he had been in charge of classes for eleven years.

Schussele was among a number of older artists who had life-class privileges at the PAFA in the 1860s. TE may have received some informal criticisms from him, as well as from other older artists in the classes; but there is no record of this. So it cannot be said that TE was a student of Schussele's in the usual sense.

In giving biographical information about himself in later years, TE always said that he was a pupil of Gérôme, Bonnat, and Dumont, never of Schussele. In 1930 I wrote SME, who had been a pupil of Schussele in the 1870s, asking if TE had studied under either Rothermel or Schussele, and she replied: "He did not study under Rothermel or Schussele."

In a letter from Paris to Emily Sartain, in Italian,

313

Notes to Pages 5–10

Dec. 16, 1866, TE spoke of "mio caro signor mae-stro," by which he evidently meant Schussele, although he gave no name. But he was writing the daughter of Schussele's close friend, and in Italian, a language which led him to uncharacteristically romantic statements. In another letter from abroad (Oct. 29, 1868) he mentioned Schussele disparagingly.

A full account of Schussele's European background, teaching principles, and connection with the PAFA, is "The Context of the Pennsylvania Academy: Thomas Eakins' Assistantship to Christian Schuessele" by Ronald Onorato in *Arts Magazine*, May 1979, p. 121–129. Mr. Onorato uses the spelling that Schussele himself used in signing his works; I am retaining the spelling generally used in Philadelphia.

10:13–15 From the "Regulations" on TE's card of admission to the life class (see the note following).

10:16–25 Both cards of admission are now owned by the Hirshhorn Museum. The second, "to draw from the life model," and so on, is undated but numbered 86. The PAFA Life Class Register of 1862–63 lists TE, on Feb. 23, 1863, as holding ticket number 86.

Hendricks, p. 14, said: "Not until shortly before he left for Paris—probably in 1865—was he allowed to go to the life classes." The PAFA's *In This Academy*, 1976, p. 266, assumes the same, based on the fact that in 1856 parental approval was required for minors to draw from the female model. But other life-class students were under twenty-one. In any case, the Life Class Register establishes the date of TE's inclusion. See Chamberlin-Hellman, note I 159.

As to when TE left the PAFA, a letter of Dec. 18, 1866, owned by the Hirshhorn Museum, from his fellow student Charles L. Fussell to TE in Paris, describing conditions in the PAFA life class, indicates that TE had been studying there recently.

10:29–33 *Philadelphia Press*, Feb. 22, 1914, p. 8.

10:36 to 11:6 The twenty-one charcoal drawings include twelve of nude figures and six of parts of nude figures. None are signed or dated. All were owned by SME, who gave nine to the PMA. She told me she thought some were done at the PAFA before TE went abroad, and some in Paris; but she had no definite information about this. The nine in the PMA are on French papers, but such papers were available in the United States and preferred by American artists.

Regarding the possibility that they, or some of them, were done in Paris: at the École des Beaux-Arts, from late Oct. 1866 to late March 1867, TE drew but did not paint. Thereafter he painted, and probably did some drawings, until he left Paris in Nov. 1869. From these almost three seasons of painting, only eleven oils (presumably done in Paris) have been preserved. Of these only six are of nudes, and of these six none show the whole figure: five are of heads only, and one shows part of a leg. Four of the five heads (G 24–27) have been cut down from larger canvases. It seems probable that TE did this to avoid the problem of bringing nude paintings through the United States customs. He would have had the same problem with drawings of the nude. It is unlikely that, although bringing back no oils of the whole nude figure, he would bring back drawings of the nude, entirely realistic and explicit.

In the PMA *T.E. Coll.*, p. 60–62, the dating suggested by Theodor Siegl is: G 6, 6A, and 8, 1863–66, at the PAFA; G 7, 1866–1868; and G 1 to 5, 1874–1876, at the Philadelphia Sketch Club, where TE gave criticisms to evening life drawing classes, held twice a week during two years, late spring 1874 to early 1876. Siegl's suggested dates were based on the relative skill of the nine drawings; he felt that G 1 to 5 were the most mature, suggesting a date later than the "relatively inexperienced and labored figure paintings" *A Street Scene in Seville*, 1870, and *Kathrin*, 1872.

The Seville painting was TE's first full-scale composition, and involved problems (figures and buildings, outdoor light and color, and technical problems in handling oil) much more complex than his black and white life drawings. His struggles with these problems are fully documented in his letters to his father while painting the picture (see Chapter 3). *Kathrin* was his first full-scale figure painting, and presented far more complex problems than his drawings. But in the early 1870s he was also painting more skillful and mature oils (e.g., *Home Scene*; *Max Schmitt*, 1871; *Elizabeth Crowell and Her Dog* and *The Pair-oared Shell*, 1872), which successfully solved problems more difficult than in his drawings. Hence a comparison in skill between the life drawings and the 1870 and 1872 paintings, and a consequent later dating of the drawings, to 1874–1876, does not seem valid.

Siegl also stated that the overhead light source in G 1 to 5 indicates that they were probably drawn in an evening class such as the Sketch Club's. But the life class in the old PAFA building in the 1860s was also an evening class, and was held in the basement, and the lighting was artificial and overhead, as

shown in a drawing by Fussell in his letter to TE, Dec. 18, 1866 (see note to 10:16–25).

A mature drawing not owned by the PMA, G 18, has on its verso a drawing of an antique cast. The Sketch Club class was for drawing from life, not from the antique. In TE's letters of 1874–1876 and the published accounts of the Sketch Club class there is no reference to his drawing there.

Going back to TE's study at the PAFA, he had been admitted to draw from life by Feb. 23, 1863. He evidently continued at the PAFA through the 1865–66 season, when he was twenty-one—old enough to have attained skill as a draftsman. He probably drew from life at the PAFA for three and a half seasons; a longer period than that of his drawing at the Beaux-Arts, or of his teaching at the Sketch Club. At the PAFA he was a student, drawing; at the Sketch Club he was a teacher. For all these reasons, it seems to me most probable that these drawings were done at the PAFA in 1863–1866. However, we must recognize that there is no definite evidence, internal or external, as to when and where these drawings were made.

13:1–6 Two cards of admission to Jefferson Medical College are owned by the Hirshhorn Museum. One reads: "Practical Anatomy / By Joseph Pancoast, M.D. / Admit Mr. T. C. Eakin" [sic]; and on the reverse, written: "Session 1864 & 65 / Wm. H. Pancoast M.D. / Demonstrator." The other: "Anatomy / by / Wm. H. Pancoast M.D. / For Thomas C. Eakins"; and on the reverse, written:

"Spring Session / Wm. H. Pancoast M.D. Demonstrator / per B. C. Andrews M.D." (The numbers "1864 & 1865" on the face of the second card are in Charles Bregler's hand, and may be incorrect.) Joseph Pancoast was professor of anatomy at Jefferson from 1847 to 1874; William H. Pancoast was demonstrator of anatomy at Jefferson from 1862 to 1874, when he succeeded his father as professor of anatomy.

13:12–14 Cecilia Beaux, *Background with Figures*, 1930, p. 95: "He is said to have hesitated in his choice of a profession. Should he be a surgeon or an artist? He decided on the latter." When I asked SME in 1931 if she thought this was true, she replied: "He was so serious about study that he very likely contemplated both professions." I have found no confirmation of Miss Beaux's statement elsewhere.

14:26–28 To Emily Sartain, undated, probably 1866. PAFA.

15:4–5 Samuel Murray to LG, July 23, 1931. McHenry, p. 9, quoting Murray's memory of what "Eakins had always said."

15:8–21 To Emily Sartain, Sept. 18, 1866. PAFA.

15:27–28 To Emily Sartain, Sept. 17, 1866. PAFA.

15:30 to 16:17 To Mrs. BE, Oct. 1, 1866. SME 3.

16:18 To Mrs. BE, Oct. 6, 1866. SME 4.

2. France, 1866 to 1869

17:12–13 To BE, Sept. 20, 1867. SME 3.

17:25–28 Letter to Shinn from John Hay of the American Embassy, Sept. 25, 1866. FHL.

17:30–31 TE to John Sartain, Oct. 29, 1866. PAFA.

18:2–7 TE's notebook with his copies of letters by Lenoir, Bigelow, and Gérôme. PMA, gift of Seymour Adelman.

18:7–8, 13–26 To BE, Oct. 13, 1866. SME 4.

18:8–12 Letter, Nov. 10, 1866. FHL.

18:27–28 To BE, Oct. 26, 1866. Hirshhorn.

18:30 to 21:2 To BE, Nov. 1, 1866. SME 3. TE's circumstantial account of his reception by the students proves that Adam Amory Albright's account in his book *For Art's Sake*, 1953, quoted by

Hendricks, p. 32–33, is a fabrication.

21:4–13 Letter, Jan. 3, 1867. FHL.

21:15–25 Probably to BE, Nov. 26, 1866. SME 4.

21:26–40 To BE, Nov. 11, 1866. SME 4. TE was mistaken about Gérôme's age; he was forty-two.

21:41 to 22:3 SME to Henry McBride, Sept. 28, 1917: "I think a better rendering of Gerome's remark is 'Eakins will never learn to paint, or he will become a very great painter.' I know from what my husband said & wrote of his early studies, that he floundered about in his struggle to understand, unwilling to do clever or smart work or deceive himself by dash" (McBride papers, courtesy of Daniel

Catton Rich). She wrote me in 1930 to the same effect.

23:19–20 The statement in my 1933 book, p. 14, 15, that TE "had to go once more through the grind of drawing from the cast" before being promoted to the life class, was incorrect.

23:21–31 To BE, March 12, 1867. SME 4.

23:32–35 Probably to BE, March 21, April 5, 1867. SME 4.

23:35–36 Charles L. Fussell's painting *The Young Art Student*, probably c. 1865, PMA, shows TE painting, with a palette. But no oils before 1867 are known. Mrs. Lucy L. W. Wilson told me in 1930 that TE told her that he did not begin to paint until he was in his twenties. (Winslow Homer, an illustrator from the age of twenty-one, did not paint regularly until he was twenty-six.)

24:11 to 25:2 To BE, Sept. 20, 1867. SME 3.

25:10–21 Probably to BE, Sept. 21, 1867. SME 4. The date may be incorrect, for he had written to BE on Sept. 20.

25:27–41 To BE, Nov. 1867. McHenry, p. 9. Also SME 4, incomplete.

25:42 to 27:12 To BE, Jan. 17, 1868. SME 4.

27:13–15 To BE, undated, early 1867, and Sept. 8, 1868. SME 4.

27:17–23 To BE, March 6, 1868. SME 3.

27:23–26 Probably to BE, April 1868. SME 3. I have found no record of how long he studied with Dumont.

27:27 to 28:6 To FE, Oct. 30, 1866. SME 3.

28:7–8 To FE, Nov. 13, 1867. Wyeth. To BE, May 9, 1868. Mr. and Mrs. Daniel W. Dietrich II.

28:22–23 To BE, Sept. 28, 1869. SME 4.

28:29 to 29:8 To BE, May 9, 1868. Mr. and Mrs. Daniel W. Dietrich II.

29:16–25 TE's notebook, 1870. See notes to p. 59.

29:34–36 SME, in reply to my question, "Did he study under Barye?" said: "No. He tried to but didn't like the reception he received from a young man—what he was supposed to do." There is no mention of Barye in TE's known letters from Paris. In giving biographical information, TE named as his teachers Gérôme, Bonnat, and Dumont, but not Barye. Samuel Murray told me in 1931 that TE had studied with Barye at the Jardin des Plantes, but many of Murray's statements have proved to be inaccurate. The obituary of TE in the *Philadelphia Inquirer*, July 2, 1916, based in part on information from Murray, said: "He studied animal sculpture with Barye, going with him to the Jardin des Plantes"; but the obituary contains several errors, such as: "Sargent and Mr. Eakins were fellow students under Bonnat."

30:10–26 To BE, May 31, 1867. SME 3.

30:42 to 31:43 To BE, March 6, 1868. SME 3. I have omitted the following between "and profits by them" and "Then the professors": "The lummix that never wondered why they were there rows his tub about instead of sailing it and where he chances to see one of Nature's marks why he'll slap his tub into the mud to make his mark too but he'll miss most of them not knowing where to look for them. But if more light comes on to the concern that is the tide comes up the marks are all hidden and the big artist knows that Nature would have sailed her boat a different way entirely and he sails his as near as he can to how Nature would have sailed her's according to his experience and memory and sense. The stick-in-the mud shows some invention he has for still hunting these old marks a plomp line to scrape the shore and he flatters himself with his ability to tell a boat mark from a musrat hole in the deepest water, and then he thinks he knows nature a great deal better than any one else. I have seen big log books kept of the distances made in different tacks by great artists without saying a word about tide or wind or anything else and the length of a certain bone in the leg of a certain statue compared to the bone of the nose of a certain other one and a connection with some mystic number the whole which would more mystify the artists that made them than any one else."

32:1–20 TE seldom put his address on letters to family and friends, but he always told them of changes of his living quarters, often in detail. Information about his successive quarters, dates of moving, rent, etc., is given in his letters to the following: *1866*, John Sartain, Oct. 29; Mrs. BE, Nov. 8. *1867*, William J. Crowell, July 18; BE, Sept. 20 and Nov., n.d.; Mrs. BE, Nov., n.d.; John Sartain, Nov. 24. *1868*, Mrs. BE, July 24; William J. Crowell, Sept. 21. *1869*, FE, March 26; Mrs. BE, April 1 and 14; BE, May 14; FE, Oct. 15.

32:4–5 To Mrs. BE, Nov. 8, 1866. Hirshhorn.

32:10–12 To FE, March 26, 1869. AAA.

32:21–22 To BE, March 6, 1868. SME 3.

32:27–29 To BE, date unknown. SME 4.

32:32–34 PAFA, TE memorial exhibition, 1917, p. 8.

32:35–38 To Mrs. BE, April 14, 1869. AAA.

32:38 to 33:2 William Sartain's Diary; unpublished manuscript in PMA.

33:3–4 To FE, "Good Friday" 1868. AAA.

33:5–11 Probably to BE, Jan. 16, 1867. SME 4.

33:13–21 To BE, May 2 or 3, no year. SME 3.

33:24–28 To BE, March 17, 1868. SME 3.

33:29–31　To FE, "April Fool's Day" 1869. AAA.

33:33–39　To BE, March 13, 1867. SME 4.

33:40–41　To FE, June 12, 1867. AAA.

33:41 to 34:10　McHenry, p. 13–14: "The Crowell family remembered a walking trip on the continent; Will Crowell, Bill Sartain and Tom Eakins tramped thru Germany, Switzerland, and perhaps France. They would start out with their knapsacks, separate, go different ways and meet again later on. The only record of the trip is an undated letter from Switzerland, written to his father from Zermat by Tom." (Letter quoted by McHenry, in part.) Page 14 contains a detailed itinerary of the Swiss trip, evidently based on other sections of this letter. William Sartain's Diary, PMA, p. 14, says only: "In 1867 I went over to Paris [from Philadelphia] to see the Great Exposition visiting England after a trip to Switzerland with my old classmates Thomas Eakins & Wm. J. Crowell." The Diary does not mention visiting Germany or France. The Crowell family may have been referring to the French Alps and the German region of Switzerland. Sartain came to Paris in late July (TE letter to William Crowell, July 18, 1867, AAA), and TE was there on July 23 (letter to FE, that date).

34:22–26　To FE and BE, Nov. 1, 1867. Wyeth.

34:25　To FE, Nov. 13, 1867. Wyeth.

34:33–35　To Mrs. BE, Nov. 8 and 9, 1866. Hirshhorn. Entire letter published and illustrated in the PMA *Bulletin*, May 1944, and in Hirshhorn *T.E. Coll.*, p. 35–37.

34:36–37　McHenry, p. 4–6, quotes two letters as addressed to "Dear Daddy" and "Dear Daddy and Maggie." From the contents and tone it is obvious that "Daddy" should be "Caddy," TE's little sister Caroline. TE always addressed his father as "Dear Father"; in speaking of him to other family members he called him "Poppy." Hendricks, p. 26–27, quoted the second letter as addressed to "Dear Daddy and Maggie"; and in a note, p. 293, gave the date as May 1876.

36:7–8, 16–22　To BE, March 17, 1868. SME 3.

36:9–12　To BE, May 24, 1867. Mr. and Mrs. Daniel W. Dietrich II.

36:12–16, 25–32　To BE, Sept. 20, 1867. SME 3.

36:39 to 37:2　To FE, Sept. 22 or 24, 1867. Wyeth.

37:6–9　To FE, July 23, 1867. Wyeth.

37:12–16　To FE, "Good Friday" 1868. AAA.

37:19–20　To FE, undated, probably spring 1867. Wyeth.

37:20–24　To FE, undated, probably early summer 1867. AAA.

37:30–32　To FE, undated, probably early May 1867. AAA.

37:33 to 38:4　To FE, June 12 and 19, 1867. AAA.

38:5–7　To FE, Oct. 29, Nov. 12, Dec. 2, 1868. AAA.

38:9–27　To FE, Nov. 13, 1867. AAA.

38:35 to 39:14　From FE, evidently to Mrs. BE, July 7, 1868. SME 4.

39:19–28　To Mrs. BE, July 24, 1868. Mr. and Mrs. Daniel W. Dietrich II.

39:29–43　The account in my 1933 book, p. 24–25, of TE's travels with his father and sister in 1868, based on scanty information from SME and Mrs. William J. Crowell (Frances Eakins), was incorrect. The present account is based on Hendricks, p. 48–50, which is based on Frances Eakins' diary of the travels owned by Hendricks.

40:2–3　TE sailed Dec. 6, 1868, for New York (to FE, Nov. 12 and Dec. 2, 1868. AAA).

40:6–13　To BE, undated, probably late Nov. 1868. AAA.

40:13–17　To FE, Nov. 12, 1868. AAA.

40:18–20　William Sartain's Diary. PMA.

40:21–31　To Emily Sartain, Oct. 30, 1866. PAFA. The complete Italian text of this letter is given in Hendricks, p. 294–295. It was TE's first letter to Emily from Paris, not the one quoted by Hendricks, p. 27, 293.

40:33 to 41:13　To Emily Sartain, Nov. 16. PAFA.

41:19–21　To FE, undated, probably early May 1867. AAA.

41:23–39　To Emily Sartain, Dec. 20, 1867. PAFA.

41:41–42　To FE, Jan. 31, 1868. Mr. and Mrs. Daniel W. Dietrich II.

42:3 to 43:16　To FE, March 11, 1868. Wyeth.

43:18–19　To Emily Sartain, June 11, 1868. PAFA.

43:24–29　To FE and Mrs. BE, Oct. 29, 1868. AAA.

44:6 & To Emily Sartain, March 7, 1886. PAFA.

44:9–10　To Emily Sartain, undated, probably March 25, 1886. PAFA.

44:24 to 45:16　To William J. Crowell, Sept. 21, 1868. Wyeth.

45:18–24　To FE, "Good Friday" 1868. AAA.

45:24–25. 45:29 to 47:12　To FE, "April Fool's Day" 1869. AAA.

46:23–24　Gérôme, *Dance of the Almeh*, 1863,

draft was lost by 1945 (correspondence with Bregler and McHenry in MMA files). TE's letter was evidently written to Gérôme, when he sent him two oils, probably *Pushing for Rail* and *Starting out after Rail*, and a watercolor, in May 1874. The full text of the McHenry translation is: "I am sending you two little paintings and one water color. The first represents a delightful hunt in my country, a hunt arranged so that one arrives at the edge of the marsh two or three hours before the height of the tide. As soon as the water is high enough for the boat to be floated on the marsh, the men get up and begin the hunt. The pusher gets up on the deck and the hunter takes a position in the middle of the boat (so as not to have his head buried), the left foot forward a little. The pusher pushes the boat among the reeds. The hunter kills the birds which take wing. I show in my first boat the movement when a bird starts to rise. The pusher cries, 'Mark,' and being on the pusher's deck, stiffens up and tries to stop the boat or at least to hold it firmer. He gains a new equilibrium, for the inertia of the boat makes considerable pressure against the thigh, pressure which he resists with his weight. The pusher always cries out on seeing birds, for during most of the season when the reeds are still green, it is he who sees first because of the more elevated position of the deck. He often sees it and the hunter doesn't see it at all, the reed is so high and thick. I have chosen to show my old codgers the season when the nights are fresh with autumn, and the falling stars come and the reeds dry out [illegible words]. But the hunter cries out just the same from habit. When a bird is killed, the hunter fires his gun if he is going to discharge his second barrel and then the pusher, having well in mind the place where the bird fell, goes there and picks up the dead bird by means of his net. Sometimes in going to see the dead bird, he sees a number of birds take the wing and there will finally be a dozen dead birds shot down before the pusher can reclaim one, although a person can kill only one at a time. It is principally in recalling well the exact locations of all our new ones alike after just one turn of the head that the good pushers distinguish themselves.

"The pusher's pole is eleven feet long. At one end is a fork to deal with the roots and the reeds and to prevent them from striking too hard in toiling through. At the other end is a knob so that the pole will not slip from between the hands. The pusher always looks ahead and plants his pole in such a way that the resistance of the boat will be equal against both his feet. Thus the least extra pressure on one or the other foot will turn the nose of the boat to the opposite side."

93:16–20 In the *American Art Journal*, May 1973, p. 41–43, Ellwood C. Parry III and Maria Chamberlin-Hellman point out a resemblance between *Will Schuster and Blackman Going Shooting* and a chromolithograph, *Rail Shooting on the Delaware*, published by John Smith, Philadelphia, in 1866. They do not express a definite opinion that the print was the origin of TE's painting. I believe that the resemblance was probably coincidental, for these reasons: the scene and action depicted by TE were entirely familiar to him, and the attitudes of the hunter and pusher were common in rail-shooting; TE had already painted the hunter in the same attitude among the six figures in *Pushing for Rail* two years earlier; the pusher's attitude in the print is not the same as in TE's two paintings; and the pusher in the print is a white man, in *Will Schuster* a black.

94:3–5, 21–27 To Shinn, Jan. 30, 1875. FHL.

98:35–39. 108:11–15 Charles Bregler, "Thomas Eakins as a Teacher," *The Arts*, March 1931, p. 384.

102:33–36 From the early 1870s on TE signed and dated certain full-length portraits and figure pieces by inscribing his name and the date as if written on the floor, and therefore seen in perspective, instead of on the flat surface of the canvas. The only surviving drawing for these signatures is that for the portrait of Leslie W. Miller, in which he first drew the signature and date at a right angle to the eye, then squared them off, and projected them in perspective, to be transferred to the canvas, probably by tracing. All these inscriptions are in upper and lower case, and in precise, flowing Spencerian style reminiscent of his father, the writing master. Such inscriptions appear in the following oils: *Kathrin*, 1872; *Elizabeth at the Piano*, 1875; *Baby at Play*, 1876; *Dr. John H. Brinton*, 1876; *The Pathetic Song*, 1881; *John McLure Hamilton*, 1895; *The Cello Player*, 1896; *Professor Benjamin H. Rowland*, 1897; *The Dean's Roll Call*, 1899; *The Thinker*, 1900; *Leslie W. Miller*, 1901; *Sebastiano Cardinal Martinelli*, 1902; *Archbishop William Henry Elder*, 1903; *Suzanne Santje*, 1903; *Robert C. Ogden*, 1904; *Professor William Smith Forbes*, 1905; *Dr. William Thomson*, 1907.

Still more frequently, in over thirty paintings, TE inscribed his signature and the date on some object in the picture rather than on the plane surface of the canvas, thus incorporating them in the three-dimensional composition.

However, when the composition did not lend it-

self to this practice, as in his pictures with blank, objectless backgrounds, such as head and bust portraits, he signed and usually dated them on the surface of the canvas, or on the verso, without projecting them in three dimensions.

108:27 ff The most complete coverage of TE's watercolors is Donelson F. Hoopes, *Eakins Watercolors*, 1971.

113:15–17 To FE, Sept. 22, 1867. AAA.

113:17–19 Henry Wadsworth Longfellow, *The Song of Hiawatha*, 1855, V, "Hiawatha's Fasting."

113:22–32 To Shinn, Jan. 30, 1875. FHL.

113:32–33 Letter from Charles Bregler to me, March 22, 1943. TE painted an oil version of the subject. Hirshhorn *T.E. Coll.*, p. 53, 54.

113:39 to 114:27. 116:11–39 SME 5. The originals of both letters were lent to me by SME.

116:4–8 The MMA watercolor *John Biglin in a Single Scull* was shown in the MMA memorial exhibition, 1917, lent by SME. The catalogue stated: "Originally painted for and presented to the artist's master. This is Eakins' copy of the original." This information must have been given by SME. It was repeated in the catalogue of the PAFA memorial exhibition, 1917–18. When the MMA bought the watercolor from SME in 1924 she wrote Bryson Burroughs of the MMA: "My husband refused always to sell it, but finally gave me permission to use my judgement regarding his pictures. I have always explained that this water-color, is a replica of the one he gave Gerome" (letter, May 22, 1924, MMA). She gave me the same information in 1931. Because the watercolor shows the rower at the end of his backward stroke, instead of the intermediate position described by Gérôme in his 1873 letter, it is evidently a replica of the second watercolor sent to Gérôme.

In the *Gazette des Beaux-Arts*, April 1969, Gerald M. Ackerman stated that the first watercolor sent to Gérôme was returned by him to TE. But Gérôme's letter of May 10, 1873, proves that it was a gift, which Gérôme accepted. Ackerman also said that Gérôme returned the second watercolor to TE, who exhibited it at the American Society of Painters in Water Colors, spring 1874, and that it is the one now owned by the MMA. But TE shipped the second watercolor to Paris in May 1874, and the ASPWC exhibition was in Feb. 1874. In this exhibition TE showed *John Biglin, of N.Y., the Sculler*, priced at $100, no record of sale. This was probably the MMA watercolor.

118:7–10, 14–27 To Shinn, April 2, 1874, and Jan. 30, 1875. FHL.

118:28–33 TE's Record Books list four oils with the notation "Paris": "Shooting Rail on the Schuylkill Flats. Paris"; "Starting out after Rail. Oil. Paris"; "Sail boats racing on the Delaware. Paris. Goupils"; "Whistling Plover. Oil Painting. Exhibited in Paris & sold by Goupil $60. gold."

The first was probably *Pushing for Rail*, dated 1874. TE's letter to Gérôme (McHenry, p. 39–40), date unknown but evidently spring 1874, says: "I am sending you two little paintings and one watercolor. The first represents a delightful hunt in my country. [Description, as above, of hunting rail birds; the subject corresponds with *Pushing for Rail*.] . . . I have chosen to show my old codgers the season when the nights are fresh with autumn . . . and the reeds dry out." No other known rail-shooting oil until 1876 fits this description. TE's letter to Shinn, April 2, 1874: "I will soon have my rail shooting picture done, and maybe it would be a good thing for me to bring it to New York and show it to two or three dealers before I send it away. I send it to Paris with my other things in May." The two oils sent in May 1874 were shown in the 1875 Salon.

J. Alden Weir wrote SME Dec. 15, 1917, about *Pushing for Rail*, which had been purchased by the MMA at his suggestion in 1916, that he had recognized the painting as being shown in the Salon, from a description given him by TE's friend Dagnon-Bouveret. "[He] and his artist friends thought that Eakins ought to have received a first medal and were greatly disappointed that he did not get his reward; it shows the impression it left in their minds. The canvas was hunting rail birds; the remarkable character of the figures made me realize it was the one he spoke of. I told Eakins this, which pleased him very much" (copy of letter owned by the MMA).

The *Revue des Deux Mondes* described both of TE's paintings in the 1875 Salon as "two hunters in a boat," which would not be entirely correct for *Pushing for Rail*. But the critic's memory could have been at fault.

The other "little painting" sent to Gérôme in May 1874 and exhibited in the 1875 Salon was evidently *Starting out after Rail*, dated 1874, 24 × 20, now owned by the Museum of Fine Arts, Boston, which fits the critic's description. Both of TE's Record Books list an oil *Starting out after Rail*; one entry saying "Paris," the other, "Phila. Acad. F. A. Sold to unknown 1915–1916. $500." The Boston painting was sold to Janet Wheeler from the PAFA 111th annual exhibition, 1916.

About the identity of the four paintings sent to Gérôme in early 1875, and referred to in TE's letter to Shinn, April 13, 1875, the painting listed in TE's Record Book as "Sail boats racing on the Delaware. Paris Goupils" must be the PMA oil of that title, dated 1874, 24 × 36; there is no other known painting of that subject. This was probably "the big one." "The nigger" must be the oil version of *Whistling Plover*, sold by Goupil in Paris; present ownership unknown. "The drifting race" must be one of the two oil versions of *Ships and Sailboats on the Delaware*, both dated 1874. TE had described the watercolor version of this subject as "a drifting race" in his letter to Shinn, Jan. 30, 1875. The two oils are practically identical in subject, composition, and size, and if one was sent to Paris, TE might well have painted a replica, as he did of the second watercolor he gave to Gérôme. Neither oil was listed in his Record Books. "The rail shooting" remains unidentified; the only known rail-shooting oil before 1876, besides *Pushing for Rail*, is *The Artist and His Father Hunting Reed-birds*, undated; the listing of it in TE's Record Book does not mention Paris, but this may have been an oversight. Or perhaps "the rail shooting" is a painting that has disappeared.

In the PMA *T.E. Coll.*, p. 63, Theodor Siegl suggested that the *Starting out after Rail* sent to Gérôme in early 1875 was the PMA's unfinished, undated *Sailing*, 31⅞ × 46¼. (*Sailing* is not listed in either of TE's Record Books.) However, it seems unlikely that TE would send Gérôme a large unfinished painting, and one of the same subject as the small Boston Museum oil *Starting out after Rail* which he had evidently sent the previous year.

118:34 to 119:18 To Shinn, April 13, 1875. FHL.

118:36 "Feeze," usually spelled "faze," means to worry.

119:20–25 M. F. de Lagenevais, "Le Salon de 1875," *Revue des Deux Mondes*, vol. 9, 1875, p. 927.

119:26–27 Record Book 1, p. 29; Record Book 2, p. 28, 174.

In 1889, when he submitted three paintings to the Salon, TE wrote the Secretary of the Treasury about getting them back through U.S. customs. Referring to the paintings he had sent to Paris in the 1870s, he wrote (March 11, 1889, SME 3): "I am an American citizen born here and a painter by profession. Some years ago I sent to France where I received my artistic education a number of my pictures and placed them for sale. Those remaining unsold after a period of two or three years, I ordered reshipped to Philadelphia, and they remained a year or so in the custom-house here (the appraiser's office I think.) while I tried to get them out. Many high authorities wise in the intricacies of the tariff were consulted without profit.

"I was shown a pleasing exception in the matter of exportation and reimportation of hog-bristles which would exactly suit my case if my pictures had been hog bristles instead of paintings.

"I was advised to inquire what express company had shipped them from N.Y. to France and what marks the box had on, and whether the remaining pictures came back in the same box with the same marks on it that the lot of pictures had been shipped in years gone by.

"After some difficulty I found the New York Co., Boas and Co., and they knew no more about the box than the man in the moon.

"Provision had been made for American artists residing abroad to send their pictures home without duty by taking out a certificate from the American consul abroad that the pictures were productions by Americans, and it was suggested to me that I might go to Paris and take out a certificate there, there being in this country no one empowered to give me one.

"The Secretary of the Treasury himself cut the Gordian knot by directing the Collector of Port of Philadelphia to deliver to me my pictures."

121:14 to 122:32 Letters to Shinn, FHL.

121:18–41 To Shinn, March 26, 1875. FHL. From the description in the letter, "the little picture" was evidently *The Schreiber Brothers*, 1874, oil, 15 × 22. The exhibition for which the varnishing day was April 6, 1875, must have been the 50th annual exhibition of the NAD, opening April 8.

121:43 to 122:32 TE's letter to Shinn is undated, but in view of his letter of March 26, 1875, and the fact that no work by him is recorded in the NAD exhibition of 1875, the undated letter evidently referred to rejection of *The Schreiber Brothers*. T. Addison Richards was corresponding secretary of the NAD.

5. *The Gross Clinic* and the Later 1870s

123:1–6 Letters to Shinn. FHL.

123:7 ff *The Gross Clinic* is discussed at length in: Ellwood C. Parry III, "Thomas Eakins and The Gross Clinic," *Jefferson Medical College Alumni Bulletin,* Summer 1967, p. 2–12; Gordon Hendricks, "Thomas Eakins's *Gross Clinic,*" *Art Bulletin,* March 1969, p. 57–64; Ellwood C. Parry III, "*The Gross Clinic* as Anatomy Lesson and Memorial Portrait," *Art Quarterly,* Winter 1969, p. 373–391; Neil Hyman, "Eakins' *Gross Clinic* Again," *Art Quarterly,* Summer 1972, p. 158–164; David Sellin, "1876—Turning Point in American Art," Fairmount Park Art Association *101st Annual Report,* 1973, p. 18–23; also Theodor Siegl, "The Conservation of 'The Gross Clinic,'" PMA *Bulletin,* Winter 1962, p. 39–62.

The successive titles of the painting have been: TE Record Book 1, *Portrait of Dr. Gross;* Record Book 2, *Dr. Gross;* SAA, 1879, *Professor Gross;* PAFA, 1879, *Portrait of Professor Gross;* World's Fair, Chicago, 1893, *Portrait of Dr. Gross;* Universal Exposition, St. Louis, 1904, *The Clinic of Professor Gross;* TE letter to Professor John Picard, University of Missouri, June 1907, *Clinic of Dr. Gross.* The first use known to me of *The Gross Clinic* was in the MMA and PAFA memorial exhibitions, 1917 and 1918. Since then that title has always been used, except in Hendricks' *Photographs* and his 1974 book, where it is called *Portrait of Professor Gross.* Although I believe that in general the earliest title of a painting should be used, if given by the artist, in this case TE gave several titles, and since his death the painting has been known as *The Gross Clinic.* A similar history applies to the title of *The Agnew Clinic.*

123:7–8 Description of *The Gross Clinic* by Dean Ross Vern Patterson, 1925; see note following. Letter to me from the Assistant Dean, May 21, 1931: "Upon examination of the records of the College, I find that Thomas Eakins studied anatomy in the Jefferson Medical College in 1873 and 1874." Letter to me from the Librarian, Joseph J. Wilson, Sept. 24, 1931: "Our records show that Thomas Eakins was registered as a student in 1873 and 1874."

123:16–23 The assisting doctors were identified as follows in "The Collection of Portraits Belonging to the College" by Charles Frankenberger, Librarian, in *The Jeffersonian,* Nov. 1915; and by a description of *The Gross Clinic* written in 1925 by Dean Ross Vern Patterson, pupil of the anesthetist, Dr. W. Joseph Hearn, who identified the doctors for Dean Patterson. The one probing the incision with a tenaculum is Dr. James M. Barton, Chief of Clinic, later Clinical Professor of Surgery in Jefferson. Dr. Daniel Apple is at the lower right holding the incision open with a retractor. The doctor in the center foreground holding the patient's legs is Dr. Charles S. Briggs, later Professor of Surgery of the University of Nashville, Tennessee. The anesthetist is Dr. W. Joseph Hearn, later Clinical Professor of Surgery in Jefferson. The clinic clerk is Dr. Franklin West. In the entrance is Dr. Samuel W. Gross, Dr. Gross's son and later his successor as Professor of Surgery in Jefferson. Behind him, in shirtsleeves, is Hughie O'Donnell, orderly in the college for many years.

Eakins' obituary in the *Philadelphia Inquirer,* July 2, 1916, said: "Mr. Eakins has included his own portrait, which is that of the man who leans, pencil in hand, upon the side of the entrance to the arena on the right." This obituary, for which Samuel Murray supplied much information, contains numerous errors. Neither SME nor any of TE's friends and pupils whom I interviewed in 1930–31 (including Murray) mentioned the above. Nor does it appear in *The Jeffersonian* article, Dean Patterson's description, or any later article on *The Gross Clinic,* except Hendricks' in the *Art Bulletin,* 1969, p. 60, and in his 1974 book, p. 88. After close examination of this figure, I feel that although there is a general resemblance to TE, it is not close enough to identify him definitely. (There is no such doubt about the self-portrait in *Max Schmitt in a Single Scull* or the portrait by SME in *The Agnew Clinic.*) In my opinion the identification remains an interesting possibility, but nothing more definite.

127:10–15 Ellwood C. Parry III, "Thomas Eakins and The Gross Clinic," *Jefferson Medical College Alumni Bulletin,* Summer 1967, p. 5, 7.

128:5–7 The Sartain Collection, Historical Society of Pennsylvania.

130:2–4 Letters to TE from the U.S. Treasury Department, May 13, 19, 1876, about reentry of the drawing through customs. SME 5.

130:12–17 *Philadelphia Evening Telegraph,* March 8, 1876.

130:18–19 The portrait sketch of Robert C. V. Meyers (G 93) is inscribed by him: "Study of R. C.

V. Meyers, for picture for Centennial Exhibition, painted by Thomas R. Eakins and presented by him to R.C.V.M. Dec. 25, 1875. Sitting of Oct. 10, 1875."

130:33 to 132:18 *Evening Telegraph*, April 28, 1876.

132:19 to 133:2 Clipping lent to me by SME; publication and date unknown.

133:5–13 *Evening Telegraph*, June 16, 1876.

133:20–21 Record Books 1 and 2: "Exhibited at Haseltine's after the close of the Centennial."

133:25–26 Record Book 2, p. 25, under "Dr. Gross": "Sold"; p. 174, under "Pictures Sold & c": "Gross 1878 $200."

134:7–9 SME 1; also see p. 170, 173.

134:34–40. 134:40 to 135:16 *New York Daily Tribune*, March 8, 22, 1879.

135:17–21 *New York Times*, March 8, 1879.

135:22–23 *New York Herald*, March 8, 1879.

135:24–29 *Daily Graphic*, March 8, 1879.

135:39 to 136:13 *The Nation*, March 20, 1879, p. 207.

136:15–17 *Art Journal*, American edition, May 1879.

136:17–18 *Art Interchange*, March 19, 1879, p. 42.

136:18–19 *Scribner's Monthly*, June 1879, p. 310.

136:21–27 S. G. W. Benjamin, *Art in America*, 1880, p. 210.

136:28–29 These clippings were preserved by SME, who lent them to me.

136:33 to 137:6 *Scribner's Monthly*, May 1880, p. 4, 12–13.

137:18–20, 22–23 Unidentified New York newspaper, May 2 or 3, 1879; clipping from SME, 1930.

137:24 to 138:3 TE's rough draft of a letter. SME 3. The draft included other repetitive phrases and sentences, mostly crossed out by TE.

138:16–17 *The Gross Clinic* had not been collected with the SAA's pictures in New York but had been brought to the PAFA by TE from the Haseltine Galleries, Philadelphia (letter from TE to George Corliss, PAFA actuary, May 4, 1879, with note by Corliss. PAFA). The PAFA directors and officers stated that the SAA had failed to send them a list of their exhibits. But *The Gross Clinic* had been the most talked-of picture in the New York exhibition.

138:29–31 *New York Times*, Feb. 25, 1951.

140:2–3 Interview with Dr. Brinton's son, Dr. Ward Brinton, 1930.

141:3–4 SME 1.

141:10 ff A detailed coverage of the Hayes portrait is "The Eakins Portrait of Rutherford B. Hayes" by Gordon Hendricks, *American Art Journal*, Spring 1969, p. 104–114; and his "Letter to the Editor," Fall 1971, p. 103.

141:16 Record Book 1, p. 39: "Portrait of President Hays. Ordered by the Union League $400." Record Book 2, p. 34: "President Hays. Ordered by The Union League Philada. Haseltine's. $400. Sold"; p. 174, under "Pictures Sold & c.": Portrait Rutherford Hays. 1878. $400."

141:17–19. 142:7–14 Rutherford B. Hayes Library, Fremont, Ohio.

141:21 to 142:5 SME 3.

142:17–29. 144:26–30 To Charles Henry Hart, Sept. 13, 1912. AAA.

142:32 to 143:3. 143:22–34 *Philadelphia Evening Telegraph*, Dec. 10, 1877.

143:4–18. 143:42 to 144:5 *Philadelphia Press*, Feb. 7, June 15, 1878.

144:7–16 Letters, June 15, mid-July, 1880. Rutherford B. Hayes Library.

144:32–33 SME told me that the Cochran Collection portrait was painted from a photograph, which she still had. She said that TE was not well, and she did a good deal of work on the portrait.

145:30 ff A detailed coverage of the various versions of the William Rush theme, in the 1870s and in 1908, is "Eakins' *William Rush Carving His Allegorical Statue of the Schuylkill*" by Gordon Hendricks, *Art Quarterly*, Winter 1968, p. 382–404. In this article and his 1974 book Hendricks used "Statue" instead of "Figure" in the title; in the book, p. 299, he said: "This one is the name Eakins gave it." Both of TE's Record Books call the 1977 version "William Rush Carving his Allegorical Figure of the Schuylkill." In its first and fourth known exhibitions, at the Boston Art Club, Jan. 1878, and the PAFA, Nov. 1881, "Figure" was used. In the second and third known exhibitions, at the SAA, March 1878, and the Brooklyn Art Association, April 1878, "Statue" was used. In exhibitions, illustrations, and published references since TE's death, "Figure" has been used.

146:2–39 This statement was written in TE's hand on a large sheet of cardboard. It was owned by SME in 1930 and was copied by me. She also had a typed copy, headed "William Rush. Copy of original writing by Thomas Eakins," with the following added: "The foregoing writing was done after Thomas Eakins finished his picture of William Rush carving the figure allegorical of the Schuylkill in 1877." Also in her possession was another hand-

written copy, with a few verbal differences; this was in a hand other than TE's, and was signed in the same hand, "Signed Thomas Eakins." The purpose of the statement is not known, but it may have been intended to be exhibited with the painting.

146:40 to 147:4 This shorter statement, evidently also by TE, was published in the catalogue of the PAFA "Special Exhibition of Paintings by American Artists, at Home and in Europe," Nov. 1881, with a line drawing by TE of the 1877 painting; the original drawing is now owned by the Hirshhorn Museum. The statement reads: "William Rush, the Ship Carver, was one of the earliest and one of the best American sculptors.

"At the completion of the first Philadelphia water-works at Centre Square, which is now occupied by the Public Buildings, he undertook a wooden statue to adorn the square, which statue was afterwards removed to the forebay at Fairmount, where it still remains, though very frail. Some years ago a cast of it was made in bronze for the fountain near the Callowhill Street Bridge.

"The statue represents the River Schuylkill under the form of a woman. The drapery is very thin, to show by its numerous and tiny folds the character of the waves of a hill-surrounded stream. Her head and waist are bound with leafy withes of the willow—so common to the Schuylkill—and she holds on her shoulder a bittern, a bird loving its quiet shady banks.

"This statue, often miscalled the Lady and the Swan, or Leda and the Swan, is Rush's best work, and a Philadelphia beauty is said to have consented to be his model.

"The painting shows, among other things, a full-length statue of Washington, intended for a ship's figure-head; a female figure, personating the water-power; and some old-fashioned ship scrolls of the time. The Washington is now in Independence Hall, and the female figure is on the wheel-house at Fairmount.

"The Academy owns casts of several of William Rush's portrait busts; among them a portrait of himself.

"A picture in the Academy, by Krimmel, an early Philadelphia painter, shows the original position of the forebay statue in Centre Square."

147:4–5 A much shorter statement appeared in the catalogue of the first exhibition of the SAA, New York, March 1878: "William Rush, ship carver, was called on to make a statue for a fountain at Central Square, on the completion of the first Water Works of Philadelphia. A celebrated belle con-

sented to pose for him, and the wooden statue he made, now stands in Fairmount Park, one of the earliest and best of American statues."

147:18–20 I have found no historical evidence for my statement that Louisa Van Uxem posed nude (National Gallery of Art, "Thomas Eakins: A Retrospective Exhibition," 1961, p. 19). Unfortunately this error has been repeated by some later writers.

148:4–6, 8–10 Henri G. Marceau, "William Rush," PMA, 1937, p. 26–29, 57–58.

148:14–16 TE's friend Mrs. Lucy L. W. Wilson told me in 1930 that she had been a close friend of Nannie Williams and had roomed with her, and that Miss Williams had posed for the Rush paintings. This was later confirmed to me by SME.

148:16 to 150:5 The story of Anna Williams as the model for the Morgan silver dollar and other coins is told in full in "The Mysterious Miss Liberty" by Walter Breen and Michael Turoff, Coins, Iola, Wisc., Oct. 1971, p. 62–67. I am indebted to Mr. Breen and Mr. Turoff for additional references: American Journal of Numismatics, Boston, April 1878, p. 107, quoting the Sunday Republic, Philadelphia, early 1878; New York Recorder Art Supplement, July 5, 1891; The Numismatist, May 1896, quoting the New York Mail and Express, 1896; Clifford Mishler, "The Goddess of Liberty," Coins, Aug. 1969, p. 28–30; letter by Michael Turoff, Coins, 1969; Cornelius Vermeule, Numismatic Art in America, Cambridge, Mass., 1971, p. 74–76.

The obituary of TE in the Philadelphia Public Ledger, June 27, 1916, said: "He was the designer of the woman's head on the standard dollar. Designated by Mr. Barber, of the United States Mint, to design a typical purely American girl head, he selected for his model the profile of his sister's friend, Miss N. Williams, a teacher in the Girls' High School, who later was the principal of the School of Practice, Girls' Normal School." SME wrote on a clipping of the obituary: "Thomas Eakins did not model the woman's head on the standard dollar, it does not in any way resemble his work. Eakins selected the model, Morgan employed in the Mint modeled the relief."

150:8–9 Record Book 1, p. 38, on Courtship, had attached a clipping of an unidentified, undated newspaper, with an illustration of the painting, captioned: "Miss Williams in a Painting. The illustration is made from a painting by Thomas Eakins, owned by Dr. Horatio C. Wood. The artist painted the girl from sketches made by him of Miss Williams."

186:5–7 Autobiographical manuscript by A. Stirling Calder. PAFA.

186:22–23 *Scribner's Magazine*, Sept. 1879, p. 739.

186:32–36 Interview with Thomas J. Eagan, 1930.

186:39–40 Interview with Francis J. Ziegler, 1930.

187:6–11 *Art Interchange*, Feb. 18, 1880, p. 32.

187:11–16 Robert Henri, *The Art Spirit*, 1930, p. 87.

187:23–29 Circular of the Committee on Instruction, 1882–83. A draft of the text in TE's hand is in the PAFA archives, as are detailed plans written by him for reorganization of the school.

187:34–35 Minutes of Board of Directors meeting, March 13, 1882.

187:39 to 188:2 76th Annual Report, for 1881–82.

188:4–5, 7–8 77th Annual Report, for 1882–1884.

188:16–18 *Art Journal*, American edition, Nov. 1881, p. 352.

188:19–20 Handwritten notes on "Professors' salaries" by TE, early 1882, PAFA. Dietrich account books, 1883–1885.

188:20–21 Letter from Anshutz to Wallace, Oct. 2, 1885: "Eakins has not got the Brooklyn school this year." WC. Dietrich account books, 1885.

188:22–31 Art Students' League of New York, Programme of Classes for Season of 1885–1886.

188:31–34 Correspondence in Art Students' League files. Dietrich account books, 1886–87.

188:35 to 189:9 *Art Interchange*, Dec. 3, 1885, p. 152. *Art Amateur*, Jan. 1886, p. 32.

7. The Early 1880s

190:1 to 196:23 The most complete coverage of *The Crucifixion* is "Thomas Eakins' 'Crucifixion' as Perceived by Mariana Griswold Van Rensselaer" by Lois Dinnerstein, *Arts Magazine*, May 1979, p. 140–145.

190:14–16 See p. 63.

190:23 to 191:12 That Wallace posed for *The Crucifixion* was told by him to me in 1938; also in 1930–31 by SME, Samuel Murray, and Francis J. Ziegler. The last, who also spoke of the preliminary posing in southern New Jersey, told me that TE said he had never seen a painting of the Crucifixion in sunlight, or one in which the figure was really hanging. An article by Curtis Wager-Smith in an unidentified Philadelphia newspaper in 1914 said that Wallace posed for the picture and that "the painter's desire was to represent the body of the Saviour as if it were really hanging on the cross." *Art Amateur*, June 1882, p. 2: "We are told that Mr. Eakins painted his picture out of doors, his model having been suspended on a cross erected on the roof of the artist's house in Philadelphia." McHenry, p. 53 (no source given): "Later he [Wallace] posed strapped to a cross on the roof of Eakins' third floor back studio while Eakins painted from the studio which formed the fourth floor at the front of the Mt. Vernon Street house." Schendler, p. xi, speaking of stories

about TE which may or may not be true, said: "I have heard, for instance, from a man who had known and photographed Eakins in his later years, that people in his neighborhood believed that the artist had strung up a corpse on the roof outside his studio for his Crucifixion."

Wallace told me that in the New Jersey posing TE simply photographed him, and that was all. However, Wallace was somewhat hipped on the subject of TE's using photographs too much; he spoke of this several times. The small oil study (G 143) of Wallace's head and shoulders in sunlight, owned by the Hirshhorn Museum, could of course have been painted at another time.

193:6–11 PMA *T.E. Coll.*, p. 89–90.

193:22–29 *Art Amateur*, June 1882, p. 2.

193:30–39 *Art Journal*, American edition, June 1882, p. 190.

193:40 to 196:3 *Evening Telegraph*, Nov. 1, 1882.

196:6–17 *American Architect and Building News*, May 20, 1882, p. 231.

196:24 to 198:42 For the information in this section on Mrs. Van Rensselaer and TE, I am indebted to Lois Dinnerstein's article in *Arts Magazine*, May 1979 (see note to 190:1 to 196:23). Mrs. Dinnerstein's presentation of Mrs. Van Rensselaer's

previously unpublished letters to Koehler gives a unique picture of TE as seen by a perceptive writer from a quite different background.

199:1 to 200:42 A thorough, comprehensive study of TE's illustrative work is "Thomas Eakins as an Illustrator, 1878–1881" by Ellwood C. Parry III and Maria Chamberlin-Hellman, *American Art Journal*, May 1973, p. 20–45. The authors include not only his illustrations proper, the wood-engraved reproductions of his paintings, and his students' illustrations for Brownell's article, but certain of his paintings and watercolors that have historical or literary content.

200:11–12 Joseph Pennell, *The Adventures of an Illustrator*, 1925, p. 57, 51–52.

200:31–35 Record Book 2, p. 174, "Pictures Sold, & c."

200:34–35 *Harper's New Monthly Magazine*, March 1879, p. 494.

200:39–42 AWCS, 11th annual exhibition, 1878, facing p. 22, "Study of Negroes." AWCS, 14th annual exhibition, 1881, "Spinning." PAFA, Special Exhibition of Paintings by American Artists, At Home and in Europe, 1881," ill. 24, "Mending the Net"; ill. 38, "William Rush Carving his Allegorical Figure of the Schuylkill." The original drawing for the last is in the Hirshhorn Museum. Of it Hendricks said, p. 320: "The figures surrounding the Nymph and the lettering are probably Charles Bregler's." But the 1881 illustration is of the drawing as it exists today.

201:32–33 Statement by Miss Harrison's daughter Mrs. Gorham Lynes, undated, after 1927.

206:14 to 207:8 Letter, A. B. Frost to Emily Phillips, June 2, 1882, owned by Henry M. Reed.

207:17–18 SME told me that the figures were Benjamin and a daughter, but did not say which daughter or identify the two other women. It seems probable that the two young women at the left were Margaret and Caroline, who were living at home in 1881. Caroline later became estranged from TE, which could have caused SME not to mention her. The heavier and probably older woman next to Benjamin may have been Aunt Eliza Cowperthwait.

Hendricks said, p. 148: "The artist depicted his mother, two of his sisters, and his father"; and, p. 343: "The figures . . . suggest Eakins' two sisters, his mother (posthumously), his father." No source for the statement as to TE's mother. If true, it is strange that SME did not mention such an extraordinarily uncharacteristic feature.

207:42 to 209:4 PMA *T.E. Coll.*, p. 93.

209:10 to 212:8 *The Meadows, Gloucester*, is not dated; it was first exhibited in Dec. 1884. A small oil study for it, undated, had on its verso an undated study for *Mending the Net*, 1881. None of the twenty-six landscape sketches are dated. Two of them (G 165A and 181) had versos of studies of horses for *The Fairman Rogers Four-in-hand*, 1879. Two other studies of horses for the latter painting (G 199A, 201A) were on the versos of studies for the oils *Arcadia* and *An Arcadian*, both probably 1883. All of which suggests that the landscape sketches were probably painted in the early 1880s, about the time that TE was painting his pictures of shad-fishing at Gloucester in 1881 and 1882.

212:9 ff The most comprehensive account of TE's sculpture is the catalogue of the Corcoran Gallery of Art exhibition, "The Sculpture of Thomas Eakins," by Moussa M. Domit, 1969.

213:23–31 Charles Bregler, "Thomas Eakins as a Teacher," *The Arts*, March 1931, p. 385–386.

213:39–40. 216:3, 7–8 SME 1.

216:25 to 218:40. 219:11–25 TE's copies of his letters to Scott were lent to me by SME, and copied by me.

218:42 to 219:17 Saint-Gaudens to TE, May 27, June 2, 1884; Sartain to TE, May 29, 1884. SME 5.

219:27–31 Dietrich account books, June 8, 1885, March 2, 1886, July 10, 1887.

8. The Middle 1880s

220:9–10 Hendricks, *Photographs*, #23–26.

220:13–17 SME 1, Mary Adeline Williams, and David Wilson Jordan, 1930.

220:17–18 Hendricks, p. 319, said of the bronze cast, now in the Hirshhorn Museum: "The hand may be that of Kathryn Crowell." SME told me that the cast, then owned by her, was of Margaret's hand; also that TE had made casts of his other sisters' hands (not seen by me).

220:21–24 Mary Adeline Williams, 1930.

221:1 ff The most complete account of Susan Macdowell Eakins as a person and an artist is the catalogue of the PAFA exhibition "Susan Macdowell Eakins," 1973, with text by Seymour Adelman and Susan P. Casteras. Much of the biographical information about Mrs. Eakins in this book is based on it.

221:1 Hendricks, *Photographs*, p. 4, note 27: "She is generally called Susan Hannah, but the family Bible entry, in her own hand, puts 'Hannah' before 'Susan.'" In his 1974 book, p. 106, Hendricks said: "a young woman named Hannah Susan Macdowell—or Susan Hannah Macdowell as she sometimes wrote it." He did not repeat the statement about the family Bible, but he called her Hannah Susan throughout the book.

Actually the entry in the family Bible, owned by SME's grandniece Mrs. Peggy Macdowell Thomas, reads: "Susan Hannah Macdowell, born in Philadelphia on 21st of September, 1851." Her letter to Fairman Rogers, Nov. 2, 1877, was signed "S. H. Macdowell," as were signed works before her marriage. The two paintings illustrated in *Scribner's*, Sept. 1879, were captioned: "By Susan H. Macdowell." After her marriage she signed her pictures (when she did): "S. M. Eakins" or "S.M.E." Her numerous letters to Bryson Burroughs of the Metropolitan Museum from 1917 on, and to me from 1930 on, were signed "Susan M. Eakins" or "S. M. Eakins."

221:1 to 222:20 SME 1.

223:3–4 *Philadelphia Public Ledger*, Jan. 21, 1884. McHenry, p. 41: "The home wedding was witnessed by Friends in the usual Quaker manner" (no source given). McHenry may have heard this from Mrs. Helen Parker Evans, who wrote Sylvan Schendler, Sept. 26, 1969: "Your book did not lay stress on the fact that they [the Thomas Eakinses] were Quakers. They were married in the parlor of their home, with only the families present, with the simple Quaker service, I guess, just saying 'Susan and Thomas you are now married'!"

The Eakins family were not Quakers. TE's grandfather Alexander Eakins was a Protestant but not a Quaker. Benjamin taught at Friends' Central School, but was not a Friend. Mrs. Benjamin's father Mark Cowperthwait was a Quaker, but his wife was not, and their daughter was not brought up as a Quaker. TE himself was an agnostic. William H. Macdowell was a freethinker, and his daughter Susan never mentioned Quakerism to me. Thomas and Susan were evidently married simply, at her home at 2016 Race Street, but a Quaker service is very unlikely.

223:6–9, 17–19 TE to J. Laurie Wallace from 1330 Chestnut Street, Feb. 27, 1884: "Sue and I are married and we live in Frost's old rooms on Chestnut St. We are very comfortable so far, and will be happy unless sickness should overtake us. . . . Sue sends you her love with mine." WC. This, like his letter to Sue of Sept. 9, 1879, indicates a previous intimacy, understood by close friends and pupils.

223:9–17, 19–21 Dietrich account books, 1884.

223:30–31 Interview with Mrs. Stanley Addicks, May 21, 1931: "My Susie is the best woman painter in America."

223:37–38 Susan Macdowell's watercolor *Chaperon*, signed "S. Macdowell / 1879," owned by R. Lee Mastin, Roanoke, Va., shows a figure identical, down to details, with that in TE's watercolor *Seventy Years Ago*, dated 1877 (G 114), except that the former does not show the whole figure as the latter does. In both watercolors the figure is seen from exactly the same angle. In view of this, and the two years difference in dates, it seems probable that she copied his watercolor.

224:3 to 227:17 Discussed in detail in "The Thomas Eakins Portrait of Sue and Harry; Or, When Did the Artist Change His Mind?" by Ellwood C. Parry III in *Arts Magazine*, May 1979, p. 146–153.

224:15–17 *Book of American Figure Painters*, J. B. Lippincott Co., Philadelphia, October 1886. Introduction by M. G. Van Rensselaer. Foreword: "With scarcely an exception they [the paintings illustrated] date no further back than the present year." The painting, *The Artist's Wife and His Setter Dog* (G 213), in the MMA, is not signed or dated.

Dietrich account book, Sept. 10, 1886: "Cash 100—/ to portrait of Sue & Harry / from J. B. Lippincott / for privilege of photographing, 100—." From this it is evident that the reproduction was made from a photograph of the painting in an earlier state, and that TE later worked more on it. The unusually heavy pigment proves that he worked long on it.

In *Art Quarterly*, Summer 1946, p. 223–224, Wallace S. Baldinger said: "Judging by her appearance in the present painting, some ten years after completion of the original portrait in 1885 [sic], Mrs. Eakins posed again for her husband in the same chair and the same dress. Illness during the interim may account for her pinched features and her careworn expression, the droop of her head and her thinner hair"; and he illustrated the painting in its present state as "final state, middle 1890's."

There is no evidence as to when TE worked further on it; almost certainly not as late as the middle 1890s, since he exhibited it in May 1887, May 1889,

and Dec. 1892. Nor is there any evidence for SME's supposed illness or the other circumstances alleged by Baldinger.

Fairfield Porter in *Thomas Eakins*, 1959, p. 28, spoke of the portrait as "a repainting after ten years of the first version," the latter referring to the 1886 reproduction.

Hendricks, p. 168: "In 1885 . . . Eakins produced the remarkable portrait of his wife with his dog Harry, and the following year a wash copy of it for reproduction in Lippincott's *Book of American Figure Painters*. There are interesting variations between the original and the copy." The entry in the Dietrich account book disproves this statement, and no such "copy" by TE has been found. Nor did Hendricks account for the fact that the sitter in the "copy" is younger than in the "original."

At least one other painting reproduced in the book, Winslow Homer's *Lost on the Grand Banks*, was later repainted extensively by the artist.

224:39 to 227:13 An interesting feature of the painting is its resemblance to Whistler's *Lady of the Lange Lijsen*, 1864, now in the John G. Johnson Collection, PMA. The two women are in similar poses, their left hands resting in their laps; one holding a Japanese picture book, the other a vase which she is painting. They are seen from the same angle. In both pictures the light is from above and to the right (in the Eakins, more overhead). In both there is a warm golden background extending from the left edge to within a quarter of the picture's width, at the right. The sizes are not far apart: the Eakins 30 × 23, the Whistler 36¼ × 24¼.

TE knew John G. Johnson, to whom he gave a watercolor in 1887. So the above resemblance would seem to be made to order for a doctoral dissertation. But unfortunately, the Whistler was not acquired by Johnson until 1893, and up to then was in a private collection in England. Unless there is evidence that the Whistler was exhibited in the United States before 1886, the resemblance would seem to be coincidental.

227:18 ff A full account of the Crowell family at Avondale and TE's relation to them is in McHenry, p. 91–100. McHenry in the early 1940s interviewed several family members, children of William J. and Frances Eakins Crowell, who "were generous with their knowledge of Eakins"; in her text she cites Benjamin, William, Jr., Arthur, and Frances. Murray also gave her information.

The most complete coverage of TE's connection with Avondale is the catalogue of the exhibition "Eakins at Avondale" at the Brandywine River Museum, Brandywine Conservancy, Chadds Ford, Pa.,

March 15-May 18, 1980, with text by William Innes Homer and seven of his graduate students.

Hendricks' statements, p. 195, that "the children remember that Uncle Tom did not pay much attention to them," and "none of the children remember Murray," do not agree with McHenry's earlier account.

229:11–35 McHenry, p. 91–92.

230:19–21 Of all the known Arcadian paintings and reliefs, only two—the reliefs *Arcadia* and *A Youth Playing the Pipes* (G 506, 508)—were dated: 1883 on the original plasters, erroneously changed to 1888 on the bronzes cast in 1930. However, the Dietrich account book lists expenses in 1884 on "Panel Piper" or "Panel of Piper": June 30, $20.27; July 31, $21.; Aug. 31, $10.; and from Sept. 8 to Dec. 31, $11. If this was G 508, as seems likely, TE probably began it in 1883 (based on the date on the plaster) and continued to work on it in 1884. The account book does not include any references to the *Arcadia* relief or the Arcadian paintings.

The model for the nude young man playing pipes, seated in the relief *Arcadia* and standing in the oil *Arcadia*, was Wallace. TE photographed him, nude, outdoors, in the same poses (Hendricks, *Photographs*, fig. 47, seated, and fig. 45, standing) and painted a small oil study of him standing (G 198); these photographs and the oil study were used in the relief and the large oil. Wallace left Philadelphia for good in Dec. 1883. The foregoing facts, and the 1883 date on the relief *Arcadia*, indicate that the relief and the large oil were at least conceived in 1883, probably in the summer, since the photographs and the oil study of Wallace could not have been made in cold weather.

Wallace was not the model for the relief *A Youth Playing the Pipes*, and the figure's pose, although generally similar to that in other photos of him, is not the same. TE may have commenced the relief with Wallace as the model, but after the latter's departure, continued it with another model.

A third relief, *An Arcadian* (G 507), undated, is of a young woman in the same pose as one in the relief *Arcadia*.

In view of the close relation in subjects, figures, and poses between the two dated reliefs and the other Arcadian paintings and sculpture, it seems probable that all the Arcadian works were conceived or commenced in 1883, probably that summer.

230:26–34 *Specimen Days*, Philadelphia, 1892; written Aug. 27, 1877.

233:17–21 Hendricks, p. 151: "Chalkmarks originally at the right in *An Arcadian* indicate that

the young woman on the greensward was initially intended to be listening to such a figure as the standing youth in *Arcadia*. But the artist became so involved in the figure of the woman that when he finished it he knew that any possible introduction of the youth would have been disjointed; to get him into the proper perspective he would have had to have been a midget. A photograph of the youth planned for *An Arcadian* and actually introduced into *Arcadia*, and a photograph for the reclining pipes player of *Arcadia*, were taken by the artist (Figs. 129 and 130)."

The youth in *Arcadia* and in the photograph is standing. The chalk marks formerly in *An Arcadian* (G 200) were of a seated figure similar to the youth playing pipes in the relief *Arcadia* (G 500). This figure would have been in correct scale with the figure of the woman. Eakins did not make mistakes of this kind in "perspective."

236:8–9 Letter, Jan. 8, 1965, from TE's niece Dr. Caroline Crowell, who owned the sketch, to M. Knoedler & Co.: "My mother, Thomas Eakins' sister said that she thought that it was a preliminary sketch of 'Ouida Cook.' I am not sure of the spelling of her first name—she was always just called 'Ouida Cook.' It was her thought that it was a preliminary sketch for a larger painting."

236:28–34 SME 2, June 5, 1931.

239:1–3 WC.

239:3 ff The Dietrich account books contain thirteen entries for expenses on "Swimming picture" in 1884 and 1885. The first, July 31, 1884, is for "Phot. expenses," $2.30, and "Car fare to Bryn Mawr & boat houses with Godley & brother," $3.30. This is followed in 1884 by: Aug. 31, $1.48, not specified; and Dec. 31, "Swimming picture from Oct. 19," $9. In 1885: Jan. 31, "to model," $9; Feb. 28, $2.50, not specified; April 30, "to Models," $7; May 31, "paint & brushes," 78¢; May 31, "to Models," $6; and Aug. 31, $2.50, unspecified. The first known exhibition was in the PAFA 56th annual exhibition, Oct. 29–Dec. 10, 1885: "Swimming. Property of Edward H. Coates." The Dietrich account for Dec. 5, 1885, records: "Cash, $800, to Picture Pathetic Song. Mr. Coates having ordered the swimming picture prefers the Pathetic Song which is given him in exchange."

"The swimming picture," curiously enough, was not recorded in either of TE's Record Books. Also he is not known to have exhibited it more than twice. Perhaps this was connected with the nakedness of the young men, his students and friends, and the trauma of his forced resignation as director of the PAFA schools in 1886.

239:5–9 Bregler, who studied under TE at the PAFA and the Art Students' League of Philadelphia from the early 1880s through the early 1890s, identified the figures in *The Swimming Hole* as follows: the standing figure, Jesse Godley, sculptor, whose "life ended at an early age"; the diver, George Reynolds, landscape painter, first curator of the League, whose portrait by TE is called *The Veteran* (G 211); the boy half out of the water, Benjamin Fox, painter. "These were students of Eakins, the other two friends." Bregler stated that the reclining figure was the man (whom he did not identify) walking in the motion photograph illustrated in the *Magazine of Art*, Jan. 1943, p. 29. In the water are Eakins and Harry (Bregler in *The Arts*, March 1931, p. 377, and Oct. 1931, p. 29, 33; Bregler's letter to Henri G. Marceau of PMA, April 20, 1943, PMA; label by Bregler on the verso of *The Swimming Hole: Study* (G 191) in the Hirshhorn Museum).

But McHenry said, p. 54: "He [Wallace] is one of the swimmers in 'The Swimming Hole'" (no source given for this statement). And Hendricks, p. 160: "J. Laurie Wallace—and A. B. Frost, George Reynolds, Jesse Godley . . . were all pictured in . . . *The Swimming Hole*"; p. 349: "Left to right: Jesse Godley?, Arthur B. Frost? unidentified model, J. Laurie Wallace, Harry, George Reynolds?, Eakins" (no sources given for these statements).

Wallace left Philadelphia in Dec. 1883. TE's letter to him, Feb. 27, 1884, and Anshutz's letters, June 18 and Aug. 7, 25, show that he was not in Philadelphia in those months. Anshutz in his Aug. 25 letter would not have written "Eakins is painting a picture for Mr. Coates of a party of boys in swimming" if Wallace had been one of them.

Frost was thirty-three in 1884. He was married in Oct. 1883, and moved to Huntington, N.Y. TE and SME settled in his Chestnut Street studio in Jan. 1884.

Regarding the reclining figure, who Bregler said was the man (unidentified) walking in the *Magazine of Art* photograph, Hendricks in his *Photographs* illustrated this photo (fig. 105) and identified the model as Jesse Godley. But Bregler stated that Godley was the standing figure.

243:3–4 Bregler in *The Arts*, Oct. 1931, p. 40. Adam Emory Albright, "Memories of Thomas Eakins," *Harper's Bazaar*, Aug. 1947, p. 139: "He modeled the figure of the diving boy in plastiline and put a spindle through the middle of the figure so that it could be turned upside down and hold the pose."

9. Photography: Still and Motion

244:28 Illustrated: a motion photo of a boy leaping, illustrated in *Animal Locomotion*, 1888, p. 14; and a portrait photo of Walt Whitman, illustrated in two volumes of Whitman's works, Boston, 1898, and in John Burroughs' *Whitman: A Study*, Boston and New York, 1896.

245:9–11 Dietrich account book, Jan. 1883.

246:7–10 Olympia Galleries, Ltd., *Thomas Eakins: 21 Photographs*, 1979. Introduction by Seymour Adelman, p. xiv.

247:15–18 Sotheby Parke Bernet, Sale 4044B, Nov. 10, 1977, "The Olympia Galleries Important Collection of Photographs by Thomas Eakins," Introduction [by Anne Horton].

251:39–40 Regarding TE's photograph of Frank Hamilton Cushing (H 217) and his painting of Cushing (see Vol. II, p. 131–135), Van Deren Coke wrote in *The Painter and the Photograph from Delacroix to Warhol*, 1964, p. 45: "Eakins altered only minimally his snapshot of Frank Hamilton Cushing, when painting his portrait. Eakins wanted to paint the prominent archaeologist standing, so as to show to full advantage the magnificent Western dress worn by his subject. But Cushing had been seriously ill and could not stand in one pose for long periods of time, which may explain in part why Eakins used the photograph as a convenience when painting Cushing. The Western regalia was intricate, and by following the photograph Eakins undoubtedly found it easier to reproduce the effect of light on the garment's many details and folds" (no source given for these statements).

Hendricks, *Photographs*, p. 208: "Eakins painted Cushing's portrait, the head and bust of which were taken directly from this photograph in 1895. Cushing was ill, and possibly the photographs saved him from longer sittings. The portrait, now in the Thomas Gilcrease Institute in Tulsa, is unfinished." Hendricks, 1974, p. 228: "Eakins' portrait is a close transcription of a photograph (Fig. 241) because Cushing was too ill to pose for long." These statements and Coke's have been repeated by other writers.

It is true that Cushing had been ill for some years, but I have found no evidence that he curtailed his posing because of illness. McHenry, p. 112–114, gives a detailed account of Cushing and the portrait, based on information from Samuel Murray, who shared TE's studio; but she does not mention any curtailment or the use of a photograph. The same is true of Bregler, who wrote me an account of being with Cushing and TE when the portrait was being painted. Cushing was much interested in the portrait, and he and TE took unusual care preparing the setting. Cushing posed in his elaborate dress as a Zuñi Priest of the Bow. Though the portrait is full-length, the photograph is only half-length, omitting Cushing's legs with decorated buckskin leggings, and his quiver of arrows. The photograph is badly out of focus, so that the details are blurred. The painting is entirely clear in its details, showing many details that in the photograph are unclear or missing. Far from being unfinished, the portrait is one of TE's most detailed and finished works. It is evident that he took the photograph (and two others in different poses) not to copy, but as a parallel visual record, like many of his portrait photographs.

260:23 ff The Muybridge work at the University of Pennsylvania and TE's part in it are covered fully in "Eakins, Muybridge and the Motion Picture Process" by William I. Homer, with the assistance of John Talbot, *Art Quarterly*, Summer 1963, p. 194–216. Also see Gordon Hendricks, "A May Morning in the Park," PMA *Bulletin*, Spring 1965, p. 48–64; Hendricks, *Photographs*, p. 6–8; Hendricks, 1974, p. 211–217; Hendricks, *Eadweard Muybridge*, 1975, p. 111, 113–114, 149, 152–176.

The section on the subject in my 1933 book, p. 65–70, contains a number of errors, particularly in giving too much credit to TE for originating technical methods, and too little to Muybridge.

263:4–21 *Art Interchange*, July 9, 1879.

263:23–28 SME 5.

263:31–43 TE's draft of a letter to Muybridge, undated, on the same sheet as the draft of a letter to George S. Pepper, about May 3, 1879 (p. 137, 138). SME 3.

264:8 ff The most complete account of the painting is Hendricks' in PMA *Bulletin*, Spring 1965.

264:10–12 Letter to the PMA, Feb. 11, 1930, from Mrs. William Alexander Dick, wife of Mrs. Rogers' nephew, when Mr. Dick gave the painting to the PMA.

264:15–16 Record Book 2: "Coaching Picture ordered by Fairman Rogers (finished Jan 1880). $500. 'A May Morning in the Park.'" This was TE's title for it in its three exhibitions in 1880 and

1881. In the MMA and PAFA memorial exhibitions, 1917–18, the title was *The Fairman Rogers Four-in-Hand.*

264:28–29 TE visited Newport at least twice: in mid-June 1879 (William Sartain letter to his mother, June 14, Sartain Collection, Historical Society of Pennsylvania); and early Sept. (TE letter to Susan Macdowell, Sept. 9, Hirshhorn).

266:3–14 *British Journal of Photography,* 1891, p. 677.

266:17–19 *Philadelphia Daily Times,* Nov. 24, 1880.

268:2–4 *Philadelphia North American,* Nov. 19, 1880.

268:29–40 *Animal Locomotion: The Muybridge Work at the University of Pennsylvania,* 1888, p. 5–7.

269:29–30 Marey's articles on his cameras, 1882 and 1883, are listed by William I. Homer in *Art Quarterly,* Summer 1963, p. 214, notes 16, 17.

269:35–41. 270:2–7. 272:3–7. 275:19–21 Letters from Anshutz to Wallace, who had settled in Chicago. WC.

270:9 to 272:2. 272:11–17 TE's original record of his motion photography was lent to me by SME. I made fairly full notes on it but did not copy the entire record.

272:3–7 Anshutz's use of the word "yard" led Hendricks in *Photographs,* p. 8, 203–204, no. 87–121, to suggest that the 1884 motion photographs were taken in the backyard of 1729 Mount Vernon Street. But TE's own record of his 1884 photography makes no reference to such a site; on the contrary, it makes frequent references to his photographing at Muybridge's shed at the University.

272:8–10 Dr. Harrison Allen of the University of Pennsylvania, to TE, Oct. 6, 1884. SME 5. Dietrich account book, Jan. 20, 1885.

272:11–14 Statement written by TE, undated,

probably Aug. 1884, about the making of two disks, by M. B. Allebach, watchmaker, in Aug. 1884. SME 3.

272:19–20 William Pepper to TE, March 20, 24, 1885. SME 5.

272:23–24 Letter from Bregler to Henri G. Marceau, PMA, April 20, 1943. PMA.

274:5–6 *La Nature,* April 22, 1882.

275:6–18 Edward H. Coates to TE, June 19, 1885. SME 5.

275:22–34 Pepper to TE, Oct. 15, Nov. 16, 1885. SME 5.

275:34–37 Hendricks in the catalogue of the PAFA exhibition "Thomas Eakins: His Photographic Works," 1969, p. 52, and p. 73, #118; in his *Photographs,* fig. 114 and p. 204; and in his 1974 book, fig. 204 and p. 217, stated that the notations of information about exposures, scale, etc., on this photograph were made by Muybridge. However, the information is such as the photographer would record at the time of taking the photograph; the writing resembles TE's; and the notations are signed "E," which would stand more probably for "Eakins" than for "Eadweard."

275:39–41 The Dietrich account books for 1884 and 1885 contain thirteen entries for expenses paid by TE, marked "Marey wheel," from June 30, 1884 ("Tools used in making quick shutter for Marey & Muybridge photos," $23.09), to Sept. 17, 1885. They total about $950, of which the University Commission reimbursed him for $814.85.

276:14–20 Muybridge, *Descriptive Zooproxography,* Philadelphia, 1893.

276:26–27 Coates to Pepper, Sept. 27, 1886. Pepper manuscript collection, University of Pennsylvania Library.

278:5–10 Bregler to Marceau, April 20, 1943. PMA.

10. Teaching, 1886 to 1895: The Academy and the League

279:19 to 280:18 Information about sales, commissions, asking prices, and amounts received, from Record Books, the Dietrich account books, and exhibition catalogues.

280:28 Letter from MMA to TE, March 22, 1881. SME 5.

280:30 to 281:9 Dietrich account book for 1883.

281:11–18 Rogers to TE, Nov. 9, 1883. SME 5.

281:21–33 PAFA archives.

281:34 The Dietrich account books list PAFA

salary payments of $100 a month from April 8, 1885, through Feb. 1886.

282:33 to 284:13 This letter is quoted in full by Schendler, p. 90–92.

284:37 to 285–14 TE's former men students whom I interviewed in 1930–31 gave differing versions of the incidents that caused his confrontation with the PAFA directors. Some spoke of his posing nude models of both sexes together (this version was given by Bregler in *The Arts*, March 1931, p. 380). Some spoke of his removing a male model's loincloth. Only two had been in the PAFA in 1886, forty-five years earlier; and they could not of course have witnessed any incident in a women's life class.

On the other hand, the newspaper accounts in Feb. 1886 state that the cause was TE's "unnecessary exposures of subjects in the anatomical class," "advocating in the life class the absolute study of the nude model," and "compelling the women to face the absolute nude." That this was the immediate issue is confirmed by the statements, reported in the newspapers, by the students who protested TE's resignation; the most explicit of these statements was that of H. T. Cresson, first president of the seceding Art Students' League of Philadelphia.

This was the same issue that was the cause of the 1895 incident at the Drexel Institute, and probably at the NAD in 1894.

285:16–32 Draft of letter, Oct. 27, 1888, to "Mr. E. Mitchell" of the Art Students' League of New York. SME 3. "E. Mitchell" was actually Edith Mitchell, the League's corresponding secretary.

285:38 to 286:2 Minutes of Board of Directors meeting, Feb. 8, 1886.

286:3–10 PAFA archives.

286:11 ff The Philadelphia newspapers published full accounts of the PAFA affair in Feb. 1886. These accounts agreed as to content, and often in wording. They included the following: *Evening Telegraph*, Feb. 15; *Evening Bulletin*, Feb. 15, 16, 18, 19 (editorial), 24; *Evening Call*, Feb. 18, 19; *Evening Item*, Feb. 18, 22; *Inquirer*, Feb. 19; *North American*, Feb. 17, 20; *Press*, Feb. 15, 16, 19 (editorial); *Public Ledger*, Feb. 22; *Record*, Feb. 17, 21.

286:11 to 287:25 *Press*, Feb. 15, 16.

287:26–42 *Evening Bulletin*, Feb. 16.

288:1–10 PAFA archives.

288:12–24, 27–32 *North American*, Feb. 18.

288:36 to 289:12 *Press*, Feb. 19.

289:13–22 *Evening Item*, Feb. 22; quoted more fully in PMA *T.E. Coll.*, p. 123.

289:29 to 290:36 *Evening Bulletin*, Feb. 19.

290:43 to 291:15 *Art Interchange*, Feb. 27, p. 69, signed "C."

291:17–23 Letter Feb. 23. WC.

291:27–40 PAFA archives.

292:5 to 293:24 David Sellin in the catalogue of the exhibition, "Thomas Eakins, Susan Macdowell Eakins, Elizabeth Macdowell Kenton," North Cross School, Roanoke, Va., 1977, p. 36–41, gives a full account of the Sketch Club Affair, based on club records not previously published. I am indebted to Mr. Sellin's research for my account of the affair.

293:28 to 294:3 Letter, undated; and statement dated March 25, 1886. PAFA.

294:10–13 Letter June 24, 1886. WC.

294:14–24 PAFA, 80th Annual Report, Feb. 1886 to Feb. 1887.

295:13–16 *Record*, Feb. 24, 1886.

295:16–17 Interview with Bregler, 1930.

295:18–20 SME 2.

295:22–26 Circular, "Art Students' League / Philadelphia / Season of 1886–87," Hirshhorn Museum. Hirshhorn *T.E. Coll.*, p. 120–121, illustrated. McHenry, p. 71, said that Bregler "cherished a piece of folded foolscap" with this statement written in TE's hand.

295:27–31, 37 to 296:5 The Edward W. Boulton record was preserved by him and his family. It was sold at auction by Sotheby Parke Bernet, New York, Sale 4044B, Nov. 10, 1977, and purchased by Lorraine Seraphin. I am indebted to Miss Seraphin for her generous permission to make a photocopy of the record and to use information from it.

Aside from the Boulton record, other League records known to have been preserved are: Circular, season of 1886–87, two copies in the Hirshhorn Museum; Hirshhorn *T.E. Coll.*, #59, ill. p. 120, 121. Circular, season of 1887–88, lent to me by SME, and copied in part by me in handwriting. Circular, season of 1889–90; copy in the MMA. Circular, season 1891–92, lent to me by SME, and copied in part by me in handwriting. Circular, season of 1892–93; copy in the Hirshhorn Museum; Hirshhorn *T.E. Coll.*, #63, ill. p. 125. Program, "Third Annual Riot," Feb. 22, 1889; copy in the Hirshhorn Museum; Hirshhorn *T.E. Coll.*, #62, ill. p. 124. Program, "Sixth Annual Round-up," Feb. 21, 1891; copy given to me by SME.

296:6–18 League circulars, as above.

296:20–22 Oral information from Bregler, Frank B. A. Linton, Samuel Murray, James L. Wood, Francis J. Ziegler. Obituary in *Philadelphia Inquirer*, July 2, 1916.

296:29–35 McHenry, p. 67–68.

296:36–40 *Art Interchange*, June 19, 1886, p. 195.

296:40 to 297:2 Oct. 22, 1888. WC.

297:3 to 298:3 Boulton record, as above.

298:24 to 300:18 Interviews with Murray, 1931. McHenry, p. 104–105. League anniversary party programs, 1889, 1891. (The third party being in 1889, and the "Sixth" two years later, suggests that someone, possibly Schenck, lost count.)

298:39 Dietrich account book, Dec. 31, 1884.

299:1 to 300:18 Information about Schenck from Murray, 1931; McHenry, p. 103–105, based on information from Murray.

300:19–21 Nelson C. White: "Franklin L. Schenck," *Art in America*, Feb. 1931, p. 84–86.

300:21–24 Catalogue of Schenck exhibition, Macbeth Galleries, New York, 1928.

304:4–7 Letter, W. D. Hawley, corresponding secretary of the League, to TE, Dec. 22, 1886. League archives.

304:8–11 Letters [Miss] E. Mitchell, corre-

sponding secretary of the League, to TE, Oct. 23, Dec. 8, 1888. Minutes of Board of Control meeting, Dec. 6, 1888. League archives. I am indebted to Lawrence Campbell for excerpts from these and the following minutes.

304:11–13 Draft of letter, Oct. 27, 1888, to "Mr. E. Mitchell." SME 3.

304:17–24 Minutes of Board of Control meetings, Dec. 28, 1888, May 21, 1889. League archives.

304:29–35 Minutes of Board of Control meetings, April 8, 14, 1890. League archives.

304:40 to 305:12. 306:20 to 307:19 *New York Sun*, March 18, 1895, in a report on the Drexel Institute affair of 1895.

305:13–36 SME 5.

305:37 to 306:11 Draft of letter, Dec. 22, 1894, with changes. SME 3.

307:21–40 *Philadelphia Evening Item*, March, n.d., 1895.

307:41 to 308:1 *Philadelphia Times*, March 14, 1895.